OUTSIDER ART
SOURCEBOOK

ART BRUT • FOLK ART • OUTSIDER ART

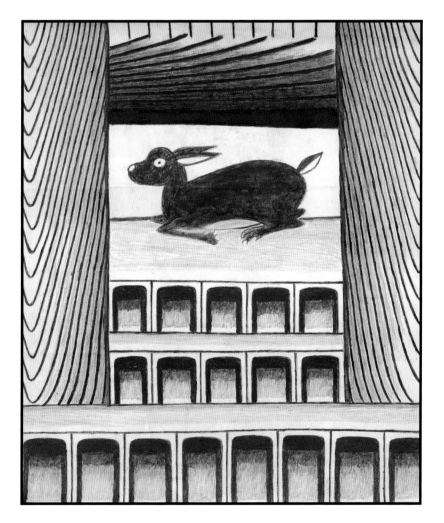

RAW VISION

Editor
John Maizels

Senior Editor
Julia Elmore

Sub Editor
Helen Banks

Design
Maggie Jones

Editorial/Production
Roger Cardinal
Laurent Danchin
Ted Degener
Nuala Ernest
Larry Harris
Kelly Ludwig
David Maclagan
Lucy Maizels
Carla Goldby Solomon
John Titone

Outsider Art Sourcebook
published by Raw Vision Ltd
PO Box 44, Herts WD25 8LN, UK
© Raw Vision Ltd, 2009
ISBN 978 0 9543393 2 6

Cover Image
Martin Ramirez, untitled.
Ricco/Maresca Gallery, copyright on this work is
retained by the Estate of Martin Ramirez.

OUTSIDER ART
SOURCEBOOK

Outsider Art – a short introduction

The first inkling of the existence of Outsider Art emerged from the work of a few enlightened psychiatrists in the mid and late nineteenth century. Gradually it became clear that a few psychiatric patients were spontaneously producing artworks, often on found small scraps of paper, of unusual quality and power. By 1922 Dr Hans Prinzhorn in Heidelberg, Germany, published the first serious study of psychiatric works, *The Artistry of the Insane*, after amassing a collection of thousands of examples from European institutions. Both book and collection received considerable attention from avant garde artists of the time and the influence on such figures as Franz Marc, Paul Klee, Max Ernst and Jean Dubuffet has been much documented. They were fascinated and inspired by an art that was produced without any influences from the modern art world yet seemed highly original, compelling and contemporary. At the same time Dr Walter Morgenthaler published the first study of work by a single psychiatric patient, Adolf Wölfli, an inmate at his Swiss asylum. Wölfli worked for 30 years in a small cell producing huge drawings which he bound in 45 vast tomes accompanied by an ornate script recounting his travels, exploits and calculations, a depiction of a whole alternative reality from the sadness of his tragic life.

It was Jean Dubuffet who realised that spontaneous, original and uninfluenced creation was not just the preserve of the mentally ill. Shortly after the end of WWII he embarked on a lifetime crusade to collect and study works by all kinds of people who were able to work in this way. None were professional artists or had contact with the art world and all were completely untrained. They included mediums, isolates and fierce individualists as well as psychiatric patients. For the first time, a name was given to this genre 'Art Brut'. By this Dubuffet meant art that was raw, 'uncooked' by culture, an art that was at its most pure, its most powerful and its most meaningful. It was an art produced entirely for individual satisfaction and inner need with no regard to exhibition, fame or monetary reward. Dubuffet's collection, eventually numbering many thousands of pieces, was established at the now famous Collection de l'Art Brut museum in Lausanne, Switzerland, in 1979.

As knowledge and awareness of Art Brut spread, so did its parameters and the first study in English, by Roger Cardinal, appearing in 1972, presented the term 'Outsider Art'. There were soon major discoveries made in the United States too, with the work of the reclusive Henry Darger only coming to light close to his death in 1973. His one-room lodging was found to reveal work of the previous 30 years: 87 large scale drawings depicting epic battles between cruel soldiers and brave children suffering terrible ordeals, which was accompanied by a text so long that it would take many years to read it all.

The United States has long respected its indigenous folk crafts and vernacular art and found it easy to accept such works as the economical drawings of ex-slave Bill Traylor, or the striking visual sermons of Rev. Howard Finster, which found ready acclaim. One of the few great American discoveries with a hospital background, Martin Ramirez, was found by his doctor to be hiding bits of drawings in his clothes to prevent the usual daily clearout of what was considered trash. After being given proper materials and allowed to preserve his creations, he went on to produce a huge quantity of work based on both a depiction and an abstraction of his Mexican background and culture. A recent discovery of almost 150 unknown works by Ramirez in a California garage has caused a sensation.

The discovery of large scale environmental works by self-taught builders and sculptors has also been very significant. André Breton was photographed at the massive structure built by country postman Ferdinand Cheval in southern France, the Palais Ideal, the first of many discoveries of sculptural and architectural creations by 'ordinary geniuses'. Since the saving of the Simon Rodia's Watts Towers in Los Angeles in 1958, hundreds of similar creations have been found around the United States, and France, too, has many extraordinary examples. Sculpture gardens and fantastical self-built structures have been found across the world with the greatest and largest being Nek Chand's Rock Garden in Chandigarh, northern India. Originally started in secret on government land, the discovery in 1972 of thousands of sculptures set in a complex of courtyards created by one man caused an immediate conundrum. In most countries the illegal structure would have been demolished for contravening planning laws but Nek Chand's magical kingdom was allowed to remain and eventually grew to over 25 acres of sculptures, waterfalls and colonnades.

Outsider Art and its many varieties and namesakes have established themselves as vibrant components of contemporary art, with impressive private collections and museums on both sides of the Atlantic. Although much of the imagery of Outsider Art is now appropriated freely and unacknowledged by many commercial contemporary artists, the genuine article is still going strong. The self-taught artists of today may not be as culturally isolated as many in Dubuffet's great collection, but they can prove to be as compulsive, inventive and self-motivated as ever.

John Maizels

The COMPAGNIE DE L'ART BRUT is a non-partisan and non-commercial association established in Paris. The founders are Messers. André BRETON, Jean DUBUFFET, Jean PAULHAN, Charles RATTON, Henri-Pierre ROCHÉ and Michel TAPIÉ.

WORKS FOR CONSIDERATION

We are looking for works of art such as paintings, drawings, statues and statuettes, objects of all kinds that owe nothing (or as little as possible) to the imitation of works of art on display in museums, exhibitions and galleries. On the contrary, they should draw upon the basic human experience and the most spontaneous personal invention.

NOTICE

SUR LA

Compagnie de l'Art Brut

17, Rue de l'Université, Paris (7')

They should be creations that their creator has produced from his own psyche (through his own invention and means of expression) his own impulses and moods, without resorting to the standard accepted resources and without reference to current convention. Works of this kind interest us even if they are crude and clumsily executed. We do not set great store by manual dexterity; most of the time it is used to imitate works created by others and disguises the creator instead of expressing himself through it, just as calligraphy disguises handwriting. We seek works in which the faculties of invention and creation that we believe to exist in every human being (at least at times) are manifested in a very immediate manner without masks and without constraints.

POINT OF VIEW

Conventional art that is pompously displayed in exhibition halls and galleries and that manages to get itself seen by the largest number of people as if it alone were worthy of the name of art, to the exclusion of any other kind, appears to us to have a very meagre content, reduced to sempiternal reworkings and imitations, in which individual creativity is almost entirely lacking. We hold it to be a parasitic substitute that apes artistic creation without adding anything thereto, substituting arbitrary aphorisms and pointless theoretical systems for true art. We believe that the day is nigh, if it is not here already, when the public will manifest ample disdain for the flashy professional "artists," with their pseudo "art critics" and dealers; it will realise the vacuity of the works of these daubers, the crassness of the commercial activity that they engender, the aberration of the commentaries with which they surround themselves and how little the true function of art has to do with all this. True art, we believe, lies elsewhere.

THE HOME OF ART BRUT

Monsieur René Drouin was kind enough to make available to us two basement rooms in his gallery in Paris, where in November, 1947, we kept our home open to the public throughout last winter and spring. We have just moved to a spacious pavilion that Monsieur Gaston Gallimard has been kind enough to lend us, which stands at the bottom of the garden at Editions Gallimard, 17 rue de l'Université, in Paris. These new premises were opened to the public on 7 September, 1948. At present, they are hosting a group exhibition of a hundred or so works by different artists, most of whom are people who are unknown or anonymous and whose work offers a general idea of our taste. This first exhibition will very soon be followed by the presentation of the works of the late Adolf Wölfli, following which there will be an uninterrupted series of exhibitions.

PROSPECTION

The works that interest us have almost always been created by very isolated individuals whose activity is only known to their closest circle. We are therefore in great need of assistance in our researches and we would be extremely grateful to people who, if they are aware of any of such unknown creators that we want to contact, put us in touch with them.

AN APPEAL TO PSYCHIATRISTS

Among the most interesting works we have encountered are some that were produced by people who are considered to be mentally ill and are detained in psychiatric hospitals. Naturally, people deprived of an occupation and pleasures show themselves (like prisoners) to be more inclined than others to make their own enjoyment through artistic activity. The preconceptions that people generally have of mental health and madness seem to us to be often based on very arbitrary distinctions. The reasons why a man may be considered unsuitable for participation in social life are of an order that we do not accept. We consequently believe that the works of creators considered to be sane and those considered to be ill should be judged with the same view, without creating special categories for them.

We ask doctors and directors of psychiatric hospitals to help us in our search by informing us of works produced by people who are being treated by their services when such works appear to them to be the sort of creation we are looking for and by sending us, if possible, the original of such works or photographs of the originals.

J. DUBUFFET, October 1948

L'ART
BRUT
PRÉFÉRÉ
AUX ARTS
CULTURELS

Un qui entreprend, comme nous, de regarder les œuvres des IRRÉGULIERS, il sera conduit à prendre de l'art homologué, l'art donc des musées, galeries, salons — appelons le L'ART CULTUREL — une idée tout à fait différente de l'idée qu'on en a couramment. Cette production ne lui paraîtra plus en effet représentative de l'activité artistique générale, mais seulement de l'activité d'un clan très particulier : le clan des intellectuels de carrière.

Quel pays qui n'ait sa petite section d'art culturel, sa brigade d'intellectuels de carrière? C'est obligé. D'une capitale à l'autre,

ART BRUT IS PREFERABLE TO CULTURAL ART
Catalogue of the first large public exhibition of Art Brut, at the René Drouin Gallery, Paris, 1949.
Edited extracts:

Whoever undertakes, like us, to consider the works of *irregulars* will be led to a completely different idea than the current one of official art – the art of museums, galleries, salons – what we shall call *cultural art*. This production does not appear to be representative of the general artistic activity, but only of the activities of a particular clan.

What country doesn't have its small sector of cultural art, its brigade of career intellectuals. It's obligatory. From one capital to the other they perfectly ape one another, practising an artificial, esperanto art, which is indefatigably recopied everywhere. But can we really call this art? Does it even have anything to do with art?

Art is precisely the sort of gum that has nothing to do with ideas, a fact often lost from sight. Ideas, and the algebra of ideas, are perhaps one path towards knowledge; but art is yet another means of understanding.

The reason art exists is because its mode of operation does not take the road of ideas. Wherever ideas are mixed in with it, art rusts, and loses all value. So let's have as few ideas as possible! Art isn't nurtured by ideas!

There are some – the author of these lines for example – who would go so far as to consider the art of intellectuals as false art, counterfeit art, an abundantly ornate currency which rings hollow. For artists, as for card players and lovers, the professional appears as somewhat a sham.

All these celebrations of the artist are quite nice, but what finally happens? Seeing all this, it's the hermit crab who arrives at full speed to lodge itself in art's shell. When you see celebrations and champagne and bravos around a shell, you can rest at ease, knowing that there is a hermit crab inside.

True art always appears where we don't expect it, where nobody thinks of it or utters its name. Art detests being recognised and greeted by its own name. It immediately flees. Art is a character infatuated by the incognito. As soon as it is divulged or pointed out, it flees and leaves in its place a glorified bit-player carrying on its back a large poster marked ART; everyone immediately sprinkles it with champagne, and lecturers lead it from town to town with a ring through its nose. This is the false Monsieur Art. He is the only one known by the public, since he bears the poster and the laurel. There is no danger that the true Monsieur Art will slap on such posters. Nobody would recognise him looking like that. Everyone would encounter him in the street and jostle him at every street corner, without anyone having a clue it was Monsieur Art himself, of whom so much good is spoken. You must understand it is the false Monsieur Art who seems to be the true one, and it is the true one who doesn't seem to be so. This means that we're mistaken! Many are mistaken!

In July 1945 we began methodical research on those productions which we have henceforth called *Art Brut*. We understand by this term works produced by persons unscathed by artistic culture, where mimicry plays little or no part. These artists derive everything – subjects, choice of materials, means of transposition, rhythms, styles of writing, etc. – from their own depths, and not from the conventions of classical or fashionable art. We are witness here to a completely pure artistic operation, raw, brut, and entirely reinvented in all of its phases solely by means of the artists' own impulses. It is thus an art which manifests an unparalleled inventiveness, unlike cultural art, with its chameleon – and monkey-like aspects.

Many of the objects in this exhibition are the works of patients. The mechanisms of artistic creativity are exactly the same in their hands as they are for all other reputedly normal people. Besides, this distinction between normal and abnormal seems quite untenable: who after all, is normal? Where is he, your normal man? Show him to us! Can the artistic act, with the extreme tension that it implies and the high fever that accompanies it, ever deemed normal? From our point of view, the artistic function is identical in all cases, and there is no more an art of the insane than there is an art of dyspeptics or of those with knee problems.
J. DUBUFFET, October 1949
(translation: Foss & Weiss, from *Art & Text* No 27, 1988)

'True art always appears where we don't expect it, where nobody thinks of it or utters its name. Art detests being recognised and greeted by its own name. It immediately flees. Art is a character infatuated by the incognito.'

Jean Dubuffet

People laughed, disapproved, and criticised me, but as this sort of alienation was neither contagious nor dangerous, they didn't see much point in fetching the doctor, and I was thus able to give myself up to my passion.

Ferdinand Cheval, *Autobiography*, 1911.

In his *Psychology of Conceptions of the World*, Jaspers repeatedly emphasises the fact that new life may emerge from despair, that new strengths may develop after a crisis, and that new forms may emerge from chaos. Wölfli has truly passed through such a crisis...The instinctual energy of the first stage now gave way little by little to something new. This new element no longer showed itself in a disorderly, chance fashion, but took a very defined form. It was not an occupation which he found but an activity which *he created* in the solitude of his cell and which took on all the value of authentic work. It is precisely thanks to this work that he has, to some degree, freed himself.

Walter Morgenthaler, *Ein Geisteskranker als Künstler: Adolf Wölfli*, 1921.

As groundwater seeps to the surface and flows toward the stream in many rivulets, many expressive impulses run in many creative paths into the great stream of art. Neither historically nor according to psychological theory does there exist a beginning point. Instead there are many springs which finally transcend all life.

Hans Prinzhorn, *Bildnerie der Geisteskranken (Artistry of the Mentally Ill)*, 1922.

These folk are not a phenomenon of our time. There have always been such artists among the people. Invariably they work quietly, away from any contact with Art. The world of art is desirable but as remote as a dream. Although they may contribute to it, they rarely become a part of it.

Sidney Janis, *They Taught Themselves*, 1942.

I am not afraid to put forward the idea – paradoxical only at first sight – that the art of those who are nowadays classified as the mentally ill constitutes a reservoir of moral health. Indeed it eludes all that tends to falsify its message and which is of the order of external influences, calculations, success or disappointment in the social sphere, etc. Here the mechanisms of artistic creation are freed of all impediment. By the way of an overwhelming dialectical reaction, the fact of internment and the renunciation of all profits as of all vanities, despite the individual suffering this may entail, emerge here as guarantees of that total authenticity which is lacking in all other quarters and for which we thirst more and more each day.

André Breton, *L'Art des fous, la clé des champs*, 1948.

In our time as in other times, certain ways of expression prevail; through fashion or circumstances, certain kinds of art receive attention and consideration to the exclusion of all others. Ultimately, these artforms are quite wrongly regarded as the only justifiable ones, the only possible ones. Thus is hollowed out a path henceforth followed by all artists, who lose consciousness of its special character, and lose sight of many other admissible paths. So strong is the power of attraction of this narrow rut which forms the domain of cultural art that productions proceeding along other paths are not even perceived, as if a sort of ultrasonics. They are thrown into some condescending category like *children's art*, *primitive art* or *the art of the insane*, all of which implies the quite false notion of maladroit, or even aberrant stammerings at the beginning of a road leading to cultural art.

The Collection de l'Art Brut, begun in 1945, is comprised of works created by persons foreign to the cultural milieu and protected from its influences. The authors of these works have for the most part a rudimentary education, while in some other cases – for example, through loss of memory or a discordant mental disposition – they have succeeded in freeing themselves from cultural magnetisation and in rediscovering a fecund ingeniousness. Contrary to the classical idea, we believe that creative artistic forces, far from being the privilege of exceptional individuals, abound in everyone, but that they are commonly restrained, debased or disguised due to worries about social conformity and deference to received myths.

Jean Dubuffet, *Make Way for Incivism*, 1967.

If there is one characteristic that marks folk artists, it is that for them the restraints of academic theory are unimportant, and if encountered at all, meaningless. In effect, the vision of the folk artist is a private one, a personal universe, a world of his or her making. There exists only the desire to create, not necessarily to find fame (although many are not without ego and pride and do very much enjoy the pleasure of being recognised). Hence the products of the folk art world are truly the art of the people, and the vigorous life of this art has no limit in time.

Herbert W Hemphill & Julia Weissman, *Twentieth Century American Folk Art and Artists*, 1974.

It may be that artistic creation, with all that it calls for in the way of free inventiveness, takes place at a higher pitch of tension in the nameless crowd of ordinary people, because practiced without applause or profit, for the maker's own delight; and that the over-publicised activity of professionals produces merely a specious form of art, all too often watered down and doctored. If this were so, it is rather cultural art that should be described as marginal.
Michel Thévoz, *Art Brut,* 1975.

Who are these Outsiders who seem so unconcerned about the splendours of the Cultural City? Where do they come from and what can they be thinking? Until we know their background, how shall we know what to make of them? They are not entered in the records of the central authority. They possess no official qualifications as artists. They have attended no classes, gained no diplomas. They are not subsidised nor even recognised. They seem to work on their own, for themselves, for the fun of it. They know nothing of the trends and snobberies of the cultural centre, with its beflagged museums and smart contemporary galleries.

They work to no commission, without links or debts to the establishment. Many are social misfits; all prefer the rule of the imagination to the strictures of officialdom. Deprived of the blandishments enjoyed by the professional artist, the Outsiders create their works in a spirit of indifference towards, if not plain ignorance of the public world of art. Instinctive and independent, they appear to tackle the business of making art as if it had never existed before they came along. What they make has a primal freshness: it is the product of an authentic impulse to create and is free of conscious artifice. It has nothing to do with contrivance and academic standards, everything to do with passion and caprice.
Roger Cardinal, *Outsiders,* ex cat, 1979.

Here is an art without precedent. It offers an orphic journey to the depths of the human psyche, filled with amazing incident, overspilling with feeling and emotion yet always disciplined by superlative technical resources. It is as if we have abruptly stumbled upon a secret race of creative giants inhabiting a land we always knew existed but of which we had received only glimmers and intimations. We may well feel impelled to survey their work with an appropriate humbleness for they seem to have penetrated the most profound and mysterious recesses of the imagination in a way that the Surrealists would have envied.
Victor Musgrave, *Outsiders,* ex cat, 1979.

It's a feeling, you can *not* explain. You're born with it, and it just comes out. That's *you*, and that's all about it.
Scottie Wilson, in *It's All Writ Out For You,* Melly, 1986.

I believe that each human being has a secret. As for myself, my work has made me realise that this secret, in the last analysis, is the same for everyone. Yet everyone believes individually in their own secret – the notion of being unique, that sort of thing. People pretend to believe that this is something unique to each individual.
Michel Nedjar, 'I am Tied to the Threads of the World', in *Art & Text* No. 27, 1988.

More than ever before, we are aware of the fact that the unconscious is the source of numinous images and symbols that possess the power to change us. The artist's most valuable possession is the ability to reach this realm and to emerge from the encounter intact. On the other hand, their knowledge of this inner world has taught us to respect and to value the experience and the contribution of those who do not, or cannot, emerge, for their visions, and the images in which they are embodied, enable us to make contact with otherwise invisible aspects of the deepest layers of our own reality.

Whether we call a person an artist or a madman matters little. In this century the two terms have become interchangeable. What is essential is that the creative freedom of both is maintained and protected, that within our society a way is kept open for those unique and courageous individuals, who, shunning the surface and the light, seek, at the bidding of inner necessity, to descend into the darkness in search of themselves.
John MacGregor, *The Discovery of the Art of the Insane,* 1989.

[Outsider Art] resembles a set of tales told by travellers who have brought back to their friends at home a full freight of impressions of foreign parts – tales of a seventh continent, of a journey into a remote interior, in a sense fragments of inner life. It is true that the seventh continent lies at no known latitude or longitude, yet this is precisely because it lies everywhere. Its landscapes are wild and primordial, dark and sensual, and they remain unknown and inexplicable. They are truly topographies of the soul, manifestations of vital, primal forces dormant within our psyche. In short, this is art situated at the boundary between the inner and the outer worlds: art which looks, acts and agitates in both an inward and an outward direction.
Paolo Bianchi, 'Bild und Seele', in *Kunstforum* No. 101, 1989.

Like traditional folk artists, outsiders use traditional skills learned on the job, coupled with innate talent and the desire to answer real needs in practical ways. And in the end, the needs they answer are also traditional if perhaps intensified in recent years: our culture's failure to deal with loneliness, isolation, and the individual's need to maintain self-worth. But far from being a celebration of simple virtues or easy nostalgia, outsider art is a cry in the dark, an attempt to deal with the shadows of culture and the mysteries of life.
Roger Manley, *Signs and Wonders,* 1989.

As children we are all artists, every one of us in the world. As we grow, the creative impetus within us often fades, yet Outsider Art proves the existence of the unending power of human creation. Within each of us is that spark, that shared universitality of human creativity. For some, thankfully, the spark never dies, never finds itself crushed by the norms of adult behaviour and cultural conditioning. It is to these natural and intuitive creators that Outsider Art owes its existence.

John Maizels, *Raw Creation*, 1996.

Art Brut has from the start been haunted by the image of a creativity that owes nothing to any external formation or encouragement, that seems to have emerged out of nowhere, independent of any tradition or cultural context. From Prinzhorn to Dubuffet, the assertion is repeatedly made that there is no apparent source, no obvious pedigree for them. They appear out of the blue; instances of automatic creation that seem to constitute 'art without tradition'.

David Maclagan, *Raw Vision*, 1997.

The fact that there are people who remain unmoved or largely unaffected by social and cultural pressures and norms and who resist normalisation allows for the possibility that some sort of dissident creation will survive. Art Brut's distinctive characteristic is its secret, clandestine, and unpredictable nature. Its sphere of activity being entirely free of any limitations, works of Art Brut are probably being created without our knowledge in places we would never have imagined.

...Scorned and rejected half a century ago, marginal creation has gradually made its way onto the social and cultural scene through the efforts of its advocates in museums, publishing, and business. Art from the humblest of origins has acquired an aristocratic title. This recognition marked the debut of a double life for Art Brut. Lifted out of the obscurity and anonymity to which they had been consigned, these creations began to be considered as full-fledged works of art. At the same time, this official acknowledgement altered and misrepresented them, since it partially distorted their originally rebellious and uncultured virtues. Having on the one hand given us a glimpse of a 'hidden side of contemporary art' – one that is both exhilarating and violently subversive – the exposure of Art Brut in museums and books has on the other hand thrust it into the cultural system from which it had been estranged, and which it was by definition opposed to. Moreover, this aesthetic and ethical recognition has gone hand in hand with social exploitation and commercial appropriation.

...Art Brut is an ideological phenomenon. It was one of the key phases in the decentering and fragmentation that marked twentieth-century culture. Without doubt, we have not heard the last of it.

Lucienne Peiry, *Art Brut, the Origins of Outsider Art*, 1997.

It is most important when addressing Outsider Art to remember that neither it nor its possible sub-categories refer to a stylistic tendency or historical movement. Rarely are the designations embraced by the artists who are inscribed in them. Compared with 'insider' movements in western art such as Impressionism or Cubism, which functioned in socially sophisticated ways, individual outsider creators seldom even know of each other, let alone form a cohesive group. In other words, Outsider Art does not follow the usual art-historical patterns. Instead, its descriptors tend to be based more on sociological and psychological factors that are held together principally by commonly made claims by Outsider Art's apologists about the artists' fundamental difference to or antagonism towards a supposedly dominant cultural norm. This difference is not merely marked by exclusion from the mainstream of the professional (western) art world, but also by exclusion from, or marginalisation in relation to, the very culture that supports the market for mainstream art.

Colin Rhodes, *Outsider Art Spontaneous Alternatives*, 2000.

All creativity lacking official authorisation must start life in the shadows, with every expectation of remaining anonymous, beneath contempt, practically invisible. In our Western culture, obscure and extraneous off-shoots are ignored and suppressed. Yet, though weeds may be banished from the central beds of a formal garden, they are still capable of sturdy growth and a beauty all their own. It is important to recognise that so much of our thinking is conditioned by inherited prejudice. The very distinction between 'weed' and 'flower' is a cultural constraint rather than a natural truth. Any celebration of creativity 'in the margins' is already hampered by the fact we must start on the defensive, wrestling with conceptual dualisms from which we should prefer to be free.

Roger Cardinal, *Marginalia*, 2000.

The idea that 'advanced' art is socially progressive, while 'folk' art is conservative, is ludicrous today; in many cases, this notion has things backwards. It is increasingly ill-conceived to declare vernacular art subordinate to, or merely a source for, 'fine' artists. Furthermore, the boundaries are collapsing between what were previously labelled 'high' art and 'folk' art. Still, much of the official art discourse continues to avoid the vernacular, except on terms that relegate it to an *a priori* secondary status. Awareness of these changes is increasing, yet the dialogue about high art has begun to co-opt the collapse of categories into its old hierarchies: these days, the label 'vernacular' is applied to a growing number of formally trained, 'insider' artists. Although labels are no substitute for genuine understanding, the danger is that the expropriation of terminology could prevent genuinely vernacular forms of artistic expression (and the cultures they represent) from being recognised and understood

on their own merits. History is written and rewritten by the victors. Must art history also suffer the same fate?
Maude Southwell Wahlman, *Souls Grown Deep Vol. 1*, 2000.

Self-taught art, properly understood, liberates postmodern thought from its temporal trap. Currently, the academy only validates the shock of the *new*, ignoring the 'shock' of strong perception, consciousness, action, or being that have been the rewards of the arts across cultures and eras, including all formulations of non-mainstream art – from the popular and folk to the outsider and self-taught.

We need to jettison this naively utopian faith in the 'new,' the seemingly unique and advanced. Reject the Modern as the defining characteristic of significant culture. Put to rest the quarrel of the ancients and the moderns. Become truly *post*modern. This is not an end to history, but is, in fact, more consistent with that aspect of postmodernist criticism which rejects Western messianic logos. Contemporary art and theory need to move from a *temporal* perspective toward a *spatial* understanding, to move from 'post' to 'trans' as informing prefixes – from postmodern to transcultural. We should seek out the expression of multivalent cultural identi*ties* in which self-taught and mainstream artists respond to shared *and* distinct cultural dialectics, recognising the affinities among the artists – even while giving voice to inescapable and desirable differences.
Charles Russell, *Self-Taught Art*, 2001.

The observation of Franz was the first case in my first book. It was the basis of my term 'state bound art'. Of course it was not the only case. In the course of time I learned many about cases of disease from the acute to recovery and I observed similarities in many cases and therefore I formulated the theory of 'state bound art', denoting an instant picture of an ongoing condition from the normal state of consciousness.
Dr Leo Navratil, *Raw Vision*, 2001.

At the dawn of the twenty-first century, we are actively reassessing the traditional narratives that have been used to chart our history. In the case of art, rigid hierarchies of value and linear notions of 'progress' are being jettisoned in favour of a looser, more egalitarian approach. Recognising that the formalist aesthetic that dominated the art world as recently as twenty years ago was conditioned by a white, male, Eurocentric bias, we are now open to a broader variety of ethnic and artistic options. In the process, people have become more aware of the multiple societal forces that shape taste. Our revised art-historical narrative documents the interaction of these forces, rather than lionising individual artist-heroes or positing qualitative absolutes.

These changes in our approach to art history have sweeping implications both for our understanding of the collector's role in a general sense and, specifically, for the appreciation of 'outsider' or 'self-taught' art.
Jane Kallir, *Self-taught and Outsider Art: The Anthony Petullo Collection*, 2001.

Public art galleries around the world show the same diet of narrow conceptualism, often by the same few, heavily promoted artists. Instead, their urgent task is to look freshly at the whole spectrum of visual creativity and begin the process of sifting this vast sea for those works of art that have lasting qualities. It is one of the most pernicious myths of modern art that we have discovered the great art of our age when, in fact, we have hardly begun to look for it.
Julian Spalding, *The Eclipse of Art*, 2003.

This cultural context presents a new way of experiencing these works of art beyond revelling in their feral beauty without an inkling of their deeper meaning. *Vernacular Visionaries* restores the culture to the art, and in so doing unleashes a fascinating universe of history, myths, folklore, magic, and the occult. At the same time it acknowledges that much of the art of these visionaries belongs to the realm of the unknowable, innately spiritual, and otherworldly. Indeed, it is this more elusive aspect of the art that has such an irresistible allure, akin to that of tribal, ethnographic, and much folk art with which we have similar visceral, primal associations.
Annie Carlano, *Vernacular Visionaries*, 2003.

For outsider artists, and for many self-taught artists, the decision to begin making art comes as suddenly and arbitrarily as an act of God. Often it is associated with psychic events and behaviours that cut the individual off from routine intercourse with the world – symptoms that provoke institutionalisation, crimes that force incarceration, personal loss or separation that shatters a fragile stability, even simple retirement that disrupts routine and throws people back on their inner resources.

Has outsider art come completely inside? I do not believe outsider and self-taught art can ever be comfortably folded into our historicised (so-and-so begat so-and-so) narratives about art, nor will time naturalise all their anomalous forms, that is, make them accessible or meaningful the way Cubist works, for example, now seem 'normal' and Picasso's distortions no longer shock. At the same time, it seems clear that the broad acceptance of outsider art signals the end of our history-obsessed view of art, a view that spawned the idea of the avant-garde and first legitimised the outsider. The whole complex of ideas involving progress in art and consciousness now belongs to what critic Robert Hughes referred to as 'the future that was'. By the same token, it seems to me that other explanatory narratives, especially post-colonial, have their limits, in spite of their success at rescuing art from categories of 'naive,' 'primitive', and even 'outsider.' Insofar as they stubbornly retain an 'otherness', outsider and self-taught art does have a distinct role to play in the art of our time. That role is to summon us back, like the tolling of a bell, to the

existential roots of art making, where apprehensions of being are transmuted into form.
Lyle Rexer, *How To Look at Outsider Art,* 2005.

Nowadays, the category, 'artworks by the mentally ill', raises even more problems, because what we now understand by a psychic crisis is no longer the same as what was meant by this term in Prinzhorn's time. Whereas, in those days, virtually everyone diagnosed as having 'dementia praecox' or 'schizophrenia' sooner or later ended up being interned in an asylum for good (not infrequently, for the last 30 or 40 years of their lives), the politically correct term in current use, 'with psychiatric experience' (psychiatrieerfahren) is appropriate inasmuch as the majority of such people spend only a short time in a psychiatric clinic for the treatment of their psychic disturbances. The use of psycho-pharmaceutical agents and a broad range of therapeutic methods has fundamentally altered the situation of people afflicted in this way as well as the way such illness is perceived.
If there are no longer any 'mental patients' in the sense of people suffering from incurable lifelong syndromes, it follows that there can be no more 'art of the mad' or 'artistry of the mentally ill'. Thus, nowadays, we encounter artistic works by patients with a psychiatric or psychotic background that (on ethical grounds alone) pose problems with respect to distinguishing between pictures produced during acute phases of their disturbances and those created during 'healthy' times.
Only one thing is certain: some persons with 'psychiatric experience' succeed (often without any previous artistic training) in creating radical drawings, paintings, sculptures, works of embroidery and objects involving other techniques that have little in common with the generally accepted art of their time and that may not be regarded as art even by their own creators.
Thomas Roeske, *Collecting Madness,* 2006.

Why is contemporary art history, a discipline capable of engaging, analysing, and assessing artistic modes as diverse as surrealism, abstract expressionism, pop art, and conceptual art – as well as performance, architecture, and film – still unable to provide us with tools for better understanding works like that of Martin Ramirez? Why are his drawings – or the works of the highly esteemed artists Aloïse Corbaz, Henry Darger, Bill Traylor, Adolf Wölfli, or Carlo Zinelli – still residing outside the art-historical canon? There have been many passionate discussions about this question, most often ending in debates based on bipolar models: outsider vs professional, self-taught vs. academic, awareness vs naivety, intelligence vs mental illness, art history vs cultural studies, and so on. A more technical way to address the issue is to approach it in terms of distribution.
During the last 50 years, art history has undergone radical changes. Most prominently, feminism, poststructuralism, and postcolonialism introduced new ways to look at art and to understand the world. They unveiled how much our thoughts, concepts, and theories are shaped by power and politics, and led to the abandonment of the idea that history forms a coherent and logical entity, that it develops in one progressive way, and that the West is the principal cradle of culture and intelligence. Despite these and other radical changes in the ways in which we conceive of art, the system of distribution, the way an artwork enters into public consciousness, has remained the same.
Daniel Baumann, 'Martin Who?' in *Martin Ramirez,* 2007.

The masters are leaving the margin, but this is a change that is limited to the reception side of the story only. Like much classical, medieval and non-Western work, outsider art has become 'art' only in this process of reception. But in spite of all the dynamic, on the production side it can still be as quiet as in the old people's home where Thévoz tried to get his modern Penelope to part with her knitting. And in spite of all the processes of modernisation and globalisation it does not look as if much will change there. There are still always people who make something from a need of there own, for their pleasure, or because they feel that they have to. It is actually those really quite ordinary circumstances of its creation that distinguishes outsider art from other categories of art, and that explains why it is not a question of style, school or movement, but of a single, collective name for a heterogeneous collection of unique individual creations which are relatively independent of the culture, tradition, fashion and developments in visual art.
Jos Ten Berge, in *Hidden Worlds at the Museum Dr Guislain,* 2007.

Dubuffet liked to oppose 'Art Brut' to 'cultural art', that is to the mainstream: the 'high' culture of museums, art schools and artistic circles, including the avant-garde. But art brut, like naive art or art singulier, has never been deprived of culture. It has its own culture, but this is not the scientific and artistic culture of schools and universities, nor the academic standards of the 'bourgeois' or upper-class establishment. A more popular form, imbued today by the mass-media as it was in the past by legends, superstitions and word of mouth transmission, and this mixture of beliefs, opinions, vulgarised knowledge and fancies is still the common property of perhaps 80 per cent of the population. But most art critics seem to be blind to it either because they were trained in a different 'milieu', or because they try their best to turn their backs on this mental environment, which would give them a better understanding of the art that they are trying to promote and document, because this kind of culture is less esteemed than Culture with a capital C. Outsider Art is not an art outside culture: it is the aculturated mode of transformation and renascence of inventive Folk culture and Folk creativity in the new post-agricultural civilisation.
Laurent Danchin *'Outsider' Art in Hypermodern Times: INSITA,* 2007.

OUTSIDER ART
SOURCEBOOK

Chronology

26 AD
While reporting on a visit by the Emperor Tiberius, Tacitus and Suetonius describe the banquet hall and grotto at Sperlonga, Italy, with its fantastical sculptures.

1520
The painter Giovanni Francesco Caroto portrays a boy holding up a stick-figure drawing.

1560
Duke Vicino Orsini commissions artists to decorate the gardens of the palace at Bomarzo, Viterbo, Italy, with large sculptures of mythical monsters.

1580
Michel de Montaigne visits the Villa of Castello near Florence, Italy, with its grotto crammed with shells, coral and sculpted animals spouting water.

1735
William Hogarth publishes his *Rake's Progress* engravings, the last plate of which depicts a mental patient drawing upon an asylum wall.

1739
The Duchess of Richmond decorates an artificial grotto at Goodwood Park, West Sussex, England, with shells and mirrors.

1762
Exhibition of artwork by sign-painters at Bow Street, London, curated by William Hogarth and Bonnell Thornton.

1787
Goethe inspects the statues at the palace of Prince Pallagonia outside Palermo, Sicily, and declares the place 'a madhouse'.

1812
Pennsylvania psychiatrist Dr Benjamin Rush discusses the artistic creativity of mental patients in his textbook *Medical Inquiries and Observations upon the Diseases of the Mind.*

1819
In London, William Blake begins a series of 'Visionary Heads', inspired by nocturnal visions.

1820
Quaker painter Edward Hicks paints the first of some three score canvases on his favourite theme of the 'Peaceable Kingdom', in Bucks County, Pennsylvania, USA.

1828
Kaspar Hauser turns up in a square in Nuremberg, Germany, a bewildered and incoherent foundling. Many believe he is untouched by culture.

1829
German therapist Justinus Kerner of Weinsberg, Swabia publishes a case-study of the clairvoyant Friederike Hauffe.

Insane arsonist Jonathan Martin is admitted to Bethlem Hospital, London, where he will pursue artistic activities.

1837
Bishop Wordsworth publishes a collection of graffiti found after excavations at Pompeii.

1838
Dr William Browne, super-intendant of the Crichton Royal Hospital, Dumfries, Scotland, begins collecting artwork by mental patients.

1841
French Romantic poet Gérard de Nerval produces hallucinatory drawings during a stay at a mental clinic in Montmartre, Paris.

1844
Artist Richard Dadd is sent to a ward for the criminally insane at Bethlem Royal Hospital, London, after murdering his father.

1848
Swiss cartoonist Rodolphe Töpffer presents an early discussion of child art in his book *Réflexions et menus propos d'un peintre genevois.*

1853
Exiled to the Channel Islands, the French Romantic writer Victor Hugo experiments with table-turning and automatic drawing.

Publication in Munich of *GolgloG*: bizarre poetry based on word-play and neologisms, by woodcarver Joseph Gutsmuehl.

1854
Birth of Bill Traylor into a slave community near Benton, Alabama.

1857
Allan Kardec publishes *Le Livre des Esprits*, the founding text of Spiritualism.

1861
In London, mediumistic artist Georgiana Houghton executes her first spirit drawing.

1864
Cesare Lombroso publishes *Genio e follia*, a study of the link between genius and mental instability.

1874
Exhibition of some 500 spirit drawings by Mrs Catherine Berry in Brighton, England.

1876
Psychiatrist Paul-Max Simon publishes the first article in France on psychotic art.

Ludwig II, the eccentric king of Bavaria, adorns his castle at Linderhof with a Venus grotto made of cast-iron stalactites.

1879
Ferdinand ('Le Facteur') Cheval starts constructing his environment, Palais Idéal, at Hauterives, Drôme, France.

1882
Establishment of the Society for Psychical Research in Cambridge, UK.

Mental patient Andrew Kennedy begins prolific picture-making and writing at Crichton Royal Hospital, Dumfries, Scotland.

1886
Self-taught artist Henri Rousseau ('Le Douanier') exhibits his work at the Salon des Indépendants, Paris, alongside Signac, Seurat and Redon.

1888
Publication of the first of two specialist studies by Dr William Noyes of the Bloomingdale Asylum in New York on the artistic production of a male patient given the anonymous identity 'G'.

1889
Karl Junker starts work on his Junkerhaus, an art environment at Lemgo, Germany.

1894
Adolphe Julien Fouré starts carving the rocks on the coast near St Malo, Brittany, France.

1895
Adolf Wölfli is detained in Waldau Clinic, Berne, Switzerland, where he will remain for 35 years. He starts to draw c.1899.

1900
Théodore Flournoy writes *Des Indes à la Planète Mars*, on the mediumistic artist Hélène Smith of Geneva.

First exhibition of artwork by the mentally ill opens at Bethlem Royal Hospital, London.

1902
Paul Klee discovers his own childhood drawings, prompting a re-orientation of his painting style.

1905
Dr Auguste Marie exhibits his 'Little Museum of Madness' at the Villejuif asylum near Paris.

French psychiatrist Rogues de Fursac attempts to use psychotic writings and drawings in the diagnosis of his patients.

1906
Important article on the diagnosis of psychotic drawings by Dr Fritz Mohr of Germany.

1907
Marcel Réja (the pseudonym of Dr Paul Meunier) publishes a text on the art of the insane, with illustrations from the Auguste Marie collection.

SP Dinsmoor starts the construction of the Garden of Eden around his house in Lucas, Kansas.

1908
Gabriele Münter begins collecting child art, later with the support of Wassily Kandinsky.

1912
Dealer and critic Wilhelm Uhde discovers the visionary flower-painter Séraphine Louis in Senlis, France.

Kandinsky and Franz Marc publish *Der Blaue Reiter* in Munich, juxtaposing child art, peasant art, naive art and tribal art with contemporary avant-garde art.

Alfred Stieglitz presents his first exhibition of child art at his 291 Gallery in New York.

1913
Exhibition of psychotic art is held during an international medical congress at Bethlem Royal Hospital, London.

Avant-garde artist Mikhail Larionov introduces paintings by self-taught Georgian artist Niko Pirosmani (Pirosmanashvili) into his 'Target' exhibition in Moscow.

1914
Exhibition of mediumistic art in Leipzig, Germany.

1919
At the University Psychiatric Clinic in Heidelberg, Dr Hans Prinzhorn begins soliciting donations of art by mental patients in German and Swiss institutions, expanding an existing small collection to some 5,000 items within two years.

Max Ernst curates the 'Gruppe D' exhibition in Cologne, mixing avant-garde works with tribal art, child art, psychotic art and found objects.

Establishment of the Institut Métapsychique International in Paris.

London housewife Madge Gill begins producing inspired drawings in a state of trance.

1920
Dr Hans Steck joins the Cery clinic near Lausanne and discovers the secretive artwork of patient Aloïse Corbaz.

1921
Walter Morgenthaler publishes *Ein Geisteskranker als Künstler*, the first monograph on a named psychotic artist, Adolf Wölfli.

Exhibition of psychotic art in Frankfurt, Germany.

Exhibition of child art at Kunsthalle, Mannheim in Germany entitled 'Genius in the Child'.

First mention of the term 'folk art' in the *Oxford English Dictionary*.

1922
Hans Prinzhorn publishes *Bildnerei der Geisteskranken*, a seminal presentation and analysis of psychotic art.

Max Ernst leaves Germany for Paris with a copy of Prinzhorn's book, which circulates among the Surrealists.

1923
While working at the meteorological office during his military service, Jean Dubuffet comes across drawings of clouds, sent in by visionary artist Clémentine Ripoche.

'Glimpses of the Imagery of the Primitives', works from the Prinzhorn Collection, is shown at Kunsthalle, Mannheim, Germany.

1924
Painter Henry Schnackenberg curates the first exhibition of American folk art, 'Early American Art', at Whitney Studio Club, New York.

Artist Elie Nadelman opens the first folk art museum in the USA, the Museum of Folk and Peasant Arts, at Riverdale, New York, including both European and American material. It closes in 1934 for financial reasons.

Birth of Nek Chand, in the village of Barian Kalan in present-day Punjab province, Pakistan.

1925
The Harlem Renaissance movement is established as a black cultural movement in various cities across northern USA.

Dr Charles Ladame, director of the Bel-Air clinic in Geneva, sets up a museum of psychotic art.

1926
Hans Prinzhorn publishes *Bildnerei der Gefangenen*, a study of prison art.

1927
Augustin Lesage demonstrates automatic painting at the Institut Métapsychique in Paris.

1928
The French Surrealists celebrate the 50th anniversary of Charcot's 'discovery' of hysteria.

In Paris, Wilhelm Uhde curates the first major show of naive art in France.

Autodidact marine painter Alfred Wallis is discovered in St Ives, Cornwall, UK by artists Ben Nicholson and Christopher Wood.

1929
Large show of psychotic art ('Exposition des artistes malades') at the Galerie Max Bine in Paris.

Art historian Waldemar Deonna curates an exhibition of work by Hélène Smith at Musée d'Art et d'Histoire, Geneva.

The Prinzhorn Collection is shown at the Gewerbemuseum, Basle, Switzerland.

1930
Artist Krsto Hegedusic discovers several peasant painters in a Croatian village, and helps launch the Hlebine School.

Work by Adolf Wölfli is shown at Gewerbemuseum Winterthur, Switzerland, alongside children's drawings.

Publication of André Breton and Paul Éluard's *L'Immaculée Conception*, a compilation of texts simulating psychotic states.

Holger Cahill curates a landmark show of 'American Primitives' at Newark Museum, New Jersey.

Arsonist Clément Fraisse is imprisoned for two years in France and carves images and designs into the wooden walls of his cell.

1931
'American Folk Sculpture: The Work of Eighteenth and Nineteenth Century Craftsmen' opens at the Newark Museum, New Jersey.

The Surrealist poet André Breton visits Ferdinand Cheval's Palais Idéal in Hauterives, France.

1932
Holger Cahill curates 'American Folk Art: The Art of the Common Man in America, 1750-1900' at the Museum of Modern Art, New York.

Madge Gill exhibits her work for the first time, entering an ink-on-calico piece 17ft (5m) wide at the annual amateur show at the Whitechapel Art Gallery in London.

1933
André Breton publishes 'Le Message automatique' in the Surrealist magazine *Minotaure*, a landmark text on pictorial automatism.

Brazilian doctor Cesar Osorio curates a show of child art and art of the insane in São Paulo.

1936
First publication on the work of psychotic artist Louis Soutter by his cousin, the modernist architect Le Corbusier, in *Minotaure* magazine.

Alfred Barr curates 'Fantastic Art, Dada, Surrealism' at the Museum of Modern Art, New York, including child art, folk art, psychotic art and

photographs of Ferdinand Cheval's Palais Idéal.

International Surrealist Exhibition is held at the New Burlington Galleries, London.

1937
Major show of naive art in Paris, 'Les Maîtres populaires de la réalité'. It travels to New York in 1938.

Foundation of the Musée des Arts et Traditions Populaires in Paris.

'Entartete Kunst', organised by the Nazi Propaganda Ministry in Munich, derisively juxtaposes 'degenerate' Modernist artworks with psychotic art from the Prinzhorn Collection.

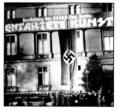

Work by African-American sculptor William Edmondson is shown at Museum of Modern Art, New York.

1938
Paintings by naive artist Grandma Moses are seen in a drugstore window in Hoosick Falls, New York. Her first solo show is held two years later.

'Masters of Popular Painting' at the Museum of Modern Art, New York, combines artists from

France (Camille Bombois, Henri Rousseau, Séraphine Louis, Louis Vivin) and America (Edward Hicks, John Kane, Joseph Pickett, Horace Pippin).

1939
Self-taught artist Bill Traylor is discovered drawing on the street in Montgomery, Alabama.

At about this time, Jean Dubuffet begins his collection of childrens art.

1941
Dr Gaston Ferdière is appointed to the Rodez Asylum, southern France, where one of his patients will be Antonin Artaud.

1942
Sidney Janis publishes *They Taught Themselves. American Primitive Painters of the 20th Century*, USA, introducing the work of 30 'self-taught artists'.

1945
Scottie Wilson exhibits alongside the Surrealists in 'Surrealist Diversity' show in London.

Jean Dubuffet travels to Switzerland with Jean Paulhan and Le Corbusier. He visits the Waldau Collection and the work of Adolf Wölfli. He first uses the term '*l'Art Brut*'.

1946
An exhibition of psychotic art by anonymous patients is held at Sainte-Anne Hospital in Paris.

International childrens drawing exhibition with 150 works opens in Paris; it travels to Luxembourg the following year.

Haitian art exhibition at UNESCO in Paris, following a visit to the island by André Breton.

1947
Foyer de l'Art Brut opens in the basement of Galerie René Drouin, Paris.

The important Van Gogh retrospective exhibition at the Orangerie, Paris inspires an impassioned essay by Antonin Artaud: *Van Gogh, le suicidé de la société*.

7th 'Exposition internationale du Surréalisme' at Galerie Maeght in Paris. Includes Scottie Wilson, Haitian art and pieces from Dr Ferdière's collection.

1948
Founding of the Compagnie de l'Art Brut by Jean Dubuffet, André Breton, Jean Paulhan, Charles Ratton, Henri-Pierre Roché and Michel Tapié.

Exhibition 'Le Cabinet du Professeur Ladame' is held in Paris with the Compagnie de l'Art Brut.

Jean Dubuffet visits Aloïse Corbaz at the Gimel Clinic in Lausanne, Switzerland.

Jean Dequeker publishes *Monographie d'un psychopathe dessinateur*, a study of Guillaume Pujolle.

1949
First large public exhibition of the Collection de l'Art Brut is shown at Galerie René Drouin, Paris.

1950
International show of psychotic art at the First World Congress of Psychiatry is held at Sainte-Anne Hospital in Paris; 1,500 items are shown, including work by the artists Ernst Josephson and Carl Fredrik Hill.

Jean Dubuffet travels to Heidelberg to visit the Prinzhorn Collection for the first time.

1951
The Collection de l'Art Brut is shipped to artist Alfonso Ossorio's estate on Long Island, USA, where it will stay for over ten years.

Dubuffet gives his influential lecture 'Anticultural Positions' at the Art Institute of Chicago.

1952
Opening of the Croatian Museum of Naive Art, in Zagreb. First named the Peasant Art Gallery, then the Museum of Primitive Art, it receives its present name in 1984.

Foundation of the Museum of Images from the Unconscious in São Paolo, Brazil.

1953
Foundation of the Museum of International Folk Art in Santa Fe, New Mexico.

1954
Autodidact artist and mental patient Martin Ramirez shows his hitherto secret work to Dr Tarmo Pasto at DeWitt State Hospital, Auburn, California.

Simon Rodia abandons his towers in Watts, Los Angeles, and disappears.

1956
In New Orleans, Sister Gertrude Morgan starts painting to illustrate her sermons, after being instructed by God.

1957
The opening of the Abby Aldrich Rockefeller Popular Art Center in Williamsburg, Virginia.

Carlo Zinelli starts drawing in a psychiatric hospital in Verona, Italy, as do Alexander Lobanov in Afonino, USSR and Ilija Bosilj in Sid, Yugoslavia.

1958
Nek Chand starts work in secret on what will become the world's largest visionary environment, on government land in a jungle clearing in Chandigarh, India.

A major international show of naive art is held at Knokke-Le-Zoute, Belgium, 'La peinture naïve du Douanier Rousseau à nos jours'.

A campaign to protect the Watts Towers from destruction by city authorities is launched in Los Angeles. They are saved after the structures are proved to be stable.

1959
Alphonse Chave curates an exhibition entitled 'L'Art Brut' at his gallery in Vence, France.

'EROS – Exposition inteRnatiOnale du Surréalisme' at Galerie Daniel Cordier, Paris includes artwork by Friederich Schröder-Sonnenstern, Aloïse Corbaz and Unica Zürn.

1960
The Chicago Imagists start collecting self-taught art.

1961
Rev Howard Finster begins his Paradise Garden evangelical environment around his house in Pennville, Georgia, USA.

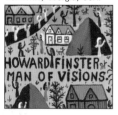

Arnulf Rainer, in Vienna, Austria, begins his collection of European Outsider Art by acquiring drawings by Louis Soutter.

The Museum of Early American Folk Art is founded in New York under the direction of Herbert W Hemphill ('Early' is later deleted from the title).

Brassaï publishes *Graffiti*, photographs of anonymous wall-imagery in Paris.

1962
The Collection de l'Art Brut is shipped back to Paris from Alfonso Ossorio's home in New York. The Compagnie de l'Art Brut is re-formed with a larger membership.

Aged over 70, Joseph Yoakum starts to draw following a dream, and becomes one of Chicago's most famous Outsider artists.

The first exhibition of the Museum of American Folk Art opens in the Time-Life building in New York.

Gilles Ehrmann publishes *Les Inspirés et leurs demeures*, the first illustrated account of Outsider architecture found in France.

Collection de l'Art Brut exhibition opens at the Cordier-Warren Gallery in New York, to minimal response.

Chomo leaves Paris to settle in the Fontainebleau forest where he will build his Preludian Art Village.

1963
'Bildnerei der Geisteskranken/Art Brut/Insania Pingens' is held at Kunsthalle, Berne.

1964
First publication of Jean Dubuffet's *L'Art brut* in Paris, later in Lausanne.

1965
Leo Navratil publishes *Schizophrenie und Kunst*.

1966
INSITA: the first International Triennale of Naive Art ('Insite Art') is held at the Slovak National Gallery, Bratislava.

1967
Major exhibition of some 700 items from the Collection de l'Art Brut at the Musée des Arts Décoratifs, Paris.

1968
Gregg Blasdel publishes 'The Grass-Roots Artist' in *Art in America*.

Publication of Jean Dubuffet's polemic, *Asphyxiating Culture*.

Artists Jim Nutt and Gladys Nilsson recover drawings by psychotic artist Martin Ramirez from the San Sacramento Hospital, California.

Clarence Schmidt's self-built House of Mirrors near Woodstock, New York State is mysteriously destroyed by a series of fires.

1969
Thanks to Minister of Culture André Malraux, Ferdinand Cheval's Palais Idéal is classed as a historic monument.

1970
Following a serious work accident, Mose Tolliver begins to paint.

Herbert W Hemphill curates 'Twentieth-Century American Folk Art and Artists' at the Museum of American Folk Art in New York.

1971
Catalogue de la Collection de l'Art Brut appears, listing 4,104 works by 135 artists.

1972
Encouraged by Jean Dubuffet, Alain Bourbonnais opens the Atelier Jacob gallery in Paris with an exhibition of Aloïse Corbaz.

Lausanne municipality agrees to house the Collection de l'Art Brut in the Château de Beaulieu; the Compagnie de l'Art Brut is dissolved.

Roger Cardinal's *Outsider Art*, the first book to survey Art Brut, launches the term 'Outsider Art'.

1973
Chicago photographer Nathan Lerner discovers the work of his tenant Henry Darger.

1974
Formation of the Kansas Grassroots Art Association in Lucas, to document and preserve environments.

'Naïves and Visionaries' exhibition at the Walker Art Center, Minneapolis.

Opening of the Creative Growth Art Center in Oakland, California.

Herbert W Hemphill and Julia Weissman publish *Twentieth-Century American Folk Art and Artists*.

1975
Drawings by Adolf Wölfli are shown alongside avant-garde art at Documenta 5, Kassel, Germany.

Publication of Michel Thévoz's seminal book *L'Art Brut*.

Pictures by self-taught artist Minnie Evans are shown at the Whitney Museum of American Art, New York.

Phyllis Kind opens New York's first Outsider Art gallery.

First issue of *The Clarion*, magazine of the Museum of American Folk Art; the name will be altered to *Folk Art* in 1992.

Massimo Mensi sets up the creative studio 'La Tinaia' in the grounds of a psychiatric clinic in Florence, Italy.

1976
The Collection de l'Art Brut opens as a public museum in the Château de Beaulieu in Lausanne, Switzerland with Michel Thévoz as the director and Geneviève Roulin as deputy.

Herbert W Hemphill curates the exhibition 'Folk Sculpture USA' at the Brooklyn Museum, New York.

Official inauguration of Nek Chand's Rock Garden in Chandigarh, India.

1977
International exhibition of mediumistic is art held at Galerie Petersen, Berlin.

1978
The Watts Towers are placed on the American National Register of Historic Places.

Seymour Rosen founds SPACES in Los Angeles, dedicated to the preservation and documentation of contemporary folk art environments.

'Les Singuliers de l'art' at the Musée d'Art Moderne de la Ville de Paris includes photographs of French environments and *art singulier*.

'Another World: Wölfli, Aloïse, Müller' exhibition at the Third Eye Centre in Glasgow, Scotland.

First exhibition of the Scottish collection of Art Extraordinary at the Glasgow Print Studio Gallery.

1979
'Outsider Art in Chicago' at the Museum of Contemporary Art, Chicago, shows six Chicago Outsiders, including Henry Darger, Lee Godie and Joseph Yoakum.

Roger Cardinal and Victor Musgrave curate 'Outsiders' at the Hayward Gallery, London, supported by the Arts Council of Great Britain.

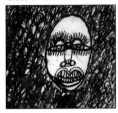

The organisation CREAHM founded in Liège, Belgium.

1980
First issue of the magazine *Folk Art Finder* is published by Flo Laffal in Connecticut.

1981
Victor Musgrave founds the Outsider Archive in London which establishes a collection and raises funds for a museum. Monika Kinley takes over on his death in 1984.

Haus der Künstler opens at the Gugging Clinic, Klosterneuberg, Austria, with Dr Leo Navratil as director.

'American Folk Art: Herbert W Hemphill Collection' opens at the Milwaukee Art Museum, USA.

Elsa Longhauser curates 'Transmitters. The Isolate Artist in America' at the Philadelphia College of Art, Pennsylvania.

1982
Jean Dubuffet uses the term 'Neuve Invention', fresh invention, to designate works he

considered ancillary to Art Brut proper.

Jane Livingston and John Beardsley curate the seminal exhibition 'Black Folk Art in America, 1930-1980' at the Corcoran Gallery of Art, Washington DC.

Self-taught artist William L Hawkins wins a prize for his painting at the Ohio State Fair.

1983
Alain Bourbonnais' collection of 'Art hors-les-normes' (Art outside the norms) moves from Paris and opens as La Fabuloserie in Dicy, Yonne.

1984
Stephen Prokopoff and Inge Jádi curate an exhibition of work from the Prinzhorn Collection, which travels to four American venues.

Collection of L'Aracine is established in Paris by three Outsider artists: Madeleine Lommel, Michel Nedjar and Claire Teller.

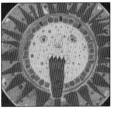

The Edward Adamson Collection of works deriving from art therapy is established at Ashton, near Cambridge, UK.

'Primitivism in 20th Century Art' exhibition at the Museum of Modern Art, New York.

1985
The Australian Collection of Art Brut/Outsider Art is established in Sydney by Philip Hammial and Anthony Mannix.

Death of Jean Dubuffet (1901-1985).

Albert Louden has a one-man show at London's Serpentine Gallery.

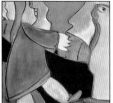

1986
Gérard Schreiner curates 'European Outsiders' at Rosa Esman Gallery, New York.

The Setagaya Art Museum in Japan opens with an exhibition entitled 'Naivety in Art' and will present Outsider Art in the future.

Herbert W Hemphill donates his folk art collection to the Smithsonian Institution, Washington, DC.

First exhibition of marginal art is organised by Art en Marge in Brussels, Belgium.

1987
Founding of the Folk Art Society of America with Ann Oppenhimer as president, alongside the publication of the first issue of the *Folk Art Messenger*.

'In Another World' begins a tour of city galleries in Britain.

1988
Kea Tawana is told by the municipal authorities to demolish her solo-built wooden Ark, in Newark, New Jersey.

Establishment of Museum im Lagerhaus at St Gallen, Switzerland.

A major retrospective of Augustin Lesage is held at Béthune and Arras, France; it travels to Lausanne, Florence and Cairo the following year.

1989
The first exhibition in his native country of art by Martin Ramirez is held at the Centro Cultural, Mexico City.

'Magiciens de la Terre' at the Pompidou Centre, Paris includes work by Ivory Coast artist Frédéric Bruly Bouabré.

First issue of *Raw Vision* magazine is published from Britain by editor John Maizels.

Site de la Création Franche is founded by Gérard Sendrey at Bègles, France.

Roger Manley curates 'Signs and Wonders: Outsider Art inside North Carolina' at North Carolina Museum of Art, Raleigh.

The Humanitarian Centre, an Outsider Art museum, opens in Moscow.

1990
Tyree Guyton's Heidelberg Project in Detroit is bulldozed for the first time by order of the mayor.

'High and Low: Modern Art and Popular Culture' opens at the Museum of Modern Art, New York.

Opening of the exhibition 'Made With Passion: the Hemphill Folk Art Collection' at the National Museum of American Art, Smithsonian Institution, Washington, DC.

Discovery of the architectural drawings of self-taught artist Achilles G Rizzoli of San Francisco.

1991
Formation of Intuit: The Center for Intuitive and Outsider Art, in Chicago.

'Särlingar', an exhibition of European Outsider Art, at the Malmö Konsthall, Sweden.

1992
'Parallel Visions: Modern Artists and Outsider Art' opens at the Los Angeles County Museum of Art; it later travels to Madrid, Basel and Tokyo.

1993
The first Outsider Art Fair opens in New York.

Alice Rae Yelen curates 'Passionate Visions of the American South: Self-Taught Artists from 1940 to the Present' at New Orleans Museum of Art.

'Driven to Create: Anthony Petullo Collection of Self-Taught and Outsider Art' opens at the Milwaukee Art Museum, Wisconsin.

The Collection de l'Art Brut in Lausanne holds the first European exhibition of Henry Darger. Further shows feature American Outsider artists and Bill Traylor.

1994
Museum De Stadshof opens in Zwolle, the Netherlands, aiming to embrace both Naive and Outsider Art. It is shut down by the local municipality in 2001.

Renewal, after a break of two decades, of the international exhibition INSITA at the Slovak National Gallery, Bratislava.

The first Folk Fest Art Fair opens in Atlanta, Georgia.

1995
American Visionary Art Museum, founded by Rebecca Hoffberger, opens in Baltimore, USA, with its first annual exhibition 'The Tree of Life', curated by Roger Manley.

Brazilian Outsider Arthur Bispo de Rosario features at the 46th Venice Biennale.

Halle Saint Pierre, Paris starts its series of Art Brut exhibitions with 'Art Brut & Cie', curated by Laurent Danchin, Martine Lusardy and Véronique Antoine-Anderson and showing work from six French-speaking Art Brut centres.

1996
Museum Charlotte Zander opens at Bönnigheim, Germany with a large collection of European naive and Outsider works.

'Pictured in My Mind: Contemporary American Self-Taught Art from the Collection of Dr Kurt Gitter and Alice Rae Yelen', is held at the Museum of Birmingham, Alabama.

'Henry Darger: The Unreality of Being' is held at the Museum of American Folk Art, New York.

L'Aracine museum closes and in 1999 the collection is donated to Musée d'Art Moderne Lille Métropole, at Villeneuve d'Ascq, France.

1997
The Museum of American Folk Art in New York opens its Contemporary Center to focus on Outsider Art.

The Nek Chand Foundation is formed in London to support the Rock Garden of Chandigarh.

'Kunst und Wahn' exhibition is held at the Kunstforum in Vienna.

Art Brut from the l'Aracine collection is shown for the first time at the Musée d'Art Moderne Lille Métropole, at Villeneuve d'Ascq, France.

1998
'Art Outsider et Folk Art des Collections de Chicago', curated by

Laurent Danchin, the first European show of American Outsider and self-taught artists held at Halle Saint Pierre, Paris.

Major retrospective of Willem van Genk at Museum De Stadshof, Zwolle, Netherlands.

The Outsider Archive collection is loaned long-term to the Irish Museum of Modern Art, Dublin and is renamed the Musgrave-Kinley Collection.

John Beardsley and Roger Cardinal curate 'Private Worlds: Classic Outsider Art from Europe' at Katonah Museum of Art, New York.

Musée de l'Art Différencié (MAD) opens in Liège, Belgium.

'Hors Champ', the first annual festival of films on Outsiders, opens in Nice.

1999
Collector Bruno Decharme launches abcd (art brut connaissance et diffusion) to promote Art Brut on an international scale.

Elsa Longhauser and Harald Szeeman curate 'Self-Taught Artists of the 20th Century: An American Anthology' at the Museum of American Folk Art in

New York and other US venues.

Roger Cardinal and Martine Lusardy curate 'Art spirite, médiumnique et visionnaire', an exhibition of international mediumistic art, at Halle Saint Pierre, Paris.

The work of Alexander Lobonov discovered at an art therapy congress in Yaroslavl, Russia.

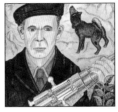

2001
Death of Geneviève Roulin, deputy director of the Collection de l'Art Brut, who brought the Collection to an international audience.

'American Folk' opens at the Boston Museum of Fine Arts as the first exhibition drawn from its permanent collection of American folk art.

'DIY Lives', the first major international exhibition of Outsider Art and contemporary folk art in Finland.

Death of Howard Finster in Georgia, USA. (1916-2001)

Death of August Walla (1936-2001) at the Gugging clinic, Austria.

Celebration of the Silver Jubilee of Nek Chand's Rock Garden at Chandigarh, India.

The Prinzhorn Collection is formally established as a public museum within the Psychiatric Clinic in Heidelberg, Germany, with Thomas Roeske appointed as Director in 2002.

The American Folk Art Museum (formerly the Museum of American Folk Art) moves into new premises in West 53rd Street, New York.

Lucienne Peiry named Director of the Collection de l'Art Brut, Lausanne.

2002
The European Commission announces a grant of one million euros for Contemporary Folk Art and Outsider Art in Europe under the title 'Equal Rights to Creativity'.

De Stadshof collection is re-located at Museum Dr Guislain in Ghent, Belgium.

Gaia Museum of Outsider Art opens in Randers, Denmark.

Raw Vision symposium takes place at Tate Modern, London.

The last issue of *L'Arte Naive*, the Italian journal of naive art, is published. After 69 issues (1973–2002) editor Dino Menozzi decides to halt publication of the magazine.

2003
'Offending the Medusa', the first show to exclusively present the work of Outsider and Art Brut artists in Estonia, takes place at Tallin Art Hall and Kullo Gallery.

79 creations by Arthur Bispo do Rosario and 117 works of psychopathological art from the Sainte-Anne Hospital are exhibited at Jeu de Paume, Paris.

Following an international symposium and artist workshops, a sculpture park is created at the Folk Art Museum, Kaustinen, Finland.

'Visionary and Fantastic Art', curated by Damian Michaels, travels throughout Australia.

'Vernacular Visionaries: International Outsider Art in Context' is held at the Museum of International Folk Art, Santa Fe.

The first Intuit Fair of Folk and Outsider Art takes place in Chicago with 30 galleries participating.

An auction sale in Paris disperses André Breton's art collection.

2004
Outsider Art is represented at the Olympics with 'The Other Side' exhibition held in Athens.

Raw Vision presents 'Equal Rights to Creativity,' an exhibition of Art Brut and Outsider Art from Europe and USA at the Mexico Gallery, London, as part of the EU initiative.

The Museum of Independence in Port-au-Prince, Haiti is ransacked by rebels wishing to destroy anything created during the Aristide government. Valuable paintings and an entire exhibition of 86 vodou dolls and sacred art are destroyed.

The first group of Nek Chand Foundation volunteers work on

restoration at the Rock Garden, Chandigarh.

'Everyday Creativity: A Finnish-Hungarian Exhibition of Outsider Art' is exhibited in Budapest.

The American Folk Art Museum presents a series of shows entitled 'The Art of Henry Darger (1892–1973)'.

The American Visionary Art Museum expands with the opening of its $9 million Jim Rouse Visionary Center.

2005
The first International Folk Art Convention to be held in India takes place in Chandigarh.

Touring exhibition 'Dubuffet and Art Brut' opens at Museum Kunst Palast, Düsseldorf, travelling to Lille and Lausanne.

Raw Vision publishes its 50th issue.

'Omissa Maailmoissa: In Another World', the first international survey of Outsider Art to be shown in Finland, opens at Kiasma Museum of Contemporary Art, Helsinki and is accompanied by a symposium.

ENVISION: the Missouri journal of folk and visionary art edited by John Foster publishes its final issue.

'Le Royaume de Nek Chand', comprising six exhibitions in Switzerland, France, Belgium and Italy,

is organised by the Collection de l'Art Brut.

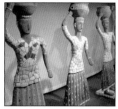

Outsider Art is exhibited at Tate Britain for the first time with works from the Musgrave Kinley Collection at the Museum of Modern Art, Dublin.

Dr Guislain Museum in Ghent, Belgium, opens a new wing housing further works from the De Stadshof collection.

2006
'The Work of Nek Chand' retrospective held at the Bhavan Centre, London.

La Maison Rouge, Paris presents the work of Henry Darger.

The 'Integrative Cultural Centre' opens with the unveiling of the Gugging Artists' Museum, Haus der Künstler, Gugging, Austria.

'Intuitives III' is held at the National Gallery of Jamaica.

Joe Coleman exhibition at Jack Tilton Gallery is the first major solo show for the artist in New York.

'Oltre la Ragione', the first large show of Outsider Art in Italy, opens at the Palazzo della Ragione, Bergamo.

Death of Seymour Rosen, founder of SPACES. (1935–2006).

'Inner Worlds Outside' touring exhibition opens in Madrid and travels to the Whitechapel Gallery, London, and the Museum of Modern Art, Dublin.

2007
Nek Chand and John Maizels are awarded the Medaille de la Ville de Paris for contributions to international culture.

'Sublime Spaces & Visionary Worlds: Built Environments of Vernacular Artists', held at John Michael Kohler Art Center, Sheboygan, Wisconsin.

Death of Anita Roddick, supporter of Outsider and Visionary Art. (1942–2007).

Discovery of 140 drawings by Martin Ramirez in a California garage.

2008
Major retrospective of the work of Michel Nedjar at the Gugging Museum.

'All Faiths Beautiful' at the American Visionary Art Museum reflects art in religious beliefs.

Japanese Art Brut shown at the Collection de l'Art Brut, Lausanne.

'Dargerism' at the American Folk Art Museum examines the Henry Darger's aesthetic influence.

With thanks to Roger Cardinal and Laurent Danchin. Sources include MacGregor (1989), Jacobs (1995) and Peiry (1997).

Bibliography

The Literature on Outsider Art

There are a number of thematic strands running through the literature on Outsider Art, connecting many of the works in the bibliography below. Firstly, there are a number of books that examine the psychiatric background to 'psychotic art',

some of which rehearse the traditional association between madness and genius. Secondly, there are those texts that look at art 'outside the norm', eccentric, free-range or untaught art that has a striking originality. Many of these books examine the origins of this creativity (both literally and metaphorically). There are also a number of texts that examine the cultural (or anti-cultural) envelope that has surrounded such art, looking at the polemical perspective in which it was first situated, and how this has developed. Finally, there are those books and catalogues that illustrate the actual range of the imagery, gathered under labels such as 'Art Brut' or 'Outsider Art', many of which detail the life stories of the artists who made them. Of course, many of the books listed below weave together several of these strands.

The first category obviously has an historical slant. Few turn-of-the century psychiatrists were interested in their patients' art as anything other than 'curiosities' or pictorial symptoms. Lombroso's famous *Genius and Madness* is hard to find, and editions vary in their amount of illustrations (several are reproduced in MacGregor, 1989). Lombroso's view of eccentric or deviant creativity seeks to explain its peculiarities in terms of external influences (hereditary and constitutional, but also geographical and even meteorological). Genius and psychopathology are assumed to be linked, to the extent that even if there is no evidence of disturbance, this must be because it is hidden.

Marcel Réja (Dr Paul Meunier), on the other hand, was less judgmental about the artistic originality and obsessive motivation of some patient art, and his enthusiasm for the marvellous anticipated Surrealism. However, in his *L'Art chez les fous* there is only one chapter on the art of madmen, with about 20 black-and-white plates (Levaillant, 1990 gives a fuller illustration of contemporary patient art).

Morgenthaler's monograph on Wölfli, although still claiming that Wölfli blindly obeyed instinctual drives in his art, was one of the first texts to present a patient artist as an individual, based on personal contact with him, and to acknowledge the

artistic quality of his work. This made Wölfli a famous 'psychotic artist' in his lifetime, and also brought him to the attention of Rilke and other artists. Elka Spoerri's *Adolf Wölfli* provides a much more in-depth analysis of Wölfli's colossal pictorial and written output, including his enigmatic status as 'composer', with superb illustrations to match.

40 years after Morgenthaler, Plokker's *Artistic Self-Expression In Mental Disease* (an unfortunate title) offers a more extensive formal analysis of some of the characteristic features of patient art, with an unusual range of illustration. On a smaller scale, Navratil, in his *Schizophrenie und Kunst,* put forward his basic model of the three 'fundamental creative functions' involved in 'schizophrenic art' (physiognomic, formalist and symbolic). But his richly illustrated study of Oswald Tschirtner's pen drawings, which forms the book's second half, begs all sorts of questions about the diagnostic perspective in which it is so confidently framed. Perhaps the final and most lavishly illustrated work within this category is Bader and Navratil's *Zwischen Wahn und Wirklichkeit.* This is an impressive survey of both historical and contemporary 'psychotic art', and the images almost make a case in their own right: nevertheless, the pathological perspective is predominant.

A number of other works set 'psychotic art' in a broader artistic context. The most famous is Prinzhorn's *Artistry of the Mentally Ill.* This elaborates a complete theory of the 'image-making urge', starting from aimless scribbling and progressing to representation, ornament and symbolism, which still bears scrutiny today. The detailed case studies of ten patient artists carry a faintly diagnostic tang; but, in the last section of his book, Prinzhorn points out the strange parallels between schizophrenic and modern art, where both attempt to deal with purely interior experience in the absence of any established pictorial conventions. No wonder his book influenced many artists, especially among the Surrealists.

Another book which presents three patient artists in an even more open-minded way is Cocteau, Schmidt, Steck and Bader's well-illustrated *Though this be Madness.* Here the artistic value of the work is clearly set off against the background information about the artist's life and clinical details, allowing the reader to appreciate it in its own right. This tendency has, of course, become more marked in recent exhibitions.

Far and away the best researched and illustrated investigation of the often uneasy relations between psychotic art and the wider art world is MacGregor's *The Discovery of the Art of the Insane*. He reproduces much of the visual material from earlier, hard-to-find, books and puts them in a careful scholarly perspective. His discussion of the changing fortunes of patient art in its relation both to psychiatry and the art world is consistently thoughtful and well-balanced. More recently several interesting catalogues have been published by the Prinzhorn Collection, notably *Collecting Madness* and *Air Loom*, which offer a more critical perspective on the whole notion of psychotic art. In a different vein, the newly renamed Art Brut Center at Gugging has published *Blug*, offering a lavish presentation of the work of its patient-artists.

'Psychotic art' may be the most controversial tip of the Outsider iceberg, but there are many other eccentric or outcast creators who have managed not to get labelled by the system. Here there is a no-man's-land between Outsider Art, naïve art and 'marginal' art. Although all of the works in Bihalji-Merin's profusely illustrated *Modern Primitives* are by untaught artists (with a strong Eastern European slant), few could be called 'Outsiders' in the strictest sense. However the archaic imagery and primitive handling of some folk art often brings it close to the feel of Outsider Art. In a sense some of the work in Kornfeld's *Cellblock Visions* comes into the same category; but there are also elaborate hyper-doodles and fantasy-symbolic images that have the rawness and intensity of Outsider Art.

'Art Brut' was the term coined by Dubuffet to define and promote forms of creativity that owed nothing to conventional notions of art and were indeed in outright contradiction to them. Hence the polemical tone of his *Asphyxiating Culture*. Thévoz's richly illustrated and equally provocative *Art Brut* conveys the combative stance of what has now become the Collection de l'Art Brut in Lausanne. The English term 'Outsider Art' comes from Cardinal's *Outsider Art,* which followed Dubuffet's lead in including untaught mediumistic and eccentric art alongside psychotic works. Though his book stays close to Dubuffet's collection, Cardinal is less belligerent, and his primary concern is with the originality and authenticity of the art itself.

As a result of the gradual recognition and acceptance of Outsider Art as a category in its own right, it can now be set in a more historical and critical perspective. Lucienne Peiry's well-researched *Art Brut: The Origins of Outsider Art* fills in the detail of many of the contradictions involved in the concept, and has an unusual choice of illustrations. Maizels' *Raw Creation* cuts a generous swathe through a broader territory which includes artists like Niki de Saint Phalle and Dubuffet himself, as well as unclassifiables such as Tatin or contemporary African or American 'folk' artists. Likewise, Rhodes' *Outsider Art: Spontaneous Alternatives*, besides offering another well-illustrated compendium, explores some of the connections between Outsiders and the wider world of art. He draws parallels between what has happened to 'Primitive Art' and what is happening to Outsider Art in the twentieth century. It is becoming increasingly hard to draw a line between Outsider Art and self-taught or contemporary Folk Art. The massive double volume survey of Southern American vernacular art, *Souls Grown Deep*, has an impressive collection of essays covering all of the major artists in this particular branch of the field.

Hall and Metcalf's *The Artist Outsider* is an important collection of essays, many of which deal with the reception of Outsider Art and its relation to the boundaries of culture, while others take a more polemical stance toward assumptions about 'art'. Likewise the four essays included in *Marginalia* (Van Berkum, Cardinal, ten Berge and Rhodes) offer refreshingly critical takes on the cultural situation of Outsider Art. Lyle Rexer's recent *How to Look at Outsider Art* is a well illustrated and more critical perspective on the field and its uncertain future. So is Laurent Danchin's *Art Brut*, which manages to pack a lot into a few hundred pages. There is also an interesting collection of essays in *Hidden Worlds*.

These are perhaps the most obviously significant books in this rapidly expanding field. A few of them (Lombroso, Réja, Navratil, Bader and Navratil) are still not available in full English translation. Some (Plokker, Schmidt, Steck and Bader, Cardinal) are out of print. Also, since the landmark 'Outsiders' show in 1979, a number of recent generic exhibitions have produced excellent and substantial catalogues (such as *Parallel Visions* 1992, *Beyond Reason* 1997, *Kunst und Wahn* 1997, *Inner Worlds Outside* 2006, *Beautes Insensees* 2006 and the *abcd Art Brut collection* 2006) which are well worth consulting.

David Maclagan

The Literature on Visionary Environments

Les Inspirés et leurs demeures by Gilles Ehrmann, published in Paris in 1962. With an introduction by André Breton and fully illustrated with Ehrmann's now historic photographs, it brought to light such creations as the Abbé Fouré's carved rocks at Rothéneuf, Brittany and

Raymomd Isidore's Maison Picassiette in Chartres, as well as extensively documenting the the Palais Idéal. In 1968 *Art in America* published an article, 'The Grass-Roots Artist', by Gregg Blasdel, which presented fourteen creations by self-taught builders and artists, including Clarence Schmidt's extraordinary House of Mirrors.

Roger Cardinal's landmark book *Outsider Art*, published in 1972, gave the world an English equivalent to *Art Brut* and also discussed such environments as Schmidt's House of Mirrors and Rodia's Watts Towers alongside works from the Dubuffet and Prinzhorn collections, firmly placing them in the same vein. The curator of Dubuffet's collection in Lausanne, Michel Thévoz, also included a few environments in his book *Art Brut*, published in French in 1975 and in English the following year, to coincide with the museum's opening.

In 1974 the Walker Art Center in Minneapolis presented a large photographic exhibition of major US environments, 'Naives and Visionaries' and in 1977 Jan Wampler's *All Their Own, People and the Places They Build* offered a comprehensive survey of American environments. It was in France again that *Jardins imaginaires* by Bernard Lassus was published in 1977, centering on major environments and also many lesser and hitherto unknown creations. Lassus introduced the term *habitants-paysagistes* to describe the artists who actually lived within their creations. Jacques Verroust's photographs in *Les Inspirés du bord des routes* (Lacarrière 1978) further emphasised the wealth of French creations.

Much of the original research in this field has been carried out by photographers, reflecting the powerful visual appeal of the environments. Photographer Seymour Rosen's involvement stemmed from his efforts in saving Watts Towers, and he formed the preservation organisation SPACES in 1978, striving to honour what were termed America's Folk Art Environments. Rosen's own book, *In Celebration of Ourselves*, mainly featuring Californian environments, appeared in 1979.

By the 1980s publications reflected new discoveries being made all around the world. *Fantastic Architecture* (1980) by Collins, Schuyt and Elffers was the first book to take a global view of the phenomenon and further discoveries were made by photographer Marcus Schubert in *Outsider Art II: Visionary Environments* (1991), a year after the first volume of photographs extensively detailing the major French sites, *Les Bâtisseurs de l'imaginaire* (Prévost and Prévost) and Claude Arz's first practical guidebook to French sites, *Guide de la France insolite.*

Sites in North Carolina were well documented by Roger Manley in his *Signs and Wonders* in 1989,

including the first wide coverage of Vollis Simpson's giant windmill automata and the haunting indoor environment by Annie Hooper, while the large number of Midwest environments were given extensive documentation in *Sacred Spaces and Other Places* (Stone, Zanzi 1993) and *Backyard Visionaries* (Brackman, Dwigans 1999). More recent books, such as the studious *Gardens of Revelation* (Beardsley 1995) and *Self-Made Worlds* (Manley, Sloan 1997), which listed 465 items worldwide, further extended the ever growing scope of support and interest in these extraordinary creations, while *Raw Creation* (Maizels 1996) included several sections on world environments. In the same year, Jim Christy's *Strange Sites*, a survey of environments on the Pacific North West coast of the USA and Canada, and Olivier Thiébaut's *Bonjour aux promeneurs!*, looking at rescued French environments, both presented further new discoveries.

The largest book to date, *Fantasy Worlds* (Maizels, von Schaewen 1999), covered over 70 environments across the world and has since been republished as an abridged version. International interest has been reflected in the publication of a range of books feat uring environmental creations of their own countries, the best of which are *Onnela* (Granö, 1989) and *DIY Lives* (Granö et al 2000) introducing discoveries in Finland and *Quirky Gardens* (Isaacs, 1995) on Australia, while we have seen detailed appraisals of, among others, the Tiger Balm Gardens (Brandel and Turbeville, 1998) in Hong Kong and Singapore, the Junkerhaus (Fritsch, Scheffler, 2000) in Germany, the Owl House in South Africa (*This is My World*, Ross 1997), and Galdwyn K Bush in the Cayman Isles (*My Markings,* Mutoo and Craig, 1994), Richard Greaves in Canada (Lombardi & Rousseau, 2006) and the first ever survey of Spanish sites (Ramirez, 2006).

Excellent recent works include Grano's *The Real Life of Veijo Rönkkönnen,* (2007, Finland), Kelly Ludwig's survey of US sites, *Detour Art* (2007), and Leslie Umberger's impressive and hefty work *Sublime Spaces and Visionary Worlds* (2007) as well two books featuring Nek Chand's Rock Garden, *The Collection, The Ruin etc* (ex cat, Liverpool 2007) and *Nek Chand's Outsider Art* (Peiry & Lespinasse, Paris 2005).

John Maizels

Abernethy, Francis Edward (ed.): *Folk Art in Texas,* Southern Methodist University Press, Dallas, 1985.

Adler, Peter & Nicholas Barnard: *ASAFO, African Flags of the Fante,* Thames & Hudson, New York, 1992.

Aigner, Carl & Helmut Zambo (ed.): *Johann Hauser. Im Hinterland des Herzens,* Verlag Christian Brandstätter, Vienna & Munich, 2001.

Aiken, Gayleen and Rachel Klein: *Moonlight and Music: The Enchanted World of Gayleen Aiken,* Harry N. Abrams, New York, 1997.

Allamel, Frédéric (ed.): 'Outsider Architectures', special edition of *The Southern Quarterly,* Vol. 35, Nos. 1–2, Fall–Winter, USA, 2000/2001.

Anderson, Brooke Davis: *Darger: The Henry Darger Collection at the American Folk Art Museum,* Harry N Abrams, New York, 2001.

Anderson, Brooke Davis (ed.): *Martin Ramirez,* Marquand Books, Seattle, 2007.

Ardery, Julia S: *The Temptation: Edgar Tolson and the Genesis of Twentieth Century Folk Art,* University of North Carolina Press, Blossom Hill, 1998.

Arnett, William & Paul Arnett et al: *Souls Grown Deep: African American Vernacular Art of the South, Volume One,* Tinwood Books, Atlanta, 2000.

Arnett, William & Paul Arnett et al: *Souls Grown Deep: African American Vernacular Art of the South, Volume Two,* Tinwood Books, Atlanta, 2001.

Aronson, Virginia: *Different Minds, Different Voices,* Paradux & Gossling Inc., Boca Raton, 1996.

Artaud, Antonin: *Van Gogh, le suicidé de la société,* Editions K, Paris, 1947.

Arz, Claude: *La France insolite,* Hachette, Paris, 1995.

Aulakh, MS: *The Rock Garden,* Tagore Publishers, Ludhiana (India), 1986.

Ayers, James: *British Folk Art,* Barrie & Jenkins, London, 1977.

Bader, Alfred: *Geisteskranker oder künstler? Der Fall Friedrich Schröder-Sonnenstern,* Hans Huber, Berne, Stuttgart & Vienna.

Bader, Alfred & Leo Navratil: *Zwischen Wahn und Wirklichkeit. Kunst – Psychose – Kreativität,* Verlag Bucher, Lucerne & Frankfurt, 1976.

Balmori, Diana & Margaret Morton: *Transitory Gardens, Uprooted Lives,* Yale University Press, New Haven & London, 1993.

Baraka, Amiri & Thomas McEvilly: *Thornton Dial: Image of the Tiger,* Harry N Abrams, New York, 1993.

Basicevic, Vojin: *My Father Ilija: A Draft for an Antimonography,* Novi Sad, 1996.

Baümer, Angelica (ed.): *Kunst von Innen. Art Brut in Austria,* Holzhausen Verlag, Vienna, 2007.

Beardsley, John: *Gardens of Revelation,* Abbeville Press, New York, 1995.

Beauthéac, Nadine & François-Xavier Bouchart: *Les Jardins fantastiques,* Le Moniteur, Paris, 1982.

Bender, Wolfgang (ed.): *Rastafarian Art,* Ian Randle, Kingston, Miami, 2005.

Berge, Jos ten (ed.): *Masters of the Margin,* Museum De Stadshof, Zwolle (Netherlands), 1999.

Berlin, Sven: *Alfred Wallis: Primitive,* Sansom & Company, Bristol, orig. 1949, re-issued 2000.

Bihalji-Merin, Oto: *Modern Primitives,* Gallery Books, New York, 1971.

Bihalji-Merin, Oto & Nebojsa-Bato, Tomasevic: *World Encyclopedia of Naïve Art,* Frederick Muller, London, 1984.

Billeter, Erika: *François Burland,* Benteli Verlag, Wabern/Berne, 2003.

Bishop, Robert & Jacqueline Marx Atkins: *Folk Art in American Life,* Viking Press, New York, 1995.

Blanc, Jean-Charles: *Afghan Trucks,* Mathews Miller Dunbar, London, 1976.

Blank, Harrod: *Wild Wheels,* Blank Books, Berkeley, 1994.

Blank, Harrod: *Art Cars: The Cars, the Artist, the Obsession, the Craft,* Blank Books, Douglas, AZ, 2002.

Blasdel, Gregg: 'The Grass-Roots Artist', *Art In America,* No 56, Sept/Oct, 1968.

Blasdel, Gregg & William C Lipke: *Schmidt,* Robert Hall Fleming Museum, University of Vermont, Burlington, 1975.

Boelen, Legs: *Art in Prison,* Nieuw-Vosseveld, Vught (Netherlands), 1996.

Bonesteel, Michael: *Henry Darger: Art and Selected Writings,* Rizzoli Intl Publications, New York, 2000.

Bonfand, Alan, Jacqueline Porret-Forel & Guy Tosatto: *Aloïse,* ELA/La Différence, Rochechouart, 1989.

Brackman, Barbara & Cathy Dwigans (eds.): *Backyard Visionaries: Grassroots Art in the Midwest,* University Press of Kansas, 1999.

Brand-Claussen, Bettina & Viola Michely: *Irre ist Weiblich: Künstlerische Interventionen von Frauen in der Psychiatrie um 1900,* Sammlung Prinzhorn/Wunderhorn, Heidelberg, 2004.

Brandel, Judith & Tina Turbeville: *Tiger Balm Gardens: A Chinese Billionaire's Fantasy Environments,* The Aw Boon Haw Foundation, Hong Kong, 1998.

Breton, André: 'Le Message automatique' in *Minotaure,* No. 3/4, Dec, Paris, 1933.

Breton, André: *Surrealism and Painting,* Harper & Row, New York, 1972.

Brousse, R; A Freytet; J Lagrange; J Meunier; B Montpied; R Nicoux; P Trapon; & P Urien: *Masgot,* Lucien Souny (France), 1993.

Brüggemann, Rolf & Gisela Schmid-Krebs: *Verortungen der Seele/Locating the Soul,* Mabuse-Verlag, Frankfurt-am-Main, 2007.

Cardinal, Roger: *The Art of George Widener,* Henry Boxer Gallery, London, 2009.

Cardinal, Roger: *Outsider Art,* Studio Vista, London & Praeger, New York, 1972.

Cardinal, Roger: *Primitive Painters,* Thames & Hudson, London, 1978.

Carlano, Annie (ed.): *Vernacular Visionaries: International Outsider Art,* Yale University Press, New Haven and London, 2003.

Carmichael, Elizabeth & Chloe Sayer: *The Skeleton at The Feast,* British Museum Press, London, 1991.

Carraher, Ronald George: *Artists in spite of Art,* Van Nostrand Reinhold, New York & London, 1970.

Carrington, Noel & Clarke Hutton: *Popular English Art,* Penguin Books, London, 1945.

Cherot, Bernard; Mario Chichorro; René Munch & Luis Marcel: *Chichorro,* Editions des 4 Coins, Loire, 1994.

Christy, Jim: *Strange Sites,* Harbour Publishing, British Columbia, 1996.

Clarke, Ethne & George Wright: *English Topiary Gardens,* Weidenfeld & Nicolson, London, 1988.

Cocteau, Jean et al: *Though this be Madness,* Thames & Hudson, London, 1963.

Collins, George; Joost Elffers & Michael Schuyt: *Fantastic Architecture,* Thames & Hudson, London, 1980. French version: *Les Bâtisseurs du Rêve,* Hachette, Paris, 1980.

Congdon, Kristin and Tina Bucuvalas: *Just Above the Water: Florida Folk Art,* University Press of Mississippi, Jackson, 2006.

Crnkovic Vladimir: *Ilija Bosilj: Zeichen und Symbole,* Edition Braus, Wachter Verlag, Heidelberg, 2000.

Crnkovic, Vladimir: *Croatian Museum of Naive Art*, Croatian Museum of Naive Art, Zagreb, 2000.

Crnkovic, Vladimir: *Art Without Frontiers*, Croatian Museum of Naïve Art, Zagreb, 2006.

Crnkovic, Vladimir: *Classics of the Naïve: Ivan Rabuzin*, Croatian Museum of Naive Art, Zagreb, 2005.

Crown, Carol (ed.): *Wonders to Behold: The Visionary Art of Myrtice West*, Mustang Publishing Company, Memphis, 1999.

Curto, Mario del: *The Outlanders, Forging Ahead with Art Brut*, Collection de l'Art Brut, Lausanne, 2000.

Danchin, Laurent: *Chomo*, Simoën, Paris, 1978.

Danchin, Laurent: *Art Brut et compagnie. La Face cachée de l'art contemporain*, La Différence, Paris, 1995.

Danchin, Laurent: *Le Manège de Petit Pierre*, La Fabuloserie, Dicy, 1995.

Danchin, Laurent: *Jean Dubuffet*, La Manufacture, Paris, 1988. (Revised edition Les Éditions de l'Amateur, Paris, 2001.)

Danchin, Laurent: *Jean Dubuffet*, Terrail, Paris, 2001.

Danchin, Laurent: *L'Art brut. L'instinct créateur*, Gallimard, Paris, 2006.

David, Francis: *Guide de L'Art insolite*, Editions Herscher, Paris, 1984.

Decharme, Bruno (dir.): *Alexandre Lobanov et l'Art Brut en Russie*, abcd, Paris, 2003.

Dejean, Philippe: *Châteaux de Sable*, Editions du Regard, Paris, 1982.

Delacampagne, Christian: *Outsiders*, Editions Mengès, Paris, 1989.

DePasse, Derrel B: *Traveling the Rainbow. The Life and Art of Joseph E Yoakum*, University Press of Mississippi, Jackson, 2001.

Dequeker, Jean: *Monographie d'un psychopathe dessinateur. Étude de son*

style, Université de Toulouse, Toulouse, 1948.

Deroeux, Didier (ed.): *Joseph Crépin, Catalogue Raisonné*, Paris, 1999.

Di Stefano, Eva: *Irregolari: Art Brut e Outsider Art in Sicilia*, Gruppo Editoriale Kalos, Palermo, 2008.

Dichter, Claudia: *Outsider Art. Collection Charlotte Zander*, Museum Charlotte Zander, Bönnigheim, 1999.

Dichter, Claudia, Hans Günter Golinski, Michael Krajewski, Susanne Zander: *The Message: Art and Occultism*, Walter König, Köln, 2007.

Dinsmoor, SP: *Pictorial History of the Cabin Home in Garden of Eden*, Lucas, Kansas, n.d.

Ditzen, Lore: *Nek Chand*, Haus der Kulturen der Welt, Berlin, 1991.

Dubuffet, Jean: *Prospectus et tous écrits suivants*, Vols I & II, Gallimard, Paris, 1967; III & IV, Gallimard, Paris, 1995.

Dubuffet, Jean: *Asphyxiating Culture and Other Writings*, New York, 1988 (original version Paris 1968).

Ehrmann, Gilles: *Les Inspirés et leurs demeures*, Editions du Temps, Paris, 1962.

Eissing-Christophersen, Christoph & Günther Gercken (eds.): *The Schlumpers. Art Without Borders*, Springer, Vienna & New York, 2001.

Fagaly, William A: *Tools of Her Ministry: The Art of Sister Gertrude Morgan*, Rizzoli International Publications, New York, 2004.

Fauchereau, Serge: *Gaston Chaissac. Environs et apartés*, Somogy, Éditions d'Art, Paris, 2000.

Feilacher, Johann (ed.): *Oswald Tschirtner: Das Rote Zebra*, Wienand Verlag, Cologne, 1997.

Feilacher, Johann (ed.): *Oswald Tschirtner: Menschen mit Heiligenschein*, Wienand Verlag, Cologne, 1997.

Feilacher, Johann: *Hauser's Frauen*, The Hildon Foundation, Hampshire, UK, 2001.

Feilacher, Johann (ed.): *Sovären: Das Haus der Künstler in Gugging*, Edition Braus im Wachter Verlag, Heidelberg, 2003.

Feilacher, Johann: *Michel Nedjar: Animo!*, Springer Verlag, Vienna & New York, 2008.

Fendelman, Helaine and Jonathan Taylor: *Tramp Art: A Folk Art Phenomenon*, Stewart, Tabori & Chang, New York, 1999.

Ferrier, Jean-Louis: *Les Primitifs du XXe siécle (art brut et art des malades mentaux)*, Terrail, Paris, 1997.

Ferrier, Jean-Louis: *Outsider Art*, Terrail, Paris, 1998.

Fine, Gary Alan: *Everyday Genius: Self-Taught Art and the Culture of Authenticity*, University of Chicago Press, Chicago and London, 2004.

Fineberg, Jonathan: *The Innocent Eye. Children's Art and the Modern Artist*, Princeton University Press, Princeton, 1997.

Finster, Howard: *Howard Finster. Man of Visions*, Peachtree Publishers, Atlanta, 1989.

Flournoy, Théodore: *Des Indes à la planète Mars*, Paris, 1900 (reprinted by Seuil, Paris, 1983).

Foucher, JP: *Séraphine de Senlis*, L'Oeil du temps, Paris, 1968.

Fritsch, Regina & Jurgen Scheffler (eds.): *Karl Junker und das Junkerhaus*, Verlag für Regionalgeschichte, Bielefeld, 2000.

Fuks, Paul: *Picassiette: Le jardin d'assiettes*, Ides & Calendes, Neuchâtel, 1992.

Gale, Matthew: *Alfred Wallis*, Tate Gallery Publishing, London, 1998.

Galipeau, Pascale: *Les Paradis du monde. L'art populaire au Québec*, Musée Canadien des Civilisations, Hull, 1995.

Garcet, Robert: *Eben-Ezer. Il était une fois*, Drukkerij Rosbeek bv. Nuth (Netherlands), 1997.

Gates, Katherine (ed.): *The*

Book of Joe: The Art of Joe Coleman, La Luz de Jesus Gallery/Last Gasp, Los Angeles, 2003.

Gates, Katherine (ed.): *Original Sin: The Visionary Art of Joe Coleman*, Heck Editions/Gates of Heck, New York, 1997.

Gercke, Hans & Inge Jarchov (eds.): *Die Prinzhornsammlung. Bilder, Skulpturen, Texte aus Psychiatrischen Anstalten (ca. 1890–1920)*, Athenäum Verlag, Königstein, 1980.

Gilley, Shelby R: *Painting By Heart: The Life and Art of Clementine Hunter*, St Emma Press, Baton Rouge, 2000.

Goekjian Karekin and Robert Peacock: *Light of the Spirit: Portraits of Southern Outsider Artists*, University Press of Mississippi, Jackson, 1998.

Goldstone, Bud & Arloa Paquin Goldstone: *The Los Angeles Watts Towers*, Thames & Hudson, London & JP Getty Foundation, California, 1997.

Goldwater, Robert: *Primitivism in Modern Art*, Belknap Press, 1938.

Gomez, Edward M: *Hans Krüsi*, Iconofolio/Objet Trouvé, Paris, 2006.

Granö, Veli et al: *Itse Tehty Elämä ITE (DIY Lives)*, Maahenki Oy, Helsinki, 2000.

Granö, Veli: *Onnela*, Markprint Lahti, Helsinki, 1989.

Granö, Veli: *The Real Life of Veijo Rönkkönen*, Maahenki Oy, Helsinki, 2007.

Granö, Veli, Marti Honkanen, Erkki Pirtola: *Itse Tehty Elämä ITE/DIY Lives*, Maahenki Oy, Helsinki, 2000.

Grassroots Art in Twelve New Jersey Communities: Kansas Grassroots Art Association, Lawrence, 1989.

Green, Candida Lycett & Andrew Lawson: *Brilliant Gardens*, Chatto & Windus, London, 1989.

Grey, Alex: *Transfigurations*, Inner Traditions International, Rochester, NY. 2001.

Gronert, Fritz: *Folly Drawings*, Galerie Atelier Herenplaats, Rotterdam, 2002.

Hadar, Dori: *Mingering Mike: The Amazing Career of an Imaginary Soul Superstar*, Princeton Architectural Press, New York, 2007.

Hall, Michael D & Eugene W Metcalf Jr (eds): *The Artist Outsider*, Smithsonian Institution Press, Washington, 1994.

Hartigan, Lynda Roscoe: *Made with Passion*, Smithsonian Institution Press, Washington & London, 1991.

Hatje, Gerd: *Adolf Wölfli*, Adolf-Wölfli-Stiftung, Berne, 1987.

Headley, Gwyn & Wim Meulenkamp: *Follies, Grottoes and Garden Buildings*, Aurum Press, London, 1999.

Helfenstein, Josef & Roman Kurzmeyer (eds): *Bill Traylor, 1854-1949, Deep Blues*, Yale University Press, New Haven & London, 1999.

Hemphill, Herbert W & Julia Weissman: *Twentieth Century American Folk Art and Artists*, Dutton, New York, 1974.

Hernandez, Jo Farb; John Beardsley & Roger Cardinal: *AG Rizzoli: Architect of Magnificent Visions*, Harry N Abrams, New York, 1997.

Hernández, Jo Farb: *Forms of Tradition in Contemporary Spain*, University Press of Mississippi, Jackson, 2005.

Herron, Jerry et al: *Connecting the Dots. Tyree Guyton's Heidelberg Project*, Wayne State University Press, Detroit, 2007.

Hong, Mi-Jen: *Art Brut: les dissidents de l'art*, Artist Publishing Co, Taipei, 2000.

Hulak, Fabienne: *La Mesure des irréguliers. Symptôme et création*, Z'éditions, Nice, 1990.

Hunger, Bettine et al: *Porträt eines produktiven Unfalls – Adolf Wölfli. Dokumente und Recherchen*, Stoemfeld/Nexus, Frankfurt am Main, 1993.

Hunt Kahlenberg, Mary et al: *The Extraordinary in the Ordinary*, Harry N Abrams, New York, 1998.

Ingolfsson, Adalsteinn: *Naive and Fantastic Art in Iceland*, Iceland Review, Reykjavik, 1989.

Isaacs, Jennifer: *Quirky Gardens*, Ten Speed Press, California, 1995.

Jádi, Ferenc: *Hans Prinzhorn*, Prinzhorn-Sammlung, Heidelberg, 1986.

Jádi, Inge & Ferenc Jádi: *Texte aus der Prinzhorn-Sammlung*, Wunderhorn, Heidelberg, 1985.

Jádi, Inge & Bettina Brand-Claussen: *August Natterer*, Wunderhorn, Heidelberg, 2001.

Jain, Jyotindra: *Other Masters. Five Contemporary Folk and Tribal Artists of India*, Crafts Museum, New Delhi, 1998.

Jakovsky, Anatole: *Dämonen und Wunder*, Verlag Du Mont Schauberg, Cologne, 1963.

Janis, Sidney: *They Taught Themselves. American Primitive Painters of the 20th Century*, New York, 1942. (Reprinted by Sanford L Smith & Associates, New York, 1999.)

Johnson, Randy, Jim Secreto & Teddy Varndell: *Freaks, Geeks and Strange Girls: Sideshow Banners of the Great American Midway*, Hardy Marks Publications, Honolulu, 1995.

Jones, Barbara: *Follies and Grottoes*, Constable, London, 1974.

Jones, Robert: *Alfred Wallis: Artist and Mariner*, Halsgrove, Tiverton, 2001.

Jovannais, Jean-Yves: *Des Nains, des jardins: essai sur le kitsch pavillonnaire*, Hazan (France), 1993.

Jungaberle, Henrik & Thomas Röske: *Rausch im Bild-Bilderrausch*, Sammlung Prinzhorn, Heidelberg, 2004.

Kallir, Jane: *The Folk Art Tradition*, The Viking Press, New York, 1982.

Kallir, Jane: *Grandma Moses*

in the 21st Century, Art Services International, Alexandria, 2001.

Karcher, Eva: *Revolution und Krieg*, Museum Charlotte Zander, Bönnigheim, 1997.

Kastener, Jeffrey, (ed): 'Environments by Self-Taught Artists', *Public Art Review*, Vol. IV, No. 7, Milwaukee, 1992.

Kemp, Kathy & Keith Boyer: *Revelations: Alabama's Visionary Folk Artists* Crane Hill, Alabama, 1994.

Kirby, Doug; Ken Smith & Mike Wilkins: *The New Roadside America*, Simon & Schuster, New York, 1986.

Kläger, Max: *Phänomen Kinderzeichnung*, Schneider, Baltmannsweiler, 1989.

Kloos, Marten: *Le Paradis terrestre de Picassiette*, Encre, Paris, 1979.

Kogan, Lee: *The Art of Nellie Mae Rowe: Ninety-Nine and a Half Won't Do*, University Press of Mississippi, Jackson, 1999.

Koide, Yukiko & Kyoichi Tsuzuki (ed): *Art Incognito*, Lampoon House, Tokyo, 1996.

Koide, Yukiko (ed.): *Adolf Wölfli: From the Cradle to the Grave*, Lampoon House, Tokyo, 1999.

Kornfeld, Phyllis: *Cellblock Visions. Prison Art in America*, Princeton University Press, New Jersey, 1996.

Körper, Bezauberte: *Michel Nedjar*, Galerie Susanne Zander, Cologne, 1994.

Krug, Hartmut: *Grenzgänger swiachen Kunst und Psychiatrie, 3rd expa. edition*, Deutscher Arzte-Verlag, Cologne, 2005.

Krug, Don and Ann Parker: *Miracles of the Spirit: Folk, Art, and Stories from Wisconsin*, University Press of Mississippi, Jackson, 2005.

Kupsh, Tom: *A Mythic Obsession: the World of Dr Evermor*, Chicago Review Press, Chicago, 2008.

Lacarrière, Jacques & Jacques Verroust: *Les Inspirés du bord des routes*, Seuil, Paris,

1978.

Laffal, Florence and Julius: *American Self-Taught Art*, Black Belt Publishing, Alabama, 2003.

Laffoley, Paul: *The Phenomenology of Revelation*, Kent Fine Art, New York, 1989.

Lambert, Don: *The Life & Art of Elizabeth "Grandma" Layton*, WRS Publishing, Waco, TX, 1995.

Lampwell, Ramona and Millard: *O, Appalachia: Artists of the Southern Mountains*, Stewart, Tabori & Chang, New York, 1989.

Landert, Markus & Dr Volker Dallmeier: *Josef Wittlich*, Wachter Verlag, Heidelberg, 1996.

Lanoux, Jean-Louis: *Chomo l'été Chomo L'hiver*, Fondation Chomo, Paris, 1987.

Laporte, Dominique Gilbert: *Laure ou la prosopopée du ciel*, Furor, Geneva, 1982.

LaRoche, Louanne: *Sam Doyle*, Kyoto Shoin, 1989.

Lassus, Bernard: *Jardins imaginaires*, Presses de la Connaissance, Paris, 1977.

Lechopier, Claude: *Une Mosaïque à Ciel Ouvert: La Maison Bleue de Dives-sur-Mer*, Editions Cahiers du Temps, Cabourg, 2004.

Le Maguet, Jocelyne & Jean-Paul: *Les Jouets de l'Imaginaire: Raymonde et Pierre Petit*, Editions de l'Albaron, Thonon-les-Bains, 1991.

Levaillant, Françoise: 'L'Analyse des dessins d'aliénés et de médiums en France avant le surréalisme' in Hulak, Fabienne, ed., *La Mesure des irréguliers*, Nice, 1990.

Levy, Mervyn: *Scottie Wilson*, Brook Street Gallery, London, 1966.

Lewery, AJ: *Popular Art Past and Present*, David & Charles, London, 1991.

Livingston, Jane & John Beardsley: *Black Folk Art in America 1930-1980*, University of Mississippi,

Jackson, 1982.

Lombardi, Sarah & Valérie Rousseau: (eds.): *Richard Greaves: Anarchitecte*, 5 Continents Editions, Milan, 2006.

Lombroso, Cesare: *Genio e Follia*, Turin, 1864.

Lommel, Madeleine: *L'Aracine et L'Art Brut*, Z'Editions, Nice, 2004.

Ludwig, Kelly: *Detour Art: Outsider, Folk Art, and Visionary Environments Coast to Coast*, Kansas City Star Books, Kansas City, 2007.

Lyons, Mary E: *Deep Blues: Bill Traylor, Self Taught Artist*, Macmillan, New York, 1994.

Lyons, Mary E: *Painting Dreams: Minnie Evans, Visionary Artist*, Houghton Mifflin Company, Boston, 1996.

MacGregor, John: *The Discovery of the Art of the Insane*, Princeton University Press, Princeton, 1989.

MacGregor, John: *Dwight Mackintosh: The Boy Who Time Forgot*, Creative Growth Art Center, Oakland, 1991.

MacGregor, John: *Metamorphosis. The Fiber Art of Judith Scott*, Creative Growth Art Center, Oakland, 1999.

MacGregor, John: *Henry Darger: In the Realms of the Unreal*, Delano Greenidge Editions, New York, 2002.

Magnin, André & Jacques Soulillou; *Contemporay Art of Africa*, Thames and Hudson, London, 1996.

Maizels, John: *Raw Creation: Outsider Art and Beyond*, Phaidon Press, London, 1996.

Maizels, John & Deidi von Schaewen: *Fantasy Worlds*, Taschen, London, 1999.

Magelos, Dimitrije Basicevic, *My Father Ilija*, Novi Sad, Serbia, 1996.

Manley, Roger: *Signs and Wonders: Outsider Art Inside North Carolina*, North Carolina Museum of Art, Raleigh, 1989.

Manley, Roger & Mark Sloan: *Self-Made Worlds, Visionary Folk Art Environments*, Aperture, New York, 1997.

Maresca, Frank & Roger Ricco: *Bill Traylor: His art, His life*, Alfred A Knopf, New York, 1991.

Maresca, Frank & Roger Ricco: *American Self-Taught*, Alfred A Knopf, New York, 1993.

Maresca, Frank & Roger Ricco: *William Hawkins: Paintings*, Alfred A Knopf, New York, 1997.

Martin, Jean-Hubert: *Dubuffet & l'Art Brut*, 5 Continents, Milan, 2005.

Materson, Roy & Melanie: *Sins and Needles: A Story of Spiritual Mending*, Alonquin Books of Chapel Hill, Chapel Hill, NC, 2002.

McKesson, Malcolm: *Matriarchy: Freedom in Bondage*, Heck Editions, New York, 1997.

Melly, George: *It's All Writ Out For You, the Life & Work of Scottie Wilson*, Thames & Hudson, London, 1986.

Messer, Thomas M & Fred Licht: *Jean Dubuffet & Art Brut*, Peggy Guggenheim Collection, Venice, 1986.

Metz, Holly: *Two Arks, A Palace, Some Robots & Mr Freedom's Fabulous Fifty Acres*, New Jersey, 1989.

Miscault, Dominique de, (ed): *Aleksander Pavlovitch Lobanov*, Paris, 2005.

Mihailsescu, Anca & Gerard Pestarque: *Sapinta, The Merry Cemetery*, Editions Hesse, France, 1991.

Monnin, Françoise: *L'Art Brut*, Editions Scala, Paris, 1997.

Monnin, Françoise: *Michel Nedjar: Envelopes / Enveloppes*, Iconofolio, Paris, 2006.

Monroe, Gary: *Extraordinary Interpretations: Florida's Self-Taught Artists*, University Press of Florida, Gainesville, 2003.

Monroe, Gary: *The Highwaymen: Florida's African-American Landscape Painters*, University Press, Florida, 2001.

Mookerjee, Priya: *Pathway Icons, the Wayside Art of India*, Thames & Hudson, London, 1987.

Morgenthaler, Walter: *Madness & Art: The Life and Works of Adolf Wölfli*, translation by Aaron H Esman, University of Nebraska Press, 1992. (English translation of *Ein Geisteskranker als Künstler: Adolf Wölfli*, 1921.)

Moses, Grandma: *My Life's History*, André Deutsch, London, 1952.

Moses, Kathy: *Outsider Art of the South*, Schiffer Publishing Ltd, Atglen, Pennsylvania, 1999.

Mutoo, Henry D, & Karl 'Jerry' Craig: *My Markings, The Art of Gladwyn K Bush*, Cayman National Cultural Foundation, Grand Cayman, 1994.

Nadau, Jean-Pierre: *Nadau: Les Turlupointus*, Dernier Cri, Marseille, n.d.

Navratil, Leo: *Schizophrenie und Kunst*, Deutscher Taschenbuch Verlag, Munich, 1965. (Reprinted 1996.)

Navratil, Leo: *Johann Hauser. Kunst aus Manie und Depression*, Rogner & Bernhard, Munich, 1978.

Navratil, Leo: *Die Künstler aus Gugging*, Medusa Verlag, Vienna & Berlin, 1983.

Navratil, Leo: *August Walla*, Greno Verlag, Nördlingen, 1988.

Navratil, Leo: *Bilder nach Bildern*, Residenz Verlag, Salzburg & Vienna, 1993.

Navratil, Leo: *Josef Karl Rädler 1844–1917*, Niederosterreichisches Landesmuseum, Vienna, 1994.

Navratil, Leo: *Art Brut und Psychiatrie. Gugging 1946-1986*, Christian Brandstätter, Vienna & Munich, 1999.

Nielsen, Johannes: *Overtaci: Pictures, Thoughts and Visions of an Artist*, Overtaci Fonden, Arhus, Denmark, 2005.

Niles, Susan A: *Dickeyville Grotto: The Vision of Father Mathias Wernerus*, University Press of Mississippi, 1997.

Notter, Annick & Didier Deroeux (eds.): *Augustin Lesage 1876–1954, (catalogue raisonné)*, Philippe Sers Editeur, Paris, 1988.

Oakes, John GH (ed.): *In the Realms of the Unreal*, Four Walls Eight Windows, New York, 1991.

Ostasenkovas, Aleksandras: *Kryziv Kalnas (The Hill of Crosses)*, Vilnius, (Lithuania), n.d.

Padgelek, Mary G: *In the Hand of the Holy Spirit. The Visionary Art of JB Murray*, Mercer University Press, Macon, Georgia, 2000.

Patterson, Tom: *Howard Finster: Stranger from another world, man of visions now on this earth*, Abbeville, New York, 1989.

Patterson, Tom: *St EOM in the Land of Pasaquan*, The Jargon Society, North Carolina, 1987.

Peacock, Robert, & Annibel Jenkins: *Paradise Garden*, Chronicle Books, San Francisco, 1996.

Peiry, Lucienne: *L'Art Brut*, Flammarion, Paris, 1997. (English version: *Art Brut*, 2001.)

Peiry, Lucienne & Philippe Lespinasse: *Nek Chand's Outsider Art: The Rock Garden of Chandigarh*, Flammarion, Paris, 2005.

Percy, Ann (ed.): *James Castle: A Retrospective*, Yale University Press, New Haven & London, 2008.

Petullo, Anthony: *Self Taught & Outsider Art*, University of Illinois Press, Urbana & Chicago, 2001.

Petullo, Anthony J & Katherine M Murrell: *Scottie Wilson: Peddler Turned Painter*, Petullo Publishing, Milwaukee, 2004.

Philadelphia's Magic Gardens, Open Eyes Press, Philadelphia, 1999.

Pierre, José: 'Raphäel Lonné et le retour des médiums', *L'Oeil*, No 216, December,

Paris, 1972.

Pirtola, Erkki: *Puuaapinen*, Maahenki Oy, Helsinki, 2003.

Plokker, JH: *Artistic Self-Expression in Mental Disease*, London & The Hague, 1964.

Porret-Forel, Jacqueline: *Aloïse et le théâtre de l'univers*, Albert Skira, Geneva, 1993.

Presler, Gerd: *L'Art Brut. Kunst zwischen Genialität und Wahnsinn*, Dumont Verlag, Cologne, 1981.

Prévost, Claude & Clovis Prévost: *Les Bâtisseurs de l'Imaginaire*, Editions de l'Est, France, 1990.

Prévost, Claude, Clovis Prévost & Jean-Pierre Jouve: *Le Palais Idéal du Facteur Cheval*, Paris 1981; revised ARIE Éditions, Hédouville, 1994.

Prinzhorn, Hans: *Bildnerei der Geisteskranken*, Springer Verlag, Berlin, 1922. (Translated as *Artistry of the Mentally Ill*, Springer, Vienna & New York, 1972, reprinted 1995.)

Prinzhorn, Hans: *Bildnerei der Gefangenen*, Alex Juncker Verlag, Berlin, 1926.

Purser, Philip: *Where Is He Now? The Extraordinary Worlds of Edward James*, Quartet Books, London, 1978.

Ragon, Michel: *Du Côté de l'Art Brut*, Albin Michel, Paris, 1996.

Ramírez, Juan Antonio (dir): *Esculcturas Margivagantes: La Arquitectura Fantástica en Espana*, Ediciones Siruela, Madrid, 2006.

Rajer, Anton: *Rudy Rotter's Spirit Driven Art*, Fine Arts Conservation, Madison, Wisconsin, 1998.

Rajer, Anton & Christine Style: *Public Sculpture in Wisconsin*, SOS, Wisconsin, 1999.

Rasmusen, Henry & Art Grant: *Sculpture from Junk*, Reinhold Book Corp, New York, 1967.

Réja, Marcel: *L'Art chez les fous*, 1907, (reprinted by Z'éditions, Nice, 1997).

Rexer, Lyle: *How to Look at Outsider Art*, HNA Books, New York, 2005.

Rexer, Lyle: *Jonathan Lerman: Drawings by an Artist with Autism*, George Braziller Inc, New York, 2002.

Rhodes, Colin: *Outsider Art. Spontaneous Alternatives*, Thames & Hudson, London & New York, 2000.

Riout, Denys: *Le Jardin des Merveilles de Bodan Litnianski*, Editions Vivement Dimanche, Amiens, 2004.

Rivers Cheryl (ed.): *Donald Mitchell: Right Here Right Now*, Creative Growth Art Center, Oakland, CA, 2004.

Roberts, Maurice (ed.): *Art Cars: Revolutionary Movement*, The Ineri Foundation, Houston, 1997.

Rodman, Selden: *Where Art is Joy*, Ruggles de Latour, New York, 1988.

Rodman, Selden & Carole Cleaver: *Spirits of the Night: the Vaudun Gods of Haiti*, Spring Publications, Dallas, 1992.

Ronné, Hervé: *Maisons de l'imaginaire*, Éditions Ouest-France, Rennes, 2004.

Rose, Howard: *Unexpected Eloquence. The Art in American Folk Art*, Raymond Saroff, Olive Bridge, New York, 1990.

Rosen, Seymour: *In Celebration of Ourselves*, California Living Books, Los Angeles, 1979.

Rosen, Seymour & Paul LaPorte: *Simon Rodia's Towers in Watts*, Los Angeles, 1962.

Rosenak, Chuck & Jan Rosenak: *Museum of American Folk Art Encyclopedia of Twentieth-Century American Folk Art and Artists*, Abbeville Press, New York, 1990.

Rosenak, Chuck & Jan Rosenak: *Contemporary American Folk Art.: A Collector's Guide*, Abbeville Press, New York, 1996.

Rosenak, Chuck and Jan: *Navajo Folk Art: The People*

Speak, Northland Publishing, Flagstaff, AZ, 1998.

Roeske, Thomas: *Der Arzt als Künstler – Ästhetik und Psychotherapie bei Hans Prinzhorn (1886-1933)*, Aisthesis Verlag, Bielefeld, 1995.

Roeske, Thomas: *Expressionismus und Wahnsinn*, Prestel Verlag, München, 2003.

Ross, Susan Imrie: *This is my world: The life of Helen Martins, Creator of the Owl House*, Oxford University Press, Cape Town, 1997.

Rousseau, Valérie: *Vestiges de l'Indiscipline: Environnements d'Art et Anarchitectures*, Collection Mercure, Gatineau, Quebec, 2006.

Roux, Guy & Murel Laharie: *Art et folie au Moyen Age*, Le Léopard d'Or, Paris, 1997.

Rush, Benjamin: *Medical Inquiries and Observations upon the Diseases of the Mind, etc.* (Facsimile of the Philadelphia 1812 edition), Hafner Publishing, New York, 1962.

Russell, Charles (ed.): *Self-Taught Art. The Culture and Aesthetics of American Vernacular Art*, University Press of Mississippi, Jackson, 2001.

Ryczko, Joe: 'Les Excentriques du pays aux bois', *Plein Chant*, No. 48, Châteauneuf-sur-Charante, 1991.

Sainsaulieu, Parie-Caroline & Valérie Boix-Vives: *Anselme Boix-Vives: Monographie, Catalogue Raisonné – Volume 1*, Editions de la Différence, Paris, 2003.

de Saint Phalle, Niki: *Der Tarot Garten*, Benteli Press, Wabern-Bern, 1998.

Schmied, Wieland: *Hundertwasser Architecture*, Taschen, Cologne, 1997.

Schubert, Marcus: *Outsider Art II: Visionary Environments*, Art Random, Kyoto Shoin, 1991.

Schuyt, Michael & Joost Elffers: *Fantastic Architecture: Personal and Eccentric Visions*, Thames & Hudson,

London, 1980.

Secretan, Thierry: *Going Into Darkness: Fantastic Coffins from Africa*, Thames & Hudson, London, 1995.

Selfe, Lorna: *Nadia. A Case of Extraordinary Drawing Ability in an Autistic Child*, Academic Press, London, 1977.

Sellen, Betty-Carol with Cynthia J Johanson: *20th Century American Folk, Self Taught and Outsider Art*, Neal-Schuman Publishers, New York, 1993 (updated version *Self-Taught, Outsider, and Folk Art*, MacFarland & Co., Jefferson, 2000).

Sellen, Betty-Carol with Cynthia J Johanson: *Outsider, Self Taught & Folk Art Annotated Bibliography*, McFarland & Co., Jefferson, 2002.

Sellen, Betty-Carol, *Art Centers*, MacFarland & Co., Jefferson, 2008

Sharpe, Mal; Sandra Sharpe & Alexander Vertikoff: *Weird Rooms*, Pomegranate Artbooks, San Francisco, 1996.

Simpson, Milton (with Jenifer Borum): *Folk Erotica: Celebrating Centuries of Erotic Americana*, Harper Collins, New York, 1994.

Smith, Glenn Robert: *Discovering Ellis Ruley*, Crown Publishers, New York, 1993.

Smither, John et al: *Collective Willeto. The Visionary Carvings of a Navajo Artist*, Museum of New Mexico Press, Santa Fe, 2002.

Spalding, Julian: *the Eclipse of Art: Tackling the Crisis in Art Today*, Prestel, Munich, Berlin, London, New York, 2003.

Spoerri, Elka: *Adolf Wölfli. Draftsman, Writer, Poet, Composer*, Cornell University Press, Ithaca & London, 1996.

Spoerri, Elka, Daniel Baumann, Daniel & Edward Gomez: *The Art of Adolf Wölfli: St Adolf-Giant Creation*, American Folk Art Museum, New York, 2002.

Stone, Lisa & Jim Zanzi: *Sacred Spaces and Other Places. A Guide to Grottos and Sculptural Environments in the Upper Midwest*, The School of the Art Institute of Chicago Press, Chicago, 1993.

Stone, Lisa & Jim Zanzi: *The Art of Fred Smith*, Weber & Sons, Phillips, Wisconsin, 1991.

Tatin, Robert: *Etrange musée Robert Tatin*, Librairie Charpentier, Mayenne, 1977.

Thévoz, Michel: *Louis Soutter ou l'écriture du désir*, L'Age d'homme, Lausanne, 1974.

Thévoz, Michel: *L'Art Brut*, Skira, Geneva 1975. (English version London & New York, 1976, reprinted 1995.)

Thévoz, Michel (ed.): *Neuve Invention*, Collection de l'Art Brut, Lausanne, 1988.

Thévoz, Michel: *Détournement d'écriture*, Minuit, Paris, 1989.

Thévoz, Michel: *Art Brut, psychose et médiumnité*, La Différence, Paris, 1990.

Thévoz, Michel: *The Art Brut Collection, Lausanne*, Swiss Museums, Zurich, 2001.

Thiébaut, Olivier: *Bonjour aux promeneurs!*, Éditions Alternatives, Paris, 1996.

Thompson, Robert Farris: *Flash of the Spirit*, Vintage Books, New York, 1984.

Thompson, William Thomas: *Art World of William Thomas Thompson*, Xlibris Corporation, 2006.

Tosatti, Bianca: *La Tinaia: 8 Künstler aus Italien*, Galerie Susi Brunner, Zurich, 2008.

Trechsel, Gail Andrews (ed.): *Pictured in My Mind*, Birmingham Museum of Art, Alabama, 1995.

Trusky, Tom: *James Castle: His Life and Art*, Idaho Center for the Book, Boise, Idaho, 2004.

Turner, JF: *Howard Finster, Man of Visions*, Alfred A Knopf, New York, 1989.

Turner, John and Deborah Klochko: *Create and Be Recognised: Photography on the Edge*, Chronicle Books,

San Francisco, 2004.

Umberger, Leslie: *Sublime Spaces & Visionary Worlds: Built Environments of Vernacular Artists*, Princeton Architectural Press, New York, 2007.

van Berkum, Ans, Roger Cardinal; Jos ten Berge & Colin Rhodes: *Marginalia. Perspectives on Outsider Art*, Museum De Stadshof, Zwolle (Netherlands), 2000.

van Berkum, Ans: *Willem van Genk*, Museum De Stadshof, Zwolle (Netherlands), 1998.

van Wyk, Gary N: *African Painted Houses*, Harry N Abrams, New York, 1998.

Vazeille, Jean-Bernard et al: *Gérard Lattier: Le Voyage en Peinture*, Editions du Chassel, Vals-les-Bains, 2004.

Viola, Wilhelm: *Child Art*, University of London Press, Bickley, 1942.

Vlach, Michael: *Plain Painters*, Smithsonian Institution Press, Washington, 1988.

Vogel, S et al: *Africa Explores*, Center for African Art, New York, 1991.

Volmat, Robert: *L'Art Psychopathologique*, Presses Universitaires de France, Paris, 1956.

Waldenburg, Hermann: *The Berlin Wall*, Abbeville Press, New York, 1986.

Wampler, Jan: *All Their Own: People and the Places They Build*, Schenkman Publishing, Cambridge, Massachusetts, 1977.

Weiss, Allen S: *Shattered Forms*, State University of New York Press, New York, 1992.

Wilbur, Ken, Carlo McCormick, Alex Grey: *Sacred Mirrors: The Visionary Art of Alex Grey*, Inner Traditions International, Rochester, 1990.

Williams, Sheldon: *Voodoo and the Art of Haiti*, Morland Lee, London, 1969.

Wilson, James L: *Clementine Hunter, American Folk Artist*, Pelican Publishing Company, Gretna, USA, 1990.

Yau, John: *James Castle. The Common Place*, Knoedler & Company, New York, 2000.

Young, Stephen Finn & DC Young: *Earl's Art Shop*, University Press of Mississippi, Jackson, 1995.

Younge, Gavin: *Art of the South African Townships*, Thames & Hudson, London, 1988.

Yust, Larry (ed.): *Salvation Mountain: The Art of Leonard Knight*, New Leaf Press, Los Angeles, 1998.

CATALOGUES

17 Naïfs de Taiwan, Halle Saint Pierre, Paris, 1998.

abcd, Touring Collection of Bruno Decharme, Paris, 2000.

abcd: Une Collection d'Art Brut, Paris Musées, Paris, 2000.

abcd: Une Collection d'Art Brut à Corps Perdu, Paris Musées, Paris, 2004.

Able Art, Osaka, 1996.

ACM, J-P Ritsch Fisch Galerie, Strasbourg, 2008.

Adolf Wölfli, Adolf Wölfli Foundation, Museum of Fine Arts, Berne, 1976.

Adolf Wölfli Zeichnungen 1904–1906, Kunstmuseum Berne, 1987.

Aftermath, France 1945–54 New Images of Man, Barbican Art Gallery, London, 1982.

Africa Now, Jean Pigozzi Collection, Groninger Museum, Netherlands, 1991.

Ai Margini dello Sguardo: l'Arte Irregolare nella Collezione Menozzi, Biblioteca Panizzi, Reggio Emilia, 2007.

The Air Loom and Other Dangerous Influencing Machines, Verlag daas Wunderhorn, Heidelberg, 2006.

Alain Bourbonnais: Architecte, Peintre, Sculpteur, Collectionneur, Edition La Fabuloserie, Dicy, 2002.

Aleksander Pavlovitch Lobonov, Editions Aquilon, Paris, 2007.

American Anthem. Masterworks from the American Folk Art Museum, American Folk Art Museum, New York, 2001.

Anna Zemánková, abcd, Paris, 2003.

Anny Servais, Mad Musée, Liège, 2004.

Another Face of the Diamond: Pathways Through the Black Atlantic South, Intar Latin American Gallery, 1988.

Anselme Boix-Vives, L'Etat des Lieux/Centre Vendome pour les Artts Platiques/La Différence, Paris, 1990.

L'Aracine, Musée d'Art Brut, Neuilly-sur-Marne, 1988.

L'Aracine, Collection de Art Brut, Musée d'Art Moderne, Villeneuve d'Ascq, 1997.

The Art of William Edmondson, Cheekwood Museum of Art, Nashville, University Press of Mississippi, Jackson, 1999.

Art Brut: abcd Collection, abcd, Paris, 2006.

Art Brut et Compagnie: la face cache de l'art contemporain, Halle Saint Pierre, Paris, 1995.

Art Brut Brésilien: Images de l'Inconscient, Halle Saint-Pierre/Passage Piétons, Paris, 2005.

Art Brut Fribourgeois, Collection de l'Art Brut, Lausanne, 2009.

Art Brut du Japon, Collection de l'Art Brut, Lausanne / Infolio, Gollion, 2008.

L'Art Brut Tcheque, Halle Saint-Pierre, Paris, 2002.

Art en Marge Collection, Art en Marge, Brussels, 2003.

Art Outsider et Folk Art des Collections de Chicago, Halle Saint Pierre, Paris, 1998.

Art spirite, médiumnique, visionnaire. Messages d'outre-monde, Halle Saint Pierre, Paris, 1999.

Art Unsolved. The Musgrave Kinley Outsider Art Collection, Irish Museum of Modern Art, Dublin, 1998.

Arte Necessaria, Galaria Bianca, Palermo, 1997.

Artists of Pure Heart, Olomouc Museum of Art, Czech Republic, 2001.

Atelier Incurve, Atelier Incurve, Osaka, 2006.

Atelier Incurve Exhibition at Suntory Museum, Atelier Incurve, Osaka, 2008.

Augustin Lesage 1876–1954, Arras, Béthune, Florence, Cairo, 1988.

Australian Outsiders, Halle Saint-Pierre, Paris, 2006.

Aux Frontières de l'Art Brut 2, Halle Saint-Pierre, Paris, 2001.

Baking in the Sun: Visionary Images from the South, University Art Museum, University of Southwestern Louisiana, Lafayette, 1987.

Les Barbus Müller, Gallimard, 1947, (reprinted 1979).

La Beauté Insensée, Collection Prinzhorn, Palais de Beaux-Arts, Charleroi, (Belgium), 1995.

Beyond Reason. Art and Psychosis. Works from the Prinzhorn Collection, Hayward Gallery, London, 1997.

Bildnerei der Geisteskranken, Galerie Rothe, Heidelberg, 1967.

Bill Traylor High Singing Blue, Hirschl/Hammer, New York/Chicago, 1997.

Bill Traylor: Observing Life, Ricco/Maaresca Gallery, New York, 1997.

Bill Traylor, William Edmondson and the Modernist Impulse, Krannert Art Museum and Kinkead Pavilion, Champaign, IL, 2004.

Black History/Black Vision, The Visionary Image in Texas, Austin College of Fine Arts Museum, University of Texas Press, 1989.

Blug: Gugging, Grounds for Art, Verlag Christian Brandstätter, Vienna & Munich, 2006.

Les Bricoleurs de l'Imaginaire, David Francis,
Loire, 1984–5.

British Outsider Art, Halle Saint Pierre, Paris, 2008.

Carlo: tempere, collages, sculture 1957–1974, Marsilio Editore, Venice, 1992.

Carlo Zinelli, catalogo generale, Marsilio Editore, Venice, 2000.

Carlo Zinelli 1916–1974, Somogy Editions d'Art, Paris, 2003.

Carom! Art from Gugging in the Essl Collection, Edition Sammlung Essl, Klosterneuburg, 1999.

The Cast-Off Recast: Recycling and the Creative Transformation of Mass-Produced Objects, UCLA Fowler Museum of Cultural History, Los Angeles, 1999.

Cat and a Ball on a Waterfall: 200 Years of California Folk Painting and Sculpture, Oakland Museum, Oakland, 1996.

Catalogue de la Collection de l'Art Brut, Compagnie de l'Art Brut, Paris, 1971.

Chaissac, Galerie Nationale du Jeu de Paume, Paris, 2000.

Charles A.A. Dellschau 1830-1923: Aeronautical Notebooks, Ricco/Maresca Gallery, New York, 1997.

Du Ciel à la terre, Musée Ingres, Montauban, 1997.

Collectie Arnulf Rainer, Museum De Stadshof, Zwolle, 1996.

Collecting Madness: Outsider Art from the Dammann Collection, Sammlung Prinzhorn, Heidelberg, 2006.

The Collection, the Ruin and the Theatre: Architecture, Sculpture and Landscape in Nek Chand's Rock Garden, Chandigarh, Liverpool University Press, Liverpool, 2007.

Coming Home! Self-Taught Artists, the Bible and the American South, University Press of Mississippi, Jackson, 2004.

*Common Ground/Uncommon Vision. The Michael and Julie Hall Collection of American
Folk Art*, Milwaukee Art Museum, 1993.

Contemporary American Folk Art: The Balsley Collection, Patrick & Beatrice Haggerty Museum of Art, Marquette University, Milwaukee, 1992.

Copier/Coller: Six Créateurs Répétitifs, Musée de l'Art Différencié, Liège, 2001.

The Cunningham Dax Collection: Selected Works of Psychiatric Art, Melbourne University Press, Carlton South, Victoria, 1998.

Devil Houses: Frank Jones Drawings, Janet Fleisher Gallery, Atlanta, 1992.

Do We Think Too Much? I Don't Think we Can Ever Stop: Lonnie Holley, A twenty-Five Year Survey, Birmingham Museum of Art, AL, USA/ IKON Gallery, Birmingham, UK, 2000.

Dream Singers, Story Tellers: An African-American Presence, Fukui Art Museum, New Jersey State Museum, 1993.

Driven To Create: The Anthony Petullo Collection of Self-Taught & Outsider Art, Milwaukee Art Museum, Milwaukee, 1993.

Ecritures Imagées, Art en Marge, Brussels, 2004.

An Eccentric World: The Art of Hung Tung, 1920–1987, Tainan County Cultural Center, Taiwan, 1996.

Echo McCallister, The Silent Outsider, NAEMI, Miami, 2005.

Eddie Arning: Selected Drawings, 1964–1973, Colonial Williamsburg Foundation, Williamsburg, 1985.

Edmund Monsiel. Odslona Druga, Plocka Galeria Sztuki, (Poland) 1997.

Elijah Pierce. Woodcarver, Columbus Museum of Art, Ohio, 1992.

Emile Ratier, Musée Henri Martin Cahors, Cahors, 2000.

The End is Near!, American Visionary Art Museum, Baltimore, 1998.

Eröffnung und Kongress,
Museum Prinzhorn-Sammlung, Heidelberg, 2001.

ET Wickham. A Dream Unguarded, Customs House Museum & Cultural Center, Clarksville, Tennessee, 2001.

Eternity Has No Door of Escape, The Eternod-Mermod Collection of Art Brut, Galleria Gottardo, Lugano, 2001.

Equal Rights to Creativity: A Celebration of Outsider Art, Raw Vision, London, 2004.

The Essence of Outsider Art: Singular Visions, Galerie Miyawaki, Kyoto, 2008.

Eugene von Bruenchenhein, Obsessive Visionary, John Michael Kohler Arts Center, Wisconsin, 1988.

European Outsiders, Rosa Esman Gallery, New York, 1986.

The Fabric of Myth, Compton Verney, Warwickshire, 2008.

La Fabuloserie: Art hors-les-normes, Dicy, France, 1983. (revised edition 1993.)

Family Found: the Lifetime Obsession of Self-Taught Artist Morton Bartlett, Marion Harris Gallery, Connecticut, 1994.

Figure Dell'Anima, Castel Viscontio, Pavia, 1998.

Frédéric Bruly Bouabré, Edition Braus, Heidelberg, 1993.

Flying Free, Abby Aldrich Rockefeller Center, Colonial Williamsburg Foundation, Williamsburg, 1997.

Folk Sculpture USA, Brooklyn Museum & Los Angeles County Museum of Art, 1976.

Gaston Chaissac, Musée de l'Abbaye Sainte-Croix, Les Sables d'Olonne, 1993.

Gaston Chaissac 1910–1964, Musée des Beaux-Arts, Nantes, 1998.

Grassroots Art in Twelve New Jersey Communities, Kansas Grassroots Art Association, Lawrence, 1989.

Harald Stoffers: Briefe/Letters, Revolver, Frankfurt-am-Main, 2004.

The Heart of Creation: The Art of Martin Ramirez, Goldie Paley Gallery, Moore College of Art, Philadelphia, 1985.

Heavenly Visions, the Art of Minnie Evans, Raleigh Museum of Art, North Carolina, 1986.

Heinrich Anton Müller. 1969–1930, Erfinder. Landarbeiter. Künstler, Bawag Foundation, 2000.

Heinrich Anton Müller. 1969–1930, Katalog der Maschinen, Zeichnungen und Schriften, Stroemfeld Verlag, Frankfurt, 1994.

Het Formaat, Museum De Stadshof, Zwolle, 1994.

Henry Darger: Disasters of War, KW Institute for Contemporary Art, Berlin, 2000.

De l'Imaginaire, au Petit Musée du Bizarre, Editions de Candide, Lavilledieu, 1993.

Ilija Bosilj, Zeichen und Symbole, Charlotte Zander Museum, 2000.

In Another World: Outsider Art from Europe and America, The South Bank Centre, London, 1987.

In Pursuit of the Invisible, selections from the collection of Janice and Mickey Cartin, Richmond Art Center, Connecticut, 1996.

Inner Necessity: Art Therapy and Art Extraordinary in Scotland, Talbot Rice Gallery, Edinburgh, 1996.

Inner Worlds Outside, Fundación La Caixa, Irish Museum of Modern Art, Whitechapel Gallery, London, 2006.

Inner Worlds Outside (supplement), Fundación La Caixa, Madsrid, Irish Museum of Modern Art, Dublin and Whitechapel Gallery, London, 2006.

Insita: International Exhibition of Self-Taught Art, Slovak National Gallery, Bratislava, 1997, 2000, 2004, 2007.

The Intuitive Eye: the Mendelsohn Collection, Ricco/Maresca Gallery, New York, 2000.

J'aime Cheri Samba, Fondation Cartier pour l'Art Contemporain, Paris, 2004.

Janko Domsic, Le Mécanicien céleste, Galerie Objet Trouvé, Paris, 2008.

Je Vous Tisse un Linceul/I Weave You a Shroud: Rosemarie Koczy, Outsiders en Vue asbl, Liége, 2001.

Jean Dubuffet & Art Brut, Peggy Guggenheim Collection, Venice, 1986–97.

Jean-Pierre Nadau: Exuvies, Culture Hors Sol, Saint Félix, 2002.

Jephan de Villiers: Le Peuple sous l'Ecorce, Editions du Rouergue, Rodez, 2007.

Jesse Howard & Roger Brown: Now Read On, UMKC Center for Creative Studies, 2005.

Johann Hauser. Im Hinterland des Herzens, Kunsthalle Krems, Krems-Stein, 2001.

Josef Hofer, Galerie am Stein, Schärding, Austria, 2008.

Josef Wittlich, Magistrat der Stadt Darmstadt, Darmstadt, 1982.

Keeping the Faith, Anheuser-Busch Gallery, Missouri, 1999.

Kentucky Spirit, The Naive Tradition, Owensboro Museum of Fine Art, Kentucky, 1991.

Knowledge of the World, Frédéric Bruly Bouabré, Nexus Press, Atlanta, 1998.

Künstler aus Gugging: Zur Art Brut der Gegenwart, Universität Oldenburg, 1989.

Kunst und Wahn, Kunstforum, Vienna, 1997.

Let it Shine: Self-Taught Art from the T Marshall Hahn Collection, High Museum of Art, Atlanta, 2001.

The Life and Art of Jimmy Lee Sudduth, Montgomery Museum of Fine Arts, Montgomery, 2005.

Der letze Kontinent: (Waldau Archive), Limmer Verlag, Zurich 1997.

Louis Soutter, 1871–1942, Hatje Cantz Verlag, Ostfildern-Ruit, 2002.

M'An Jeanne, Centre Regional d'Art Contemporain, Fontenoy, 2002.

Madmusée Collection 1998–2008, Mad Musée Liège, Belgium, 2008.

Made in USA, Collection de l'Art Brut, Lausanne, 1993.

Magiciens de la Terre, Musée National d'Art Moderne, Éditions du Centre Pompidou, Paris, 1989.

Malcolm McKesson: an Exquisite Obsession, Henry Boxer Gallery, London, 1997.

Marie-Rose Lortet: Territoires de Laine, Architecture de Fils, 1967-2000, Musées d'Angers, Angers, 2000.

Martín Ramírez, Marquand Books, Seattle, 2007.

Masters of the Margin, Museum De Stadshof, Zwolle, 2000.

Masters of Popular Painting, Museum of Modern Art, New York, 1938.

Matt Lamb, Fassbender Gallery, Chicago, 1994.

Matt Lamb: Obsessive Spirit, Wrestling with the Angels, Rockford Art Museum, Rockford, 1997.

The Message: Art and Occultism, ed: Claudia Dichter, Kunstmusem Bochum, Wather König, Köln, 2008.

Michel Nedjar: Animo! Springer, Vienna, New York, 2008.

Minnie Evans, Wellington B Gray Gallery, East Carolina University, Greenville, 1993.

Miroslav Tichy, Kunsthaus, Zurich, 2005.

Naive and Marginal Art in Serbia, Museum of Naive Art, Jagodina, Serbia, 2007.

Naives and Visionaries, Walker Art Center, Minneapolis, 1974.

Naivety in Art, Setagaya Art Museum, Tokyo, 1996.

Nek Chand Shows the Way, Watermans Arts Centre, London, 1997.

Nellie Mae Rowe, Morris Museum of Art, Augusta, Georgia, 1996.

Noir/Blanc: Mondes Intérieurs, Travioles/Halle Saint-Pierre, Paris, 2001.

Not By Luck, Self-Taught Artists in the American South, Lynne Ingram Southern Folk Art, Milford, New Jersey, 1993.

Oinirické vize Anny Zemánkové, Olomouc Museum of Art, Czech Republic, 1998.

Oltre la Ragione: Le Figure, i Maestri, le Storie dell'Arte Irregolare, Skira, Milan, 2006.

Open Mind, Museum van Hedendaagse Kunst, Gent, 1989.

The Other Side of the Moon: The World of Adolf Wölfli, Goldie Paley Gallery, Moore College of Art, Philadelphia, 1988.

Outsiders. An art without precedent or tradition, Arts Council of Great Britain, London, 1979.

Outsider Art from the Outsider Archive, Random Art, Kyoto Shoin, 1990.

Outsider Art: An Exploration of Chicago Collections, City of Chicago Department of Cultural Affairs, 1997.

Outsider Art in Italia, Skira, Milan, 2003.

Outside/In: Outsider and Contemporary Artists in Texas, Texas Fine Art Association, Texas, 1994.

Parallel Visions, Modern Artists and Outsider Art, Los Angeles County Museum of Art, Princeton University Press, 1992.

Passionate Visions of the American South, Self Taught Artists from 1940 to the Present, New Orleans Museum of Art, 1993.

Paul Duhem Retrospective, Art en Marge, Brussels, 2004.

Phanton: Christine Sefolosha, Collection SlushLarry, Lausanne, 2005.

Pictured In My Mind, contemporary American Self-Taught from the Collection of Dr Kurt Gitter and Alice Rae Yelen, Birmingham Museum

of Art, 1995.

Pioneers in Paradise: Folk and Outsider Artists of the West Coast, Long Beach Museum of Art, 1984.

Portraits From the Outside, Parsons School of Design Gallery, New York, 1990.

Private Worlds. Classic Outsider Art from Europe, Katonah Museum of Art, New York, 1998.

Private Worlds. Outsider and Visionary Art, Orleans House Gallery, Twickenham, 2001.

Rabuzin, a Bio-Biography, Croation Museum of Art, Zagreb, 2008.

Raymond Reynaud: Un Singulier de l'Art, Images en Manœuvres Editions, Marseille, 1999.

Reclamation and Transformation: Three Self-Taught Chicago Artists, Terra Museum of American Art, Chicago, 1994.

Recycled, Re-Seen: Folk Art from the Global Scrap Heap, Museum of International Folk Art, New Mexico, 1996.

Religious Visionaries, John Michael Kohler Arts Center, Sheboygan, Wisconsin, 1991.

Reverend McKendree Robbins Long: Picture Painter of the Apolcalypse, Davidson College, North Carolina, 2002.

Roy Wenzel: Works on Paper, Stichting Museum de Stadshof, 2000.

Sacred Arts of Haitian Vodou, UCLA Fowler Museum, Los Angeles, 1995.

Sang d'encre. Théophile Bra, 1797–1863, Un Illuminé romantique, Musée de la vie romantique, Paris, 2006.

Särlingar, Malmö Konsthall, Malmö, 1991.

Schmidt, The Robert Hull Fleming Museum, University of Vermont, 1975.

Self-Taught Artists of the 20th Century, Elsa Longhauser & Harald Szeeman (eds.), Museum of American Folk Art, New York, 1998.

Self Taught, Outsider, Art Brut: Masterpieces from the Robert M Greenberg Collection, Ricco Maresca Gallery, New York, 1999.

Serge Vollin: Un Regard sur l'Art Singulier, Villa des Arts, Voreppe, 2001.

A Silent Voice: Drawings and Constructions of James Castle, Fleisher/Ollman Gallery, Philadelphia, 1998.

Les Singuliers de l'art. Des inspirés aux habitants paysagistes, Musée d'Art Moderne de la Ville de Paris, 1978.

Site de la Création Franche. Regards sur la collection, Bègles, 1994.

Solitärer, Eternod-Mermod Collection, Malmö & Stockholm, 2000.

Sonneastro - Die Künstler aus Gugging, Vienna, 1990.

Sound and Fury: The Art of Henry Darger, Andrew Edlin Gallery, New York, 2006.

Spirited Journeys. Self-Taught Texas Artists of the Twentieth Century, Archer M Huntington Gallery, The University of Texas, Austin, 1997.

Stiftung fur Schweizerische Naïve Kunst und Art Brut, St Gallische Kantonalbank, 1988.

A Surreal Life: Edward James, Brighton Museum & Art Gallery, 1988.

Tatin, Musée du Vieux Château, Laval, 1978-1979.

Testimony: Vernacular Art of the African-American South, The Ronald and June Shelp Collection, Harry N Abrams, New York, 2001.

Theo: Eine Retrospektive, Museum Schloss Moyland, Bedberg-Hau, 2003.

Thornton Dial. Image of the Tiger, Museum of American Folk Art, New York, 1993.

Thornton Dial: Strategy of the World, Southern Queens Park Association, Jamaica & New York, 1990.

The Ties that Bind: Folk Art in Contemporary American Culture, Contemporary Arts Center, Cincinnati, 1986.

Through the Looking Glass: Drawings by Elizabeth Layton, Nid-America Arts Alliance, Kansas City, 1984.

Traum Welt Pferd: Das Pferd in der Aussenseiterkunst, Museumm im Lagerhaus, St. Gallen, 2003.

Tree of Life, American Visionary Art Museum, Baltimore, 1995.

Two Painters. Works by Alfred Wallis and James Dixon, Irish Museum of Modern Art, Dublin, 1999.

Univers Cachés/Hidden Worlds: L'Art Outsider au Musée Dr Guislain, Lannoo, Tielt, 2005.

Visions, annual publication of AVAM, issued in conjunction with the exhibitions. From Vol. 1, 1995.

Wölfli Dessinateur-compositeur, L'Age d'Homme, Lausanne, 1991.

Wos Up Man? Selections from the Joseph D and Janet M Shein Collection of Self-Taught Art, Palmer Museum of Art, Pennsylvania State University, 2005.

A World of their Own. Twentieth-Century American Folk Art, The Newark Museum, Newark, New Jersey, 1995.

PERIODICALS

Arte Naive, 69 issues (1973–2002) editor Dino Menozzi

Artesian, Journal of the Scottish and international outsider art. 7 issues 2000–2004.

Artlink, Vol. 12, No 4, Australia, 1992–93.

Barbus Müller, Les, Collection de l'Art Brut, Paris, 1947.

Bulletin d'Association d'Ozenda, 1997–2005, ed. Dr J Caire.

Aspect, Outsider Art in Australia, No 35, 1989.

Art Papers, On Folk/Self-Taught/Outsider Artists, Vol 18, No 5, ed. Glen Harper, 1994.

Art Papers, Inside the Outside: Re-thinking Folk Art,

Vol. 22, No 1, ed. Jerry Cullum, 1998.

Art & Text, No. 27, ed. Allen S Weiss, Australia 1988.

Art Visionary, international visionary, surreal and 'art fantastique'. 3 issues, ed. Damian Michaels.

Envision, journal of the Envision Folk Art of Missouri organisation, ed. John Foster.

Folk Art Finder, ed. Florence Laffal, Vols 1–14, Connecticut 1978–2000.

KGAA Newsletter, Kansas Grassroots Art Association, Lucas, 1980–92. Conservation and discovery of environments.

Kunstforum 101, Bild und Seele, ed. Paolo Bianchi, Köln, 1981.

Kunstforum 112, Outside USA I, ed. Paolo Bianchi, Köln, 1991.

Kunstforum 113, Outside USA II, ed. Paolo Bianchi, Köln, 1991.

Kunstforum 122, Africa, ed. Paolo Bianchi, Köln, 1992.

L'Oeuf sauvage, Nos 1–9, Paris, 1991–1994. Articles on mainly European art brut subjects.

SPACES – Notes on America's Folk Art Environments, ed. Seymour Rosen, Nos 1–11, Los Angeles, 1982–92. Detailed information on the documentation and preservation of environments.

SPOT, Folk Art Environments, Vol. X, Nos 1 & 2, Houston, 1991.

REGULAR PUBLICATIONS

L'Art Brut fascicules
The official publication of the Collection de l''Art Brut in Lausanne.

Artension
French contemporary art magazine with a strong interest in Outsider Art.

Création Franche
Colourful publication of the Musée de la Création Franche, Bègles.

Folk Art
Regular publication of the American Folk Art Museum.

Folk Art Messenger
The journal of the Folk Art Society of America.

Gazogène
French review focusing on various forms of *singulier* and marginal subjects.

The Outsider
The newsletter of Intuit, with news, reviews and articles.

Raw Vision
International journal of Outsider, Art, Art Brut and contemporary folk art.

FILMS

Paul Amar
Paul Amar, pape des coquillages: Philippe Lespinasse, Andress Alvarez, France, 2004, 30'.

Art Brut
Art Brut: Ni-Tanjung (Bali), Lobonov (Russia), Santoro (Swiss): Manoni, Clement, Woodtil, Collection de l'Art Brut, Lausanne, 2008, three films, 9', 12', 12'.

Art Cars
Driving the Dream: Harrod Blank, USA, 1998, 29'.

Art Cars
Wild Wheels: Harrod Blank, USA, 1992, 29'.

Art Cars at the Houston Art Car Parade
Just Another Day at Art Car: Erik Kolflat, USA, 2004, 28'.

Arthur Bispo do Rosario
L'Apothéose d'Arthur Bispo do Rosario: Maione De Queiroz Silva, France. 2006, 26'.

Calvin Black
Possum Trot, the Art of Calvin Black: Irving & Allie Light, USA, 28'.

François Burland
Les cinq saisons de François Burland: Philippe Lespinasse, Andress Alvarez, France, 2006, 60'.

James Castle
James Castle: Portrait of an Artist: Jeffrey Wolf, 2008, USA, 53'.

Nek Chand
Nek Chand: Ulli Beier, Paul Cox, Australia, 1985, 20'

Nek Chand
Le Royaume de Nek Chand: Philippe Lespinasse, France, 2005, 52'.

Ferdinand Cheval
Le Palais ideal: Ado Kyrou, Jacques Demeure, France, 1958, 13'.

Ferdinand Cheval
Le Facteur Cheval: où le songe devient la réalité: Clovis Prévost, Claude Prévost, France, 1980, 28'.

Joe Coleman
R.I.P. Rest in Pieces: Robert Pejo, Austria, 1997, 87'.

Tony Convey
Days of Gold, The Art of Tony Convey: Simon Cooper, Australia, 1995, 20'.

Henry Darger
In the Realms of the Unreal: the Mystery of Henry Darger: Jessica Yu, USA, 2003, 81'.

Rev Dennis & Margaret Dennis
Home of the Double Headed Eagle: Brian Greaves, Ali Colleen Neff, USA, 2006, 15'.

Dernier Cri – brut animation
Hopital Brut: Pakito Bolino, France, 2001, 20'.

Minnie Evans
The Angel That Stood By Me: Irving & Allie Light, USA, 28'.

Dr Evermor
Statues by the Road: Bob Leff, USA, 2003, 50'.

Pearl Fryer
A Man Named Pearl: Scott Galloway, Brent Pierson, USA, 2006, 78'.

Gees Bend
The Quilts of Gees Bend: Matt Arnett, Venessa Vadim, USA, 28'.

Joaquin Gironella
Joaquim Vicens Gironella: le liège et la mémoire: Louis-Michel Vicens, France, n.d., 20'.

Richard Greaves
Les châteaux de planches de Richard Greaves: Philippe Lespinasse, Andress Alvarez, Mario Del Curto, France, 2006, 34'.

Houston Environments
Eye Openers: Laurie McDonald, Orange Show, USA, 45'

Clementine Hunter
Clementine Hunter, American Folk Artist: Katina Simmons, USA, 1993, 26'.

Japanese Art Brut
Diamants bruts du Japon: Philippe Lespinasse, Andress Alvarez, France, 145'.

Edward James
Edward James: Builder of Dreams: Avery Danziger, USA, 58', 1995.

Leonard Knight
Salvation Mountain Tour: Leonard Knight, USA, n.d., 18'.

Harry Lieberman
Hundred and Two Mature, the Art of Harry Lieberman: Irving & Allie Light, USA, 28'.

Angus McPhee
The Mystery of Angus McPhee: Nick Higgins, UK, 25'.

Living Museum
The Living Museum: Jessica Yu, USA, 1999, 80'.

Alexander Lobanov, Zdenek Kosek, Henry Darger, Gene Merritt, Richard Greaves
Art Brut: portraits: Bruno Decharme, abcd, France, 2006, 53'.

Raphael Lonné
Raphaël Lonné dessinateur médiumnique: Bernard Gazet, Laurent Danchin, France, 1987, 13'.

Charlie Lucas, Vollis Simpson, Thornton Dial, Bessie Harvey, Lonnie Holley
Boneshop of the Heart: Scott Crocker, Toshiaka Ozawa, USA, 1991, 53'.

Gustav Mesmer
Gustav Mesmer: Son frei sein wie die Vögel: Holger Reile, Germany, 1999, 32'.

Fernando Nannetti
I graffiti della mente. N.O.F.4 moro secco spinaceo: Pier Nello Manoni, Erika Manoni, Italy. 2002, 20'.

Tressa Prisbrey
Grandma Prisbrey's Bottle Village: Irving & Allie Light, USA, 28'

Emile Ratier
Emile Ratier: les articles de bois: Alain Bourbonnais, France, n.d., 21'.

Achilles Rizzoli
Yield to Total Elation: Pat Ferrero, USA, 50'.

Royal Robertson, Hawkins Bolden, Judith Scott, Ike Morgan
Make: Scott Ogden, Malcolm Hearn, USA, 2008.

Simon Rodia
I Build the Tower: Edward Landler and Brad Byer, 2006, USA, 86'.

Alma Rumball
The Alma Drawings: Jeremiah Munce, Canada, 2008, 48'.

Judith Scott
Les cocons magiques de Judith Scott: Philippe Lespinasse, France, 2006, 26'.

Judith Scott
Outsider, the Life and Art of Judith Scott: Besty Bayha, USA, 2006, 26'.

Alan Streets
My Name is Alan and I Paint Pictures: Johnny Boston, USA, 2007, 86'

Robert Tatin
Robert Tatin – Sa vie, son oeuvre: Musée Communal Rober Tatin, France, nd, 12'.

Chief Rolling Thunder
Monument of Chief Rolling Thunder, Irving & Allie Light, USA, 28'.

Albert Wagner
One Bad Cat: The Rev Albert Wagner Story: Mark Belasco, Ostrow & Co, USA, 2008, 80'.

Susanne Wenger
Living With the Gods: Claudia Wilke, Austria, 1998, 56'.

Kenneth Williams
Sun Always Shining, the Art and Life of Kenneth Williams: Gabrielle Goodstein, USA, 2003, 25'.

Adolf Wölfli
St Adolf II: Leonard Miskin, UK, 1971, 20'.

World Environments
Journeys into the Outside: Jarvis Cocker, Martin Wallace, UK, 2000, 3 x 50'.

World Environments
Shrines & Homemade Holy Places: Judy Holm, Michael McNamara, Canada, 2005, 8 x 24'.

Purvis Young
Purvis of Overtown: David Raccuglia, Shaun Conrad, USA, 2006, 66'.

Artists

A.C.M.

b. 1951

Museums etc
abcd Collection, Paris.

L'Aracine Collection, Musée d'Art
Moderne, Lille Métropole.

References
ACM, J-P Ritsch Fisch Galerie,
ex cat, 2008.

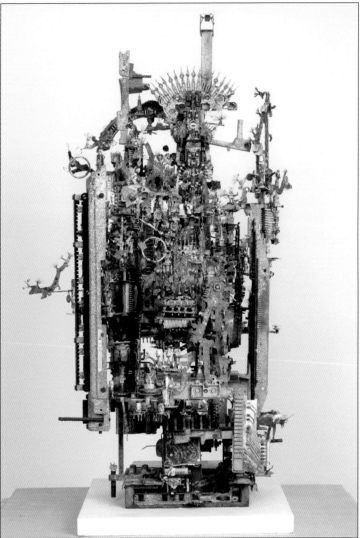

Untitled, c. 2005–07

The complex and detailed sculptures of the artist known as A.C.M. reflect his attempt to find validity in his life. Born in Hargicourt, Aisne, France, A.C.M. was a very timid child who enjoyed spending time on his own. In 1968 he was accepted onto a place at the Tourcoing Academy of Fine Arts to study painting, but he suffered a breakdown and attempted suicide. In 1976 his father left him a dilapidated weaving factory which he spent several years renovating, restoring the old building and adding gardens and ponds. He began again to explore his identity through art, collecting and archiving hundreds of objects which he carefully cleaned, sanded, and coated and then framed like arrays of botanical or zoological specimens. These works were followed by increasingly elaborate collages of found materials including electronic components and typewriter parts, and then by free-standing sculptures of extraordinary complexity. Using wood, metal, plaster and found objects, which he manipulates by burning them with acid, allowing them to rust, deforming and painting them, he constructs intricately worked assemblages which reveal fantastic creatures and faces as they are viewed from different angles.

Leroy **Almon**
1938–1997

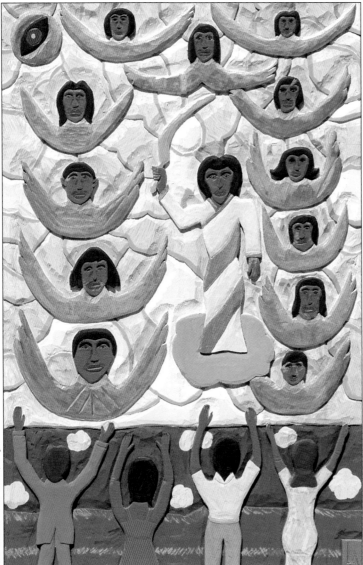

Jesus Returns In The Clouds, c. 1988

Museums etc
American Folk Art Museum, NY.

High Museum of Art, Atlanta, GA.

Museum of International Folk Art, Santa Fe, NM.

Rockford Art Museum, Rockford, IL.

St James Place Folk Art Museum, Robersonville, NC.

Taubman Museum, Roanoke, VA.

References
American Anthem: Masterworks from the American Folk Art Museum, ex cat, 2001.

Art Outsider et Folk Art des Collections de Chicago, ex cat, 1998.

Souls Grown Deep, Vol. 1, Arnett et al, 2000.

Leroy Almon, Sr was born in the Georgian city of Tallapoosa. Although not much is written of Almon's early life, it is known that he moved to Columbus, Ohio, in the 1970s where he worked as a salesman and marketing supervisor for the Coca-Cola Company. It was near the end of the 1970s that Almon first came into contact with the already celebrated self-taught artist Elijah Peirce, while attending Peirce's sermons at the Gay Tabernacle Baptist Church. On losing his position with Coca-Cola, Almon soon convinced Peirce to apprentice him at his barber shop and studio. Collaboration on Peirce's religious works soon turned into Almon's own creations, where he continued the traditions learnt from his mentor. Using vivid colours to paint over chiselled images on softwood, Almon became famous for tackling political, social and religious subjects, many relating to the African American experience. Returning in 1982 to Tallapoosa with his family, Almon began preaching and continued creating his brightly coloured reliefs which reflected both contemporary and historical themes. Almon managed to establish a gallery and studio at his home and continued to work until his death.

Zebedee
Armstrong
1911–1993

Museums etc
Birmingham Museum of Art,
Birmingham, AL.

Kentucky Folk Art Center,
Morehead, KY.

The Louisiana State Museum,
New Orleans, LA.

Morris Museum of Art, Augusta,
GA.

New Orleans Museum of Art,
New Orleans, LA.

Rockford Art Museum, Rockford,
IL.

St James Place Folk Art Museum,
Robersonville, NC.

References
The End is Near, ex cat, 1998.

*Museum of American Folk Art
Encyclopedia of Twentieth-
Century American Folk Art and
Artists*, Rosenak, 1990.

*Passionate Visions of the
American South, Self Taught
Artists from 1940 to the Present*,
New Orleans Museum of Art,
1993.

Raw Vision No. 59, 2007.

Untitled Dial, n.d.

Zebedee Armstrong, also known as Z.B., is best known for the powerful and complex boxes and time machines designed as calendars to predict the coming of doomsday. Armstrong showed great talent as a young carpenter while growing up in Thompson, Georgia. After leaving school in the eighth grade, he followed in his father's footsteps by picking cotton. He married in 1929 and soon began to make wooden safes for those who mistrusted the banking system after the Wall Street Crash. Armstrong continued supplementing his income with carpentry, even after his wife's death in 1969 and his move to a new job as foreman in a box factory. It was in 1972 that Armstrong was to have the experience that would change his life. A vision of an angel appeared before him and warned the already-religious Armstrong of the coming apocalypse. He went on to produce almost 1,500 box calendars, all with the intention of methodically predicting the date of doomsday. The calendars took many forms, with clocks, dials and timing devices painted white and over-layered with a powerful series of grids or text denoting the box's purpose. Armstrong also made use of found objects to embellish his unique works.

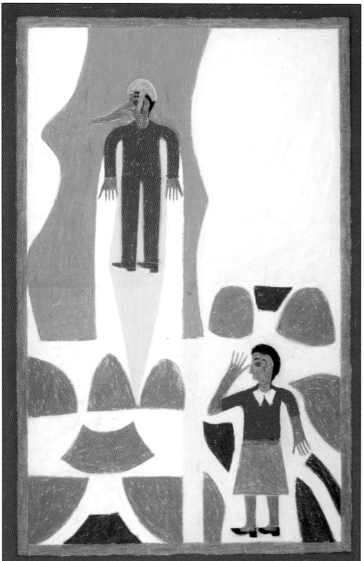

Man in Red with Big Nose, 1972

Eddie
Arning
1898–1993

Museums etc
Abby Aldrich Rockefeller Folk Art Center, Williamsburg, VA.

American Folk Art Museum, NY.

American Visionary Art Museum, Baltimore, MD.

Anthony Petullo Collection, Milwaukee, WI.

High Museum of Art, Atlanta, GA.

Intuit, Chicago, IL.

National Museum of American Art, Smithsonian Institution, Washington, DC.

References
American Anthem: Masterworks from the American Folk Art Museum, ex cat, 2001.

American Self-Taught, Maresca & Ricco, 1993.

Museum of American Folk Art Encyclopedia of Twentieth-Century American Folk Art and Artists, Rosenak, 1990.

Passionate Visions of the American South, Self Taught Artists from 1940 to the Present, New Orleans Museum of Art, 1993.

Raw Vision No. 28, 1999.

Self-Taught Artists of the 20th Century, ex cat, 1998.

Eddie Arning was raised in the strict German Lutheran farming community of Germania, near Kenney, Texas. He suffered violent bouts of depression and anxiety from an early age, resulting in a life spent mainly in institutions. It was during a 30 year stay at the Texas Confederate Home for Men that Arning was first introduced to drawing by his occupational therapist, Helen Mayfield in 1964. His initial work was executed using simple coloured crayons supplied by the hospital. But by 1969, Arning had switched to oil pastels, and was producing more complex compositions. The subjects of his early work were autobiographical, with his pictures depicting scenes from his childhood. Animals, flowers, windmills and local churches were frequent themes. Later, more graphic images appeared, benefiting from the inspiration he gained from popular material such as newspapers, advertisements and magazine illustrations. Figures also began to appear in his work during this later period. Arning was asked to leave the hospital in 1973, and moved in with his widowed sister Ida Buck. He soon ceased drawing after a prolific 10-year period in which he produced over 2,000 drawings.

41

Josef
Bachler
1914–1979

Museums etc
Collection de l'Art Brut,
Lausanne.

References
Die Künstler aus Gugging,
Navratil 1983.

L'Art Brut, fascicule No.12, 1983.

Art Brut und Psychiatrie, Navratil
1999.

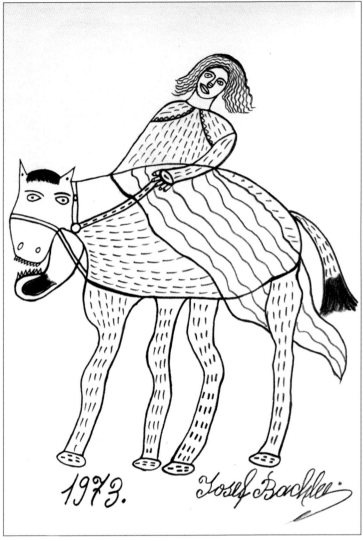

Horsewoman, 1973

Josef Bachler was born in Vienna, Austria, in 1914. He grew up in an orphanage, later working there as a cleaner and then eventually learning the trade of a roofer. Considered mentally disabled, he was interned in Dachau concentration camp during WWII until his release in 1945, when he re-entered his trade and married. However, he suffered worsening violent alcoholic episodes and was eventually sent to a psychiatric hospital for treatment. Arriving at the Gugging Hospital in 1970, Bachler was diagnosed with a chronic mania, known as 'hypomania'. Although a manic depressive, he was not psychotic, unlike many of the other patient-artists living in Gugging. Originally his works were drawn on cards and used for diagnosis by his doctor Leo Navratil. Bachler's drawings were clear and simply composed, with subjects taking the form of women, men and animals. Although a violent and often intoxicated patient, his images much impressed critics. The figures were drawn in dark pencil onto a plain paper background. Bachler's animals are often covered with sweeping one-line textures, whilst the expressions of his human figures are exceptionally distinctive. All his work is signed and dated in his own stylistic hand.

Barbus Müller
anon

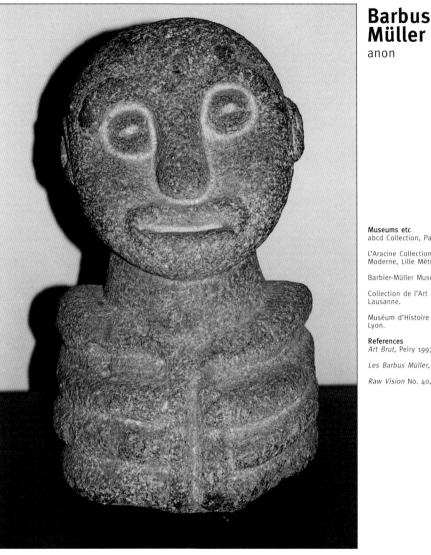

Museums etc
abcd Collection, Paris.

L'Aracine Collection, Musée d'Art Moderne, Lille Métropole.

Barbier-Müller Museum, Geneva.

Collection de l'Art Brut, Lausanne.

Muséum d'Histoire Naturelle de Lyon.

References
Art Brut, Peiry 1997.

Les Barbus Müller, 1947.

Raw Vision No. 40, 2002.

Untitled, n.d.

These mysterious carvings were named after the Swiss collector O.J. Müller, who first discovered some examples while searching through brocante shops in France in the 1940s. Meaning literally 'Müller's bearded men', the Barbus Müller sculptures appear to be the work of a single creator, yet there is no information available about their background or origins, which remain subject to debate. Despite their ancient appearance which is reminiscent of Easter Island's monolithic statues, it is believed that the pieces are probably modern. They are carved from granite or volcanic lava, and are relatively small, with a maximum height of 40 inches/96 cm. Some appear to have been carved from stolen milestones, giving them an extra sinister edge. The majority are of heads or faces; others depict short, limbless torsos. All have simple and stylised facial features, including blank, staring expressions and thin, slit-like lips or full mouths. Many of the carvings are of bearded male figures, though there are a few female examples, including one carrying a child on her back. All possess the potent, archaic quality of pre-Columbian stonework, their complete anonymity adding to their enigmatic power.

Morton
Bartlett
1909–1992

Museums etc
American Folk Art Museum, New York, NY.

Collection de l'Art Brut, Lausanne.

References
American Anthem: Masterworks from the American Folk Art Museum, ex cat, 2001.

Family Found, Harris, 1994.

Raw Vision No. 16, 1996.

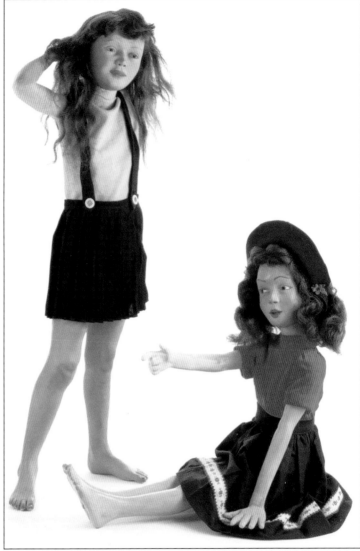

Girl in blue with pleated skirt with seated pointing girl, n.d.

Morton Bartlett, born in Chicago, was orphaned at the age of eight. Adopted by the Bartlett family of Cohasset, Massachusetts, he made Boston his assumed home town. After a short education at Harvard College, Bartlett undertook a number of jobs throughout his early life, including positions in advertising, furniture sales and management. He eventually established himself as a self-employed businessman in printing design. It was not until his death in 1992, while arrangements for his funeral were being prepared, that his private collection of self-made figures of children, was finally discovered. It is

believed he first started creating his accurately executed figurines over a period of 30 years until stopping in the mid-1960s. He left 13 statues of children: three boys most likely modelled in his own image and the rest girls. He used anatomy books to ensure his figures were accurately scaled, revealing a compulsive attention to detail. Bartlett took photographs of his dolls in life-like situations, either nude or wearing clothes that he made himself. Bartlett described the purpose of his 'hobby' in his College Yearbook as 'to let out urges which do not find expression in other channels'.

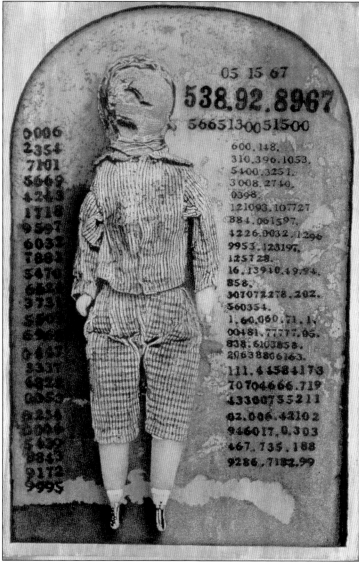

Hygenic Toys I, 1995-96

Charles
Benefiel
b. 1967

Museums etc
abcd Collection, Paris.

References
Raw Vision No. 30, 2000.

Charles Benefiel was born in Venice Beach, California. Following a nervous breakdown in 1997, he was diagnosed with obsessive compulsive disorder. The stippling technique Benefiel employs to create his highly detailed works exemplifies the condition in its entirety. Using draughtsman's pens, the artist draws series of accurate dots and points to compose his pictures of linear numbers and different-sized, yet uniform geometrical figures. The disorder enables Benefiel to make use of control and to strive for complete perfection, creating his pictures freehand, without any preconceived composition. Numbers are drawn out in lines flowing from left to right, following a process similar to that of a computer printout. Dots are counted in sequence and in repetition. Benefiel also produces pictures with human-like figures, reminiscent of a giant sized child's doll which dominates the composition in a central position and is often surrounded by further numbers. He likes to dye his pictures, first with tea and then with varnish, to create an aged look, indicative of old family photos. Many of Benefiel's works are on paper are on a fairly large scale, with some reaching 8 x 5 ft/2.4 x 1.5 m.

Peter Attie (Charlie)
Besharo
1899–1960

Museums etc
American Folk Art Museum, New York, NY.

National Museum of American Art, Smithsonian Institution, Washington, DC.

References
American Anthem: Masterworks from the American Folk Art Museum, ex cat, 2001.

American Self-Taught: Paintings and Drawings by Outsider Artists, Maresca & Ricco, 1993.

Self-Taught Artists of the 20th Century, ex cat, 1998.

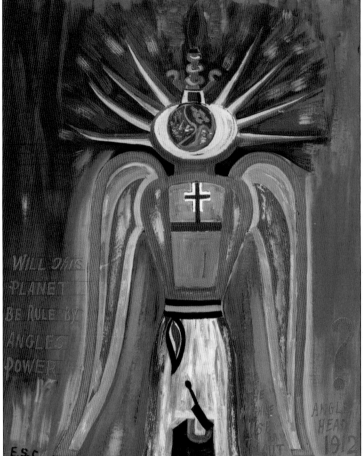

Untitled (Will This Planet Be Ruled By Angels' Power), 1959

For almost 40 years, Peter Besharo painted unbeknown to his many acquaintances. After his death, 69 paintings were found in a garage he rented near his home. Besharo was born in Syria and emigrated to the USA when he was in his teens. After working as a pedlar selling dry goods to mining communities, he settled in Leechburg, Pennsylvania, where he followed the trade of a housepainter and signwriter. A devout Catholic, Besharo believed that church leaders could bring about universal peace. His works, executed in oil paint in deeply saturated colours and strong earth tones, portray the horrors of discord embodied in nuclear weapons and propose a future free from conflict in which ethnic figures commune with angels, clergy, mythological creatures and extra-terrestrial beings. His use of text underlines the gravity and urgency of the themes explored in his paintings, and Catholic imagery such as rosaries and candles, Arabic motifs such as the all-seeing eye, and dates, dimensions and abbreviations are integral to his designs. The scientific references in his work were probably fuelled by the exploration of space and the Cold War that were taking place during his lifetime.

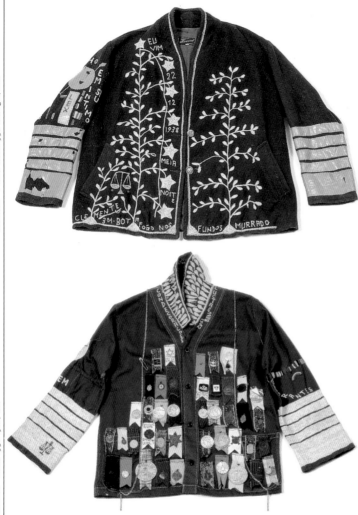

Vestment – i came 12.22.1938 midnight, n.d.

Vestment – luctas 1938 1982, n.d.

Arthur
Bispo do Rosario
c.1909–1989

Museums etc
Museu Bispo do Rosario, Rio de Janeiro, Brazil.

References
The Fabric of Myth, ex cat, 2008.

Raw Vision No. 47, 2004.

Arthur Bispo do Rosario was born in Brazil's northeastern state of Sergipe, a religious area populated by the poor descendants of African slaves. Bispo do Rosario spent around nine years in the Brazilian navy as a rifleman after leaving home at just 15, moving to Rio de Janeiro in 1933. There he worked when and wherever he could. His life continued in this way until what he termed his 'rebirth' in 1938, when a vision appeared before him led by the Virgin Mary, whom he called 'Mother'. He was found, two days later on Christmas Eve, wandering into a Rio church and was swiftly arrested and hospitalised. Diagnosed as schizophrenic, Bispo do Rosario was to spend the next 50 years in the Colonia Juliano Moreira Hospital. There, he began collecting discarded objects with the help of his fellow patients, the hospital staff and even rubbish collectors. Materials such as buttons, car tyres, rolling pins, string, clothes and tin cans were soon transformed into sculptures, montages, embroideries, even ceremonial clothing. He truly believed he was a medium for the divine and refused to show any of his art to all but a few trusted friends. It was not until after his death in 1989 that his work was put on public exhibition.

'Prophet' William J.
Blackmon
b. 1921

Museums etc
Milwaukee Art Museum, WI.

Minnesota Museum of American Art, St. Paul, MN.

National Museum of American Art, Smithsonian Institution, Washington, DC.

References
American Self-Taught: Paintings and Drawings by Outsider Artists, Maresca & Ricco, 1993.

Art Outsider et Folk Art des Collections de Chicago, ex cat, 1998.

Museum of American Folk Art Encyclopedia of Twentieth-Century American Folk Art and Artists, Rosenak, 1990.

Raw Vision No. 52, 2005.

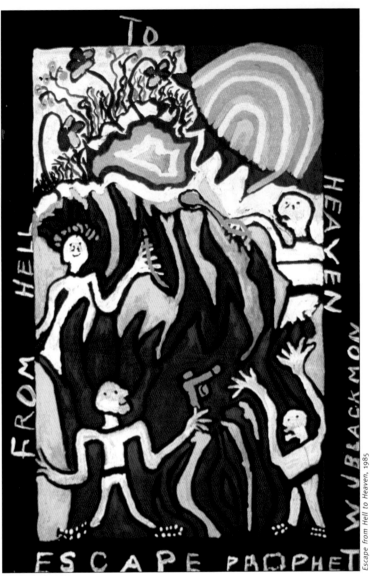

Escape from Hell to Heaven, 1985

When William J. Blackmon was cured of a chronic stomach ailment by a Baptist minister in Chicago, he realised his vocation and became a preacher, gaining a reputation for prophecy and healing powers. After many years of travelling and spreading his ministry, Blackmon set up his Revival Center and Shoe Repair Shop in Milwaukee, Wisconsin. As part of his mission he would display large handwritten notices warning of the perils of drunkenness, adultery and the abandonment of family life. In 1984 a passer-by offered to buy one of the signs. Seeing this as a way of further disseminating his message of salvation, Blackmon readily agreed. This marked the beginning of his recognition as an artist. Using house paint, he began to embellish his signs with imagery, filling the spaces between the words with a fusion of biblical scenes, symbols of deliverance and retribution and visual commentary on social marginalisation such as he himself had experienced as an African American who also had Native American forebears. Gradually the images took over from the words, which still formed an integral part of Blackmon's paintings but gradually became largely confined to a distinctive border.

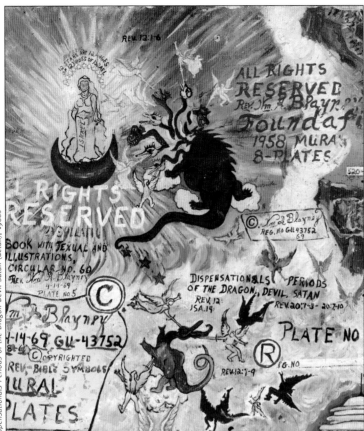

William
Blayney
1918–1985

Museums etc
National Museum of American
Art, Smithsonian Institution,
Washington, DC.

References
*Museum of American Folk Art
Encyclopedia of Twentieth-
Century American Folk Art and
Artists*, Rosenak, 1990.

*Self-Taught Artists of the 20th
Century*, ex cat, 1998.

At school in Claysville, Pennsylvania, William Alvin Blayney showed a natural talent for drawing, and while he was serving in the US Army Air Corps during the Second World War he would paint cartoon-like figures on the side of bombers. When he was in his forties he underwent a profound religious conversion and abandoned his wife and his business as a motor mechanic to become a Pentecostal preacher. He began to paint in order to illustrate the sermons he gave in his Oklahoma roadside ministry, and believed both his painting and his preaching to be the fulfilment of biblical prophecy. He related the predictions in the book of 'Revelation' and the book of 'Daniel' to actual historic events, and constantly warned of the need for repentance and the imminence of the second coming of Christ. Blayney's richly coloured paintings demonstrate a meticulous rendering of biblical texts, often accompanied by lengthy citations. Strange beasts and fantastic landscapes abound in his work. He was happy to see his paintings in museums, seeing this as an opportunity to spread his teachings, yet he was obsessed with copyright, and his paintings are often peppered with trade marks.

Anselme
Boix-Vives
1899–1969

Museums etc
abcd Collection, Paris.

L'Aracine Collection, Musée d'Art
Moderne, Lille Métropole.

Arnulf Rainer Collection, Vienna.

Charlotte Zander Museum
Bönningheim, Germany.

Eternod/Mermod Collection,
Lausanne.

Intuit, Chicago, IL.

References
*Anselme Boix-Vives:
Monographie*, Catalogue
Raisonné, Vol. 1, Sainsaulieu &
Boix-Vives, 2003.

Art Brut, abcd Collection, 2006.

*Eternity Has No Door of Escape,
The Eternod-Mermod Collection
of Art Brut, ex cat,* Lugano,
2001.

Raw Vision No. 42, 2003.

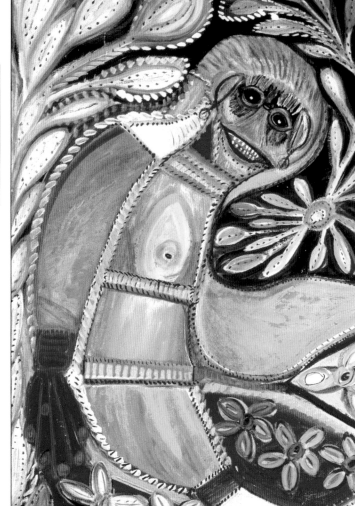

Large Figure, 1969

Born in Catalonia to a poor farming family, Anselme Boix-Vives never went to school. At the age of 18 he moved to France where he worked as a shepherd, a vineyard labourer and a fishmonger, and in 1926 eventually realised his ambition to open a greengrocer's shop. His horror at the sight of war victims and his belief in a utopian society led him to draft a series of manifestos as part of his peace plan for the world, but his ideas were ridiculed. In 1962 Boix-Vives' wife died, and he retired from the shop. Encouraged by his son, Michel, he began to paint, and in seven years he produced more than 2000 drawings and paintings in gouache and oil. His mystical, joyful works became a visual manifestation of his hopes for the world and a way for him to ensure paradise on earth. The vibrant, colourful compositions always fill the canvas, and scenes of biblical harmony alternate with images of famous people, birds, animals and insects. In 1963 André Breton was so impressed with Boix-Vives' work that he used one of his paintings for the cover of his magazine *La Brèche: Action Surréaliste*. After his death a Foundation was established to preserve and and promote his work.

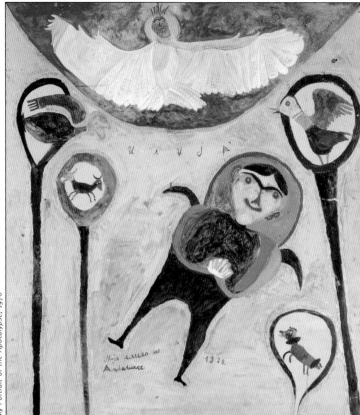

My Portrait of the Apocalypse, 1970

Ilija
Bosilj
1895–1972

Museums etc
Collection de l'Art Brut, Lausanne.

Charlotte Zander Museum Bönningheim, Germany.

Croatian Museum of Naïve Art, Zagreb.

Museum of Naive and Marginal Art, Jagodina, Serbia.

References
Art without Frontiers, Crnkovic, 2006.

Ilija Bosilj: Zeichen und Symbole, Crnkovic, 2000.

Modern Primitives, Bihalji-Merin, 1971.

My Father Ilija, Yugoslavia, 1996.

Raw Vision No. 34, 2001.

Ilija Bosilj Basicevic, known as 'Ilija', was born into a farming family in Sid, in northern Serbia. Driven in his sixties to find meaning in his life, he suddenly started to paint, developing his own visual language to communicate his personal philosophy. Working after his daily farming tasks had been completed, Ilija painted quickly, working without a palette, painting straight from the tube onto wood, paper, glass and board. According to his son, his choice of colour was arbitrary: he often used any tube of paint close at hand. Although his first painting, of his guardians, Saints Cosmas and Damian, depicts a traditional theme, and he often illustrated scenes from Serbian folk tales and biblical stories, his paintings depict a unique, largely imaginary world, distinct from the traditional peasant style of the region. His is a flat two-dimensional world, a landscape inhabited by an imaginary universe of men and demons, snakes, fish, anthropomorphic creatures, and even spacemen. Ilija's work can be divided into three distinct colour phases: white, gold and multi-coloured. Tragically, sickness and paralysis meant Ilija was forced to abandon his creative activities almost as suddenly as they had begun.

Frédéric Bruly
Bouabré
b. 1923

Museums etc
Collection de l'Art Brut,
Lausanne.

National Museum, Abidjan, Ivory
Coast.

Pigozzi Collection, Geneva.

References
Africa Now, ex cat, 1991.

Contemporary Art of Africa,
Magnin & Soulillou, 1996.

Frédéric Bruly Bouabré, ex cat,
1993.

*Frédéric Bruly Bouabré.
Knowledge of the World*, ex cat,
1998.

Magiciens de la Terre, ex cat,
1989.

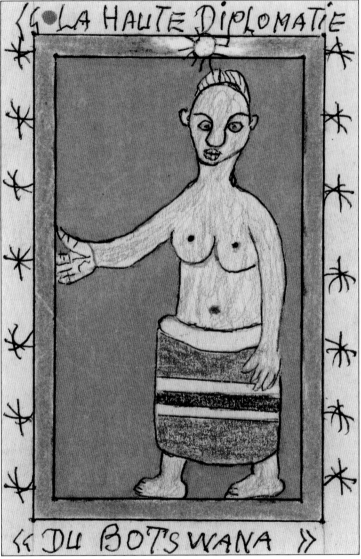

La Haute Diplomatie du Botswana, 2007

Frédéric Bruly Bouabré lives and works in the Ivory Coast capital of Abidjan. His schooling was cut short by poverty and the need to earn a living, but his life was transformed in the late 1940s by what he described as 'a magnificent sunlit vision'. From that moment, he adopted the name 'Cheik Nadro the Revealer' and dedicated his life to philosophical research into the state of Africa and the meaning of life. His researches have included studies of scarification designs, clouds and stars and the histories of Africa and the world. Bouabré believes that his people, the Bété, need an oral tradition to interpret his thoughts. He has also invented a visual language, which he portrays on cards cut to 3.75 x 5.9 in/9.5 x 15 cm, designed to carry his messages. Using ballpoint pens and crayons, Bouabré draws symbolic images on each card and surrounds them with a border of text. The 1000-plus cards include images of steam trains, animals, field tools, preachers and political leaders. They may resemble the hand-painted signs announcing barbers' shops, tailors and grocery stores all across Africa, but their significance lies in their unique divinatory messages and their comments on life and history.

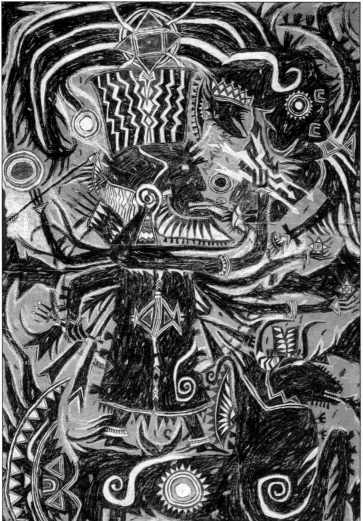

Azawak, 1990

François
Burland
b. 1958

Museums etc
Eternod/Mermod Collection,
Lausanne.

Musée de la Création Franche,
Bègles.

References
Art Brut et Compangnie, ex cat,
1995.

*Eternity Has No Door of Escape,
The Eternod-Mermod Collection
of Art Brut*, ex cat, Lugano,
2001.

François Burland, Billeter, 2003.

François Burland had a difficult childhood in his hometown of Lausanne, Switzerland. He left school early, after his secret drawings enabled teachers to brand him 'difficult' and 'stubborn'. Burland underwent psychotherapy whilst still a young man and it is at this time that he began to express himself through painting. His pictures are large and often painted on brown paper, giving his works an aged or antique look. Burland is fascinated by mythology from all cultures. His paintings have explored subjects such as mythical monsters, Ancient Greek legends, African epics and Celtic fables. Burland's work has benefited from his travels through Africa and beyond, visiting Arabic towns and sub-Saharan villages. On these travels the life of the nomads encouraged him to create many vibrantly coloured tribal-inspired pieces. The use of dark colour is frequent in many other examples of his work, with a central figure of a human or animal coloured in black pastel, surrounded by varied and almost sinister detailing. Burland also produces toy cars constructed from scrap metal and other discarded items. He now lives on a farm in rural Switzerland, dedicating himself to the creation of his instinctive art.

Richard
Burnside
b. 1944

Museums etc
High Museum of Art, Atlanta, GA.

Morris Museum of Art, Augusta, GA.

National Museum of American Art, Smithsonian Institution, Washington, DC.

Rockford Art Museum, Rockford, IL.

St. James Place Folk Art Museum, Robersonville, NC.

Taubman Museum, Roanoke, VA.

References
Art Outsider et Folk Art des Collections de Chicago, ex cat, 1998.

Museum of American Folk Art Encyclopedia of Twentieth-Century American Folk Art and Artists, Rosenak, 1990.

Raw Vision No. 9, 1994.

Souls Grown Deep, Vol. 1, Arnett et al, 2000.

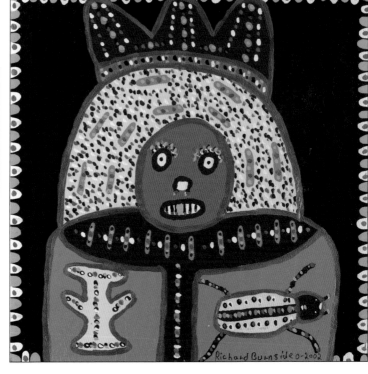

Untitled (Blue top), n.d.

Although a native of Baltimore, Maryland, Richard Burnside has spent most of his life in South Carolina, moving there with his family of seven at the age of five. He began to paint in 1976 following a stint in the army. Although he never saw active service, military life continued to inspire Burnside long after the end of his service. His work is characterised by vividly painted images, which are balanced on the page in order to create simple, yet strong compositions. Burnside's subjects most often depict the human face, although an animal like a snake or tiger also takes centre stage. He makes use of bright reds, greens and yellows, painting a coloured border around the main picture, which more painted animals and large-scale insects inhabit. While the blocks of colour are flat and his subjects are always one-dimensional, the effect that such a combination produces is enormously powerful. Burnside paints on many found objects and salvaged materials. Large plywood panels make up the majority of his base canvases, although paper bags and even furniture also make an appearance. Living in a trailer park, Burnside continues to paint his unpretentious yet warmly evocative pictures copiously and effortlessly.

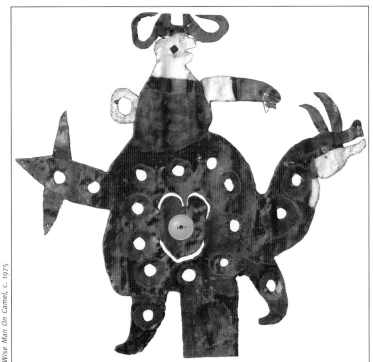

Wise Man On Camel, c. 1975

David
Butler
1898–1997

Museums etc
African American Museum, Dallas, TX.

Akron Art Museum, OH.

American Folk Art Museum, NY.

Fenimore House Museum, Cooperstown, NY.

High Museum of Art, Atlanta, GA.

The Louisiana State Museum, New Orleans, LA.

Meadows Museum of Art, Shreveport, LA.

Milwaukee Art Museum, WI.

Museum of International Folk Art, Santa Fe, NM.

New Orleans Museum of Art, New Orleans, LA.

Newark Museum, Newark, NJ.

References
American Anthem, ex cat, 2001.

American Self Taught, 1993.

Encyclopedia of Twentieth Century American Folk Art, Rosenak, 1990.

Pictured in My Mind, ex cat, 1995.

Souls Grown Deep, Vol. 2, Arnett et al, 2001.

David Butler was the eldest of eight children born to a carpenter father and missionary mother in Louisiana, USA. Only attending school for one year, Butler helped to look after his siblings and worked at a variety of manual jobs. When Butler was in his forties, he suffered a serious injury whilst working at a sawmill. This forced him into early retirement, leaving him to survive on state benefits. Although Butler later insisted that he had been drawing all his life, it was his forced retirement which led him to devote the rest of his life to art. He began to cut out shapes from discarded scraps of tin sheet, using a hammer and chisel. Then, using house paints, Butler drew boldly coloured compositions and hung the finished pieces around his home. Whirligigs, sculptures and bright constructions were soon added and rapidly filled his house and yard. The subjects of his paintings encompassed those associated with his experiences of life. People, animals, celebrations, but also more symbolic and fantasy themes gave Butler his inspiration. A much used image, which appeared in many of his works was a four-pointed star, reminiscent of those which exist in much of Haitian or African art. His work was much sought after and his yard environment soon emptied.

James
Castle
1900–1977

Museums etc
High Museum of Art, Atlanta, GA.

Intuit, Chicago, IL.

References
American Anthem: Masterworks from the American Folk Art Museum, ex cat, 2001.

James Castle: The Common Place, Yau, 2000.

James Castle: His Life and Art, Trusky, 2004.

James Castle: A Retrospective, Percy, 2009.

Raw Vision No. 23, 1998; No 46, 2004.

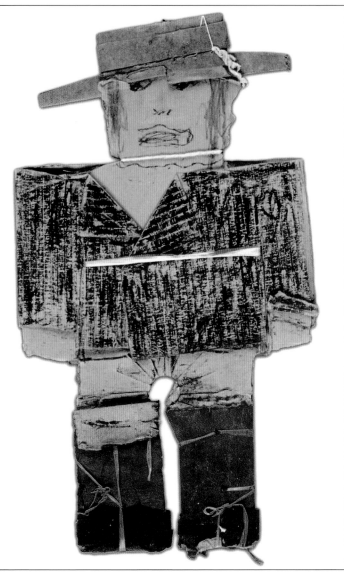

Untitled, c. 1949

James Castle was born deaf, into the isolated community of Garden Valley, Idaho. Castle's early life was spent at home, after his parents decided against sending their strong-willed but vulnerable child to a public school. Obsessed with art from childhood, Castle devoted his life to producing drawings and collaged pictures. Home provided inspiration for his art, with the community post office and local general store housed within the family residence. Early subjects were clearly inspired by the postage stamps, calendars and catalogues Castle witnessed pass through his family home on a daily basis. Other depictions included Castle's versions of family photos and framed landscapes. Part of his work was sculptural, with Castle making inspired use of found materials such as fabric, paper, string, wood grain, nails and even fish bones. His 'dreamhouses' are examples of this technique, where Castle would use saliva-and-soot ink, or homemade twig pens, to draw houses on ice cream cartons and other pieces of discarded paper. Extremely prolific, Castle produced numerous stylised bound volumes with titles such as Code Books, Calendar Books, How-to Books and Pattern Books.

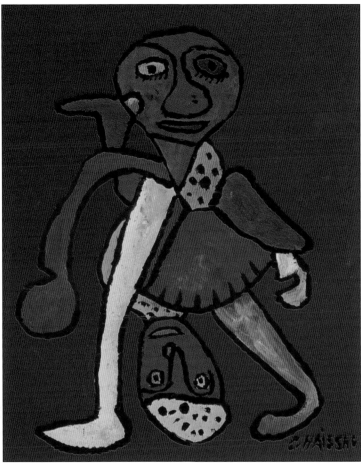

Untitled, c. 1949

Gaston
Chaissac
1910–1964

Museums etc
Collection de l'Art Brut,
Lausanne.

Musée de l'Abbaye Sainte-Croix,
Les Sables d'Olonne.

References
Chaissac, ex cat, 2000.

Gaston Chaissac, ex cat, 1993.

Gaston Chaissac. Environs et apartés, Fauchereau, 2000.

L'Oeuf sauvage No 7, 1993.

Outsider Art, Cardinal, 1972.

Raw Vision No. 32, 2000.

Known as 'Picasso in clogs', Gaston Chaissac, a French cobbler and saddle maker, started to paint in the late 1930s. He developed a simple, unique style and vocabulary, describing his work as 'modern rustic painting'. His paintings were constructed from blocks of contrasting colours, outlined in painterly black lines that built up an internal space. For his collages he used wallpaper and other found materials. In later life, Chaissac concentrated on wooden 'totems', again using a variety of discarded objects painted in strong outlined hues. His first exhibition, in 1938, followed the publication of some of his writings. Although untrained and living in an isolated provincial village, Chaissac was in contact with the Paris art circle, a contradiction which followed him through life. Dubuffet was an important figure in Chaissac's artistic development and recognition, but the relationship between the two became strained, due to Chaissac's professional contacts and desire for success. Dubuffet originally classified him as an Art Brut artist, later placing him in the Neuve Invention category. Chaissac became an influence in mainstream contemporary art, yet he was unable to find success in his lifetime.

Nek
Chand
b. 1924

Museums etc
American Folk Art Museum, NY.

Collection de l'Art Brut, Lausanne.

John Michael Kohler Arts Center, Sheboygan, WI.

Museum Dr Guislain, Belgium.

Museum of International Folk Art, Santa Fe, NM.

References
L'Art Brut, fascicule No 22, 2007.

The Collection, the Ruin and the Theatre, Bandyopadhyay & Jackson, 2007.

Folk Art Vol. 13, No 1, 2000.

Nek Chand, Ditzen, 1991.

Nek Chand's Outsider Art: The Rock Garden of Chandigarh, Peiry, 2005.

Nek Chand Shows the Way, ex cat, 1997.

Raw Creation, Maizels, 1996.

Raw Vision No. 1, 1989; No. 9, 1994; No. 35, 2001.

The Rock Garden, Aulakh, 1986.

Vernacular Visionaries: International Outsider Art, Carlano, 2003.

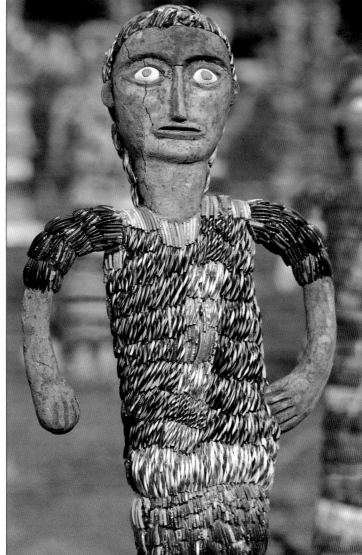

Queen After Bath, c. 1970

Nek Chand Saini spent his early years in what is now Pakistan, but in 1947 was forced to flee to India during Partition, along with the rest of his Hindu family. A deeply spiritual man, Chand was fascinated by the mystical significance of rocks. In 1958, while working as a roads inspector in the new city of Chandigarh being built by Le Corbusier, he started collecting river stones of different shapes and sizes, and industrial waste materials. For years he worked in secret on what would become the Rock Garden (see Environments, p. 174), which was inaugurated in 1976. Chand has become mainly known for his magnificent Rock Garden

site where he has installed over 2,000 sculptures. Using recycled materials, including discarded bicycle seats, forks and frames for armatures, he builds up the mass with a cement and sand mix. A final coating of smoothly burnished pure cement combined with waste materials such as broken glass bangles, crockery mosaic, or iron-foundry slag is then placed on the figures. Many of his earlier pieces have shells for eyes. In addition to his concrete figures he makes small open-fired clay pieces, and hundreds of giant stuffed 'ragdolls' from scraps of vibrantly coloured waste cloth, which are used for events and ceremonies.

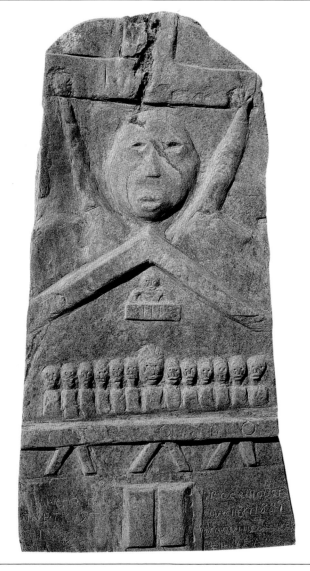

Stele Commemorating the Founding of a Church, c. 1975

Raymond
Coins
1904–1998

Museums etc
Anthony Petullo Collection, Milwaukee, WI.

High Museum of Art, Atlanta, GA.

The Louisiana State Museum, New Orleans, LA.

National Museum of American Art, Smithsonian Institution, Washington, DC.

New Orleans Museum of Art, LA.

St James Place Folk Art Museum, Robersonville, NC.

References
American Anthem: Masterworks from the American Folk Art Museum, ex cat, 2001.

Museum of American Folk Art Encyclopedia of Twentieth-Century American Folk Art and Artists, Rosenak, 1990.

Passionate Visions of the American South, Self Taught Artists from 1940 to the Present, New Orleans Museum of Art, 1993.

Pictured in My Mind, ex cat, 1995.

From the time he was a young man, Willie Raymond Coins had what he considered to be prophetic dreams, but he did not reveal them for many years. He was born on a small farm in Virginia, and at the age of ten he moved to North Carolina where he became a farmer and tobacco worker. In 1950, he bought his own farm where he lived with his wife and children. After he retired he began carving river stones, inspired by ancient artefacts that were found in the area. His first pieces imitated Native American arrowheads, but eventually he would carve whatever was suggested to him by the shape of a stone or a piece of wood. Using chisels, knives and a sander, he would produce the forms of animals, angels, people and his famous 'baby doll' carvings. Some of his works are life-size renderings weighing as much as 700 lb/1,500 kg. A deeply religious man, Coins believed that his dreams contained divine guidance, and he began to record them in bas-relief carvings, using scale to emphasise the relative importance of the figures he portrayed. Coins stopped carving in 1990 through advanced age and lack of inspiration. In 1995 he received a North Carolina Folk Heritage Award for his work.

59

Joe
Coleman
b. 1955

References
The Book of Joe: The Art of Joe Coleman, Gates, 2003.

Cosmic Retribution: The Infernal Art of Joe Coleman, Parfrey & Moriarty, 1992.

The End is Near, ex cat, 1998.

Original Sin: The Visionary Art of Joe Coleman, Gates, 1997.

Raw Vision No. 11, 1995; No. 64, 2008.

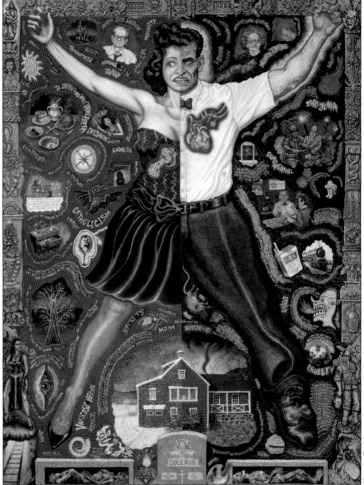

Mommy/Daddy, 1994

Joe Coleman was born in the city of Norwalk, Connecticut. As a boy, he was labelled 'emotionally disturbed' following his pictures of bleeding saints. Known initially as a practical joker and performance artist who bit off the heads of mice, Coleman gatecrashed parties, only to detonate concealed explosives strapped to his body in front of shocked guests. Words such as 'apocalyptic', 'visionary', and 'twisted' are used liberally to describe his distinctive works, painted with a tiny detail brush using a jeweller's eyepiece. Coleman's portraits often use an iconic central figure, surrounded by graphic detailed images, juxtaposed with text and illustrations. His subjects remain human-centred and often explore his childhood relationship with his parents. Favoured themes include religion, sexuality, mythology and sin, with humourous imagery placed beside scenes of tragic family incidents. Coleman's Brooklyn home exemplifies his obsession for the fantastic, incorporating his own museum of morbid objects, known as the 'odditorium'. The imagery and metaphors of Coleman's art have been much analysed, helping to cement his reputation as a cult figure and iconic artist.

Ronald and Jessie
Cooper
b. 1931 & 1933

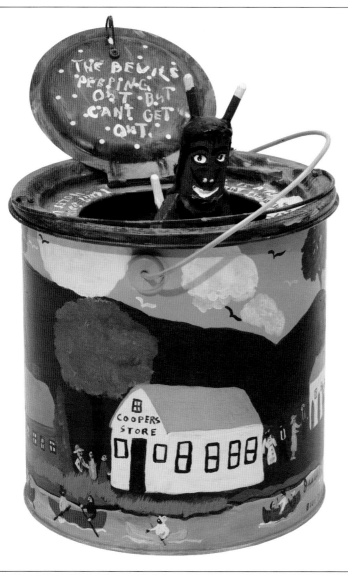

Museums etc
Birmingham Museum of Art,
Birmingham, AL.

Huntington Museum of Art, WV.

Kentucky Folk Art Center,
Morehead, KY.

Owensboro Museum of Fine Art,
KY.

Taubman Museum, Roanoke, VA.

References
*Art Outsider et Folk Art des
Collections de Chicago*, ex cat,
1998.

*Museum of American Folk Art
Encyclopedia of Twentieth-
Century American Folk Art and
Artists*, Rosenak, 1990.

*Passionate Visions of the
American South, Self Taught
Artists from 1940 to the Present*,
New Orleans Museum of Art,
1993.

Raw Vision No. 64, 2008.

Hell Bucket, 2002

Ronald and Jessie Cooper did not become artists until they were in their fifties. Natives of Kentucky, they worked in stores and factories while raising their four children. As a child, Jessie would draw on rocks using coloured clay, but Ronald showed no interest in making art until an accident in 1984 left him unable to work. His children bought him some woodworking tools to occupy him, and he began to make simple wooden toys which were then painted by Jessie and sold in local craft shops. Encouraged by a university art professor, Ronald began to sculpt animal and human forms from sticks. Following a vivid nightmare his work took the form of figures based on the characters in apocalyptic stories, while Jessie painted biblical and historical narrative scenes on items of furniture. The Coopers worked alone as well as collaborating on a number of pieces, mostly on admonitory religious themes, in which the lids and doors of Jessie's cabinets and boxes would open to reveal Ronald's startling yet often humourous scenes with figures of Christ, red devils and bleeding humans, warning of the consequences of immoderate living. Jessie has now become too frail to paint, but Ronald continues to make his sculptures.

Aloïse
Corbaz
1886–1964

Museums etc
abcd Collection, Paris.

L'Aracine Collection, Musée d'Art Moderne, Lille Métropole.

Arnulf Rainer Collection, Vienna.

Cantonal Art Museum, Lausanne.

Collection de l'Art Brut, Lausanne.

Eternod/Mermod Collection, Lausanne.

References
Aloïse, Bonfand et al, 1989.

Aloïse et le théâtre de l'univers, Porret-Forel, 1993.

Art Brut, Peiry, 1997.

L'Art Brut, fascicule No 7, 1966.

L'Art Brut, Thévoz, 1975.

L'Oeuf sauvage No 9, 1994.

Outsider Art, Cardinal, 1972.

Raw Vision No. 33, 2000; No. 57, 2006.

Though This be Madness, Cocteau et al, 1963.

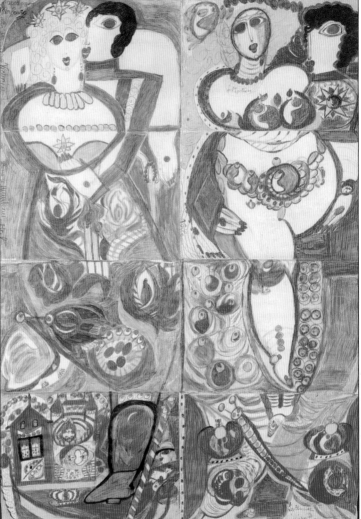

Star of the Paris Opera, between 1952 and 1954

Aloïse Corbaz was a cultured and educated woman who worked as a private tutor at the German court of Kaiser Wilhelm II, where she taught his pastor's daughters. However, on developing an over-powering infatuation with the Kaiser, her mental state became increasingly agitated and she was returned to Switzerland and admitted to an asylum in Lausanne. The hospital director, Hans Steck, and his successor, Jacqueline Porret-Forel, encouraged Aloïse to draw and write. Initially, she illustrated romantic pieces of writing, but she soon developed her flowing drawing style using coloured pencils. Many of her earlier works are on folded pieces of paper and in sketch books, and centre on a romantic couple or a single feminine figure. Her chosen colours are warm pinks and reds, which contrast sharply with the empty blue wells of the figures' eyes. Her later works are less complex in composition but have bolder imagery and a stronger range of colours. Dubuffet claimed that Aloïse was not mad at all: she made believe. He was convinced that she had cured herself by ceasing to fight against her illness. She cultivated and made use of it, eventually turning her illness into an exciting reason for living.

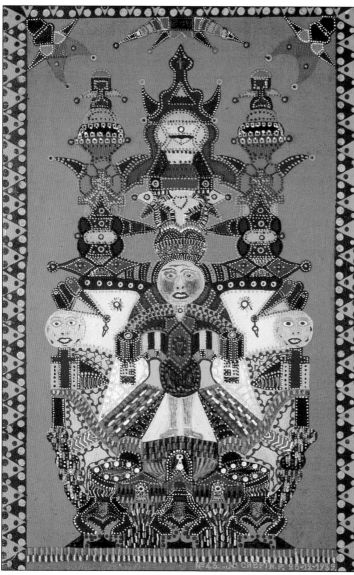

No. 43, 1939

Fleury-Joseph
Crépin
1875–1948

Museums etc
abcd Collection, Paris.

L'Aracine Collection, Musée d'Art Moderne, Lille Métropole.

Collection de l'Art Brut, Lausanne.

Eternod/Mermod Collection, Lausanne.

References
L'Art Brut, fascicule No. 5, 1965.

Art spirite, médiumnique, visionnaire. Messages d'outre-monde, ex cat, 1999.

Joseph Crépin, catalogue raisonné, Deroux (ed.), 1999.

L'Oeuf sauvage No. 5, 1992.

Raw Vision No. 2, 1989.

Fleury-Joseph Crépin, a French plumber from the port of Calais, started painting in his sixties following an increased awareness of his spiritual powers. Encouraged by fellow mediumistic artist Augustin Lesage and influenced by the supernatural forces which Crépin said guided his every move, he began to fill exercise books with spontaneous motifs. He later meticulously copied the designs onto large pieces of paper, using coloured pencils and then oils, carefully numbering each of his works. A strict symmetry is central to his work, the elements in his pictures suggesting fantastical architectural forms, temples and statues. Jean Dubuffet was intrigued by his acutely symmetrical style, and believed Crépin to be an 'anti-natural' artist, whose mathematical scheme could be explained through his contact with supernatural voices. In his later works Crépin used a unique painting technique, applying globules of paint and varnish in an unusual method thought to have been effected with a baker's icing pump. This became one of the hallmarks of his impeccable style. Crépin completed 300 paintings and then embarked on a series of what he termed 'Tableaux merveilleux', completing 45 by the end of his life.

Henry
Darger
1892–1973

Museums etc
American Folk Art Museum, NY.

L'Aracine Collection, Musée d'Art
Moderne, Lille Métropole.

Art Institute of Chicago, IL.

Collection de l'Art Brut,
Lausanne.

High Museum of Art, Atlanta, GA.

Milwaukee Art Museum, WI.

Museum of Contemporary Art,
Chicago, IL.

National Museum of American
Art, Smithsonian Institution,
Washington, DC.

References
*American Anthem: Masterworks
from the American Folk Art
Museum*, ex cat, 2001.

Darger, Anderson, 2001.

*Henry Darger: Art and Selected
Writings*, Bonesteel, 2000.

*Henry Darger: In the Realms of
the Unreal*, MacGregor, 2002.

Raw Vision No. 13, 1995;
No. 39, 2002.

*Self-Taught Artists of the 20th
Century*, ex cat, 1998.

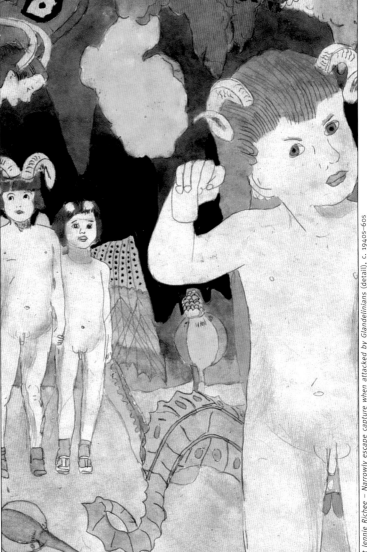

At Jennie Richee – Narrowly escape capture when attacked by Glandelinians (detail), c. 1940s-60s

An orphaned child, Henry Darger spent his early years in a Chicago institution, and much of his adult life working as a hospital porter while living alone in a cheap rented room. In complete isolation, he feverishly explored his inner world by writing and drawing. *The Story of the Vivian Girls in What is Known as the Realms of the Unreal, of the Glandeco-Angelinnian War Storm, Caused by the Child Slave Rebellion*, is a 15-volume epic describing a war between a group of innocent children and a pack of child-slave owners. The stories were illustrated using a technique of traced images cut from magazines and catalogues, arranged in huge panoramic landscapes, painted in delicate watercolours. Some are as large as 30 feet (10 m) wide, and many are painted on both sides of the paper. Subject matter ranges from idyllic childhood scenes in Edwardian interiors and tranquil flowered landscapes, to scenes of horrific terror and carnage showing the girls being tortured and massacred. Darger wrote himself into the narrative as the children's protector. His legacy of thousands of pages of typed texts, hand-bound in huge volumes, and hundreds of paintings, was discovered by his landlord shortly before his death.

Thornton
Dial
b. 1928

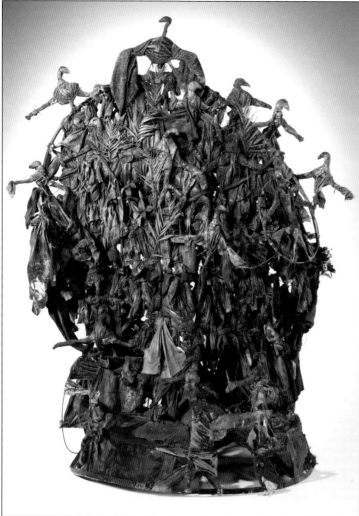

Freedom Cloth, 2005

Museums etc
American Folk Art Museum, NY.

Birmingham Museum of Art,
Birmingham, AL.

High Museum of Art, Atlanta, GA.

Intuit, Chicago, IL.

Milwaukee Art Museum, WI.

New Orleans Museum of Art, LA.

Rockford Art Museum, Rockford,
IL.

References
*American Anthem: Masterworks
from the American Folk Art
Museum,* ex cat, 2001.

American Self-Taught, Maresca &
Ricco, 1993.

*Passionate Visions of the
American South, Self Taught
Artists from 1940 to the Present,*
New Orleans Museum of Art,
1993.

Raw Vision No. 55, 2006;
No. 43, 2003.

*Self-Taught Artists of the 20th
Century,* ex cat, 1998.

Souls Grown Deep, Vols 1 & 2,
Arnett et al, 2000 & 2001.

*Thornton Dial: Image of the
Tiger,* Baraka & McEvilly, 1993.

Thornton Dial was born to a poor family in rural Alabama. He was expected to work from an early age to support his unmarried mother. Having received minimal education, he worked tirelessly at many jobs until his retirement at the age of 55 in 1983. He admits that although he produced artwork before this time, it was only when he stopped work that he could focus all his attention on his passion. This was partly due to his early lack of confidence in his creative abilities. Dial said of his retirement, 'I didn't have no real job, so I made a job of art'. Many of his pictures and sculptures are put together using old scraps, tin, found wood, wire and layers of waste paint. The unique feature of Dial's art is perhaps the very variety of themes he makes use of. He takes inspiration from everything from animals and scenes of everyday life, right through to commentaries on the political and social situation in America today and the position of African Americans within it. Dial's compositions range from simple and delicate drawings to dramatic and dark paintings which are typically large-scale powerful creations with a strong use of colour and fluid forms, often with additional pieces attached to the canvas.

Janko
Domsic
1915–1983

Museums etc
abcd Collection, Paris.

L'Aracine Collection, Musée d'Art
Moderne, Lille Métropole.

Collection de l'Art Brut,
Lausanne.

La Fabuloserie, Dicy.

References
Art Brut, abcd Collection, ex cat,
2006.

L'Art Brut, fascicule No. 16,
1990.

The End is Near, ex cat, 1998.

La Fabuloserie, ex cat, 2001.

*Janko Domsic: Le Mécanicien
céleste,* ex cat, 2008.

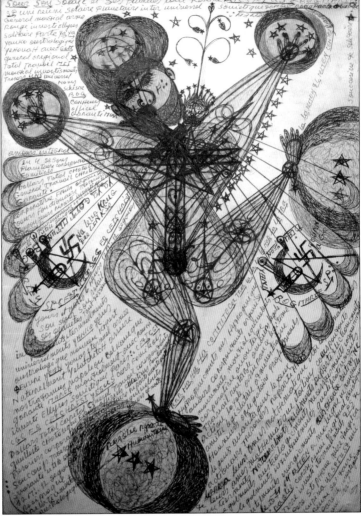

Untitled, c. 1970

Very little is known of the early life of Janko Domsic. According to some, he was born in the Croatian village of Malunje, although it is not clear how he came to live in his adopted country of France. The little information we have is mainly gained from an interview Domsic gave to the collector Alain Bourbonnais. It is believed that Domsic was a railway worker in the 1930s and later carved out a tramp-like existence in Paris. What caused Domsic to begin to draw is a complete mystery. His creations are distinctive drawings composed of figures and texts. Domsic drew in a mathematical and systematic style, making use of parallel and geometric patterns. The texts that surround the central figures are written mainly in French, but occasionally he used his native Croatian or German to spell out thoughts and ideas. Domsic's work has been described as 'map-like' and certainly his use of ballpoint pens and coloured pencils gives his drawings a sense of clarity and accuracy. The meanings behind the use of certain symbols are unclear, as are his writings concerning mystical, religious or political ideas. Domsic died in Paris in 1983, leaving behind a large body of unique work.

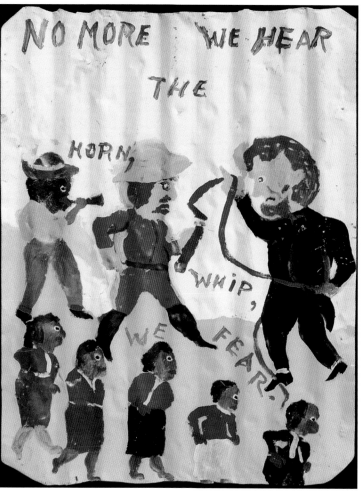

No More the Horn We Hear, No More the Whip We Fear, c. 1981

Sam
Doyle
1906–1985

Museums etc
American Folk Art Museum, NY.

Asheville Art Museum, NC.

High Museum of Art, Atlanta, GA.

Rockford Art Museum, IL.

National Museum of American Art, Smithsonian Institution, Washington, DC.

South Carolina State Museum, Columbia, SC.

References
American Anthem: Masterworks from the American Folk Art Museum, ex cat, 2001.

American Self-Taught, Maresca & Ricco, 1993.

Black Folk Art in America, Livingston & Beardsley, 1982.

Passionate Visions of the American South, Self Taught Artists from 1940 to the Present, New Orleans Museum of Art, 1993.

Pictured in My Mind, ex cat, 1995.

Raw Vision No. 23, 1998; No. 42, 2003; No. 61, 2007.

Sam Doyle, LaRoche, 1989.

Souls Grown Deep, Vol. 1, Arnett et al, 2000.

Sam Doyle painted his life and times on St Helena Island with reverent devotion. As a youngster, Doyle received encouragement for his artistry at the Island's Penn School, which had been established by Quaker missionaries during the early days of the Civil War to provide educational and vocational training to the Sea Isles' newly liberated slaves. Imbued by elders with a deep respect for his heritage and fortified by his Baptist faith, Doyle wholeheartedly committed himself to painting his world following his retirement. Using house paint, he created vibrant portraits of figures and themes both real and folkloric on cast-off pieces of corrugated metal and plywood. Visitors to the St Helena Out Door Art Gallery overflowing the yard of his small house encountered uniquely styled tributes to First Black Midwife, Penn Drummer, Rocking Mary, Net Maker, Rev. Martin Luther King Jr, Abraham Lincoln, Joe Louis, Ray Charles and Elvis Presley as well as depictions of root doctors such as Dr Crow and Dr Buz and mythic spirits Old Hag, Devil Spirit and Jack O Lanton. The highly personal nature of Doyle's work is further enhanced by the words and abbreviated phrases which often adorned his paintings.

Paul
Duhem
1919–1999

Museums etc
L'Aracine Collection, Musée d'Art Moderne, Lille Métropole.

Art en Marge Collection, Brussels.

Collection de l'Art Brut, Lausanne.

Mad Musée Collection, Liège.

Musée de la Création Franche, Bègles.

Museum Dr Guislain, Gent.

References
Art Brut et Compangnie, ex cat, 1995.

Art en Marge Collection, ex cat, 2003.

Eternity Has No Door of Escape, The Eternod-Mermod Collection of Art Brut, ex cat, Lugano, 2001.

Paul Duhem Retrospective, ex cat, 2004.

Raw Vision No. 60, 2007.

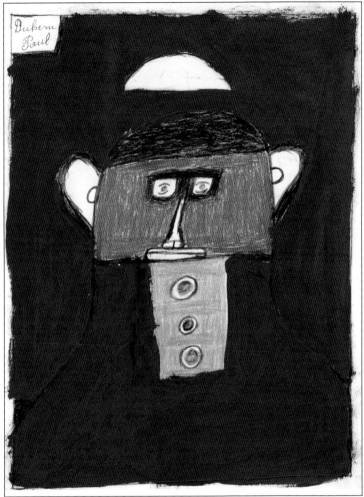

Untitled, 1998

Born in Belgium out of wedlock, Paul Duhem experienced difficult relationships with his family. He left school at 13, having learnt only the basic skills of reading and writing, and became a farm labourer. His workmates encouraged him to drink alcohol and, though industrious, he became rebellious and aggressive. During the Second World War he spent two years laying railways in Germany. On his return to Belgium he was jailed as a collaborator but was subsequently transferred to Les Marronniers psychiatric unit in Tournai. The need for agricultural workers in post-war Belgium led to his discharge, and he again became a farm hand. In 1978 he entered La Pommeraie Centre in Ellignies-Sainte-Anne, a home for adults with learning difficulties, where he spent a contented 12 years tending the garden. At the age of 70 he began to paint and attended the creative workshop at La Pommeraie enthusiastically until his death 10 years later. Duhem worked in ink, crayon, oil pastel and paint on paper, producing numerous images of male figures that at first glance appear to be very similar, a closer regard revealing the different emotions underlying each one. He also painted a series of doors, as well as birds and windmills.

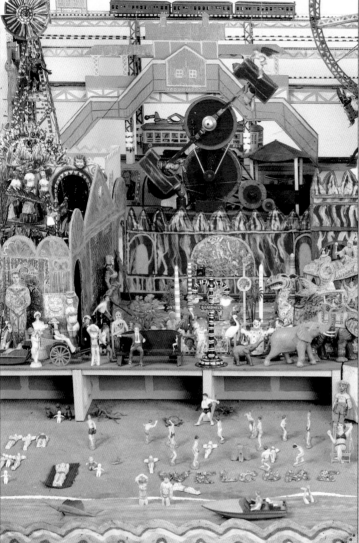

Coney Island (detail), 2004

Tom
Duncan
b. 1939

Museums etc
Box Art Museum, Hoghem, Sweden.

Library of Congress, Washington, DC.

New Museum of Contemporary Art, New York, NY.

References
Raw Vision No. 61, 2007.

Tom Duncan was born in Shotts, Scotland, at the beginning of the Second World War. He spent his early years believing war was the natural state of the world. Given clay to model with as a child, Duncan spent much of his time making art in the bomb shelters with his family. The influence of those early fatherless years would have a significant impact on the sculptural landscapes he later produced. After the war, Duncan and his family left Scotland for Coney Island and New York City. Again, it is this experience of leaving his homeland which, combined with a boyhood spent experiencing the dramas and horrors of wartime, provided the central inspiration for Duncan's art. Although he trained in the USA in fine arts, his creations are unorthodox to the extreme. Duncan's work has been described as a strange blend of toy and tragedy, mixing small figurines of boys with gas masks, with chilling depictions of concentration camp deaths. Many of the works are encased in dusty boxes, often with a glass-fronted frame, openly presenting his expression of painful past memories and wartime brutality. Other work is more upbeat, remembering icons of pop culture and the fairground rides of Coney Island.

William
Edmondson
1870–1951

Museums etc
Abby Aldrich Rockefeller Folk Art Center, Williamsburg, VA.

Austin Peay State University, Clarksville, TN.

Birmingham Museum of Art, AL.

Cheekwood Museum of Art, Nashville, TN.

Fenimore House Museum, Cooperstown, NY.

High Museum of Art, Atlanta, GA.

Museum of the University of Tennessee, Knoxville, TN..

National Museum of American Art, Smithsonian Institution, Washington, DC.

Newark Museum, Newark, NJ.

References
The Art of William Edmondson, ex cat, 1999.

Black Folk Art in America, Livingston & Beardsley, 1982.

Passionate Visions of the American South, Self Taught Artists from 1940 to the Present, New Orleans Museum of Art, 1993.

Raw Vision No. 45, 2003.

Souls Grown Deep, Vol. 1, Arnett et al, 2000.

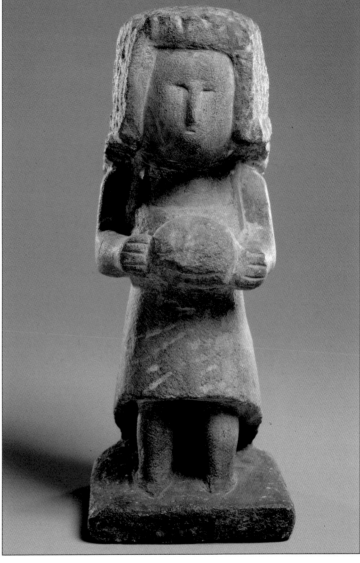

Lady with Muff, c. 1940

In 1937, William Edmondson, the son of freed slaves living on a plantation outside Nashville, Tennessee, was the first African American artist to have a one-man show at the Museum of Modern Art in New York. Edmondson was among the first wave of self-taught artists to come to the fore in the USA. With little formal education and working originally as a labourer, farmhand and porter, he began carving enigmatic limestone tombstones in the early 1930s, claiming he had been directed to create by God. At first he made memorials for the congregation of his local church; he then began selling tombstones from his front yard along with carved 'garden ornaments'. Edmondson gradually developed his skills, sculpting a whole range of distinctive subjects, including biblical figures such as Noah, Adam and Eve, angels and crucifixions, and local subjects such as preachers and school teachers, birds and animals, celebrities of the day, nudes and female figures. His forms are simple and serene with a minimum of detail, the texture of his rough carving balancing with areas of smooth fullness. All share his unique brand of religious symbolism, combining a simple elegance of overall mass with inner strength.

Airlie Garden Design (detail), 1960s

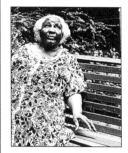

Museums etc
American Folk Art Museum, NY.

Anthony Petullo Collection, WI.

Art Institute of Chicago, IL.

Collection de l'Art Brut, Lausanne.

High Museum of Art, Atlanta, GA.

Intuit, Chicago, IL.

Smithsonian Institution, Washington, DC.

Newark Museum, NJ.

North Carolina Museum of Art, Raleigh, NC.

Whitney Museum of American Art, New York, NY.

References
American Anthem, ex cat, 2001.

American Self-Taught, Maresca & Ricco, 1993.

Encyclopedia of Twentieth-Century American Folk Art and Artists, Rosenak, 1990.

Folk Art Vol. 19, No. 4, 1994-5.

Heavenly Visions, ex cat, 1986.

Minnie Evans: Artist, ex cat, 1993.

Raw Vision No. 11, 1995; No. 41, 2002.

Minnie Evans was a descendant of slaves from Trinidad. Leaving school in the sixth grade, she worked as a domestic servant and later as a gatekeeper at Airlie Gardens in North Carolina. Driven by a need to record her dreams, she began to draw and paint at the age of 43. Her first piece of artwork, drawn on a Good Friday on a scrap of paper bag, was titled 'My Very First'; she made a second a day later. However, it was not until another five years later, when she rediscovered the two original drawings tucked inside some magazines, that she began to create in earnest. Evans painted her early works on US Coast Guard stationery, but in later years she worked with more precision with ink, graphite, wax crayon, watercolour and oil on canvas, board and paper. The daily experience of working at the lush floral Airlie Gardens had an impact on her style: her paintings and drawings depicted colourful organic flowing forms, with faces and flowers emerging from symmetrical patterns and complex designs, the overall composition balancing abstract and semi-naturalistic elements. The colours in her later paintings were even more lush and vibrant, with the compositions more complex and on a larger scale.

Roy
Ferdinand
1959–2004

Museums etc
African American Museum,
Dallas, TX.

Art Museum of Southeast Texas,
Beaumont, TX.

The Louisiana State Museum,
New Orleans, LA.

Mississippi Museum of Art,
Jackson, MS.

New Orleans Museum of Art, LA.

St. James Place Folk Art
Museum, Robersonville, NC.

References
*Art Outsider et Folk Art des
Collections de Chicago*, ex cat,
1998.

Raw Vision No. 46, 2004.

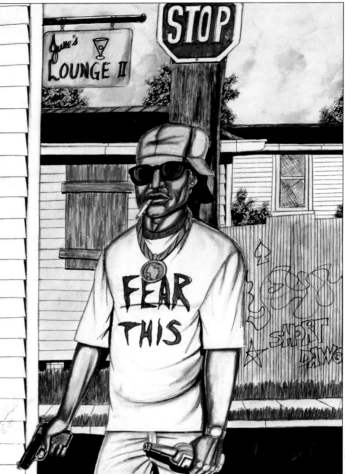

Fear This, 1998

The work of Roy Ferdinand is a graphically detailed depiction of characters and events in the impoverished neighbourhood of New Orleans where he spent most of his life. At school, Ferdinand would pass the time drawing comic strips in his notebooks. He dropped out and joined a street gang and after working at various jobs including as a morgue assistant and a sign-painter, and a short spell in the army, he became a full-time artist in the late 1980s. Having no studio, he would use any available flat surface as a drawing board, colouring his starkly detailed drawings with children's paints, coloured pencils and ink markers. Working from memory, and with an ability to convey character and mood through the depiction of gesture and facial expression, he would portray everyday scenes that were often characterised by the violence of guns, gangs and crime. Uncompromisingly realistic, at times sexually explicit, and not without humour, his paintings depict brutality and beauty, conflict and celebration, the figures set against the blue skies, exotic vegetation and run-down buildings of the city. Ferdinand died from cancer at the age of 45, leaving a rich and formidable documentary legacy.

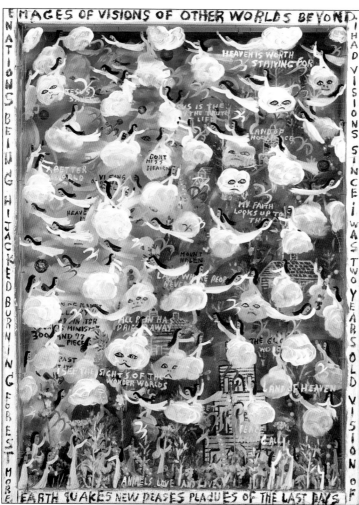

Emages (sic) of Visions of Other Worlds Beyond, 1983

Howard
Finster
1916–2001

Museums etc
abcd Collection, Paris.

American Folk Art Museum, NY.

Birmingham Museum of Art, AL.

High Museum of Art, Atlanta, GA.

Intuit, Chicago, IL.

Morris Museum of Art, Augusta, GA.

Smithsonian Institution, Washington, DC.

St. James Place Folk Art Museum, Robertsonville, NC.

Taubman Museum, Roanoke, VA.

Whitney Museum of American Art, New York, NY.

References
The Clarion Vol. XIV, No. 3, 1989.

Folk Art Messenger Vol. XIV, No. 3, 2001-02.

Howard Finster: Man of Visions, Turner, 1989.

Howard Finster: Stranger from Another World, Patterson, 1989.

Raw Vision No. 2, 1989; No. 35, 2001; No. 51, 2005; No. 63, 2008.

Self-Taught Artists of the 20th Century, ex cat, 1998.

The Reverend Howard Finster was an obsessively evangelical preacher. Paradise Garden, his religiously inspired environment in Georgia, along with his artworks, became visual sermons, an extension of his evangelical quest. In 1976, inspired by a visionary experience, he abandoned all his other work and began to paint rough but strongly composed paintings using enamel on wood, burlap and metal. Combining images and words to illustrate biblical texts, each painting is a sermon in its own right, trumpeting the message of the Lord through art. In time, Finster's art became more complex, his flat graphic imagery accompanied by more detailed intricate elements, as well as his signature evangelical text. His subjects also became increasingly diverse: his later paintings contain references to UFOs and visiting aliens, Elvis Presley, war and politics, as well as countless biblical evocations. Finster worked at an accelerated pace, producing thousands of works that were each carefully numbered: from the most complex of visionary paintings and painted objects, to small flat wooden figures which were mass-produced with his family's help, cutting round templates before being painted by Finster himself.

Johann
Fischer
b. 1919–2008

Museums etc
abcdCollection, Paris.

Anthony Petullo Collection,
Milwaukee, WI.

L'Aracine Collection, Musée d'Art
Moderne, Lille Métropole.

Arnulf Rainer Collection, Vienna.

Collection de l'Art Brut,
Lausanne.

Haus der Künstler, Gugging,
Austria.

Musée de la Création Franche,
Bègles.

Reference
L'Art Brut, fascicule No. 17,
1992.

Art Brut und Psychiatrie.
Gugging 1946–1986, Navratil,
1999.

Die Künstler aus Gugging,
Navratil, 1983.

Raw Vision No. 15, 1996.

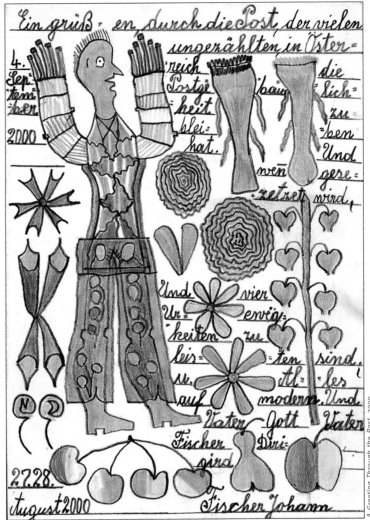

A Greeting Through the Post, 2000

Johann Fischer, a patient at the Haus der Künstler in Gugging, Austria, first began to draw in 1981 following the example of the patient-artists living around him. His first pictures, were simply drawn compositions. In these drawings flat two-dimensional images of single or pairs of figures, objects and animals float in white space. These early pictures are often signed, or include a title or date written in Fischer's precise ornamental handwriting. Over the next 20 years Fischer's writing became a more prominent feature of his work. His neat text encircled and crowds his figures, the calligraphy emphasised by Fischer's confident and precise use of underlining. The imagery in the pictures has also become more complex. Fischer's figures have become less isolated and more dynamic: his figures bake bread, lift weights and catch butterflies. Fischer also developed images of partially transparent figures. Stylised muscles and bones can be seen through trousers; torsos and arms are divided into patterned segments. In his later pictures Fischer also extended his colour range. From his early use of black and graphite, he developed to use browns and yellows, making his works resemble faded historical documents.

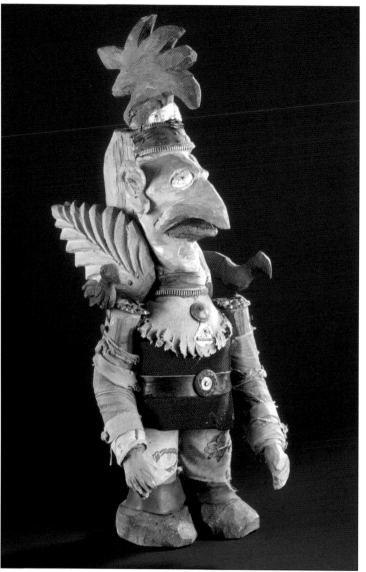

Figure with Bird's Head, c. 1935–1949

Museums etc
abcd Collection, Paris.

L'Aracine Collection, Musée d'Art
Moderne, Lille Métropole.

Collection de l'Art Brut,
Lausanne.

References
Art Brut, Peiry, 1997.

L'Art Brut, fascicule No. 8, 1966.

L'Art Brut, Thévoz, 1975.

Auguste Forestier was born into a farming family in central France. As a young man he was often arrested for travelling on the railway without a ticket and his fascination with trains eventually led to him derailing one by placing rocks on the railway line. He was subsequently interned, at the age of 27, in the psychiatric hospital at St Alban-sur-Limagnole, where he remained until his death. His obsession with transport and trains in particular was noted by Jean Dubuffet as the only real reason for his internment. At the hospital, tolerant staff allowed Forestier to begin drawing with coloured pencils and later to roughly carve objects from wood. He was even allowed to set up a rudimentary workshop in the hospital corridor where he worked daily. Principally using a cobbler's knife, he would start by roughly shaping the wood. He then added scraps of material, leather and found objects, to make clothing and other details. His carvings emerged as strong figures with belts, fancy hats, medals and uniforms, or as fierce animals and monsters with disturbingly human features. Forestier's rough assemblages were collected by Dubuffet and were included in his Art Brut exhibition of 1949 in Paris.

Johann
Garber
b. 1947

Museums etc
Anthony Petullo Collection,
Milwaukee, WI.

L'Aracine Collection, Musée d'Art
Moderne, Lille Métropole.

Charlotte Zander Museum
Bönningheim, Germany.

Collection de l'Art Brut,
Lausanne.

Haus der Künstler, Gugging,
Austria.

Musée de la Création Franche,
Bègles.

References
L'Art Brut, fascicule No. 12,
1983.

Art Brut und Psychiatrie.
Gugging 1946–1986, Navratil,
1999.

Die Künstler aus Gugging,
Navratil, 1983.

Raw Vision No. 5, 1991; No. 15,
1996.

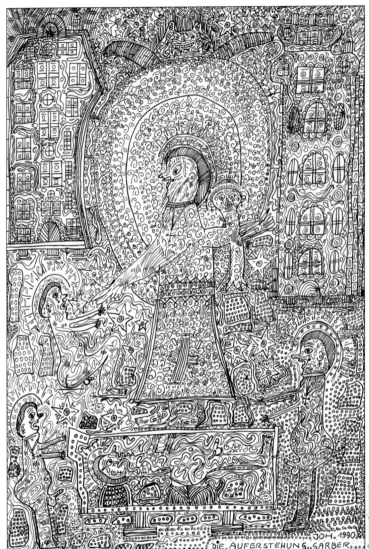

Resurrection, 1990

Johann Garber, a resident at the Haus der Künstler in Gugging, Austria, has been creating art since the late 1970s. His first works were roughly blocked-in figures drawn with coloured pencil. By the early 1980s he had developed his characteristic technique of fine black ink line drawing. Taking inspiration from old calendars, photos and other materials, he began to embellish his pictures, overcrowding the paper with figures, faces, plants, buildings and cityscapes. Garber also uses words and symbols in his pictures, adding tiny decorative elements to complete the crowded mass of his compositions. In some of his works sexual organs become compositional elements, filling the paper, while in others he expresses his experiences of cities he has never visited himself. The result is a tension between the 'noise' and chaos of the mass of detail, and an overall sense of calmness. Garber also paints looser, freer paintings of people and objects, using bright colours. In addition he has constructed sculptures in the grounds of the Gugging hospital, using the forms of existing tree trunks, and the Haus der Künstler's large boiler has been adorned with his decoratively painted imagery.

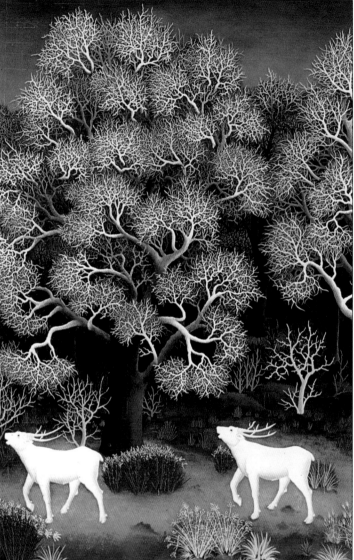

Deer Courting (detail), 1959

Ivan
Generalic
1914–1992

Museums etc

Charlotte Zander Museum, Bönningheim, Germany.

Croatian Museum of Naïve Art, Zagreb.

References
Modern Primitives, Bihalji-Merin, 1971.

World Encyclopedia of Naïve Art, Bihalji-Merin & Tomasevic, 1984.

Born into a poor peasant family in the northern Croatian village of Hlebine, Ivan Generalic started life as a cowherd. Throughout his childhood he drew scenes of village life. His simple sketches soon developed into the paintings for which he is known worldwide. Generalic's inspiration was his home and the traditions and experiences of a peasant in Yugoslavia at that time. His pictures have a unique reflective quality, as a result of his use of a technique of using oil paints on the reverse of a glass pane, instead of a conventional canvas. Weddings, farm work, seasonal celebrations and funeral processions all played a role in his art, with figurative work including portraits and the lyrical figure of the rooster. His scenes of rural existence were not only idyllic, but often included explorations and political commentaries on the social injustices of the time. Generalic first exhibited in 1931 with two other well-known peasant painters, Mirko Virius and Franjo Mraz. Generalic's work became immensely popular, and inspired many other Hlebine residents to take up a paintbrush. Generalic is now considered to have been the originator for the 'Hlebine' school of Croatian naive artists.

Carl
Genzel
1871–1925

Museums etc
Prinzhorn Collection, Heidelberg, Germany.

References
Bildnerei der Geisteskranken, Prinzhorn, 1922.

Outsider Art, Cardinal, 1972.

Raw Creation, Maizels, 1996.

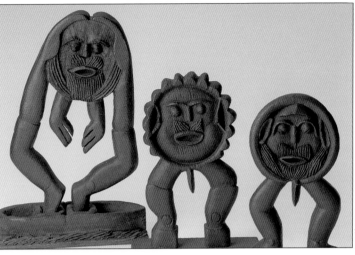

Headfooters, c. 1912–20

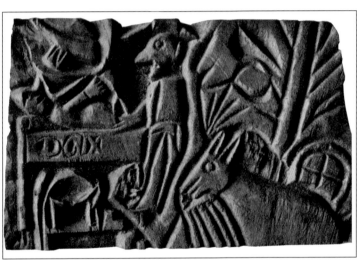

Doctor at the Sickbed, c. 1920

Carl Genzel's carvings are some of the most powerful examples in the collection built up by Dr Hans Prinzhorn. Prinzhorn gave his patients pseudonyms to protect their identity and Genzel therefore became known as Carl Brendel. He had numerous convictions for violent offenses and was admitted to hospital suffering from paranoid delusions in 1906 after an accident caused the amputation of his leg. He began to write and draw and then to fashion small busts out of chewed bread, a common medium in the asylums and prisons of the time. He then went on to carve bits of discarded broken furniture and other scraps of hard wood. Some of his works were small relief tableaux depicting scenes with animals and rough human shapes. His figures had strongly sexual overtones: he even combined both sexes, making single hermaphrodite carvings. This unity of opposite forces is also apparent in his depictions of Jesus and the Devil in the same form, perhaps an attempt at unifying the conflicting forces within himself. On one dual figure, Genzel had even carved four heads. He also produced a series of 'Headfooters', figures with their legs directly connecting to a large circular head without a torso.

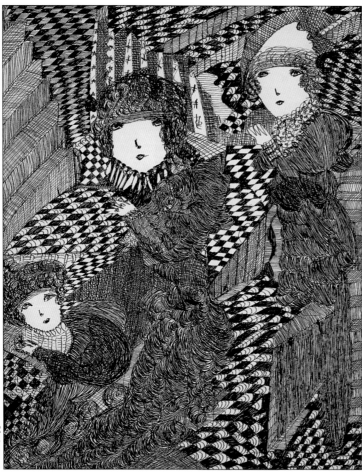

Untitled, 1951

Madge
Gill
1882–1961

Museums etc
abcd Collection, Paris.

Anthony Petullo Collection, Milwaukee, WI.

L'Aracine Collection, Musée d'Art Moderne, Lille Métropole.

Arnulf Rainer Collection, Vienna.

Collection de l'Art Brut, Lausanne.

Eternod/Mermod Collection, Lausanne.

Musée de la Création Franche, Bègles.

The Musgrave Kinley Outsider Art Collection, The Irish Museum of Modern Art, Dublin.

References
American Anthem: Masterworks from the American Folk Art Museum, ex cat, 2001.

L'Art Brut, fascicule No. 9, 1973.

Eternity Has No Door of Escape, The Eternod-Mermod Collection of Art Brut, ex cat, Lugano, 2001.

L'Oeuf sauvage No. 4, 1992.

Outsider Art, Cardinal, 1972.

Raw Vision No. 2, 1989; No. 36, 2001.

Born illegitimate in London at the end of the 19th century, Madge Gill began drawing in 1919, inspired to to create by the encouragement and intervention of her spirit guide, 'Myrninerest'. Her initial work was in the form of intense knitting and embroidery, but she later developed her distinctive detailed drawing style. Worked predominantly in black pen on card, although at times also using coloured inks, her drawings are characterised by geometric chequered patterns and flowing organic ornamentation, interrupted by female faces with blank staring eyes, their flowing clothing becoming a part of the overall surface design. Her creations took many forms, from hundreds of small postcards, usually inscribed and dated, to enormous calico drawings. These calico pieces were worked on gradually, as the length of cloth was slowly unrolled. Despite not being able to see the entire work at one time, Gill managed to maintain a sense of harmony in these larger pieces, with her dense designs, scores of faces, figures and distinctive ornamentation. She exhibited locally in London's East End, and was rumoured to have been offered a smart London show, but she claimed her work was not hers to sell. She bequeathed her work to her local London borough.

Lee
Godie
1908–1994

Museums etc
American Folk Art Museum, New York, NY.

Arkansas Arts Center, Little Rock, AR.

Intuit, Chicago, IL.

Miami University Art Museum, Oxford, OH.

Milwaukee Art Museum, WI.

Museum of Contemporary Art, Chicago, IL.

National Museum of American Art, Smithsonian Institution, Washington, DC.

References
American Anthem: Masterworks from the American Folk Art Museum, ex cat, 2001.

American Self-Taught: Paintings and Drawings by Outsider Artists, Maresca & Ricco, 1993.

Museum of American Folk Art Encyclopedia of Twentieth-Century American Folk Art and Artists, Rosenak, 1990.

Raw Vision No. 27, 1999.

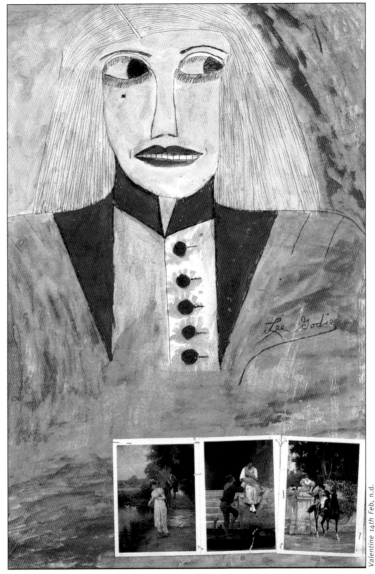

Valentine 14th Feb, n.d.

Lee Godie was born Jamot Emily Godie in Chicago, one of 11 children. Her early life is unclear, but it is known that Godie married in the 1930s and had three children. Her belief in Scientology caused friction within the marriage following the death of her youngest child. Divorce followed and Jamot, her eldest daughter, contracted diphtheria and died after her mother refused medical treatment on religious grounds. By the early 1960s Godie was living on the streets, surviving on handouts. It is thought that she began painting soon after she lost her home. Godie produced an enormous body of work. Early subjects included face portraits of dapper men in uniform and glamourous women, their eyes and lips heavily swathed with the same paint make-up used by the artist herself. Godie also painted still lifes, animals and birds. She enjoyed creating her self-invented 'pillow paintings' which consisted of two pictures sewed together and stuffed with newspapers. Using photo-booths, she created altered self-portraits, which provide a glimpse into her undiagnosed mental state. Godie's reunion with her daughter in 1989 meant her remaining years were lived out happily in the company of long-lost family.

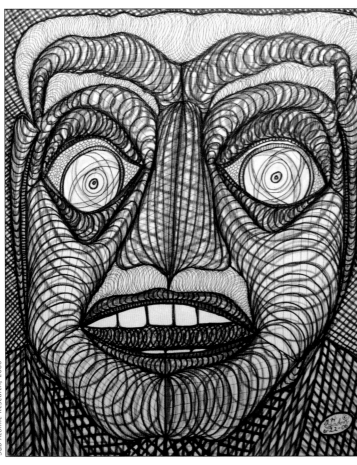

Sub-Atomic Research, 2006

Ted
Gordon
b. 1924

Museums etc
abcd Collection, Paris.

American Folk Art Museum, New York, NY.

American Visionary Art Museum, Baltimore, MD.

L'Aracine Collection, Musée d'Art Moderne, Lille Métropole.

Birmingham Museum of Art, Birmingham, AL.

Eternod/Mermod Collection, Lausanne.

High Museum of Art, Atlanta, GA.

Intuit, Chicago, IL.

Milwaukee Art Museum, WI.

Musée de la Création Franche, Bègles.

National Museum of American Art, Smithsonian Institution, Washington, DC.

References
L'Art Brut, fascicule No. 16, 1990.

Eternity Has No Door of Escape, The Eternod-Mermod Collection of Art Brut, ex cat, Lugano, 2001.

Museum of American Folk Art Encyclopedia of Twentieth-Century American Folk Art and Artists, Rosenak, 1990.

Theodore 'Ted' Gordon came from a strict Jewish family of Lithuanian-descent in Louisville, Kentucky. He had a difficult childhood. Abandoned by his mother and losing his father to suicide, the young Gordon felt isolated and excluded. At the age of 26, Gordon moved to San Francisco and worked in hospital administration. In 1954 he began producing 'doodle' line drawings on notepaper and continued doodling for another 30 years, by which time his pictures were starting to become recognised as art. His style revolves around lines and spirals, usually taking the form of the human head. Gordon uses coloured pens, crayons, markers and pencils to create his detailed images. Compositions are simple, yet striking. The membership of a therapeutic centre influenced his work post-1967 with a more expressed emotional meaning behind these later pictures. Gordon's body of work includes a large number which he describes as self-portraits, with the focus a male head formed of orbiting lines and shapes. The representational theme of the human head permeates all of his work, but repetition is avoided by his use of endless variations. Gordon's art affirms his own existence following the traumas of his early life.

Alex
Grey
b. 1953

Museums etc
The Chapel of Sacred Mirrors
(CoSM), 540 West 27th Street,
New York, NY 10001.
www.cosm.org

References
Raw Vision No. 26, 1999;
No. 49, 2004.

*Sacred Mirrors: The Visionary
Art of Alex Grey*, Wilbur et al,
1990.

Transfigurations, Grey, 2001.

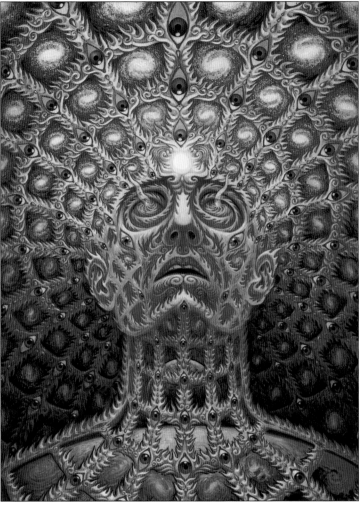

Oversoul, 1998-99

The visionary artist Alex Grey was brought up in a happy middle-class family in Columbus, Ohio. Fascinated with death from an early age, the young Grey used to collect and dissect dead animals and insects, then bury them in the family's back yard. Although Grey attended art school in Columbus, he dropped out after two years, working as a billboard painter and later studying under the tutelage of conceptual artist Jay Jaroslav. But it was the LSD trips he took with his wife Allyson that provided the impetus to begin his art. Working at Harvard Medical School for five years, his job was to prepare corpses for dissection. The position enabled him to study human anatomy, providing the perfect training for Grey to paint his visions. His work transcends normal anatomical illustrations, exploring the spiritual as well as the physical structure of the human body. His 21-piece series of life-size works named 'The Sacred Mirrors' took 10 years to create and examines in great detail all aspects of the mind, body and soul of the human life cycle. Grey's highly detailed paintings are spiritual and scientific in equal measure, revealing the artist's psychedelic, spiritual and super-natural view of the human race.

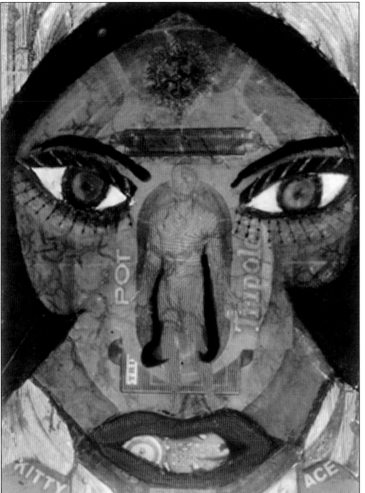

Queen Tripoley, c. 2000

Anne
Grgich
b. 1961

Museums etc
Anthony Petullo Collection,
Milwaukee, WI.

Musée de la Création Franche,
Bègles.

References
Raw Vision No. 22, 1998.

Anne Grgich, the creator of a vast number of intensely detailed art-filled poetry books and large-scale paintings, had a troubled and unusually unlucky background. Following a serious car accident at the age of 19, she spent two months in a coma. Her early adulthood continued with an involvement in punk-rock subculture, drug use and membership of a religious cult. Throughout all this, Grgich continued to create in any way she was able. Initially, her work was focused on the production of powerful and absorbing sketch or 'doodle' books, full of her innovative pictures and poems. Sadly, under the influence of some dubious advice, Grgich burnt and destroyed these early volumes. Although more books continue to come out of her creative mind, later work has been on a larger, more dramatic scale. Her current focus is on portraits, for which she is inspired by the everyday people she meets or sees on the street. Grgich terms the process of painting faces 'creating a persona', and makes use of a vast array of materials to create absorbing and intense images. She frequently employs a layered collage technique, with verses and text covering much of the piece, creating art full of meaning.

Ken
Grimes
b. 1947

References
American Self-Taught: Paintings and Drawings by Outsider Artists, Maresca & Ricco, 1993.

Raw Vision No. 50, 2005.

Self-Taught Artists of the 20th Century, ex cat, 1998.

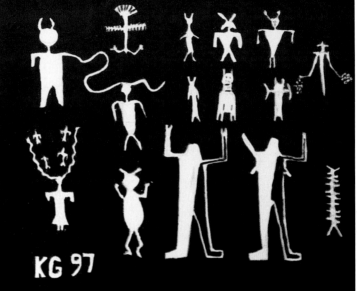

IN WESTERN AMERICA THERE ARE MANY ROCK SYMBOLS WHICH MAY BE TAKEN AS SIGNS OF CONTACT WITH ALIENS. THE REAL ANSWER

KG 97

In Western America (detail), 1997

Ken Grimes was born in New York City and moved to Cheshire, Connecticut, at the age of six. He was deeply impressed by his grandfather, who was a semi-professional magician and inventor. At college he received some art training, and since the 1970s he has participated in a community mental health programme that encourages creativity. In 1971 Grimes attempted to influence the Cheshire state lottery telepathically. A few days later, a man named Kenneth Grimes who lived in Cheshire, England, won a huge payout on the football pools. This experience of synchronicity spurred Grimes on to investigate this and other phenomena including alien communications, mind control and government cover-ups, and led him to his theory of the Coincidence Board. His findings are meticulously recorded in his characteristic white-on-black paintings, which in themselves are a visual demonstration of the contrast between truth and deception that Grimes sees so clearly and endeavours to convey to the world in an attempt to transform human consciousness and awareness. The large-scale, carefully composed works, which sometimes consist entirely of text, are sketched in pencil before the background is filled in with black ink or paint.

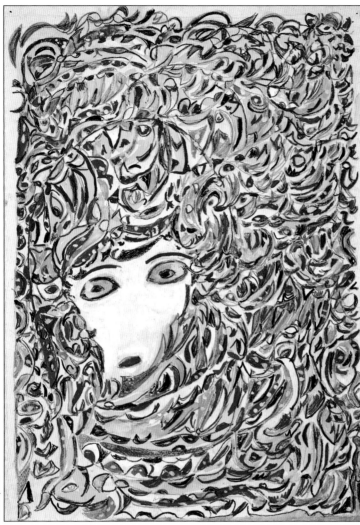

Untitled, n.d.

Martha
Grunenwaldt
1910–2008

Museums etc
abcd Collection, Paris.

L'Aracine Collection, Musée d'Art Moderne, Lille Métropole.

Art en Marge Collection, Brussels.

Eternod/Mermod Collection, Lausanne.

Musée de la Création Franche, Bègles.

References
Art Brut et Compangnie, ex cat, 1995.

Art en Marge Collection, ex cat, 2003.

Eternity Has No Door of Escape, ex cat 2001.

Raw Vision No. 43, 2003.

Not much is known of the early life of Martha Grunenwaldt. She was born in the Walloon part of Belgium to a family of musicians. As a child she often travelled with her father through the region, playing folk violin, to help feed the family. Grunenwaldt went on to marry a fellow musician, who took her daughter away from her following their separation. Her later life was spent on a farm, where employers forbade her from even touching her now stringless violin. Reunited with her daughter many years later, it was not until the age of 71 that Grunenwaldt picked up the crayons and pencils of her grandchildren and started to draw prolifically, preferring to carry out her art on the back of used card or her daughter's political posters. Grunenwaldt's pictures overflow with coloured fluid lines, which seemingly float across the page. Her central themes are always female faces, depicted as soft, delicate and blooming personalities, looking out from the dense ornamentation. Experimenting more with different media, her later works are filled with more intense patterns and increasingly complex compositions. Although ignored initially, her distinctive art is now much admired.

Johann
Hauser
1926–1996

Museums etc
abcd Collection, Paris.

L'Aracine Collection, Musée d'Art
Moderne, Lille Métropole.

Arnulf Rainer Collection, Vienna.

Collection de l'Art Brut, Lausanne.

Eternod/Mermod Collection,
Lausanne.

La Fabuloserie, Dicy, France.

Haus der Künstler, Gugging,
Austria.

Intuit, Chicago, IL.

References
L'Art Brut, fascicule No. 12,
1983.

*Art Brut und Psychiatrie.
Gugging 1946–1986*, Navratil,
1999.

Die Künstler aus Gugging,
Navratil, 1983.

Hauser's Frauen, Feilacher, 2001.

*Johann Hauser. Im Hinterland
des Herzens*, ex cat, 2001.

*Johann Hauser: Kunst aus Manie
und Depression*, Navratil, 1978.

Raw Vision No. 14, 1996; No. 15,
1996; No. 22, 1998; No. 34,
2001.

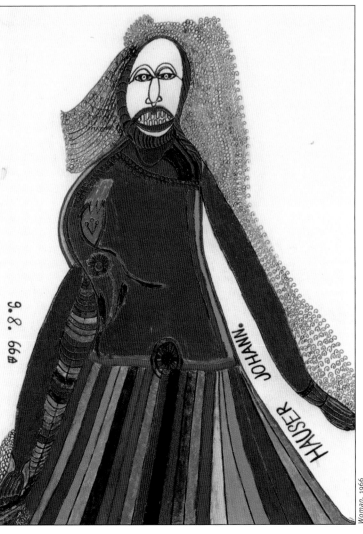

Woman, 1966

Johann Hauser, a founder member of the Haus der Künstler in Gugging, Austria, became one of its most successful artists. He first began to draw in the 1950s in response to encouragement from his psychiatrist, Dr Leo Navratil, and developed his own highly characteristic style. His powerful use of form and colour belie the fact that his favoured medium was coloured pencil. Drawing with a fierce intensity, he managed to create an overall painterly effect. The intense pressure he applied left indents in the paper and occasionally even tore it, but at other times his work was quiet and restrained, featuring just one

object or form. Navratil argued that this difference resulted from contrasts between Hauser's manic and depressive phases and that the dramatic mood changes he experienced transferred onto his work. Hauser's favourite themes were female figures, sexualised by emphasising their femininity and physical features. These intense drawings with their strong contrasts in tone and heavy pencil work are among his most powerful. In other moods he chose simple visual motifs such as airplanes, rockets and, most famously, a blue star, which became the emblem of the Haus der Künstler itself.

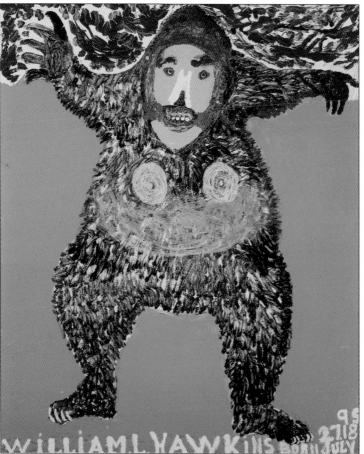

King Kong, 1985

William L.
Hawkins
1895–1990

Museums etc
American Folk Art Museum, NY.

Anthony Petullo Collection, WI.

Arkansas Arts Center, Little Rock, AR.

Columbus Museum of Art, OH.

Fenimore House Museum, Cooperstown, NY.

High Museum of Art, Atlanta, GA.

Intuit, Chicago, IL.

New Orleans Museum of Art, LA.

Newark Museum, Newark, NJ.

Smithsonian Institution, Washington, DC.

References
American Self-Taught, Maresca & Ricco, 1993.

Encyclopedia of Twentieth-Century American Folk Art and Artists, Rosenak, 1990.

Raw Vision No. 45, No. 57.

Self-Taught Artists of the 20th Century, ex cat, 1998.

Souls Grown Deep, Vol. 1, Arnett et al, 2000.

Vernacular Visionaries, Carlano, 2003.

William L. Hawkins started painting in the 1930s in his hometown of Columbus, Ohio, but a lifetime of truck driving and other jobs prevented him from being fully engaged in his creative work until he retired in the late 1970s. Hawkins was an energetic man all through his life and on his travels took black-and-white photographs of animals and cityscapes. His dramatic paintings, inspired by commercially printed images from magazines, newspapers, brochures and posters, are unhampered by detail or perspective. Hawkins often used unconventional recycled materials, painting on plywood, pieces of masonite and other found objects, and adding relief and dimension by attaching materials to raise the surface before painting over them. His themes include architectural views of townscapes, images of wild animals and history paintings, often depicting scenes from the 'Wild West'. Using house paint, his palette was bright and spectacular; he would mix vivid yellows, reds and whites to create unusual bold images. A particular feature of his work is his use of a painted frame around the main content of the painting, and the inclusion of his name and date of birth in large strong letters.

Chris
Hipkiss
b. 1964

Museums etc
American Folk Art Museum, NY.

Intuit, Chicago, IL.

John Michael Kohler Arts Center,
Sheboygan, WI.

Moscow Museum of Outsider Art,
Moscow.

Museum of International Folk
Art, Santa Fe, NM.

The Musgrave Kinley Outsider
Art Collection, The Irish Museum
of Modern Art, Dublin.

References
The End is Near, ex cat, 1998.

*Noir sur Blanc: Mondes
Interieurs*, ex cat, 2001.

Raw Vision No. 9, 1994.

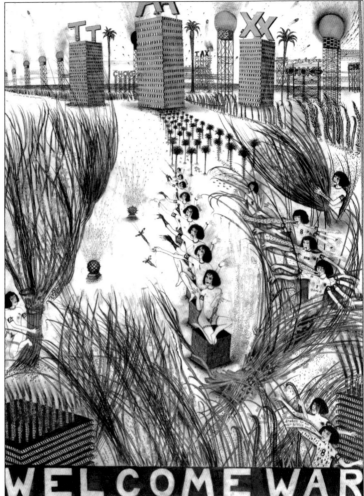

Welcome War, 2005

Chris Hipkiss was raised in the London suburb of Uxbridge. His weekends were spent on the boats of the River Thames, which is where, as a youth, he began to explore his surroundings, learning the Latin names of plants and studying the animals and birds of the river environs. His passion for art was visible from an early age, and he left school at 16 to apprentice as a model-maker in his father's joinery business. However, he soon became frustrated with the conventions of joinery and following his marriage he began to devote himself full time to the creation of art. Hipkiss admits to having a breakthrough in terms of a highly individualistic style while on a trip to Paris. His vast panoramic city- and landscapes of fantastical images are executed entirely in lead pencil. Often included are nonsensical statements and texts, wrapping round the central subjects which inhabit his minutely detailed pieces. Hipkiss' works are seen as intense and sometimes disturbing explorations into urban, industrial or alien environments, completed painstakingly and often to a massive scale. His largest work took over two years to finish and several of his drawings are over 20feet/7m in length. Hipkiss now lives with his wife in rural France.

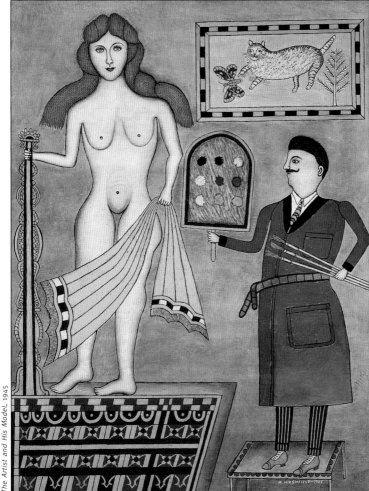

The Artist and His Model, 1945

Morris
Hirshfield
1876–1946

Museums etc
Charlotte Zander Museum,
Bönningheim, Germany.

American Folk Art Museum, New
York, NY.

References
*American Self-Taught: Paintings
and Drawings by Outsider
Artists*, Maresca & Ricco, 1993.

Modern Primitives, Bihalji-Merin,
1971.

*Museum of American Folk Art
Encyclopedia of Twentieth-
Century American Folk Art and
Artists*, Rosenak, 1990.

*Self-Taught Artists of the 20th
Century*, ex cat, 1998.

*They Taught Themselves.
American Primitive Painters of
the 20th Century*, Janis, 1942,
reprinted 1999.

World Encyclopedia of Naïve Art,
Bihalji-Merin & Tomasevic, 1984.

The son of a German mother and a Russian-Jewish father, Morris Hirshfield was born in Poland. From the age of 12 he would make wood carvings, amongst them a prayer stand for the village synagogue. He emigrated to the USA when he was 18, worked in a New York City coat factory and went on to set up a highly successful business manufacturing slippers. In 1937, Hirshfield retired from work through ill-health. He took up painting as a pastime and was recognised soon afterwards as one of the major folk artists of the 20th century. The influence of his career in the textile industry can be clearly seen in his paintings, which are characterised by bright colours and dense pattern. He would sometimes arrange sketches of the different parts of a design on the canvas as if he were making a garment pattern. Each element, whether an animal, a rug, vegetation or the sky, had its own carefully portrayed, often fanciful texture, and Hirshfield particularly liked to create mother-of-pearl, fur and woven fabric effects. His favourite subjects were animals and women. The women in his paintings resemble tailor's dummies; he considered the use of a live model to be inappropriate for a man of his age.

Lonnie
Holley
b. 1950

Museums etc
African American Museum,
Dallas, TX.

American Folk Art Museum, NY.

Birmingham Museum of Art, AL.

Fayette Art Museum, AL.

High Museum of Art, Atlanta, GA.

Intuit, Chicago, IL.

Meadow Farm Museum,
Richmond, VA.

Morris Museum of Art, Augusta,
GA.

New Orleans Museum of Art, LA.

Rockford Art Museum, IL.

References
*American Anthem: Masterworks
from the American Folk Art
Museum,* ex cat, 2001.

*Passionate Visions of the
American South, Self Taught
Artists from 1940 to the Present,*
New Orleans Museum of Art,
1993.

Raw Vision No. 7, 1993.

*Self-Taught Artists of the 20th
Century,* ex cat, 1998.

Souls Grown Deep, Vols. 1 & 2,
Arnett et al, 2000 & 2001.

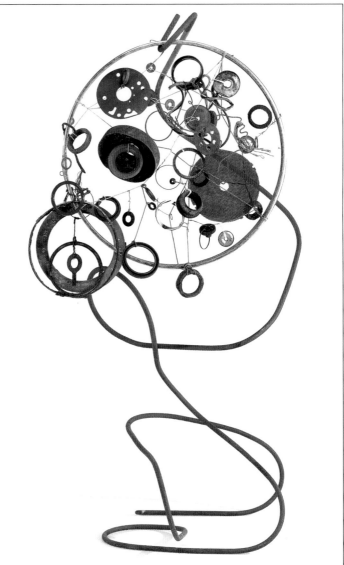

Ruling for the Child, 1982

Lonnie Holley, the seventh of 27 children, grew up in the Alabama city of Birmingham. He began work on his vast environmental art site near Birmingham airport following the tragic deaths of his two nieces. What started as memorial tombstones soon became an explosion of creative energy. Holley's sculptures, numbering several thousand, are made from a variety of materials. Traditional methods such as carvings from sandstone or wood stand beside intricate figures made entirely from waste products and found objects. Holley reclaims and uses everything from wire, bottles and electronic equipment to cable, fabric and papers, gathered on scavenging missions around the city. His inspirations are numerous, with many pieces celebrating African American achievements and history. Other works honour his family, African traditions and Egyptian mythology, or are comments on social and political issues. Holley also produces vibrant pictures, using household paint on plain wood. His pieces are poetically titled, with many containing a second, more spiritual meaning. Following the expansion of Birmingham Airport, Holley now lives and works in Harpersville, Alabama.

Hung
Tung
1920–1987

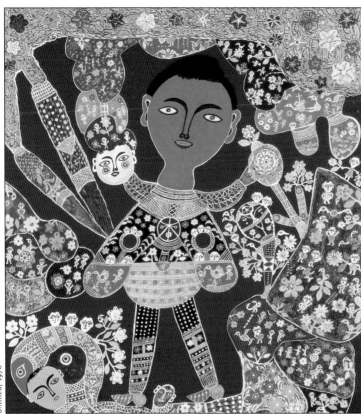

Untitled, 1978

Museums etc
Collection de l'Art Brut,
Lausanne.

Tainan District Cultural Center,
Taiwan.

References
17 Naïfs de Taiwan, ex cat,
1998.

*An Eccentric World: The Art of
Hung Tung*, 1920-1987, ex cat,
1996.

Raw Vision No. 48, 2004.

*Vernacular Visionaries:
International Outsider Art*,
Carlano, 2003.

Hung Tung, an illiterate painter from an impoverished fishing village in Taiwan, did not start to paint until 1969, when he was almost 50 years old. During an intensely creative period, often working obsessively all day and night, he painted hundreds of images. Although his use of bright colours and fine precise outlines reflects traditional formal Taiwanese art, Hung's style was distinctly his own. He painted onto paper with brushes normally used for calligraphy, blocking the outlines with solid china inks or oil paints. Combining bold semi-figurative elements with detailed abstract decoration, Hung used stripes and fabric-like patterns to create a rainbow effect around his figures, filling the picture plane. He sometimes added a script to his pictures, using a text intelligible only to himself. Hung painted a variety of subjects, but most recurrent were human figures with flat, doll-like faces, machinery, themes from the fishing village where he spent his life, and images connected with his personal religious beliefs. He achieved some notoriety during his lifetime, and although Taiwanese press reports led some visitors to seek him out, Hung always sent them away, jealously guarding his privacy.

91

Clementine
Hunter
c.1886–1988

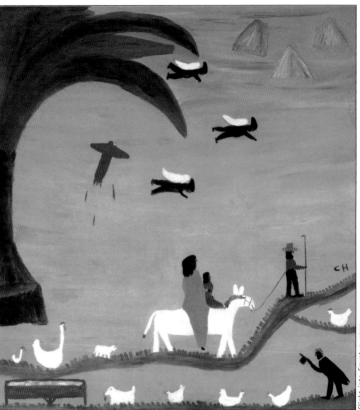

Flight into Egypt, c. 1955

Museums etc

African House, Melrose
Plantation, Natchitoches, LA.

American Folk Art Museum, NY.

Birmingham Museum of Art, AL.

Dallas Museum of Fine Arts, TX.

Fisk University, Nashville, TN.

High Museum of Art, Atlanta, GA.

Louisiana State University, Baton
Rouge, LA.

The Louisiana State Museum,
New Orleans, LA.

Montgomery Museum of Fine
Arts, Montgomery, AL.

New Orleans Museum of Art, LA.

Roger Ogden Museum, New
Orleans, LA.

References

*Clementine Hunter. American
Folk Artist*, Wilson, 1990.

Painting by Heart, Gilley, 2000.

Raw Vision No 24, 1998; No 59,
2007.

Souls Grown Deep, Vol 1, Arnett
et al, 2000.

Clementine Hunter was the grand-daughter of a slave, born on a plantation in north-western Louisiana. In her teens, the family moved to Melrose Plantation, near Natchitoches in the same county. Hunter remained there for most of her adult life, working as a cotton picker and farm hand, and, from the 1920s, as a house maid. Melrose was unusual in that it housed an arts and community centre, established in 1940 by its owners. Hunter's work as a maid, which included quilting and the decorative domestic arts, brought her incipient artistic talent to the attention of the centre's curator who suggested she paint. The plantation was a rich source of inspiration, though Hunter claimed her main impetus came from God and his creations. She painted every day, after finishing her chores. Beginning with house-paint on card or wood panels and other found materials, she later moved on to watercolours, oils and canvas. Her narrative paintings, almost entirely lacking in perspective, document scenes of plantation life, including funerals, weddings, church-going and people at leisure. She also created floral still lifes and pastoral scenes with animals, all painted with bold brushstrokes and set against warm backgrounds.

Hector
Hyppolite
1894–1948

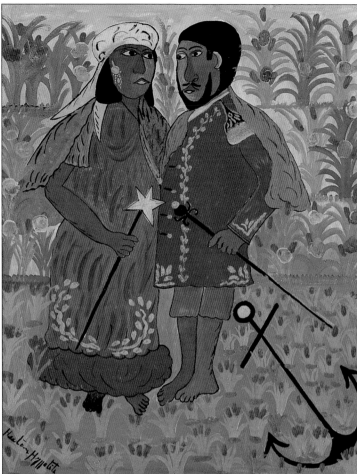

Agoué and his Consort, 1947

Museums etc
Milwaukee Art Museum.

Musée d'Art Haitien, St Pierre, Haiti.

Seldon Rodman Collection of Popular Art, NJ.

References
Sacred Arts of Haitian Vodou, ex cat, 1995.

Surrealism and Painting, Breton, 1972.

Voodoo and the Art of Haiti, Williams, 1969.

Where Art is Joy, Rodman, 1988.

Known in his Haitian neighbourhood for the murals he painted on the outside of shops and bars, Hector Hyppolite was encouraged by the American watercolourist DeWitt Peters to join the newly established Art Centre in Port-au-Prince. Refusing to work in the communal space on offer, Hyppolite set up his own makeshift studio in a dockside hut, producing a series of distinctive paintings in the short but creative period before his death. Hyppolite never doubted he would sell his paintings. As a *hougan*, or Vodou priest, he had been told in a dream that five paintings would be bought, taking his message

abroad. Vodou also influenced the style and subject matter of his paintings. Working with furniture enamel, Hyppolite depicted the ceremonies and the mythology of the *loas* (deities), as well as the everyday lives of the people around him. His use of tropical colours, with clashing complementaries, together with his lush floral borders and backgrounds, adds to the overall visionary effect of his pictures. Hyppolite's dream-like paintings appealed to the Surrealists: while travelling in Haiti André Breton bought five paintings, which brought Hyppolite's work to a European audience.

Mr
Imagination
b. 1948

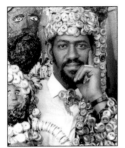

Museums etc
Anthony Petullo Collection, Milwaukee, WI.

L'Aracine Collection, Musée d'Art Moderne, Lille Métropole.

Intuit, Chicago, IL.

Museum of International Folk Art, Santa Fe.

National Museum of American Art, Smithsonian Institution, Washington, DC.

References
American Anthem: Masterworks from the American Folk Art Museum, ex cat, 2001.

Art Outsider et Folk Art des Collections de Chicago, ex cat, 1998.

Raw Vision No. 24, 1998.

Reclamation and Transformation, ex cat, 1994.

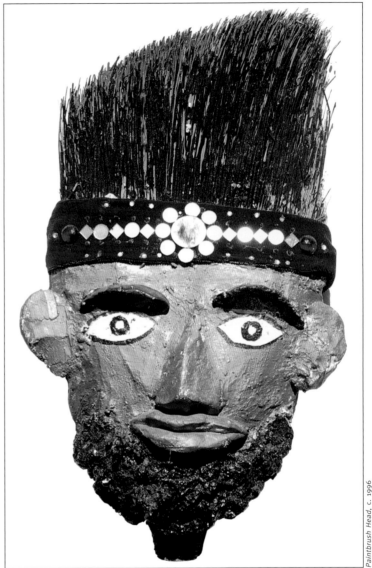

Paintbrush Head, c. 1996

Born Gregory Warmack in 1948, Mr Imagination spent his childhood in the rough and poverty-stricken South Side area of Chicago. As a child, he made art out of anything and everything. He would create jewellery from small beads, carve African tribal-style heads and produce paintings on old boxes and packets. Throughout the 1970s, Mr Imagination continued creating, making particular use of a lorry-load of sandstone which was dumped near the family home. He realised that he could carve faces and sculpt his ideas into the malleable stone using just a nail. His creative explorations have taken him into the realm of the simple bottle top. Using thousands of the metallic caps of countless discarded bottles, Mr Imagination has decorated totem poles, transformed seats into regal thrones and embellished coats, jewellery and hats. This ability to transform his environment is also revealed within his renowned grotto at the Elliot Donnelley Youth Center near his home in Bethlehem, Pennsylvania. He has stated that his art is a forum to turn the tragedies of life into a celebration of power and joy. In 2008 he was hit by a catastrophe when much of his work was lost when his home was gutted by fire.

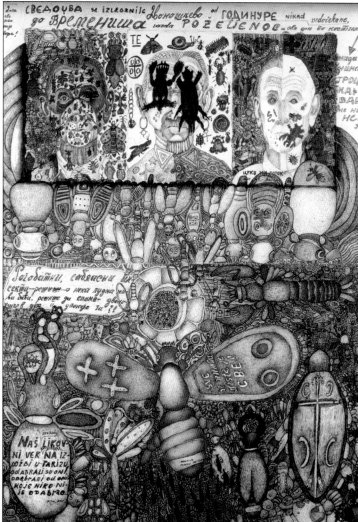

The Frightening Horned Insects, c. 1970

Vojislav
Jakic
1932–2003

Museums etc
abcd Collection, Paris.

L'Aracine Collection, Musée d'Art Moderne, Lille Métropole.

Charlotte Zander Museum, Bönningheim, Germany.

Museum of Naive and Marginal Art, Jagodina, Serbia.

References
L'Art Brut, fascicule No. 10, 1977.

Art Brut et Compangnie, ex cat, 1995.

The End is Near, ex cat, 1998.

Vojislav Jakic came from a strict Serbian Orthodox family in Macedonia, then a republic of Tito's Yugoslavia. His family later moved to Serbia. Jakic suffered a poor existence in his early life, scraping together money from painting portraits of the dead for local grieving families. He began creating earnestly in 1954, initially carving wooden sculptures with cupboards filled with bones and skulls, progressing to large-scale paintings from around 1960. Jakic wrote his semi-fictional autobiography titled *Nemanikuce* ('Homeless') in 1970 in which he examined the themes of pain and suffering which penetrate his powerful paintings. With some extending to up to 16 feet (5 m) in size, Jakic's art overflows with minutely detailed pictures and text, among images which fill the page completely. His subjects are predominantly dark, nightmarish visions of death, insects and human insides. The illustrations that inhabit his paintings intertwine and overlap, creating complex and frightening configurations. His paintings are not merely representation. One of his paintings carries the explanation, 'This is neither a drawing nor a painting, but a sedimentary deposit of suffering.'

James Harold
Jennings
1931–1999

Museums etc
American Visionary Art Museum, Baltimore, MD.

Art Museum of Southeast Texas, Beaumont, TX.

Birmingham Museum of Art, Birmingham, AL.

The Louisiana State Museum, New Orleans, LA.

Mississippi Museum of Art, Jackson, MS.

Morris Museum of Art, Augusta, GA.

New Orleans Museum of Art, LA.

North Carolina State University, Raleigh, NC.

Owensboro Museum of Fine Art, KY.

Taubman Museum, Roanoke, VA.

References
Encyclopedia of Twentieth-Century American Folk Art and Artists, Rosenak, 1990.

Passionate Visions, New Orleans Museum of Art, 1993.

Raw Vision No. 63, 2008.

Signs and Wonders, Manley, 1989.

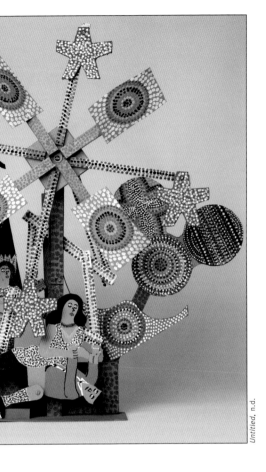

Untitled, n.d.

A resident of North Carolina for all of his life, James Harold Jennings began to paint following the death of his mother in 1974. She had been his teacher at home for most of his childhood, in addition to the many journals and magazines which lay around their rural home. This unusual education no doubt had a great influence on Jennings. He worked for a while as a tobacco picker, cinema projectionist and night watchman, but stayed at home for the most part, due to the unstable nature of his nerves. He began to create painted sculptures on scrap wood and placed them around a group of derelict buses, located near his home. Jennings' creations become increasingly complex, often involving mechanical or wind-powered assemblages. He painted bright whirligigs and wooden angels, taking inspiration from popular culture, religion and his immediate environment. Jennings' decorative creations took over his life. He eventually moved into the buses across from his house, living there without electricity or modern appliances, dedicated in his drive to continue his artwork. Sadly, the prolific artist committed suicide in 1999, evidently out of fearful anticipation for the end of the 20th century.

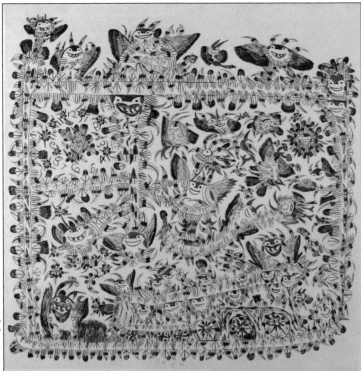

Untitled, c. 1965

Frank
Jones
1900–1969

Museums etc
African American Museum, Dallas, TX.

American Visionary Art Museum, Baltimore, MD.

High Museum of Art, Atlanta, GA.

The Menil Collection, Houston, TX.

Miami University Art Museum, Oxford, OH.

National Museum of American Art, Smithsonian Institution, Washington, DC.

New Orleans Museum of Art, LA.

References
American Self-Taught: Paintings and Drawings by Outsider Artists, Maresca & Ricco, 1993.

Museum of American Folk Art Encyclopedia of Twentieth-Century American Folk Art and Artists, Rosenak, 1990.

Passionate Visions of the American South, Self Taught Artists from 1940 to the Present, New Orleans Museum of Art, 1993.

Raw Vision No. 62, 2008.

Souls Grown Deep, Vol. 1, Arnett et al, 2000.

Frank Jones was brought up in a poor, yet deeply religious African-American household in Clarksville, Texas. He was denied the opportunity to be schooled, so he spent much of his early life doing odd jobs and surviving on what he could. When he was nine years old, Jones began to see spirits. His mother, who had abandoned Jones as a three-year-old, had foreseen this as the inevitable outcome of his being born with the 'caul' membrane over his left eye. Jones was insistent that his ability enabled him to see through to the world of spirits, which appeared to him under many guises. Beginning in 1941, Jones spent over 20 years of his life in Texan jails. He always maintained his complete innocence of the crimes of which he was accused, but the racist judicial system of the day was stacked against him. During the early 1960s, the imprisoned Jones began to collect pieces of paper and to paint the haints or devils which had been present all of his life. Naming his pictures 'devil houses' he would paint the spirits within architectural box frames, surrounded by flame-like flicks of colour. Although he was due for release, he became unwell and died in Huntersville Prison Hospital in 1969.

Shields Landon
Jones
1901–1997

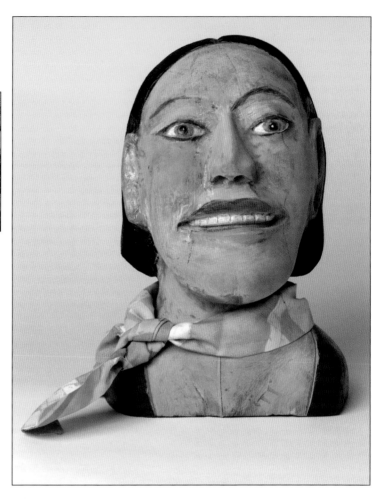

Female Bust (Green Scarf), n.d.

Museums etc
Akron Art Museum, OH.

American Folk Art Museum, NY.

Anthony Petullo Collection, WI.

Arkansas Arts Center, Little Rock, AR.

Art Museum of Southeast Texas, Beaumont, TX.

Columbus Museum, GA.

Meadow Farm Museum, Richmond, VA.

Milwaukee Art Museum, WI.

Musée de la Création Franche, Bègles.

Museum of International Folk Art, Santa Fe, NM.

Owensboro Museum of Fine Art, KY.

Smithsonian Institution, Washington, DC.

References
Encyclopedia of Twentieth-Century American Folk Art and Artists, Rosenak, 1990.

Passionate Visions, New Orleans Museum of Art, 1993.

Pictured in My Mind, 1995.

Raw Vision No. 62, 2008.

Shields Landon ('S.L.') Jones was born and raised in West Virginia. He left school after only eight years of education and embarked on a career working on the railroads, eventually achieving the position of shop foreman. But it was the death of his first wife, Hazel, in 1969 which established the impetus in Jones to start carving. He began with producing small wooden sculptures of animals, but soon progressed to larger carvings of people and heads. He mainly used wood from the yellow poplar, maple and walnut trees, carving out his figures with locally produced chisels. His figures are representational, both male and female, and generally portray smiling, joyful personalities with strong features. Many are musicians like Jones, who was an accomplished fiddle player. Jones insisted all the carvings were of no-one he knew, but rather were depictions of how he felt that day, stating 'They come from me.' As well as around 150 heads in the same style, Jones also produced a number of drawings, executed in factual colours, fairly accurate to his subject matter of faces and figures. He continued to carve until illness slowed him down, and in later years he concentrated solely on his drawings.

Untitled, 1987

Rosemarie
Koczÿ
1939–2007

Museums etc
Anthony Petullo Collection, Milwaukee, WI.

L'Aracine Collection, Musée d'Art Moderne, Lille Métropole.

Charlotte Zander Museum, Bönningheim, Germany.

Eternod/Mermod Collection, Lausanne.

Musée de la Création Franche, Bègles.

References
Art Brut et Compangnie, ex cat, 1995.

Eternity Has No Door of Escape, The Eternod-Mermod Collection of Art Brut, ex cat, Lugano, 2001.

Je Vous Tisse un Linceul/I Weave You a Shroud: Rosemarie Koczy, Liége, 2001.

Portraits From the Outside, ex cat, 1990

Raw Vision No. 25, 1998; No 63, 2008.

The traumatic experiences of artist Rosemarie Koczÿ's holocaust childhood shaped her artwork. Born in Recklinghausen, Germany, Koczÿ' was deported along with her family to the Traunstein concentration camp, and then to the Ottenhausen camp, where she stayed until the end of the Second World War. The death of her grandmother, her legal guardian, forced the young Rosemarie into a workhouse orphanage. Following her mother's death, Koczÿ became distraught and ill. At the age of 20, with the help of her grandfather, she left the orphanage and found work as a maid in Switzerland. Finally, she was able to draw out the experiences which had tarnished her childhood so cruelly. Rosemarie Kozcÿ began to study drawing and tapestry techniques at the Ecole des Arts Decoratifs in Geneva. Her immensely personal tapestries were her way of communicating the pain of the past. In 1975, Kozcÿ began to produce a multitude of small ink drawings, some in black and white, but many in colour. Later, she undertook larger drawings and wood carvings, again symbolising the experience of the victim. Despite the harrowing subjects, Kozcÿ wanted to show the importance of the existence of hope and justice.

Johann
Korec
1937–2008

Die Alexandra Korbusz und Korec Johann in Mödling, 1980

Museums etc
abcd Collection, Paris.

L'Aracine Collection, Musée d'Art Moderne, Lille Métropole.

Arnulf Rainer Collection, Vienna.

Charlotte Zander Museum, Bönningheim, Germany.

Collection de l'Art Brut, Lausanne.

Musée de la Création Franche, Bègles.

References
L'Art Brut, fascicule No. 12, 1983.

Art Brut und Psychiatrie. Gugging 1946–1986, Navratil, 1999.

Die Künstler aus Gugging, Navratil, 1983.

Johann Korec was born in Vienna, Austria. Following a childhood spent in institutions, he worked as a farmhand and shepherd, but always suffered from manic depression and hypomania. He was institutionalised in 1958 and sent to the Gugging hospital, near Vienna, where he soon started experimenting with art. Showing great promise, Korec was moved into the Gugging House of Artists at its inception in 1981 and soon developed the unique style for which he is now known. Korec's paintings usually depict lovers in intimate poses, with a second section below the main picture describing the scene above, although many commentators are now viewing this narrative as part of the essential artwork. Animals occasionally enter his pictures, but it is the eroticism of the human form which interests Korec the most. He works in Indian inks and watercolours, and using magazines as the main inspiration for his coupling figures employing calm colours to present his illustrations. Critics have viewed his work as similar to a sketchbook or pictorial diary, as his paintings could be perceived to be scenes from a continuous love story. Korec's intimate portraits have been exhibited widely.

The Sallman Head of Christ or The Salmon Headed Christ, 2004

The Sallman Head of Christ
or
THE SALMON HEADED CHRIST

DAGON

THE
FISH GOD
WAS
A FALSE
CHRIST
OF
THE PAGANS

DAG-AUN

"FISH OF
THE SUN"
MANIFESTED
THE
SUN GOD

DAGON
IN THE BIBLE
JUDGES 16:
1 SAM. 5:2
1 CHRON
8:1

"Dag want us to see Jesus"
(FORWARD)
"Says he's Jesus son of God"
(via: hypostrephonic echo: REVERSE SPEECH)
N.H. Kox

Norbert
Kox
b. 1945

Museums etc
American Visionary Art Museum,
Baltimore, MD.

References
The End is Near, ex cat, 1998.

Raw Vision No. 14, 1996; No 65,
2008.

Religious Visionaries, ex cat,
1991.

Norbert H. Kox was born in Green Bay, Wisconsin. Whilst a member of the notorious 'Outlaws' biker gang, Kox began working on custom bikes and cars, soon progressing to painting on other items, creating artworks from rubbish and salvaged objects. Leaving the biker gang was an emotional struggle, which Kox only achieved through immersing himself in religion. Kox soon found that he disbelieved the conventional teachings of Christianity, preferring his own interpretations. He joined the army and, with the help of art instruction books, began painting. Between 1975 and 1985, Kox went through a period of religious isolation, living as a hermit in the wilderness of his personal outdoor chapel known as 'Gospel Road'. On his return to Green Bay, he continued to work on his apocalyptic yet spiritual paintings. His pictures are religious visions of the battle between good and evil, detailing spiritual scripts and examining the worship of false icons. Kox organises his compositions with pencil, then employs a complex layering technique, depositing layers of vivid oils and watercolours. The final glazing of his paintings combines with the strong contrast of his hues to give a brilliant and translucent quality.

Pushpa
Kumari
b. 1969

Museums etc
Mingei International Museum,
San Diego, NM.

National Museums, Liverpool.

References
Raw Vision No. 54, 2006.

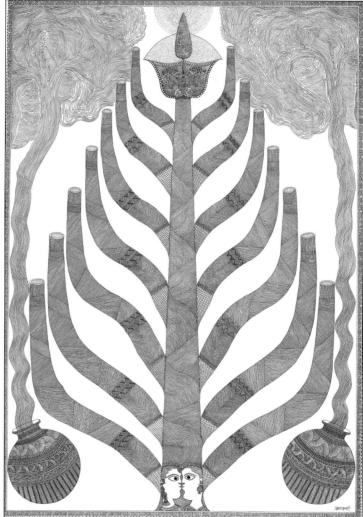

The Toddy Tappers, 2004

Pushpa Kumari comes from a long line of artists from the Madhubani region of Northern India, renowned for its female painters and artists, who cover the walls and floors of their houses with detailed drawings. Kumari's grandmother Maha Sundari Devi, one of the leading painters of the region, popularised the individual style of Mithila art by drawing on paper rather than the traditional domestic surfaces of the past. Kumari began to draw at the age of seven. Forced by an absent father to take responsibility over her large family, Kumari, the eldest sibling, soon found that by selling her work, she ensured her relatives' survival. Although her technique follows tradition, Kumari is constantly experimenting with new themes and ideas, often using more abstract concepts as the basis for her intricately detailed ink-drawn pictures. In addition to stories from Hindu epics, she works on contemporary social themes such as female foeticide and women's empowerment. Kumari has imbued a collective tradition with greater individualistic artistry. Working directly on paper in ink without any preliminary sketches, she has become a renowned artist of the region made famous by her female predecessors.

Dimensionality: The Manifestation of Fate (detail), 1992

Paul
Laffoley
b. 1940

Museums etc
American Visionary Art Museum,
Baltimore, MD.

Hirshhorn Museum, Washington,
DC.

References
The End is Near, ex cat, 1998.

The Message, ex cat, 2008.

Phenomenology of Revelation,
Laffoley, 1989.

Raw Vision No. 14, 1996.

Paul Laffoley grew up within the confines of a strict Irish Catholic family in Boston, Massachusetts. Educated in progressive schools throughout his childhood, he graduated in Classics from Brown University with honours, but was later dismissed from Harvard Graduate Design School because of his unconventional ideas. Laffoley trained as an architect, but later worked at the membership office of the Boston Museum of Science. Since the 1960s, Laffoley has rented an 18 x 30 feet (5 x 9m) utility room that he christened the 'Boston Visionary Cell'. Here he has created over 800 works, displaying his philosophical and scientific ideas, executed in the form of architectural and scientific drawings. An obsessive reader and collector of some 7,000 books, Laffoley absorbs information and knowledge at an unusual rate. He employs this knowledge in his paintings, combining it with his own ideas and conventions to produce complex diagrammatic pictures. Laffoley's unique work is often large-scale. He uses many different types of paints; oils, acrylics and also simple coloured pens to produce his complex works, relying on an emotional and creative state which he calls 'Lucid Dreaming'.

103

Gérard **Lattier**
b. 1937

Museums etc
Eternod/Mermod Collection,
Lausanne.

References
Art Brut et Compangnie, ex cat,
1995.

*Eternity Has No Door of Escape,
The Eternod-Mermod Collection
of Art Brut*, ex cat, Lugano, 2001.

*Gérard Lattier: Le Voyage en
Peinture*, Vazielle et al, 2004.

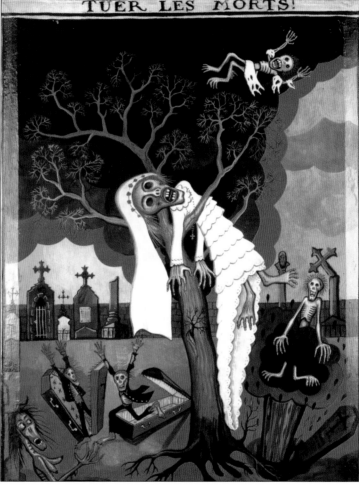

Kill the Dead, 1972

Gérard Lattier was born in the French town of Nîmes, in 1937. The heartbreaking death of his father in 1944 affected the young boy deeply, along with a serious bout of encephalic meningitis, contracted when he was just six. Lattier coped with these tragedies by teaching himself how to draw. By his early adolescence, numerous sketchbooks had been filled to the brim with dark pictures of fantasy scenes. He continued painting, even through his internment in a psychiatric hospital following his refusal to serve militarily in the Algerian War. Returning to Nîmes to work as a draughtsman, Lattier persisted in creating his gothic and text-infused cartoon-like images until his breakdown in 1965. The breakdown caused severe damage to his eyesight for over a year, but he soon recovered, going on to marry and start a family. His pictures are dominated by events, both personal and historic, painted in great detail with frequent depictions of a nightmarish or manic quality. Lattier is a poet, who adds texts to his paintings, often attaching the verses to the main piece via a leather strap to create a continuous narrative. His paintings are powerful explorations of religion, sex, death and the madness of life.

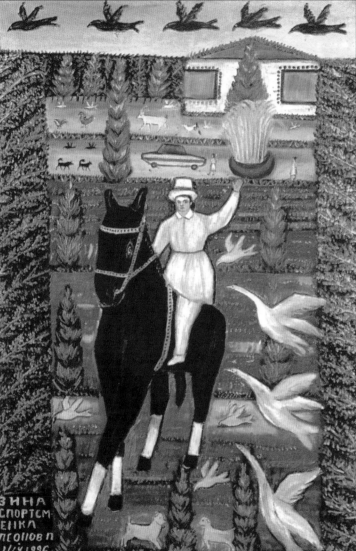

Zina, Sportswoman, 1996

Pavel
Leonov
b. 1920

Museums etc
Charlotte Zander Museum,
Bönningheim, Germany.

Croatian Museum of Naïve Art,
Zagreb.

References
Art without Frontiers, Crnkovic,
2006.

INSITA, ex cat, 2000.

Raw Vision No. 28, 1999.

Pavel Leonov started life in a small rural village in the Russian region of Orel. Forced to escape from an abusive father, he began to wander around the then Soviet Union at an early age. Although Leonov studied at the Extramural People's Arts University during the 1960s and received outstanding reviews for his student works, he soon disappeared from view. He undertook numerous jobs and entered prison three times for what he describes as 'my struggle against injustice'. 37 years later, he finally settled in the Ivanovo village of Mekhovitsy where his later pictures were created. Calling his paintings 'constructions',

Leonov assembles colourful scenes, often framed like a window view or a theatre stage, with a small strip of sky filled with his signature birds inhabiting the uppermost border. Essentially idealistic, his themes show the happier times in a Russian villager's life. Celebrations, weddings, dances and modernist scenery are common subject matter for Leonov, who uses any paint he can find to create his pictures. Leonov's work was finally recognised by the INSITA exhibition at the Slovak National Gallery in Bratislava when he was awarded the Grand Prix in 1997 and a one-man show in 2000.

Augustin
Lesage
1876–1954

Museums etc
abcd Collection, Paris.

L'Aracine Collection, Musée d'Art
Moderne, Lille Métropole.

Charlotte Zander Museum,
Bönningheim, Germany.

Collection de l'Art Brut,
Lausanne.

Musée de Béthune, France.

References
*American Anthem: Masterworks
from the American Folk Art
Museum*, ex cat, 2001.

L'Art Brut, fascicule No. 3, 1965.

*Art spirite, médiumnique,
visionnaire. Messages d'outre-
monde*, ex cat, 1999.

Augustin Lesage 1876–1954, ex
cat, 1988.

Outsider Art, Cardinal, 1972.

Outsiders, Delacampagne, 1989.

Raw Vision No. 1, 1989; No. 2,
1989; No. 26, 1999.

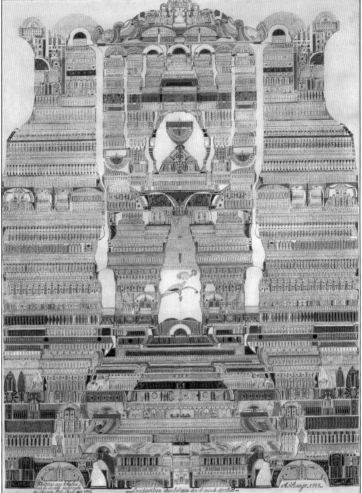

Symbolic Composition of the Spiritual World, 1923

Augustin Lesage was born into a mining family near Lille, in northern France. While working at the coalface, he became aware of voices telling him of his spiritualist powers. The voices became a central factor in his art; Lesage followed their orders and bought materials in response to their instructions. With no previous knowledge or experience of painting and no technical skill, his hand was guided by the voices. On purchasing his first canvas, he mistakenly bought one ten times the intended size, but his spirit guides instructed him not to be daunted and to begin painting; huge canvases became his chosen format.

His first painting, made with small brushes, starting in the top right-hand corner, was covered with architectural motifs, stylised vegetation and organic forms. He later went on to develop his unique highly symmetrical style, drafting detailed patterns and monolithic constructions reminiscent of Egyptian and Oriental architectural forms. Lesage initially left his paintings unsigned, then began adding the name 'Leonardo da Vinci'. It was only later that he added his own signature. In later life he became a respected artist, though spiritualism remained at the core of all his work.

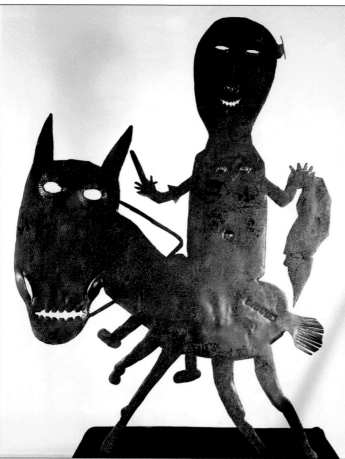

Saint Anthony Giving his Cloak to the Poor, n.d.

Georges
Liautaud
1899–1991

Museums etc
Milwaukee Art Museum, WI.

Musée d'Art Haitien, St Pierre, Haiti.

Seldon Rodman Collection of Popular Art, NJ.

References
Sacred Arts of Haitian Vodou, ex cat, 1995.

Voodoo and the Art of Haiti, Williams, 1969.

Where Art is Joy, Rodman, 1988.

Originally a blacksmith, Georges Liautaud made beaten metal crosses, which he attached to tombstones at his home town of Croix-des-Bouquets, the centre of Haitian Vodou. The stylised crosses were spotted in the 1950s by the American painter and art collector DeWitt Peters, who suggested that Liautaud make 'works of art'. The blacksmith began to create his enigmatic two-dimensional sculptures by cutting out sheets of metal reclaimed from oil drums. Liautaud sometimes made portraits or other secular pieces, but the majority of his sculptures depict the mythical world of the Haitian Vodou spirit deities (*loas*). Typically the sculptures record aspects of ceremonies, the possession of the body (symbolised by a horse rider), or figures from the Vodou pantheon, including the sacred twins or Ezili, the female spirit of love and creativity. Most of Liautaud's two-dimensional sculptures are highly stylised, with large heads and short or elongated limbs. Many have cut-out, punched-out features. After drawing the outline of his designs on brown paper, he transferred this graphic quality to his sculptures. Many of his dark metal forms are reminiscent of stark minimalist line drawings.

Alexander
Lobanov
1924–2003

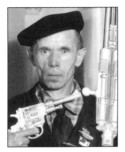

Museums etc
abcd Collection, Paris.

L'Aracine Collection, Musée d'Art
Moderne, Lille Métropole.

Collection de l'Art Brut,
Lausanne.

Moscow Museum of Outsider Art,
Moscow.

Musée de la Création Franche,
Bègles.

References
*Alexandre Lobanov et l'Art Brut
en Russie*, Decharme, 2003.

Alexandre Pavlovic Lobanov, Ed.
Miscault, 2007.

Raw Vision No. 58, 2007.

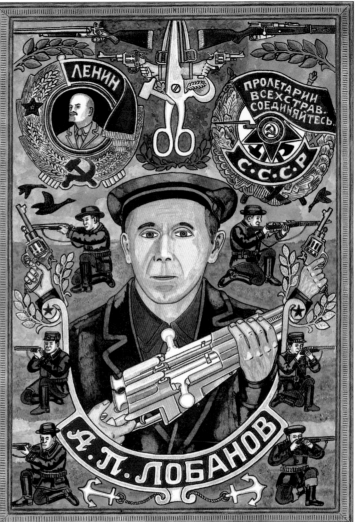

Untitled, n.d.

Alexander Lobanov was born in the Yaroslavl Region of Russia. Following a bout of meningitis as an infant, he lost his speech and hearing at the age of seven. The young Lobanov began to attend specialist schools but his family was forced to relocate to another town. He became increasingly violent and aggressive and was condemned to the Yaroslavl asylum at the age of 27. Although his aggression softened with time, Lobanov became progressively insular and was diagnosed with autism. It was in this calmer state of mind, within a more open hospital and under the attention of his psychiatrist Vladimir Gavrilov, that Lobanov began to paint his gun-inspired portraits. Initially very secretive about his work, he soon gained the confidence to present them to hospital officials. Lobanov's detailed paintings are primarily inspired by the communist propaganda and symbolism which surrounded him all his life. The central theme of the gun is absolute, whilst the appearance of Cyrillic slogans is also a characteristic of his work. During the 1970s, Lobanov began to experiment with photography, using montage images of himself in hunting regalia, surrounded by other hunters, guns and animals.

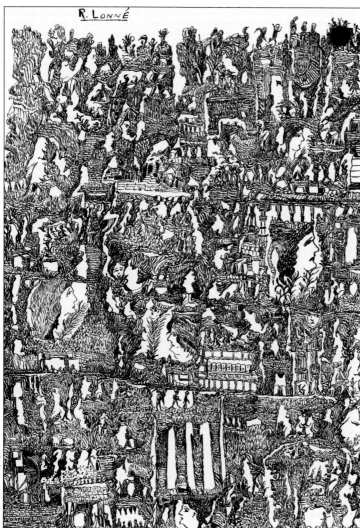

Untitled (detail), 1963

Raphaël
Lonné
1910–1989

Museums etc
abcd Collection, Paris.

L'Aracine Collection, Musée d'Art Moderne, Lille Métropole.

Collection de l'Art Brut, Lausanne.

Eternod/Mermod Collection, Lausanne.

References
L'Art Brut, fascicule No. 1, 1964.

L'Oeil No. 216, 1972.

Raw Vision No. 2, 1989; No. 35, 2001.

Raphaël Lonné was a country postman in south-west France who showed no interest in art until he was 40. His parents were farm labourers and Lonné had little education, leaving school at the age of 12. Lonné claimed he had been instructed to begin to draw by a sudden visitation from a spirit medium. Working first in pencil, and later in pen and ink, he drew in an intense trance-like state, claiming that his hand was directed by his spirit guides. He only stopped once he had completed the picture, never returning to alter anything once it had been drawn or taking his pen from the paper. Superficially, Lonné's pieces appear to be roughly textured, dense, organic masses, but on closer inspection they are revealed as delicate and confidently executed landscapes, filled with detailed figures. From the organic surface, resembling lava-rock, emerge tiny heads, outlined faces, and animals, punctuated with amoeba-like lacunae. He also included cryptic writing in his artworks, which he claimed were reminiscences from previous lives. Initially Lonné refused to sell his work, saying it was the property of his spirit guides, but later he became more commercialised and attempted to align himself with the Parisian art world.

Marie-Rose
Lortet
b. 1945

Museums etc
Collection de l'Art Brut,
Lausanne.

La Fabuloserie, Dicy, France.

References
Art Brut et Compangnie, ex cat,
1995.

La Fabuloserie, ex cat, 2001.

*Marie-Rose Lortet, Territoires de
laine – Architectures de fils,
1967-2000*, ex cat, 2000.

Raw Vision No. 40, 2002.

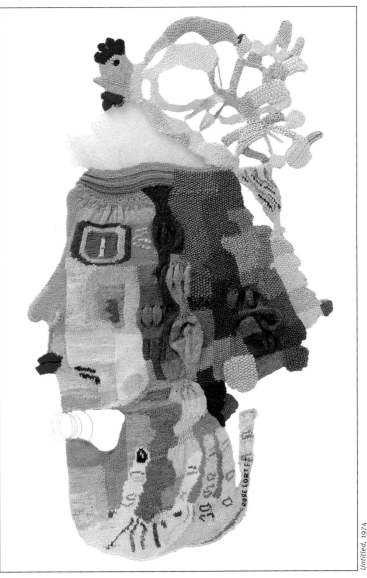

Untitled, 1974

Marie-Rose Lortet, originally from Strasbourg, began knitting at an early age, inspired by the tradition which ran through the female members of her family. Creating small fabric pictures and textile pieces, her knitwork was never of a conventional nature. In 1967, with the attention and encouragement of Jean Dubuffet, Lortet's work began to be taken seriously. Following the inclusion of her work in the Art Brut Collection, Lortet started to experiment with looser textile pictures. During the 1980s, her exploration into the possibilities of working with wool and fibres led Lortet to try white thread lace, solidified with resin or sugar. These inspired fabric sculptures often took the form of houses, rooms, windows and domestic scenes, as well as more abstract images and collages. Her experimentation continued into the 1990s, when she began creating new pieces by mixing previous techniques. Her fairy-size clothes with titles such as 'Outfit for a Crisis' and 'An Architecture of Threads' reflect Lortet's belief that her work represents a journey, or a travel map to an unknown destination. Many of her incalculable works are created using multiple layers of fabric, threads and knitted yarns.

Untitled, c. 1991

Albert
Louden
b. 1943

Museums etc
American Visionary Art Museum, Baltimore, MD.

Anthony Petullo Collection, Milwaukee, WI.

L'Aracine Collection, Musée d'Art Moderne, Lille Métropole.

Musée de la Création Franche, Bègles.

The Musgrave Kinley Outsider Art Collection, The Irish Museum of Modern Art, Dublin.

References
Inner Worlds Outside, ex cat, 2006.

Portraits From the Outside, ex cat, 1990.

Raw Vision No. 18, 1997.

Albert Louden, a former van driver and weight lifter from East London, is perhaps Britain's best-known living Outsider. In 1981 Louden, who had painted for his own pleasure for many years, saw an old advertisement for the 1979 exhibition 'Outsiders' at the Hayward Gallery, London and contacted co-curator Victor Musgrave. Encouraged by Musgrave's enthusiasm for his work, Louden began to show his pictures more and more. His individual style and use of colour depict large full-bodied figures and rotund faces taking centre stage. 1985 saw Louden exhibit his work in London's Serpentine Gallery: a breakthrough for the artist. Classic Louden work often has central characters dominating, block-coloured in pastels of orange and brown. In more recent years, experimentation has led Louden to undertake more landscape and oil-based abstract work, although his figurative pastel pictures, characterised by bold, strong and sweeping lines, are perhaps the most loved of all his pieces, many of which are on a grand scale. Louden has stated in the past that his art is created 'from the unconscious', where a picture and its lines evolve without the need for a grand vision of any end result.

Dwight
Mackintosh
1906–1999

Museums etc
abcd Collection, Paris.

Anthony Petullo Collection,
Milwaukee, WI.

L'Aracine Collection, Musée d'Art
Moderne, Lille Métropole.

Collection de l'Art Brut,
Lausanne.

High Museum of Art, Atlanta, GA.

Intuit, Chicago, IL.

Milwaukee Art Museum, WI.

National Museum of American
Art, Smithsonian Institution,
Washington, DC.

References
*American Self-Taught: Paintings
and Drawings by Outsider
Artists*, Maresca & Ricco, 1993.

L'Art Brut, fascicule No. 17, 1992

*Art Outsider et Folk Art des
Collections de Chicago*, ex cat,
1998.

*Dwight Mackintosh: The Boy
Who Time Forgot*, MacGregor,
1991.

Raw Vision No. 52, 2005.

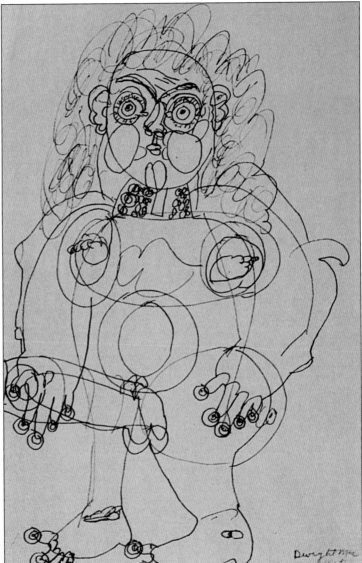

Male Figure, 1984

Dwight Mackintosh was interned in a mental institution at the age of 16, having become 'unmanageable at home', only to be released a lifetime later at the age of 72. On his release he was encouraged to attend sessions at the Creative Growth Art Center in Oakland, California, and began to draw. He is said to have undertaken drawing with an obsessive vigour, hurriedly crossing out mistakes as he went. Mackintosh's work is basically calligraphic: using felt-tipped pens and coloured pencils on white paper, the line is scribbled over the paper, creating his signature text, whirls and swirling figures. There are few basic colours in his artwork. Areas of blue may represent the sky. Green may symbolise grass. Mackintosh obsessively explored two main themes in his work: the human figure and transport. The 'Boys' series of drawings are of groups of distorted human male figures with large heads and over-sized penises. He also drew transparent cars and buses, based on images he may have recalled from his boyhood before his hospitalisation. Written text-forms also appear in his work, flowing above and around his subjects. Most of the text is illegible, with the exception of a few stray words.

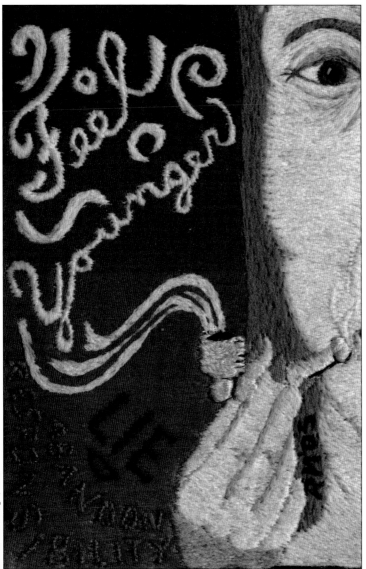

SMOKE: Feel Younger, 2006

Ray
Materson
b. 1954

References
The Fabric of Myth, ex cat, 2008.

Raw Vision No. 17, 1996.

Sins and Needles: A Story of Spiritual Mending, Materson, 2002.

Ray Materson, the creator of a multitude of tiny detailed and coloured embroideries, has his origins in Michigan, USA. He first started creating his pieces during a stay in a Connecticut prison. Remembering his grandmother's stitching techniques, he took up embroidery after fellow inmates saw his self-sewn Michigan football emblem. Orders came for various different symbols, logos and flags, which Materson undertook enthusiastically, happy to have found something to occupy his time inside. He later embarked on producing more scenic embroideries, capturing his experience in prison and his views of life outside. His works are meticulously constructed, with many details only fully appreciated with the use of a magnifying glass. Since leaving prison in 1996, Materson has continued to create his tiny embroidered scenes of American life, preferring the nylon sock thread he used to stitch with in prison to the manufactured thicker embroidery thread available outside. His first one-man show opened at a New York gallery in 1995 to critical acclaim, despite the absence of the artist, who was still imprisoned at that time. In recent years his work has been included in museum exhibitions on both sides of the Atlantic.

Justin
McCarthy
1892–1977

Museums etc
Akron Art Museum, OH.

American Folk Art Museum, NY.

Anthony Petullo Collection,
Milwaukee, WI.

L'Aracine Collection, Musée d'Art
Moderne, Lille Métropole.

Birmingham Museum of Art, AL.

Intuit, Chicago, IL.

National Museum of American
Art, Smithsonian Institution,
Washington, DC.

New Orleans Museum of Art, LA.

References
*American Anthem: Masterworks
from the American Folk Art
Museum*, ex cat, 2001.

American Self-Taught, Maresca &
Ricco, 1993.

*Museum of American Folk Art
Encyclopedia of Twentieth-
Century American Folk Art and
Artists*, Rosenak, 1990.

*Self-Taught Artists of the 20th
Century*, ex cat, 1998.

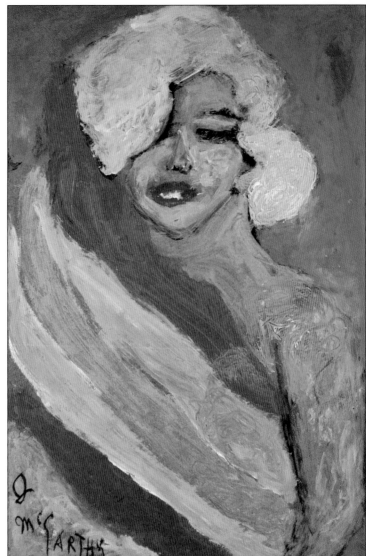

Marilyn Monroe, n.d.

Justin McCarthy came from a wealthy family in Pennsylvania. When he was 16 his father died suddenly, and the family subsequently lost all its savings in the 1908 stock-market downturn. In 1911, McCarthy enrolled in law school, but left after failing his exams. Following a mental breakdown he spent several years in institutional care, during which time he began to draw, sometimes signing his work with a pseudonym such as Prince Dashing or Gaston Deauville. He returned to the family mansion, where he continued to live alone after his mother's death, pursuing his art and growing and selling fruit and vegetables in order to get by. McCarthy's work varies greatly in style and medium, from detailed line-drawings and cartoons to watercolours, oils and acrylics. His subjects included animals, flowers and insects, historical and biblical events, landscapes and figures, and he used colour and proportion to dramatic effect. In addition to working from life, he would paint sports and film personalities and particularly enjoyed portraying glamourous, fashionably dressed women. He showed his paintings at outdoor art fairs and in 1960 he was befriended by a collector who helped to promote his work.

Malcolm
McKesson
1909–1999

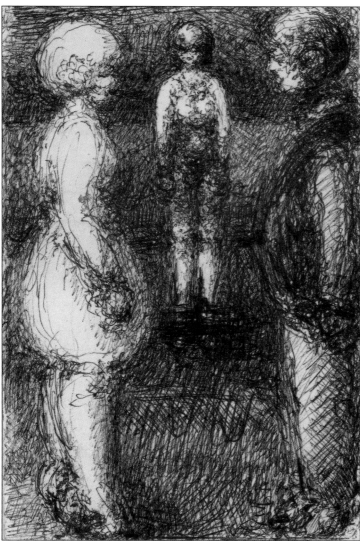

Domesticated Giant and His Little Mistress, c. 1980

Museums etc
American Visionary Art Museum, Baltimore, MD.

Collection de l'Art Brut, Lausanne.

Musée de la Création Franche, Bègles.

References
Malcolm McKesson. An Exquisite Obsession, ex cat, 1997.

Matriarchy: Freedom in Bondage, McKesson, 1997.

Raw Vision No. 10, 1994; No. 53, 2005.

Malcolm McKesson was a reclusive artist who created his obsessive and fetishistic art from the safety of his Manhattan apartment. His background is somewhat unclear. After a Harvard education and a period overseas with the US army, a failed business career, led McKesson and his poet wife Madeline Mason to withdraw into virtual isolation inside their Manhattan apartment. It was then that McKesson started to make his pen and ink drawings. In his heavily executed art, voluptuous fleshy doll-like figures emerge from a scribbled darkness. The rounded figures are drawn with few details, their gender never quite determined, though the erotic enigmatic undertone is always present. Amid the dense compositions, McKesson's figures bow and submit. Scenes of bondage and fantastical masochistic dreams are explored. McKesson's lifetime's work, his 'masterpiece', is a heavily illustrated book, *Matriarchy: Freedom in Bondage*, a chronicle of his inner fantasy life as a page in the service of a cruel mistress. It was only after the death of his wife towards the end of his life that McKesson felt able to show his drawings to the world and publish his book.

R.A.
Miller
1912–2006

Museums etc
Asheville Art Museum, NC.

Birmingham Museum of Art,
Birmingham, AL.

Kentucky Folk Art Center,
Morehead, KY.

Morris Museum of Art, Augusta,
GA.

Museum of International Folk
Art, Santa Fe, NM.

New Orleans Museum of Art, LA.

References
*Art Outsider et Folk Art des
Collections de Chicago*, ex cat,
1998.

*Passionate Visions of the
American South, Self Taught
Artists from 1940 to the Present*,
New Orleans Museum of Art,
1993.

Raw Vision No. 36, 2001;
No. 56, 2006.

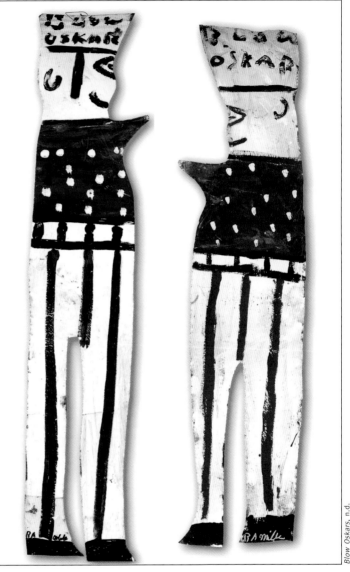

Blow Oskars, n.d.

R.A. Miller was born and brought up in Georgia, USA.
A life-long farmer and labourer, Miller also preached
in the Free Will Baptist Church. But it was his art-
filled home and yard for which he was renowned.
'Windy Hill'; an area of home-made metallic and
painted whirligigs, previously numbering around 300,
has since diminished in size due to the high demand
for his work. But his paintings on cut-out wood, tin
cans, more whirligigs, crosses and other unusual
materials continued to be produced until his death in
2006. Miller's style is colourful and decorative, with
a common theme of religion and patriotism. Family
members, people he knew and famous Americans
also received the attention of the prolific self-taught
painter. Many pieces include a silhouetted character
known as 'Blow Oskar', said to have been inspired
by Miller's cousin Oscar. Miller first gained
recognition following the appearance of his work in
a video for rock band REM and a TV documentary in
the early 1980s. His popularity exploded, with much
of his work sold to locals and collectors, who were
drawn to his simple, yet bold pieces. Despite critical
acclaim, Miller described his work as simply 'nothing
but junk'.

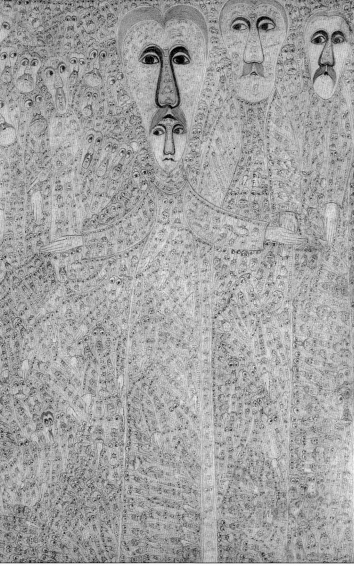

Untitled (Madonna), c.1945

Edmund
Monsiel
1897–1962

Museums etc
abcd Collection, Paris.

Collection de l'Art Brut,
Lausanne.

Eternod/Mermod Collection,
Lausanne.

Ethnographic Museum, Warsaw.

References
L'Art Brut, fascicule No. 11,
1982.

*Art Brut, psychose et
médiumnité*, Thévoz, 1990.

Edmund Monsiel adslona druga,
ex cat, 1997.

*Eternity Has No Door of Escape,
The Eternod-Mermod Collection
of Art Brut*, Galleria Gottardo,
Lugano, 2001.

Raw Vision No. 10, 1994; No. 54,
2006.

Edmund Monsiel, a Polish shopkeeper started drawing during the Second World War. When the German forces took over his shop, he feared arrest and fled to his brother's house, where he passed the remainder of the war hiding in a dark attic. Under these conditions, by the light of a candle, Monsiel started to draw his highly detailed pencil works. After the end of the war, he continued to live in isolation, but took a job as a machine operator. He was a quiet and devout man who feared the forces of evil. Much of his work is dominated by religious imagery, particularly representations of priests, God, Christ or the Devil. His intricate, highly detailed line drawings are frequently dominated by moustached faces, in full face and in profile, often reproduced in multiples within larger forms, the background of his pictures made up of hundreds of pairs of staring eyes. The overall effect is overwhelming, particularly given the scale of the drawings (average size just 6 x 4 inches/15 x 10 cm). The composition threatens to be lost in the elaborate chaos of detail. Monsiel produced hundreds of pieces of artwork in a 20-year period. Although many were lost, a large body of work remains intact.

Sister Gertrude
Morgan
1900–1980

Museums etc
African American Museum, Dallas, TX.

Akron Art Museum, OH.

American Folk Art Museum, NY.

Birmingham Museum of Art, AL.

Intuit, Chicago, IL.

The Louisiana State Museum, New Orleans, LA.

Milwaukee Art Museum, WI.

Morris Museum of Art, Augusta, GA.

New Orleans Museum of Art, LA.

Smithsonian Institution, Washington, DC.

St James Place Folk Art Museum, Robersonville, NC.

References
Black Folk Art in America 1930–1980, Livingston & Beardsley, 1982.

Pictured in My Mind, ex cat, 1995.

Self-taught Artists of the 20th Century, ex cat, 1998.

Tools of Her Ministry: The Art of Sister Gertrude Morgan, Fagaly, 2004.

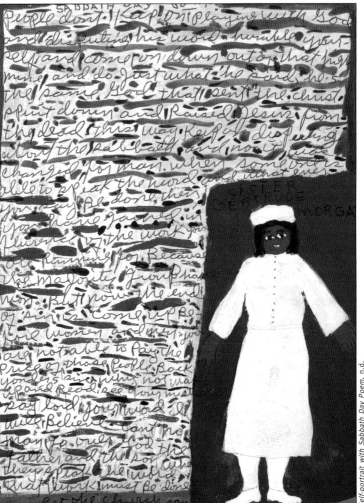

Self-portrait with Sabbath Day Poem, n.d.

Sister Gertrude Morgan's paintings form part of the canon of African-American folk art which relies for its inspiration on Christian mythology. Devoutly religious, Morgan claimed to have received a message from God instructing her to become a missionary and to spread the word of the Lord. She preached on the streets of New Orleans, where she lived from the 1930s. In the late 1950s, she became the 'bride of Christ', and from then on wore only white, decorating her home with all-white furnishings. To help her in her missionary work, Morgan began to create colourful paintings. These included scenes from *The Bible*, particularly the book of 'Revelation', the Second Coming, Paradise and Jerusalem. Using cheap card and found materials, including pitchers, toilet rolls and pieces of wallpaper, she worked by outlining her subjects with pencil or pen, filling in the shapes with watercolour, crayon, pastels and acrylics. She also developed her own technique, rubbing chalk into paint. Her pictures include evangelical texts, a characteristic of religious folk art from the American South. She ignored the acclaim she achieved, preferring to preach rather than attend the many exhibitions which featured her work.

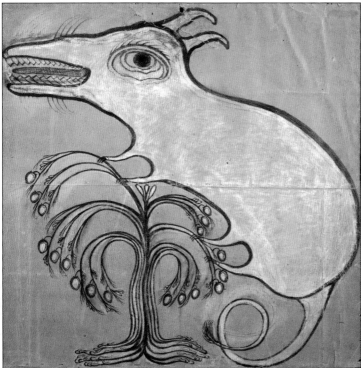

Horned Squirrel, 1917–1922

Heinrich Anton
Müller
1865–1930

Museums etc
Collection de l'Art Brut,
Lausanne.

Waldau Clinic, Berne.

References
L'Art Brut, fascicule No. 1, 1964.

Heinrich Anton Müller, ex cat,
1994.

Heinrich Anton Müller, ex cat,
2000.

Outsider Art, Cardinal, 1972.

Raw Vision No. 63, 2008.

During his early life, Heinrich Anton Müller worked on a vineyard in the hills above Lake Geneva in Switzerland. While there, he invented an ingenious contraption for trimming the vines, but its theft and the exploitation of his idea by other vineyards seemed to trigger a dormant mental health crisis. He was confined at the Münsingen hospital, where he was able to make elaborate machines. In keeping with hospital practices of the time, they were all destroyed by the hospital management, but existing photographs reveal spectacular models, albeit with no obvious purpose. Between 1917 and 1927, Müller turned to drawing. Using black pencil and white chalk on sewn wrapping paper, he drew ambiguous, distorted, often humourous images. His subjects were often human, but he also depicted animals, and machinery was a constant inspiration. Müller delighted in changing scale; he sometimes made heads larger than bodies, and added over- or under-scaled limbs. He later gave up drawing for a year; when he resumed, his style had changed, using coloured pencils with a trembling and agitated line. Jean Dubuffet collected Müller's work and is thought to have been influenced by his drawings.

John Bunion
Murray
1908–1988

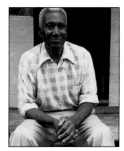

Museums etc
abcdCollection, Paris.

American Folk Art Museum, NY.

L'Aracine Collection, Musée d'Art Moderne, Lille Métropole.

Birmingham Museum of Art, AL.

Eternod/Mermod Collection, Lausanne.

High Museum of Art, Atlanta, GA.

Meadows Museum of Art, Shreveport, LA.

Milwaukee Art Museum, WI.

National Museum of American Art, Smithsonian Institution, Washington, DC.

Rockford Art Museum, IL.

St. James Place Folk Art Museum, Robersonville, NC.

References
American Anthem, ex cat, 2001.

American Self-Taught, Maresca & Ricco, 1993.

In the Hand of the Holy Spirit. The Visionary Art of J.B. Murray, Padgelek, 2000.

Passionate Visions, 1993.

Raw Vision No. 58, 2007.

Souls Grown Deep, Vol. 1, Arnett et al, 2000.

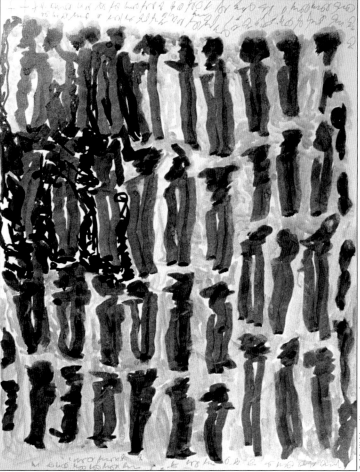

Spirit Writing No. 2, n.d.

John Bunion (J.B.) Murray attended school for just one month, and spent most of his life as a farm worker in Georgia, USA. By the 1970s, he was living alone in a shack on a patch of poor land. It was there that he had a religious experience and felt a compulsion to paint. His early work was three-dimensional, in the form of piles of rocks and stones placed around his home. These may have had some protective significance but most of Murray's work was essentially calligraphic: he painted an indecipherable script, messages he claimed to have received from God. The virtually illiterate Murray would read the text to neighbours through a bottle of 'holy water'. The paintings combine his scrawling script, often in marker pen, with rhythmic daubed paint, compartmentalised into rounded or rectangular forms. Some of the letter forms are in rigid horizontal designs, others vertical. He carefully coded his colours, symbolically representing spirits, devils and the divine. At first he used scraps of paper, but his doctor later supplied him with better-quality materials. His later works are more organic: as Murray battled with cancer, he began to represent cells and anatomical forms.

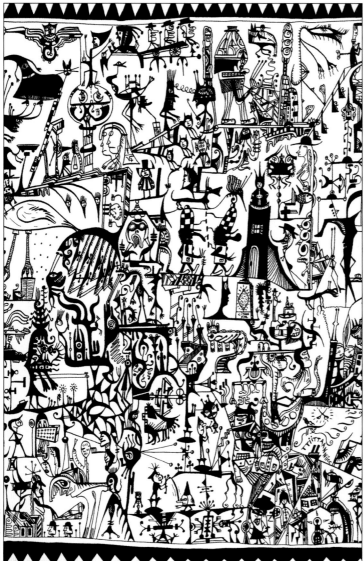

Untitled (detail), c. 2000

Jean-Pierre
Nadau
b. 1963

Museums etc
Charlotte Zander Museum,
Bönnigheim, Germany.

Collection de l'Art Brut,
Lausanne.

Musée de la Création Franche,
Bègles.

References
Art Brut et Compangnie, ex cat,
1995.

Jean-Pierre Nadau: Exuvies, Saint
Félix, 2002.

Nadau: Les Turlupointus, Dernier
Cri, n.d.

When Jean-Pierre Nadau was 12 years old, the fields and woods he loved were destroyed to make way for a new town, and his family moved away from the village where he had spent his idyllic childhood. Nadau became hostile and withdrawn. At one time a top pupil, he failed his baccalauréat. He went to Paris to study theatre and worked as a school caretaker until 1987, when he came across the work of the reclusive artist Roger Chomeaux (CHOMO). Realising that drawing was a better means of expression for him than acting, he withdrew to Morillon in the French Alps with his wife and child, and began to draw the imaginary towns which had filled his visions in childhood. Meticulously worked in black ink on fine canvas or paper, fantastic distorted cathedrals and skyscrapers mingle with vegetation, mythical monsters, disproportionate humans and sci-fi androids in a dense, closely-knit lacework that is timeless, devoid of perspective and flowing like a musical score. Working flat on a table, little by little Nadau unrolls a sheet of paper or canvas as much as 30 feet/10 m long, exposing only the area on which he is working and covering the whole of the background with minute detail.

August
Natterer
1868–1933

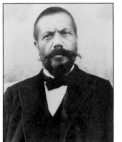

Museums etc
Prinzhorn Collection, Heidelberg,
Germany.

References
August Natterer, Jadi & Brand-
Claussen, 2001.

Bildnerei der Geisteskranken,
Prinzhorn, 1922.

The End is Near, ex cat, 1998.

Outsider Art, Cardinal, 1972.

Raw Vision No. 51, 2005.

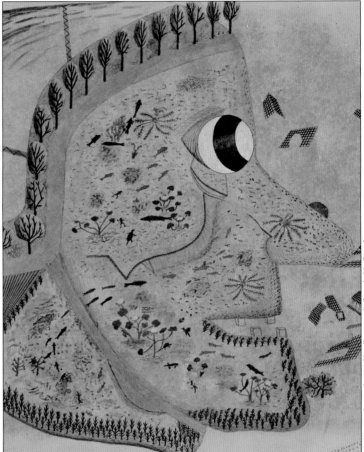

Witch's Head - Landscape (detail, verso, lit from behind), n.d.

August Natterer's tight, exact and detailed drawings were collected by the psychiatrist Hans Prinzhorn, who gave him the name August Neter in his book *Artistry of the Mentally Ill*, to protect his identity. There was little in Natterer's early life to suggest that he would be institutionalised. He served in the army, travelled widely, married and later set up his own business. But in 1907, Natterer was hospitalised after succumbing to a bout of depression and attempting suicide. He also suffered from delusions and experienced a major hallucination. Prinzhorn believed he was suffering from schizophrenia. When Natterer began to draw in 1911, he used images and symbols from his major hallucinatory experience. Many of his drawings and watercolours are of religious and biblical themes. Other artworks juxtapose human figures with animals and plants. All are drawn or painted in a meticulous style, using a steady firm line, making some of his work resemble meticulous technical drawings. His use of symbols and his style of metamorphosing disparate objects appealed to the Surrealists and his work is considered to have especially influenced Max Ernst as well as Paul Klee and Jean Dubuffet.

Untitled, 1990

Michel
Nedjar
b. 1947

Museums etc
Anthony Petullo Collection, Milwaukee, WI.

L'Aracine Collection, Musée d'Art Moderne, Lille Métropole.

Charlotte Zander Museum, Bönningheim, Germany.

Eternod/Mermod Collection, Lausanne.

Intuit, Chicago, IL.

Musée de la Création Franche, Bègles.

References
L'Art Brut, fascicule No. 16, 1990.

Art Brut et Compangnie, ex cat, 1995.

Michel Nedjar, Körper, 1994.

Michel Nedjar: Animo!, Feilacher, 2008.

Michel Nedjar: Envelopes/ Enveloppes, Monnin, 2006.

Raw Vision No. 63, 2008.

Born into an immigrant Jewish tailor's family, Michel Nedjar spent his childhood mesmerised by the clothes and materials abundant at the family residence near Paris. Leaving school early in 1962, he was moved to train as a tailor himself. Following compulsory military service, during which he spent time in a sanatorium recovering from tuberculosis, Nedjar travelled to Mexico, one of his many voyages abroad. He was fascinated by the vivid colours of the Mexican dolls and began to create his own versions on his return. Working on his grandmother's market stall, Nedjar made use of any remnants or found materials to create clothed figures and animals. His rag dolls were initially figurative but soon became more abstract and grotesque in style. His powerful paintings are produced on all possible surfaces, from canvas to envelopes. They are normally of a dark, shadowy quality, giving the subjects of man and beast an almost sinister character. Nedjar was a founding member of l'Aracine, the leading French Art Brut collection, now housed in the Musée d'Art Moderne Lille Métropole. He is also a successful experimental film-maker and received national recognition at the Pompidou Centre in 1987.

Nikifor
1895–1968

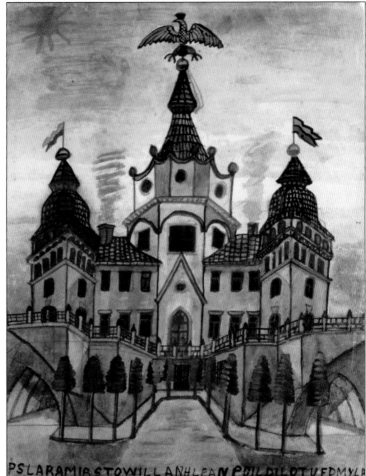

Orthodox church at sunset, n.d.

Museums etc
abcd Collection, Paris.

Anthony Petullo Collection, Milwaukee, WI.

L'Aracine Collection, Musée d'Art Moderne, Lille Métropole.

Arnulf Rainer Collection, Vienna.

Charlotte Zander Museum Bönningheim, Germany.

Croatian Museum of Naïve Art, Zagreb.

References
Art without Frontiers, Crnkovic, 2006.

Raw Vision No. 62, 2008.

For Nikifor, art was an escape from his alienation from society. His mother, who worked as a domestic in Polish resort spas, died when he was still a child. Poor and illiterate, and with a severe speech impediment, he relied upon the goodwill of others for his survival. He began to paint by the age of 13, working on discarded scraps of paper and cigarette packets. He produced thousands of images, both religious icons and landscapes, which he stamped on the back with homemade seals to identify the work as his own and sold as souvenirs to visitors. Travelling from place to place by train and on foot,

Nikifor would paint wherever he found himself. Working mainly in watercolour, gouache and crayon, and later in pencil, he would portray the countryside and buildings of his surroundings in precise detail, elevating the architecture to transcendent proportions by the use of colour. He often wrote largely indecipherable inscriptions along the bottom edges of his paintings. Nikifor believed that as an artist he was superior to other people, but he received little acknowledgement during his lifetime. After his death, the Nikifor Museum opened in his home town of Krynica.

Six 1000 Year Days, 1990

Benjamin Franklin
Perkins
1904–1993

Museums etc
Birmingham Museum of Art, AL.

Fayette Art Museum, AL.

Kentucky Folk Art Center, Morehead, KY.

The Louisiana State Museum, New Orleans, LA.

Mississippi Museum of Art, Jackson, MS.

Morris Museum of Art, Augusta, GA.

New Orleans Museum of Art, LA.

Owensboro Museum of Fine Art, KY.

St James Place Folk Art Museum, Robersonville, NC.

Taubman Museum, Roanoke, VA.

References
American Self-Taught, Maresca & Ricco, 1993.

Museum of American Folk Art Encyclopedia of Twentieth-Century American Folk Art and Artists, Rosenak, 1990.

Passionate Visions of the American South, Self Taught Artists from 1940 to the Present, New Orleans Museum of Art, 1993.

Raw Vision No. 65, 2008.

The Reverend Benjamin Franklin Perkins grew up in rural Alabama, departing to undertake military service, in part carrying out 'secret missions', and then to study in preparation for his ordainment in 1929 as a minister in the Assembly of God. Perkins later became a bishop in 1945 under the auspices of the Church of God. Returning to Alabama after a time working as an engineer at the National Airport in Washington DC, Perkins decided to establish his own place of worship. Art had never been a part of the preacher's life until his retirement at the age of 75. Perkins later asserted that his paintings were done 'to keep from sitting down and doing nothing'. He predictably used religion as a key theme in many of his paintings, but patriotism, biblical and national history and people all appeared as subjects in his countless works. Perkins used very bright and vivid colours, painting with oils and watercolours. Much of his work was produced on canvas, but he also made use of more unusual surfaces, such as metal and the gourd fruit which was widely sold locally. It is believed that Perkins painted more than 300 gourds in his unique and brightly decorative style.

125

Elijah
Pierce
1892–1984

Museums etc
Akron Art Museum, OH.

American Folk Art Museum, NY.

Columbus Museum of Art, OH.

High Museum of Art, Atlanta, GA.

Miami University Art Museum, Oxford, OH.

Montgomery Museum of Fine Arts, Montgomery, AL.

Museum of International Folk Art, Santa Fe, NM.

New Orleans Museum of Art, LA.

References
American Anthem: Masterworks from the American Folk Art Museum, ex cat, 2001.

American Self-Taught, Maresca & Ricco, 1993.

Museum of American Folk Art Encyclopedia of Twentieth-Century American Folk Art and Artists, Rosenak, 1990.

Passionate Visions of the American South, Self Taught Artists from 1940 to the Present, New Orleans Museum of Art, 1993.

Pictured in My Mind, ex cat, 1995.

Self-Taught Artists of the 20th Century, ex cat, 1998.

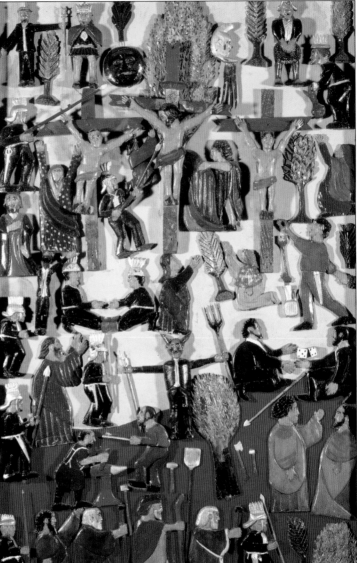

Crucifixion, mid-1930s

By the time Elijah Pierce was seven years old he was already giving away wooden animals he had carved. He was born in Baldwin, Mississippi, where his father, a former slave, was a church deacon. At the age of 16 Pierce apprenticed himself to a barber and continued this trade for most of his life. In 1924 he moved to Columbus, Ohio. There he was ordained as a preacher, and he began to make painted carved wooden panels to illustrate his sermons, believing that his creative ability was a divine calling. One of his best-known pieces is *The Book of Wood*, an illustration in bas-relief of the life of Christ.

However, Pierce did not restrict himself to religious imagery but also included scenes from history as well as representations of contemporary personalities, particularly African-Americans who had made a name for themselves. The panels were embellished with symbols such as trees, fruit and foliage, and he often added glitter. In 1954, whilst continuing his ministry, Pierce opened his own barber shop in Columbus, Ohio, and hung his work on its walls. He went on to carve full time and eventually changed the name of the shop to the Elijah Pierce Art Gallery.

Untitled, 1957

Laure
Pigeon
1882–1965

Museums etc
Collection de l'Art Brut,
Lausanne.

Reference
Art Brut, Thévoz, 1975.

L'Art Brut, fascicule No. 6, 1966.

*Art spirite, médiumnique,
visionnaire. Messages d'outre-
monde*, ex cat, 1999.

Laure ou la prosopopée du Ciel,
Laporte, 1982.

Outsider Art, Cardinal, 1972.

Raw Vision No. 2, 1989.

Born in Brittany, France, Laure Pigeon first started drawing after separating from her husband. Her work has been interpreted as a form of art therapy to help her through the crisis, but Pigeon herself believed she was guided by spirits. Her early work, using blue ink on pages from a drawing book, is delicate and sinuous. Her fluid ribbon-like lines meander across the page, sometimes woven together into complex web-like compositions. Occasionally, she placed text in her work, inserting words or phrases among the tendrils. In 1953, the same year her estranged husband died, she began to draw in a new graphic style. Using good-quality plain paper, but retaining her signature blue ink, she moved beyond her early linear forms. The later work is made up of broader, denser shapes; the organic images seem to flow from the page, and have a ghostly quality, suggesting that the drawing process was automatic and influenced by her spirit guides. Pigeon was a prolific artist, but she never recognised her work as 'art' and drew in secret. The true extent of her achievement was only realised after her death at the age of 83, when her collection was uncovered.

Mary
Proctor
b. 1960

Museums etc
American Visionary Art Museum,
Baltimore, MD.

Morris Museum of Art, Augusta,
GA.

References
Raw Vision No 29, 1999.

Souls Grown Deep, Vol 2, Arnett
et al, 2001.

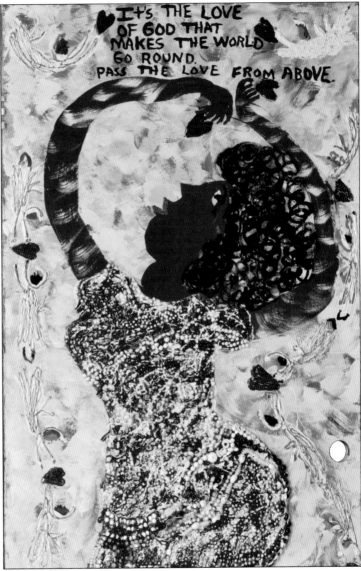

The Love of God, 1997

Mary Proctor lives and works in her 'American Folk Art Museum and Gallery' in Florida. Initially, she was a flea market proprietor and collector. Buttons, bottle tops, watches, dolls, trinkets and other objects filled her home and garden. But it was only after a tragic fire took the life of her beloved grandmother that Proctor began to paint her now famous bright and religiously inspired doors. She maintained that it was a holy vision appearing in 1995 which instructed her to create, saying 'the door was the way'. From that date forward, Proctor has been painting doors, decorating them with bold figures and religious passages, often signing them 'Missionary Mary L Proctor'. Her belief in God clearly is the inspiration of the many mottos and moral warnings painted on the doors, alongside figurative depictions of animals, family and religious characters. Proctor's repertoire goes beyond the production of the powerfully decorated doors, with paintings and sculptures in all shapes and sizes, from her car to carved wooden poles, making use of her vast collections of trinkets and knick-knacks. She is currently undertaking a project to record her life in a large tin-panelled illustrated autobiography.

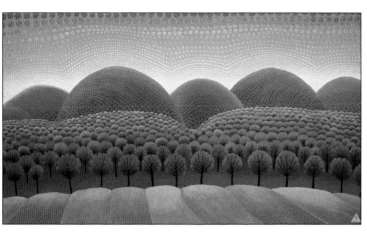

Green Woods, 1965

Ivan
Rabuzin
1921–2008

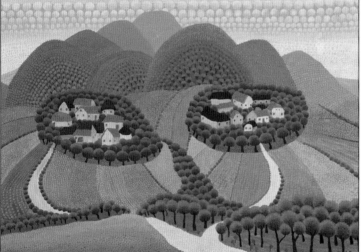

Orehovec Hills, 1959

Museums etc
Charlotte Zander Museum,
Bönningheim, Germany.
Croatian Museum of Naïve Art,
Zagreb.

References
*Classics of the Naïve: Ivan
Rabuzin*, Crnkovic, 2005.

Modern Primitives, Bihalji-Merin,
1971.

Rabuzin, ex cat, 2008.

Raw Vision No. 52, 2005.

World Encyclopedia of Naïve Art,
Bihalji-Merin & Tomasevic, 1984.

The son of a miner, the artist Ivan Rabuzin originated from the Croatian village of Kljuc, near the Hungarian border. Despite producing drawings and paintings during his many years working as a master carpenter, joiner and foreman, it was not until 1959 that Rabuzin perfected his own personal style. Just one year later, he held his first one-man show, encouraged by the enthusiasm of the art historian and critic Mica Basicevic. He continued with solo shows in Paris and even Sao Paolo, quickly gaining great acclaim. Known for his lyrical landscapes and rural scenes, the self-taught Rabuzin simplified his natural subjects by depicting rolling hills, rounded trees, soft flowers and peaceful panoramas lit by blue, sunny skies. Rabuzin described his style as 'beautifying nature', which explains the dream-like quality of his work. He achieved great success with his paintings, which critics have termed as optimistic in outlook. Rabuzin uses colour to make a luminous effect. Pastel blues, yellows, greys and soft greens help to create his idealistic world of summer harmony. Critics assert that Rabuzin's skill was in his paintings' displays of radiance, despite the simplicity of the subject matter.

Martin
Ramirez
1895–1963

Museums etc
Abby Aldrich Rockefeller Folk Art
Center, Williamsburg, VA.

abcd Collection, Paris.

American Folk Art Museum, NY

American Visionary Art Museum,
Baltimore, MD.

Anthony Petullo Collection, WI.

Intuit, Chicago, IL.

Milwaukee Art Museum, WI.

Musée d'Art Moderne, Lille
Métropole.

Smithsonian Institution,
Washington, DC.

References
The Artist Outsider, Hall &
Metcalf, 1994.

*Encyclopedia of Twentieth-
Century American Folk Art and
Artists*, Rosenak, 1990.

The Heart of Creation, ex cat,
1985.

Martin Ramirez, Anderson, 2007.

*Self-Taught Artists of the 20th
Century*, ex-cat, 1998.

Vernacular Visionaries, Carlano,
2003.

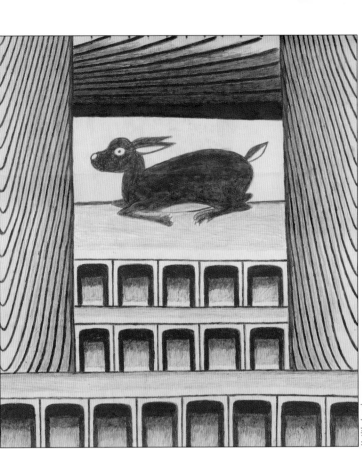

Untitled, n.d.

Martin Ramirez, a Mexican immigrant to the USA, was considered a virtually mute schizophrenic. Hospitalised in 1930, he began to draw only 13 years before his death. His first works were confiscated and destroyed at the end of each day by the hospital authorities, but the arrival of a psychology lecturer, Dr Tarmo Pasto, brought encouragement and materials. With Pasto's help, Ramirez began to create larger, free-scale compositions. He rapidly developed his own distinctive personal style. An important feature of his work was his use of linear frames and concentric curves encircling a central figure, the contoured lines giving a sense of depth and perspective. Most of the central figures in his artworks are human, often a lone horseman or sometimes a woman, occasionally a train or an animal. Many theories abound concerning Ramirez's frames and their meaning: some argue a sexual significance while others stress the importance of Ramirez's background, his experience of the Mexican landscape and the folklore surrounding Emiliano Zapata, Mexico's revolutionary hero. Ramirez left some 340 drawings in total, some as large as 12 feet (4 m) in height.

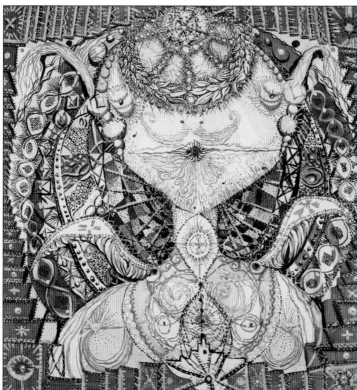

Pride – Monsieur Bellatre, 1977

Raymond
Reynaud
1920–2007

Museums etc
La Fabuloserie, Dicy, France.

Musée de la Création Franche, Bègles.

References
Art Brut et Compangnie, ex cat, 1995.

La Fabuloserie, ex cat, 2001.

Raw Vision No. 4, 1991.

Raymond Reynaud: un singulier de l'art, 1999.

The prolific artist and art collector Raymond Reynaud lived and worked in Senas, France. He was one of the best known *Artistes Singuliers* of the Provence region and widely influential to other artists in the area. Originally a house painter, Reynaud was inspired by the paintings of the Yugoslav naives and in the late 1960s he began producing his own work seriously. Difficult to characterise stylistically, Reynaud started by creating powerful line drawings but soon went on to paint large-scale pictures and to carve twisted-root sculptures. His work is complicated and intense, displayed throughout his self-constructed jam-packed home alongside his many collections of African art and the work of local students whom he proudly taught. Reynaud gained great respect for the variety of his techniques and the intensity of his detailing. Although the themes of his art were diverse, the use of vibrant colour was often present. French politicians, historical figures, abstract and symmetrical patterns all received attention in his unique pieces. His paintings display an energy and a power which command concentration. Reynaud delighted in showing his creations to guests who visited his Provence home.

131

Achilles
Rizzoli
1886–1981

Museums etc
abcd Collection, Paris.

References
AG Rizzoli: Architect of Magnificent Visions, Hernandez et al, 1997.

American Self-Taught: Paintings and Drawings by Outsider Artists, Maresca & Ricco, 1993.

Folk Art Vol 22, No. 1, 1997.

Raw Vision No. 6, 1992; No. 39, 2002.

Self-Taught Artists of the 20th Century, ex cat, 1998.

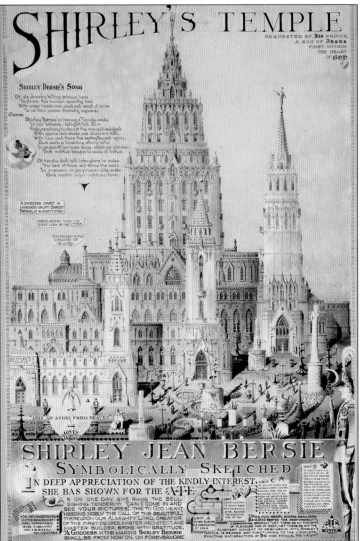

Shirley Jean Bersie Symbolically Sketched / Shirley's Temple, 1939

Achilles Rizzoli's monumental visionary architectural drawings were only discovered in 1990, some years after his death. The son of Swiss immigrants to America, Rizzoli led an isolated existence. A lifelong bachelor, he lived at home with his mother until her death, and worked as a technical draughtsman in an architect's office. He first began to write short stories, novellas and a novel, but these were all rejected by publishers. He later turned to architectural drawing, including his own neatly scripted text in his pen, ink and pencil pictures. Many of his artworks are symbolic representations ('transfigurations', as he called them) of his family and neighbours, including several young girls. Each is portrayed as a splendid monumental building. He also worked on a utopian world, Y.T.T.E. (Yield to Total Elation), and, towards the end of his life, began work on A.C.E. (Amte's Celestial Extravaganza), a 'new' section of *The Bible*. All his drawings are highly detailed, his line tight and controlled. While his drawings reveal the influence of several architectural styles, including Roman, Baroque, Art Deco and Art Nouveau, the overall vision and intensity of the drawing are uniquely Rizzoli's own.

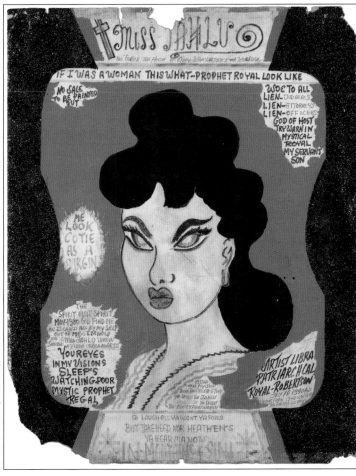

If I was a Woman (Miss Tahlu), n.d.

'Prophet' Royal
Robertson
1930–1997

Museums etc
African American Museum,
Dallas, TX.

Art Museum of Southeast Texas,
Beaumont, TX.

Birmingham Museum of Art, AL.

High Museum of Art, Atlanta, GA.

The Louisiana State Museum,
New Orleans, LA.

Mississippi Museum of Art,
Jackson, MS.

National Museum of American
Art, Smithsonian Institution,
Washington, DC.

New Orleans Museum of Art, LA

Rockford Art Museum, Rockford, IL.

St. James Place Folk Art
Museum, Robersonville, NC.

References
American Self-Taught, Maresca &
Ricco, 1993.

The End is Near, ex cat, 1998.

*Museum of American Folk Art
Encyclopedia of Twentieth-
Century American Folk Art and
Artists,* Rosenak, 1990.

Raw Vision No. 13, 1995.

Souls Grown Deep, Vol. 1, Arnett
et al, 2000.

Royal Robertson's work was fuelled by an intense bitterness towards his wife Adell following the break-up of their 19-year marriage. Believing that God had commanded him to denounce the evil ways of women, he spent the rest of his life alone, recording his ideas and feelings in words and imagery on numerous double-sided drawings which he displayed in and around his house in Louisiana. A sign-writer by trade, he worked on poster board in felt marker, pen, crayon and tempera paint. Robertson was preoccupied with numerology and biblical prophesy. Visions of spaceships and architecturally detailed futuristic cities, and portraits of Adell and other women are mingled with admonitory verses from the Old Testament and the book of 'Revelation'. Images of aliens and superheroes are backed by calendars documenting exact dates such as when Adell was unfaithful to him. Erotic imagery accompanies biblical references to the licentiousness that Robertson saw as the cause of natural disasters. Scorned by his neighbours, Robertson considered himself a prophet foreseeing a time in which the crimes of which he saw himself as a victim would cease, his illness would disappear and peace would come about.

Sulton
Rogers
1922–2003

Museums etc
African American Museum, Dallas, TX.

Art Museum of Southeast Texas, Beaumont, TX.

Birmingham Museum of Art, AL.

Fenimore House Museum, Cooperstown, NY.

Mississippi Museum of Art, Jackson, MS.

National Museum of American Art, Smithsonian Institution, Washington, DC.

New Orleans Museum of Art, LA.

The Old Capitol Museum of Mississippi History, Jackson, MS.

St James Place Folk Art Museum, Robersonville, NC.

University of Mississippi, Oxford, MS.

References
Museum of American Folk Art Encyclopedia of Twentieth-Century American Folk Art and Artists, Rosenak, 1990.

Passionate Visions of the American South, Self Taught Artists from 1940 to the Present, New Orleans Museum of Art, 1993.

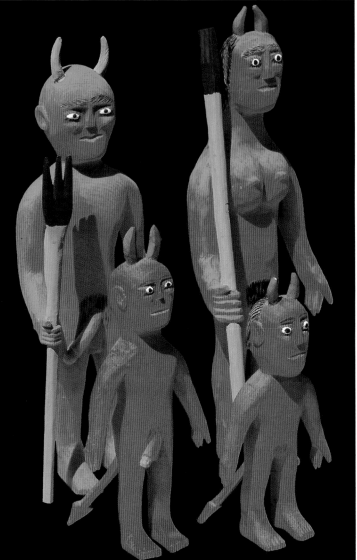

Devil Family, n.d.

Born and raised in Oxford, Mississippi, Sulton Rogers was originally taught wood carving as a child by his father, who Rogers claimed could 'build anything'. His wooden figurines and painted groupings are noted for their satirical style, mirroring the apparently amenable character of the artist himself. Rogers spent many years away from Mississippi, joining the army and later travelling through numerous states in the early 1950s before finally settling in New York State and finding work as a foreman. The boredom of the job led him to carve in earnest, which he continued to do during his retirement back in Mississippi. Using softwood, he carved his figures with a pocketknife, then painted them accordingly. Most themes are human-related, but Rogers also enjoyed depicting snakes, 'haints' (spirits) and vampires, with occasional sexual or erotic references. His humans sometimes have exaggerated and comedic features, or amusing facial expressions. Rogers claims inspiration from dreams or people he has met during his travels. His groupings of haunted houses or graveyards are particularly noted for their workmanship, combined with Rogers' ever-present sense of humour.

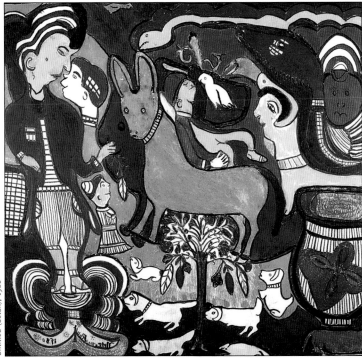

Untitled (detail), 1980

Museums etc
American Folk Art Museum, NY.

High Museum of Art, Atlanta, GA.

Milwaukee Art Museum, WI.

Morris Museum of Art, Augusta, GA.

Museum of International Folk Art, Santa Fe, NM.

New Orleans Museum of Art, LA.

Smithsonian Institution, Washington, DC.

References
American Self-Taught, Maresca & Ricco, 1993.

The Art of Nellie Mae Rowe, Kogan, 1999.

Black Folk Art in America, Livingston & Beardsley, 1982.

Museum of American Folk Art Encyclopedia of Twentieth-Century American Folk Art and Artists, Rosenak, 1990.

Nellie Mae Rowe, ex cat, 1996.

Pictured in My Mind, ex cat, 1995.

Self-Taught Artists of the 20th Century, ex cat, 1998.

Souls Grown Deep, Vol 1, Arnett et al, 2000.

The daughter of a former slave, Nellie Mae Rowe was born on Independence Day in Georgia, USA, at the beginning of the 20th century. She was encouraged to draw and paint as a child, but it was only after the death of her second husband in 1948 that she was able to concentrate on her art. She decided to return to the playfulness of her childhood, converting her yard into a 'playhouse' and making dolls, sculptures, paintings and hanging constructions from recycled domestic materials, including chewing gum. Many of her pictures depict scenes from her own everyday life in rural Georgia. Her early drawings and paintings, using crayon, pencil and pen on paper, are mainly single unembellished images, simple outline representations of hands, fish and animals. Her later works are more intricate, her single imagery replaced by a collection of animals, people and plants scattered over the picture surface. Her use of colour also became more intense and vibrant. Rowe understood that she was a visionary and believed her art to be a gift from God. After being diagnosed with cancer, Rowe became more prolific, determined to fulfil her artistic potential before she died.

Ody
Saban
b. 1953

Museums etc
L'Aracine Collection, Musée d'Art Moderne, Lille Métropole.

Charlotte Zander Museum, Bönningheim, Germany.

Musée de la Création Franche, Bègles.

References
Art Brut et Compangnie, ex cat, 1995.

Raw Vision No. 27, 1999.

Telescoped Mythology, 1994

Odette ('Ody') Saban was born in Istanbul, Turkey, to a Sephardic Jewish family. Her parents divorced when she was just five, her mother re-married a Turkish Muslim, whose artistic tendencies made their mark on the creative young girl. From the age of 16, Saban led an itinerant existence, living in Israel and eventually settling in Paris, France, where she began her artistic career. But it was the horrific experiences of a traffic accident in Turkey in 1978 which marked much of her early work. Operated on under no anaesthetic, Saban endured enormous pain and agony. Her move back to Paris the following year saw the colours in her paintings become stronger and themes evolving to be more hostile and controlling. Saban credits her powerful paintings to the hallucinations which dominate her life. The subject matter she paints can be viewed as aggressive, with sexual imagery and nightmarish scenarios often depicted through her complex style. Her paintings and pictures are intrinsically detailed compositions, which she says grow organically, with no preconceived end result. Saban continues to create, having exhibited widely and achieving more than 30 solo shows to date.

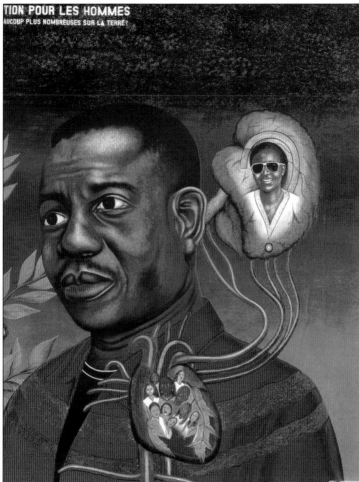

What Solution for Men? (detail), 2001

Cheri
Samba
b. 1956

Museums etc
Pigozzi Collection, Geneva.

References
Africa Explores, Vogel, 1991.

Contemporary Art of Africa,
Magnin & Soulillou, 1996.

J'aime Cheri Samba, ex cat,
2004.

Samba wa Mbimba N'zingo Nuni Masi Ndo Mbasi, better known as Cheri Samba, was raised in a rural village in Congo, over 50 miles (80 km) from the capital Kinshasa, by a poor blacksmith father and a farmer mother. Despite being one of ten children, Samba managed to attend school and excelled in drafting and drawing. His adolescent copies of the Kinshasa comics which he bought on his few excursions to the city delighted his friends and neighbours. Leaving school and home in 1972, Samba ventured to Kinshasa alone, soon making a good living as a sign painter. His talent and well-earned reputation ensured him a rapid rise in standing. By the mid-1970s, he had obtained his own studio and enough commissions to make a steady living. Samba went on to exhibit his work all over the world, way beyond the borders of his homeland. His work is characterised by a modern and highly stylistic view of life in Congo, choosing themes which explore the contemporary social and political scene in his country. Added texts give the work a narrative feel, as do commentaries which border on satire. His bold paintings powerfully represent the dichotomies between African traditions and Western civilisation.

Friedrich
Schröder-Sonnenstern
1892–1982

Museums etc
abcd Collection, Paris.

Anthony Petullo Collection, Milwaukee, WI.

Arnulf Rainer Collection, Vienna.

Charlotte Zander Museum, Bönningheim, Germany.

Collection de l'Art Brut, Lausanne.

Eternod/Mermod Collection, Lausanne.

References
American Anthem: Masterworks from the American Folk Art Museum, ex cat, 2001.

Modern Primitives, Bihalji-Merin, 1971.

Outsider Art, Cardinal, 1972.

Outsiders, ex cat, 1979.

Raw Vision No. 2, 1989.

World Encyclopedia of Naïve Art, Bihalji-Merin & Tomasevic, 1984.

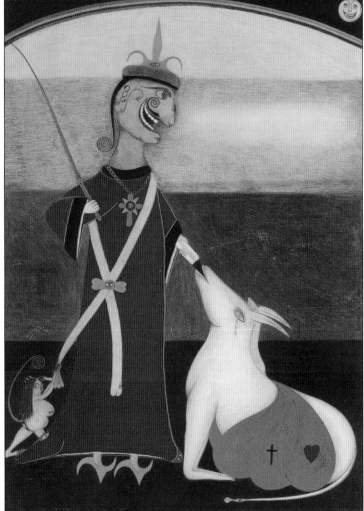

The Moon-moral Ass-driver, 1952

Friedrich Schröder-Sonnenstern was born on the German-Russian border and received little education. As a child, accusations of theft and subsequent threatening behaviour led to his being sent to a series of reform schools and ultimately to an asylum. These experiences gave him a lifelong hatred of authority. After a number of menial jobs, including time spent in the army, in a circus and as a fortune-teller, Schröder-Sonnenstern became ill, and eventually became bed-ridden. He turned to painting and drawing, having been introduced to art during a short spell in prison at an earlier period in his life.

Using coloured pencil over thin washes of paint to achieve depth, Schröder-Sonnenstern depicted a colourful series of grotesque caricatures, flat distorted figures and partly recognisable monsters and animals, all drawn with a crisp fine line. An overwhelming feeling of menace and sadistic subversion characterises all of Schröder-Sonnenstern's work: the grotesques inhabit a sinister and sexually charged mythical world. There is a sense of authority being undermined. In the 1960s Schröder-Sonnenstern exhibited his work and gained some notoriety as an artist.

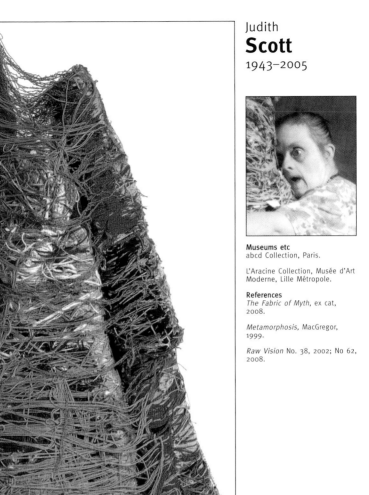

Untitled, 1992

Judith
Scott
1943–2005

Museums etc
abcd Collection, Paris.

L'Aracine Collection, Musée d'Art
Moderne, Lille Métropole.

References
The Fabric of Myth, ex cat,
2008.

Metamorphosis, MacGregor,
1999.

Raw Vision No. 38, 2002; No 62,
2008.

Judith Scott came from Cincinnati, Ohio. She suffered from acute Down's syndrome and an inability to hear, meaning her use of language was almost non-existent. Until the age of seven, Scott lived at home with her parents, her brothers and, most importantly, her twin sister Joyce. For the next 36 years, she lived in institutions and homes for the severely disabled. But it was Scott's removal to her beloved sister Joyce's home in 1986 which transformed her life completely. Judith enrolled in the Creative Art Growth Center in California and began her first pieces of the fabric-bound sculpture for which she is now known.

The production of her creations began with a 'thing' or object which was then hidden inside multiple layers of spun yarn and twisted wool. Some of her pieces can be identified as representing figures, such two near-identical forms, perhaps demonstrating the concept of twins. Other work is of a more abstract form, although critics and fans alike have been unable to ascertain the real meaning behind most of her work, because of Scott's inability to communicate her inspiration. She worked compulsively and was truly dedicated to the creation of her remarkable bound sculptures.

Christine
Sefolosha
b. 1955

Museums etc
Musée de la Création Franche,
Bègles.

References
Art Brut et Compangnie, ex cat,
1995.

The End is Near, ex cat, 1998.

Phantom, Lausanne, 2005.

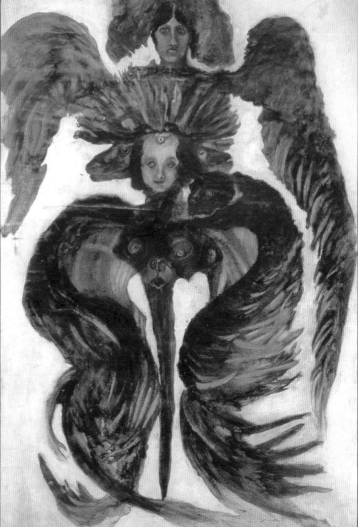

Feathered Portrait, 2006

Christine Sefolosha was born in Montreux, Switzerland. Her father was a fruit and vegetable merchant and her grandmother was a poet and musician. A solitary child beset by vivid dreams, Sefolosha would seek solace in drawing. After leaving high school she married a white South African and had a son. They moved to Johannesburg, South Africa, where Sefolosha assisted her husband in his veterinary practice. They divorced seven years later. Sefolosha became interested in the music, dance and visual art traditions of the area, and married a black South African musician, with whom she had two more children. The constraints and prejudices of apartheid led Sefolosha to move back to Switzerland with her husband and children, but after her parents' death her husband returned to South Africa. She began to draw again, combining materials such as tar and dust with more conventional media. Sefolosha's work is a dreamlike combination of reality and myth and demonstrates her great respect and reverence for birds and animals, especially deer, which to her represent freedom. She draws on the figures that appear in her unconscious and imbues them with a ghostly aura of timelessness.

Sava
Sekulic
1902–1989

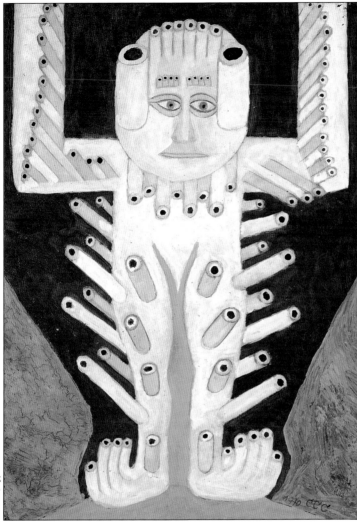

Museums etc
abcd Collection, Paris.

Arnulf Rainer Collection, Vienna.

Charlotte Zander Museum,
Bönningheim, Germany.

Croatian Museum of Naïve Art,
Zagreb.

Musée de la Création Franche,
Bègles.

Museum of Naive and Marginal
Art, Jagodina, Serbia.

References
Art without Frontires, Crnkovic,
2006.

Raw Vision No 26, 1999.

Sava Sekulic, a Croatian of Serb ethnicity, lost his beloved father at the age of ten. Abandoned by his mother and later his grandparents, Sekulic experienced a very difficult and isolated childhood. He went on to spend his early life in poverty, working intermittently as a farm labourer, bricklayer and factory worker. With minimal education, Sekulic taught himself to read and write poetry and to paint. From 1932 onwards, he painted as much as he could, but it was only after he retired in 1962 until his death in 1989, that Sekulic had the time to devote himself fully to his painting. All of his pre-war paintings have been destroyed, as were the post-war works he created while working in factories with unsympathetic and malicious managers. His discovery came in 1969, when he exhibited a few of his paintings in the Djuro Salaj Gallery in Belgrade. Although insisting that the inspiration for his work came from nature, Sekulic often used the theme of the human form as his central subject. The combination of coloured blocks in muted shades of reds, blues and greens with the intense eyes of faces, results in striking images, produced by a poet and artist whose celebration is much deserved.

141

Herbert
Singleton
1945–2007

Museums etc
African American Museum,
Dallas, TX.

High Museum of Art, Atlanta, GA.

The Louisiana State Museum,
New Orleans, LA.

Mississippi Museum of Art,
Jackson, MS.

National Museum of American
Art, Smithsonian Institution,
Washington, DC.

New Orleans Museum of Art, LA.

References
*Museum of American Folk Art
Encyclopedia of Twentieth-
Century American Folk Art and
Artists*, Rosenak, 1990.

*Passionate Visions of the
American South, Self Taught
Artists from 1940 to the Present*,
New Orleans Museum of Art,
1993.

Pictured in My Mind, ex cat,
1995.

Raw Vision No. 40, 2002.

Souls Grown Deep, Vol. 1, Arnett
et al, 2000.

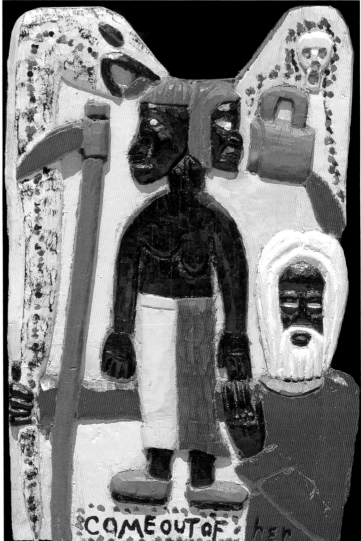

Come Out Of Her, n.d.

Algiers, Louisiana artist, Herbert Singleton, overcame many hardships, some compounded by his own misdeeds. He dropped out of school at 12 and worked odd jobs before finding steady employment as a carpenter. Singleton survived a near-fatal shooting, endured years of drug abuse and, cumulatively, spent nearly 14 years in prison. He first derived meaningful income from artistic endeavours in the early 1980s, carving walking sticks and 'voodoo protection' stumps for friends. After his final stint of incarceration, Singleton fortuitously embraced bas-relief as his primary form of creative expression. On boldly carved and painted salvaged panels, he both skewered and exalted his life and times. He appended each of his stirring works with text, railing against hypocrisy while revealing keen insight into the socio-economic limitations imposed upon many in the American South. Singleton matter-of-factly addressed racism and the ravaging effects of self-destructive indulgences, such as sex, drugs and gambling. His biblically-inspired works point out our seeming inability to meet the standards we set for others and his festive works pay tribute to the uniqueness of New Orleans culture.

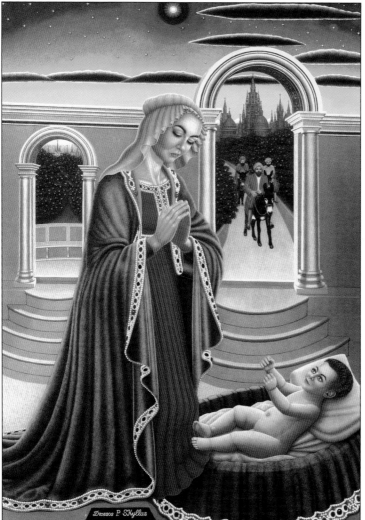

Madonna, 1960-1965

Drossos
Skyllas
1912–1973

Museums etc
Intuit, Chicago, IL.

Milwaukee Art Museum, WI.

References
American Self-Taught: Paintings and Drawings by Outsider Artists, Maresca & Ricco, 1993.

Museum of American Folk Art Encyclopedia of Twentieth-Century American Folk Art and Artists, Rosenak, 1990.

Drossos P. Skyllas was born into a strict Greek Orthodox family on the island of Kalymnos. Although showing an early creative zeal, Skyllas was encouraged by his father to train instead as an accountant. Following the end of the Second World War, he emigrated to Chicago, USA, and began to paint, as he had always dreamed of doing. The support of his wife Iona was central to the confidence he had in his own abilities as an artist. During his lifetime, Skyllas produced just 35 paintings, none of which was sold, due to the excessive prices laid on his work by Skyllas himself.

His style was meticulous, with a perfectionist technique which he described as '100 per cent like photographs'. Skyllas was inspired by the Greek traditions of classical art, and many of the representational subjects he painted had their roots in Greek symbolism. Often using homemade brushes to produce smoother brushstrokes, Skyllas painted portraits, nudes, still-life compositions and landscapes. His belief in and dedication to his work were unconditional, but it was only after his death in 1973 that his paintings were seen more widely and taken seriously by galleries and collectors.

143

Mary T.
Smith
1904–1995

Museums etc
Birmingham Museum of Art, AL.

High Museum of Art, Atlanta, GA.

Kentucky Folk Art Center, Morehead, KY.

Louisiana State Museum, New Orleans, LA.

Milwaukee Art Museum, WI.

Morris Museum of Art, Augusta, GA.

National Museum of American Art, Smithsonian Institution, Washington, DC.

New Orleans Museum of Art, LA.

The Old Capitol Museum of Mississippi History, Jackson, MS.

St James Place Folk Art Museum, Robersonville, NC.

References
American Self-Taught, Maresca & Ricco, 1993.

Museum of American Folk Art Encyclopedia of Twentieth-Century American Folk Art and Artists, Rosenak, 1990.

Raw Vision No. 32, 2000.

Souls Grown Deep, Vol. 2, Arnett et al, 2001.

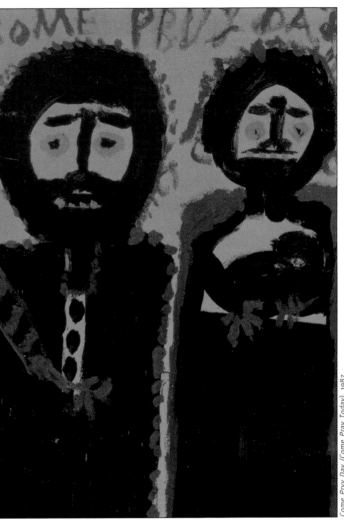

Come Prvy Day (Come Pray Today), 1987

Like that of many other self-taught artists from the American South, Mary Tillman Smith's art was directed by her powerful Christian faith. One of 13 children, in a family of sharecroppers, Smith was partially deaf. As a result she received little schooling and was relatively isolated. After her second marriage ended, she settled in a wooden house on an acre of land in Hazelhurst, Mississippi, and began transforming her yard. Starting with her corrugated iron fence, she proceeded to fill her land with paintings, covering every surface with images of Christ and other religious icons, written statements and portraits of her family and friends, as well as images of herself. She also made sculptures of people and created makeshift buildings. All Smith's images are painted with the same bold brushstrokes. She developed an iconography of invented words and symbols, including irregular dots, stripes and circles-within-a-circle. Her style developed over time: her early paintings are black outlines on white, but her later works include background fields of colour. Smith's yard became an autobiographical record of her daily life, as well as a testament to her art and her religious beliefs.

Henry
Speller
1900–1996

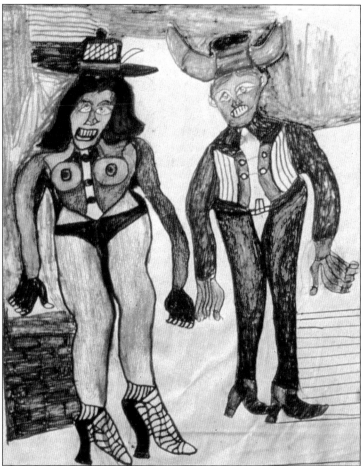

Couple (detail), c. 1982

Museums etc
High Museum of Art, Atlanta, GA.

Mississippi Museum of Art, Jackson, MS.

National Museum of American Art, Smithsonian Institution, Washington, DC.

The Old Capitol Museum of Mississippi History, Jackson, MS.

Rockford Art Museum, Rockford, IL.

St James Place Folk Art Museum, Robersonville, NC.

White Hall Gallery, Richmond, VA.

References
American Self-Taught: Paintings and Drawings by Outsider Artists, Maresca & Ricco, 1993.

Museum of American Folk Art Encyclopedia of Twentieth-Century American Folk Art and Artists, Rosenak, 1990.

Souls Grown Deep, Vol 1, Arnett et al, 2000.

Raw Vision No. 64, 2008.

Henry Speller was born into a sharecropper family in Rolling Fork, Mississippi in 1900. Raised by his grandparents and educated in school for just six years, he spent his early life helping his family on the farm. In 1939, Speller moved to Memphis, Tennessee, and began to draw a few years later. A blues musician, he also worked on his art for hours a day, producing many drawings. Inspiration came from Speller's experiences of everyday life, but his subjects were mostly female. The sexual content of his paintings, although innocent, is evident. Breasts are exaggerated; clothes are transparent. Female figures from popular culture, such as the group The Supremes and the glamour actresses from the TV drama Dallas, received his attention. Many have commented that the bold colours and patterned style of Speller's work are reminiscent of African American quilts. Certainly he admitted helping his grandmother to embroider as a child. Speller's wife Georgia, whom he married in 1964, was also an artist, and she inspired him to continue drawing. Speller drew until his death in 1996. Describing his motivation, Speller simply answered, 'I took it up by my own self. If I get it in my mind, then I can draw it.'

Jimmy Lee
Sudduth
1910–2007

Museums etc
African American Museum, Dallas, TX.

American Folk Art Museum, NY.

Birmingham Museum of Art, AL.

Fayette Art Museum, Fayette, AL.

Milwaukee Art Museum, WI.

Mississippi Museum of Art, Jackson, MS.

National Museum of American Art, Smithsonian Institution, Washington, DC.

New Orleans Museum of Art, LA.

Owensboro Museum of Fine Art, KY.

St James Place Folk Art Museum, Robersonville, NC.

References
American Self-Taught, Maresca & Ricco, 1993.

Folk Art, Vol. 18, No. 4, 1993.

Passionate Visions of the American South, Self Taught Artists from 1940 to the Present, New Orleans Museum of Art, 1993.

Raw Vision No. 19, 1997.

Souls Grown Deep, Vol.1, Arnett et al, 2000.

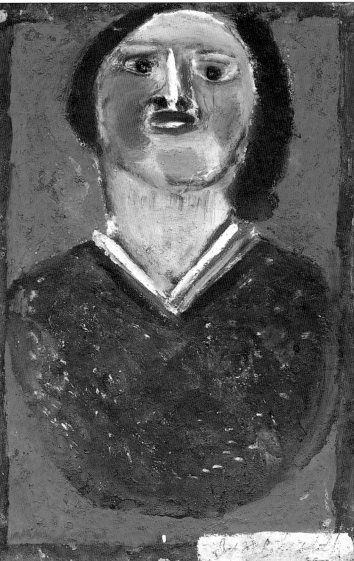

Mrs Fowler from Fayette, c. 1985

As a child in the American South, Jimmy Lee Sudduth discovered the secret qualities of nature's palette when he went collecting healing plants with his mother, a herbalist, in woods near their home. He became fascinated by the possibilities of using mud to create hues. For staining and colour, he would grind grass, berries, walnut husks, and even coffee and soot into mud. His technique involved outlining the design of the painting with a soft stone he called 'dye rock', creating a heavy earthy line. He then put mud onto plyboard, rubbing plants and berries into it when dry to create a range of natural colours, from yellows and reds to browns and greens. He also experimented with house paint. Sudduth's hands were his brushes, his fingers as delicate as the finest. Sudduth's subject matter remained consistently focused on local churches and houses in Lafayette, local people and their animals (including his own dog Toto), and self-portraits with his banjo (he was an accomplished musician from an early age). His flower paintings, executed on vertical panels, with white blob-flowers and splatter paint effects, were reminiscent of sophisticated traditional Chinese paintings.

Katsuhiro
Terao
b. 1960

Museums etc
abcd Collection, Paris.

References
Atelier Incurve, atelier incurve, 2006.

Atelier Incurve Exhibition at Suntory Museum, ex cat, 2008.

The Third Floor (detail), 2003

After leaving school, Katsuhiro Terao became a welder in his father's manufacturing business in Osaka, Japan, and worked there until his father's death 20 years later. He now attends the Atelier Incurve, a vocational training centre in Osaka for artists with learning disabilities, where he has access to all the materials he needs for his art. It is steel in all its forms that fascinates Terao, and he photographs and sketches steel fences, bridges and other structures that he comes across on holiday excursions and in his everyday life. Using a pencil and a ruler and marking rivets and baseplates with hand-drawn symbols, he drafts compositions based on his findings, turning the paper or board on which he is drawing and working from the edges inwards. The patterns of beams and girders interlace to form intricately layered structures which fill the pages and have neither top nor bottom. Working from these delicately and meticulously worked blueprints, he skillfully welds heavy sculptures from components that he selects with care from steel scrap. In addition to his numerous pencil drawings, Terao produces etchings, collages and striking coloured acrylic works, all driven by his passion for steel.

James 'Son'
Thomas
1926–1993

Museums etc
American Visionary Art Museum, Baltimore, MD.

Art Museum of Southeast Texas, Beaumont, TX.

Delta Blues Museum, Clarksdale, MS.

Intuit, Chicago, IL.

Meadows Museum of Art, Shreveport, LA.

Mississippi Museum of Art, Jackson, MS.

National Museum of American Art, Smithsonian Institution, Washington, DC.

The Old Capitol Museum of Mississippi History, Jackson, MS.

University of Mississippi, Oxford, MS.

References
Encyclopedia of Twentieth-Century American Folk Art and Artists, Rosenak, 1990.

Passionate Visions of the American South, Self Taught Artists from 1940 to the Present, New Orleans Museum of Art, 1993.

Raw Vision No. 64, 2008.

Souls Grown Deep, Vol 1, Arnett et al, 2000.

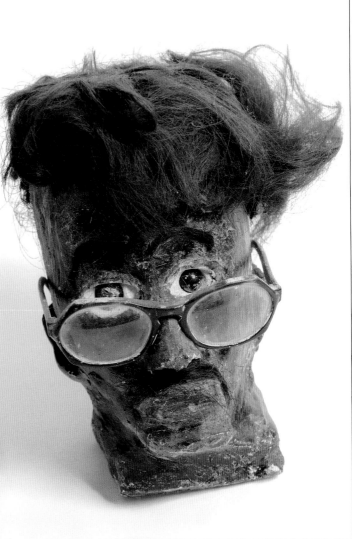

Untitled (head with hair and glasses), n.d.

Not only was James Henry Thomas renowned for his music, but he was also a gifted sculptor. Growing up in his grandparents' home in the Mississippi Delta, he rarely played with other children but would spend his time exploring clay and learning the guitar. At school he was given the nickname 'Son Ford' after the Ford tractors he modelled in clay or wood, later shortened to 'Son'. He began to sell his sculptures, initially to pay for school materials, but it was not until the 1960s that he gained recognition for his art. After leaving school, Thomas worked as a sharecropper alongside his father. He became popular for his blues guitar playing and eventually he was able to leave the cottonfields and earn a living from his music. Working from mental images and using local river-clay, he would sculpt animals, birds and heads, and leave them to dry in the sun, afterwards embellishing the heads with paint, glass marble eyes, ribbons and artificial hair. A stint as a gravedigger revived his interest in the skulls he had fashioned from clay as a child, and he began to make more as a reminder to people of their mortality, often giving drama to his creations by adding human teeth or lining the eye-sockets with aluminium foil.

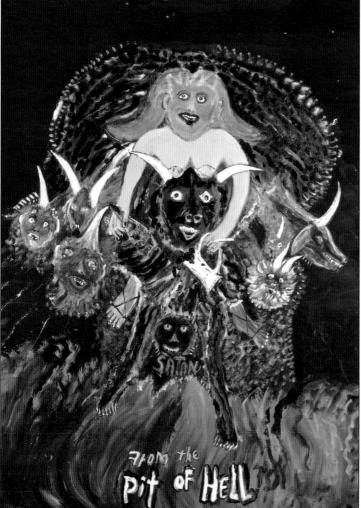

The Pit Beast of Revelation (detail), 1994-97

Outsiders & Visionaries

William Thomas
Thompson
b. 1935

Museums etc
Las Vegas Art Museum, NV.

South Carolina State Museum, Columbia, SC.

References
Art World of William Thomas Thompson, Thompson, 2006.

Coming Home! Self-Taught Artists, the Bible and the American South, ex cat, Jackson, 2004.

The End is Near, ex cat, 1998.

Raw Vision No. 33, 2000.

William Thomas Thompson grew up on a dairy farm in the rural area of Greenville County, South Carolina. He was baptised under fundamentalist Christian principles at the age of 13. From the early 1960s through to the early 1980s, the ambitious Thompson managed to build a million-dollar business. But his venture ultimately went bankrupt and Thompson was struck down with a crippling disease which left him with little control over his hands. On a Haitian medical retreat in 1989, a vision appeared to Thompson and the need to create first entered his mind. He later described his terrifying vision as seeing 'the coming of the Lord and the world on fire'. Thompson interpreted this as a direct order from God to paint. Completely self-taught, he painted his vision and later began work on a series of enormous 150 feet./50 m. paintings known as the 'Revelations Murals'. Although his artwork has religion as its primary theme, Thompson also produces pictures detailing his commentaries on politics, war and family morals and the occasional apocalyptic landscape. All his work is characterised by bold colours and a unique movement in his brushstroke that results from his disability.

Mose
Tolliver
1919–2006

Museums etc
African American Museum, Dallas, TX.

American Folk Art Museum, NY.

Birmingham Museum of Art, AL.

Fayette Art Museum, Fayette, AL.

High Museum of Art, Atlanta, GA.

Intuit, Chicago, IL.

Kentucky Folk Art Center, Morehead, KY.

Louisiana State Museum, New Orleans, LA.

Milwaukee Art Museum, WI.

Montgomery Museum of Fine Arts, AL.

National Museum of American Art, Smithsonian Institution, Washington, DC.

New Orleans Museum of Art, LA.

Taubman Museum, Roanoke, VA.

References
American Self-Taught, Maresca & Ricco, 1993.

Black Folk Art in America, Livingston & Beardsley, 1982.

Raw Vision No. 12, 1995; No. 58, 2007.

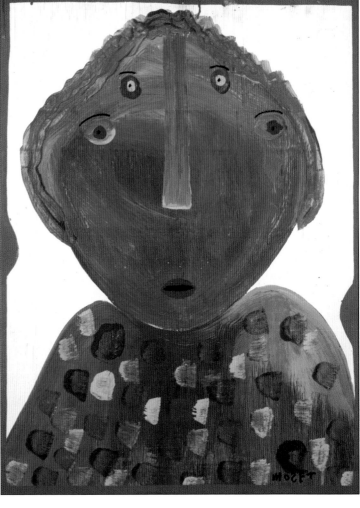

Untitled, n.d.

Mose Tolliver lived in rural Alabama all his life. He worked as a farmer and labourer until an accident damaged his legs and left him unable to walk without crutches. He took up painting, working by balancing a board on his knees. Tolliver's colourful poster-like style appears to be relatively simple: in many of his works flat images, often with round heads and simple stylised features, dominate the composition. The curves of his organic forms give a sense of rhythm to the painting. He sometimes finished off a picture by adding a 'frame', consisting of a band of colour around the edge. Tolliver's subjects included portraits of himself and his wife, anthropomorphic birds and animals, vegetables and plant life. He also painted sexualised images of women resting on pointed objects he referred to as 'scooters' or 'exercising bicycles'. Tolliver's family initially provided him with scraps of wood they found in alleyways and on the street, but later he painted on plywood using house paint. He was a prolific, fast-working artist who finished each artwork with a distinctive signature, 'MOSET', including a backward 'S'. His daughter, Annie Tolliver, also paints in a similar but more simple vein.

Edgar
Tolson
1904–1984

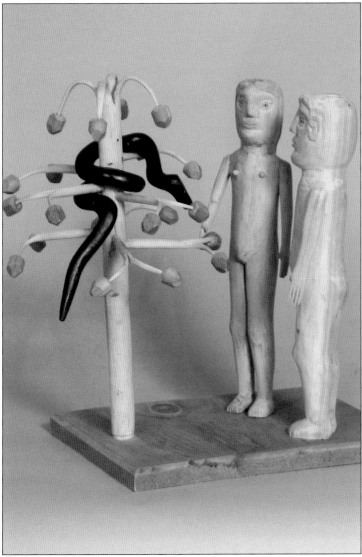

Temptation, c. 1970

Museums etc
American Folk Art Museum, NY.

Columbus Museum, Columbus, GA.

Fenimore House Museum,
Cooperstown, NY.

High Museum of Art, Atlanta, GA.

Kentucky Folk Art Center,
Morehead, KY.

Museum of International Folk
Art, Santa Fe., NM

National Museum of American
Art, Smithsonian Institution,
Washington, DC.

References
*American Anthem: Masterworks
from the American Folk Art
Museum*, ex cat, 2001.

*Museum of American Folk Art
Encyclopedia of Twentieth-
Century American Folk Art and
Artists*, Rosenak, 1990.

*Passionate Visions of the
American South, Self Taught
Artists from 1940 to the Present*,
New Orleans Museum of Art,
1993.

*Self-Taught Artists of the 20th
Century*, ex cat, 1998.

*The Temptation: Edgar Tolson
and the Genesis of Twentieth
Century Folk Art*, Ardery, 1998.

Edgar Tolson was a Baptist preacher who abandoned his ministry because he felt that he was unable to live up to the high standards he set for himself. His explicitly detailed, carved tableaux illustrate his unerring belief that the temptation and fall of Adam and Eve set the course of history. A native of Kentucky, Tolson began carving wood as a hobby. Using a penknife he would whittle animals, walking-sticks and simple figures in the Appalachian tradition. After leaving school he became a preacher and earned his living as a carpenter and stonemason, until a disabling stroke forced him to give up work in his early fifties. He became a full-time woodcarver and began to produce more ambitious pieces on religious and political themes as well as continuing to carve stylised figures of people and animals, assembled and partially coloured with ink, paint or pencil. Tolson carved over a hundred versions of the Temptation, the best-known of which is his 'Fall of Man' cycle, a series of eight tableaux telling the story of Adam and Eve and the consequences of their actions. Tolson's work first gained national recognition through a government scheme to assist Appalachian craftspeople.

Bill
Traylor
1854–1947

Museums etc
Abby Aldrich Rockefeller Folk Art Center, Williamsburg, VA.

American Folk Art Museum, NY.

Charlotte Zander Museum Bönningheim, Germany.

High Museum of Art, Atlanta, GA.

Intuit, Chicago, IL.

Montgomery Museum of Fine Arts, AL.

National Museum of American Art, Smithsonian Institution, Washington, DC.

References
Bill Traylor, High Singing Blue, ex cat, 1997.

Bill Traylor, His Art, His Life, Maresca & Ricco, 1991.

Black Folk Art in America, Livingston & Beardsley, 1982.

Deep Blues, Lyons, 1994.

Deep Blues, Bill Traylor 1854–1949, Helfenstein & Kurzmeyer, 1999.

Raw Vision No. 15, 1996; No. 38, 2002.

Souls Grown Deep, Vol. 1, Arnett et al, 2000.

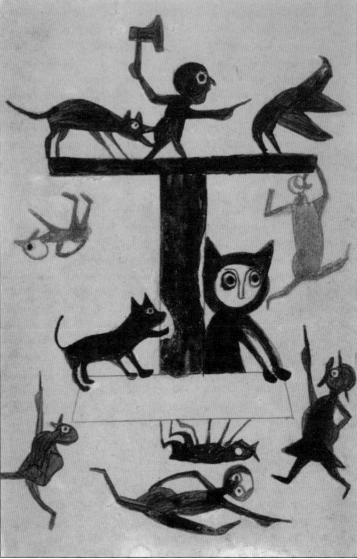

Untitled, c. 1939–42

Bill Traylor was born into slavery on a plantation in the heart of Alabama. After the American Civil War he gained his freedom but remained a field-hand at the same plantation. At the age of 84, no longer able to work, Traylor went to live in the city of Montgomery, where he began to draw. In 1939 he came to the attention of local artist Charles Shannon, who befriended him, provided him with art materials, and later promoted his work extensively. Traylor drew vignettes of life on the street where he sat every day, as well as memories of his experiences on the plantation. He worked initially on found scraps of cardboard with pencil stubs, carefully outlining his figures and then filling in the line with the simplest of colours. His flat silhouetted images are stark, with no ornamentation. He developed devices to create a sense of depth, including a two-eyed profile. Traylor drew either simple one-figure compositions, or pictures with groups of figures, often composed around a central form. His flat imagery, use of space and complex compositions make his drawings echo African and ancient imagery. Traylor left behind 1,500 works, all produced during a brief creative period.

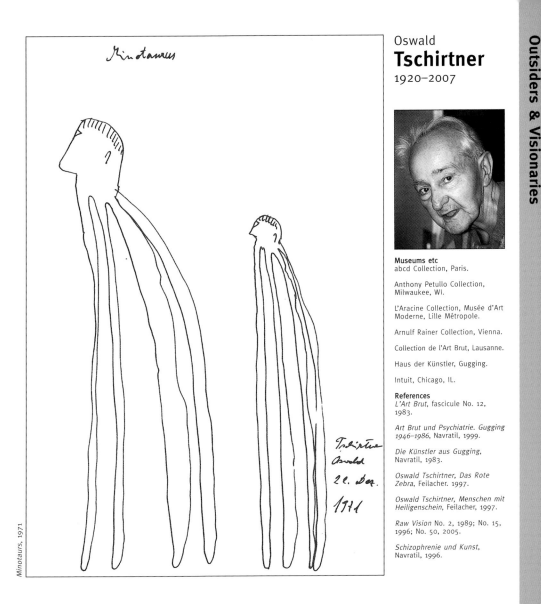

Minotaurs, 1971

Oswald
Tschirtner
1920–2007

Museums etc
abcd Collection, Paris.

Anthony Petullo Collection, Milwaukee, WI.

L'Aracine Collection, Musée d'Art Moderne, Lille Métropole.

Arnulf Rainer Collection, Vienna.

Collection de l'Art Brut, Lausanne.

Haus der Künstler, Gugging.

Intuit, Chicago, IL.

References
L'Art Brut, fascicule No. 12, 1983.

Art Brut und Psychiatrie. Gugging 1946–1986, Navratil, 1999.

Die Künstler aus Gugging, Navratil, 1983.

Oswald Tschirtner, Das Rote Zebra, Feilacher. 1997.

Oswald Tschirtner, Menschen mit Heiligenschein, Feilacher, 1997.

Raw Vision No. 2, 1989; No. 15, 1996; No. 50, 2005.

Schizophrenie und Kunst, Navratil, 1996.

Oswald Tschirtner fought in the German army during the Second World War, and was institutionalised in 1946. A member of the Haus der Künstler in Gugging, Austria, he was encouraged to begin drawing by the hospital's psychiatrist, Dr Leo Navratil. Tschirtner continued to work only after suggestion or encouragement, but from the outset his works were always different from those of other residents. Using pen and ink, Tschirtner relied on a stark, highly controlled linear style to create repeated motifs. His representations are almost entirely modelled on human figures, always elongated and mostly possessing little more than a distinctively shaped head and simple face to register them as being human. The mathematical equality in Tschirtner's images, his sublime sense of space, and his use of line produce an infallible sense of calm and simplicity. The pictures are occasionally based on newspaper and magazine images or other works of art, but still worked in his elongated style. Tschirtner signed some of his pictures 'O.T.' and chose titles as simple and poetic as the pictures themselves: 'Health', 'Line', 'Snow', 'People' and 'The Genius of Skyscrapers'.

153

Willem
van Genk
1927–2005

Museums etc
L'Aracine Collection, Musée d'Art Moderne, Lille Métropole.

Charlotte Zander Museum Bönningheim, Germany.

Collection de l'Art Brut, Lausanne.

Croatian Museum of Naïve Art, Zagreb.

Dr Guislain Museum, Gent, Belgium.

References
L'Art Brut, fascicule, No. 14, 1986.

Art without Frontiers, Crnkovic, 2006.

Création Franche No. 11, 1995.

Masters of the Margin, ex cat, 2000.

Raw Vision No. 3, 1990; No. 30, 2000; No. 36, 2001.

Willem van Genk, van Berkum, 1998.

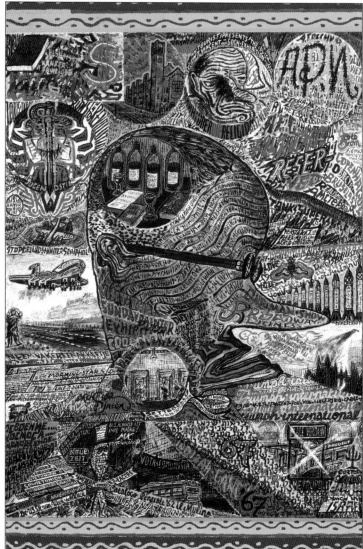

Parnasky Culture (detail), 1972

Dutch artist Willem van Genk came from a wealthy family of designers and architects, but he was unable to find a secure career for himself. After a short period working as a second-hand book dealer he began to draw and paint, creating his own monumental urban landscapes, with transport systems, train and trolleybus stations and aircraft as his central theme. His garish colours and strong lines portray images he found in travel books and magazines, but he also included details of actual journeys he had taken himself. An obsession with Russia and Communism inspired many of his paintings. His early work consists of cityscapes drawn in pencil and in black ink. He later developed his own unique collage technique, taking his smaller drawings, sticking them to wrapping paper, canvas or board, and cutting out silhouettes, before adding areas of paint and text in different languages. Grids and parallel lines are used to create a claustrophobic and overwhelming sense of perspective. Van Genk gradually drifted away from painting, concentrating instead on his collection of raincoats and his vast model of a trolleybus station, which he kept with him at his apartment.

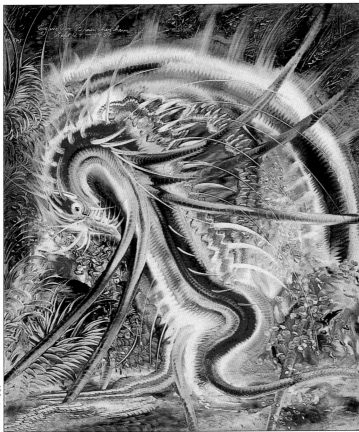

Untitled, 1957

Eugene
von Bruenchenhein
1910–1983

Museums etc
Akron Art Museum, OH.

Anthony Petullo Collection, Milwaukee, WI.

Intuit, Chicago, IL.

John Michael Kohler Arts Center, Sheboygan, WI.

Milwaukee Art Museum, WI.

References
American Anthem: Masterworks from the American Folk Art Museum, ex cat, 2001.

American Self-Taught, Maresca & Ricco, 1993.

Art Outsider et Folk Art des Collections de Chicago, ex cat, 1998.

The End is Near, ex cat, 1998.

Eugene Von Bruenchenhein, Obsessive Visionary, ex cat, 1988.

Museum of American Folk Art Encyclopedia of Twentieth-Century American Folk Art and Artists, Rosenak, 1990.

Raw Vision No. 10, 1994.

Sublime Spaces & Visionary Worlds: Built Environments of Vernacular Artists, Umberger, 2007.

Eugene von Bruenchenhein was born and grew up in Wisconsin, where he spent most of his working life employed in a bakery and lived an isolated and obsessional life, shared only with his wife Marie. Self-taught, von Bruenchenhein was convinced of his artistic talent and was always hopeful of success, but it was not until long after his death that his work was revealed to the public. He developed his own unique painting technique: using his fingers to rapidly manipulate the thin wet oil paint, he created magical swirls and twists of bright, visionary colours. These organic shapes represent deep-sea monsters, spiky plants and, later, cities and floral forms. In the 1950s, at the height of the Cold War, he expressed his fear of nuclear attack by painting apocalyptic scenes of mushroom clouds and luminous depictions of fallout. Von Bruenchenhein was a prolific photographer, shooting thousands of semi-erotic pin-up images of his wife, some of which he handcoloured. He also made home-fired clay masks and concrete sculptures, and used recycled chicken and turkey bones to construct towers and chairs, giving himself the grandiose title of 'bone artifacts constructor'.

August
Walla
1936–2001

Museums etc
abcd Collection, Paris.

Anthony Petullo Collection,
Milwaukee, WI.

L'Aracine Collection, Musée d'Art
Moderne, Lille Métropole.

Arnulf Rainer Collection, Vienna.

Collection de l'Art Brut, Lausanne.

Haus der Künstler, Gugging,
Austria.

Intuit, Chicago, IL.

Musée de la Création Franche,
Bègles.

References
L'Art Brut, fascicule No 12, 1983.

*Art Brut und Psychiatrie. Gugging
1946–1986*, Navratil, 1999.

August Walla, Navratil, 1988.

Die Künstler aus Gugging,
Navratil, 1983.

Raw Vision No. 15, 1996.

Schizophrenie und Kunst,
Navratil, 1996.

Zwischen Wahn und Wirklichkeit,
Bader & Navratil, 1976.

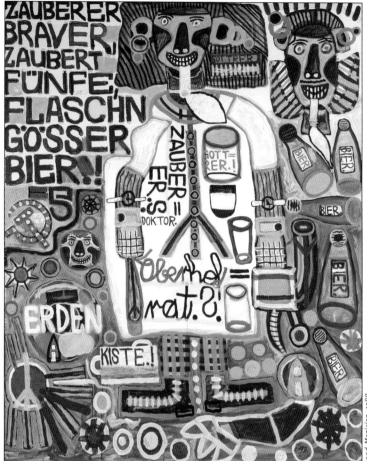

Good Magician, 1988

The schizophrenic artist August Walla was creative from his early childhood, when he painted obsessively in the family garden and constructed assemblages out of wood and other recycled materials. His style developed spectacularly after he moved into the Haus der Künstler in Gugging, Austria. One of the most versatile artists at Gugging, Walla painted, drew, etched, constructed objects from discarded recycled materials, wrote and took photographs to record his work, in a constant creative outpouring. In his powerful paintings, images of animals and people, together with religious, political and sexual symbols, are crammed together to fill the picture. Woven among or on top of his symbols and images are pieces of text, often in different languages, revealing Walla's obsession with words. Walla transformed the interior of his room at Gugging, covering the walls and ceiling with striking murals of figures, symbols, bold slogans and messages. He also painted his images on the exterior walls of the Haus der Künstler and placed objects around a small garden building, leaving them to decay, forming an organic, constantly changing environment.

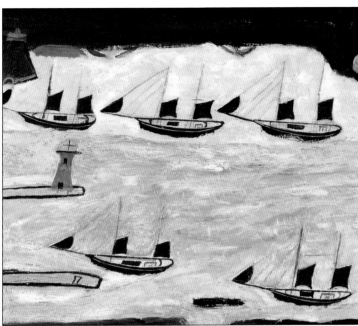

St Ives Harbour and Godrevy, c. 1934-8

Alfred
Wallis
1855–1942

Museums etc
Anthony Petullo Collection, Milwaukee, WI.

Arnulf Rainer Collection, Vienna.

Charlotte Zander Museum, Bönningheim, Germany.

Kettle's Yard, Cambridge, UK.

The Pier Arts Centre, Stromness, Orkney, UK.

References
Alfred Wallis, Gale, 1998.

Alfred Wallis: Artist and Mariner, Jones, 2001.

Alfred Wallis: Primitive, Berlin, 1949, re-issued 2000.

Raw Vision No. 33, 2000.

Junk shop owner and retired Cornish fisherman Alfred Wallis is perhaps the most renowned of all British naive and self-taught painters. Wallis began to paint in 1925, three years after the death of his wife, Susan, stating that he did so 'for the company'. Living and working in St Ives, an artists' colony in the picturesque coastal British county of Cornwall, could have inspired his activities. But it was a trip to St Ives by London artist Ben Nicholson which marked the discovery of this unique self-taught painter. Wallis painted on old cardboard, primarily scenes of the Cornish coast and the boat-filled sea view from his home. His use of subtle colours and delicate compositions has marked Wallis out as a folk art inspiration for many. He painted prolifically, even through wartime, connecting to the sea and its wildlife through his art. Boats, lighthouses, birds, fish and seaside houses all became subjects, each portrayed in a raw, yet enormously graceful way. His signature pastel colours of varying greys and blues mark the majority of his pieces. Wallis' work never gained the acceptance of his Cornish neighbours, but it was been much admired by the London art scene and beyond.

Myrtice
West
b. 1923

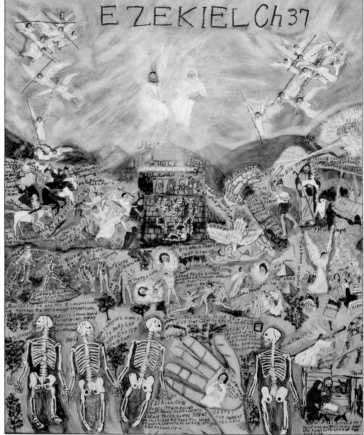

Museums etc
St James Place Folk Art Museum,
Robersonville, NC.

References
*Coming Home! Self-Taught
Artists, the Bible and the
American South*, ex cat, Jackson,
2004.

Raw Vision No. 62, 2007.

*Wonders to Behold: The
Visionary Art of Myrtice West*,
Crown, 1999.

Ezekiel Chapter 37, 1993–1997

Myrtice West was born in the town of Centre, Alabama. After her schooling she found a husband and settled down to the everyday life of an Alabama housewife. To complete her dream, West longed for a child. The medical profession insisted that she was not capable of a natural conception, but after many years of hope she gave birth to a daughter. Tragically, West's daughter was brutally murdered as a young adult. West was distraught and sought solace in her religion and her paintings. Viewing art as a way in which to channel her loss and inspired by her talent, which she was convinced came to her as a gift directly from God, West began painting sections of *The Bible*. Her initial piece was a series of studies from the book of 'Revelation', but she soon moved on to illustrate other books of *The Bible*, always studying each section in detail before beginning to plan her painting. West also composes portraits and memories of her everyday life in Alabama, often including texts or narratives within the pictures. She makes use of many materials on which to paint her bold work, including wood panelling, canvases and even found objects such as birdhouses.

Mary
Whitfield
b. 1947

Grieving Family (Lynching), 1999

Museums etc
Birmingham Museum of Art, AL.

National Museum of Women in the Arts, Washington, DC

References
Raw Vision No. 49, 2004.

Mary Whitfield's paintings are a vibrant visual expression of the misery of racial discrimination. Whitfield was born in Birmingham, Alabama, and her grandmother, who was active in the civil rights movement, frequently recounted the deprivation and struggle which were to figure in Whitfield's paintings. As a child Whitfield would make drawings to illustrate the stories she told her young relatives. When she was seven years old she moved to New York, where she and her sister were the only black students at their school. She married and had three sons, but her husband was often absent and their relationship was unhappy. Early in her marriage, Whitfield began to work in house paint on plywood, creating images of happy family life and the injustices of slavery and segregation. Lynching, which frequently appears in her work, symbolises her outrage at the past and continual suffering of African Americans. Dense layers and translucent washes of pigment in her later watercolour paintings add depth to the flattened shapes and simplified forms. The bright clothes of her faceless figures contrast with the muted backgrounds, and colour is used symbolically and to convey emotion.

George
Widener
b. 1953

Museums etc
abcd Collection, Paris.

Collection de l'Art Brut,
Lausanne.

References
The Art of George Widener,
2009

Raw Vision No. 51, 2005.

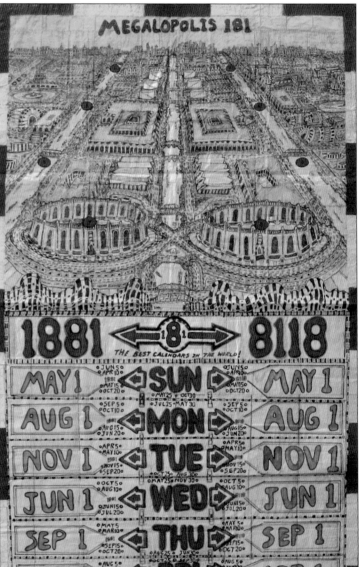

Megalopolis 181 (detail), 2007

Dates and numbers hold an irresistible fascination for George Widener, who from childhood has been able to effortlessly multiply in his head two times two to the power of forty, and to calculate distant past and future dates. Born in Cincinnati, Ohio, Widener's childhood was marked by socially awkward behaviour but it was not until he was almost 50 years old that he was diagnosed with Asperger's syndrome. At school he excelled in any subject that required rote memory, and he was well ahead of his age in reading. When he was 17 he enlisted in the military for four years, after which he worked at various unskilled jobs and took some college classes. Widener has always excelled in drawing, but it is its combination with his extraordinary numeric ability and prodigious memory that makes his art unique. His detailed technical drawings are complemented by lists of statistics and historical facts, all recalled from memory. His magic squares and calendars refer to often disastrous events such as the sinking of the Titanic, a particular interest of his. Widener has learned to overcome his literal nature and create original work, often drawing on found pieces of paper such as table napkins.

Charlie
Willeto
1905–1964

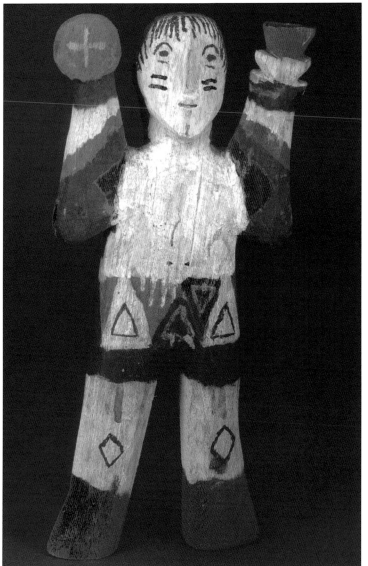

Untitled, n.d.

Museums etc
Milwaukee Art Museum, WI.

National Museum of American Art, Smithsonian Institution, Washington, DC.

References
Collective Willeto. The Visionary Carvings of a Navajo Artist, Smither, 2002.

Museum of American Folk Art Encyclopedia of Twentieth-Century American Folk Art and Artists, Rosenak, 1990.

Vernacular Visionaries: International Outsider Art, Carlano, 2003.

Charlie Willeto grew up in the Navajo tradition within a New Mexico Native American Reservation. Leaving school after just two years, Willeto made his living out of herding and as a medicine man. Willeto began carving at the age of fifty-six. His artistic career lasting just four years until his death in 1964. Numbering 400 in total, Willeto's wooden sculptures pushed him to the forefront of modern Navajo folk art. Challenging the community's conventional interpretation of art, his work instead expressed the Navajo sprit in a more individual way. Willeto's figures stand tall and represent Navajo people and animals. Many of the carvings have upright arms, mirroring the warrior pose of Navajo fighters at the time. His portrayal of the Navajo used colours reflecting the clothes worn by the members of his community, or patterned in the style of traditional Navajo weavings. Willeto often included real feathers to echo the customary head wear of the Navajo men. His expressive and shamanistic wooden carvings were discovered by a collector on a trading trip in the early 1960s, and have inspired a new generation of sculptors within the Navajo community and even within the Willeto family.

Ben
Wilson
b. 1963

Museums etc
American Visionary Art Museum, Baltimore, MD.

Museum of Finnish Contemporary Folk Art, Kaustinen.

The Musgrave Kinley Outsider Art Collection, The Irish Museum of Modern Art, Dublin.

References
British Outsider Art, ex cat., 2008.

Raw Vision No. 21, 1997; No. 55, 2006.

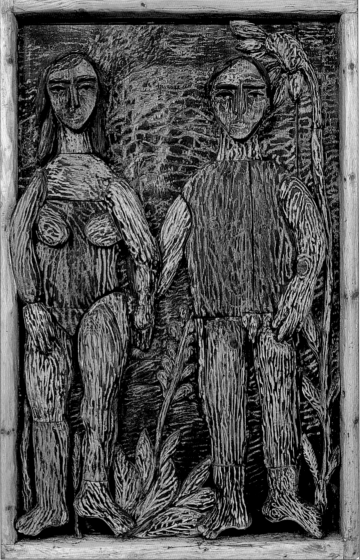

Two Figures in the Woods, 2001

As a child, Ben Wilson regularly carved objects and sculptures out of pieces of found wood and fallen trees. He continued throughout his early life, encouraged by understanding and artistic parents, eventually creating vast carvings in secret corners, some of which are still evident in the parks and woods of North London. Many of Wilson's wooden creations and framed carvings appear at locations such as AVAM in Baltimore and the Folk Art Museum in Finland, in addition to his spontaneous urban decorations. Sadly, over the years, much of his work in wood built in public spaces has been destroyed by vandals. Wilson's most recent endeavour has been to paint minutely detailed and colourful images on discarded pieces of chewing gum on the pavements of London. He started experimenting with this unusual medium in 1998, but it was not until 2004 that he began to create his gum paintings in earnest. Wilson is constantly looking for ways to escape the controls of the mainstream art world, and taking requests from passers-by for his gum paintings is a way for him to transform rubbish into beauty. Each vibrant and miniature painting measures no more than 2 inches (5 cm) in diameter.

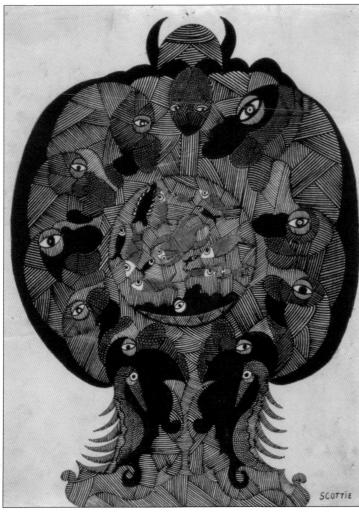

Untitled, c.1946

Scottie
Wilson
1888–1972

Museums etc
abcd Collection, Paris.

Anthony Petullo Collection,
Milwaukee, WI.

L'Aracine Collection, Musée d'Art
Moderne, Lille Métropole.

Arnulf Rainer Collection, Vienna.

Charlotte Zander Museum
Bönningheim, Germany.

Collection de l'Art Brut, Lausanne.

Eternod/Mermod Collection,
Lausanne.

References
*American Anthem: Masterworks
from the American Folk Art
Museum*, ex cat, 2001.

L'Art Brut, fascicule No. 4, 1965.

It's All Writ Out for You, Melly,
1986.

Outsider Art, Cardinal, 1972.

Raw Vision No. 29, 1999;
No. 47, 2004.

Scottie Wilson, Levy, 1966.

*Scottie Wilson; Peddler Turned
Painter*, Murrell, 2004.

Scottie Wilson (born Louis Freeman), a near-illiterate Glaswegian junk dealer living in Canada, was captivated by a particularly fine fountain pen. Feeling the compulsion to draw, he became intensively involved, drawing swirling sinister faces, organic forms and abstract patterns which he hatched and filled with ink. Many of his pictures include central figures which he called his 'Greedies', surrounding many of them with contrasting natural images, particularly flowers and fish, using his linear technique. Some of his drawings are densely coloured, the designs filled with inks, surrounded by a vibrant background. Others are set against a white background and the colours are more muted. Wilson's early drawings have a freer expressive line with few elements. His work gradually became more intricate, his line tight and controlled. In his later years his drawing became more decorative, with fewer motifs. In the 1950s, Wilson became very successful following his acceptance by London's Surrealist set. He had several exhibitions, his work was collected by Picasso and André Breton, and Victor Musgrave included his drawings in his Outsider Archive collection.

163

Josef
Wittlich
1903–1982

Museums etc
L'Aracine Collection, Musée d'Art
Moderne, Lille Métropole.

Charlotte Zander Museum,
Bönningheim, Germany.

Eternod/Mermod Collection,
Lausanne.

References
L'Art Brut, fascicule No 14, 1986.

*Eternity Has No Door of Escape,
The Eternod-Mermod Collection
of Art Brut*, ex cat, Lugano,
2001.

Josef Wittlich, Landert &
Dallmeier, 1996.

Josef Wittlich, ex cat, Darmstadt,
1982.

Raw Vision No 53, 2005.

His Highness Pope Paul VI with Swiss Guard, 1972

Josef Wittlich was born in a small rural village near Neuwied, Germany. He experienced a happy but underprivileged childhood under the protection of his poor button-maker father and went on to spend most of his adolescence wandering around the Balkans and other Eastern European regions. Wittlich settled in the small town of Nauort in 1934 and soon began his drawings and paintings, undertaken at night in his small attic lodgings. He returned to the same town after spending the war forced to work in an arms factory and escaping from a Russian prisoner-of-war camp. He sadly found his early works

had long been buried under the rubble of conflict. Wittlich was employed at the town's cement works from 1948 until his retirement in 1968. Throughout this time, he continued to create his vibrant paintings. Obsessed by the theme of war and soldiers, and entranced by bright colours, he painted his pictures in a block-style, reminiscent of stained-glass windows or the much later Pop Art movement. His work was finally discovered by a ceramicist who saw his paintings on a visit to the factory in 1967. Wittlich went on to publicly exhibit his work, to the bemusement of his colleagues.

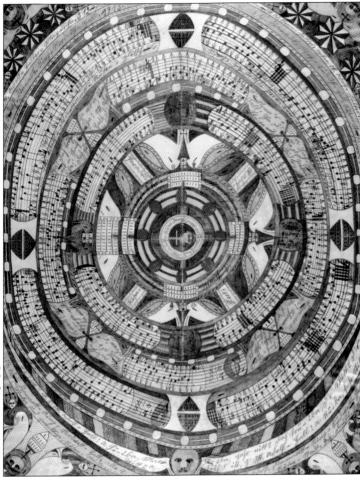

Skt. Adolf=Diamantt=Ring, 1913

Adolf
Wölfli
1864–1930

Museums etc
Adolf Wölfli Foundation,
Kunstmuseum, Berne.

Anthony Petullo Collection, WI.

L'Aracine Collection, Musée d'Art
Moderne, Lille Métropole.

Arnulf Rainer Collection, Vienna.

Charlotte Zander Museum
Bönningheim, Germany.

Collection de l'Art Brut,
Lausanne, Switzerland.

Waldau Clinic Collection, Berne.

References
Adolf Wölfli, ex cat, 1976.

*Adolf Wölfli, Draftsman, Writer,
poet, composer*, Spoerri, 1996.

L'Art Brut, fascicule, No. 2,
1964.

*The Art of Adolf Wölfli: St Adolf-
Giant Creation*, Spoerri, 2002.

*Madness & Art: The Life and
Works of Adolf Wölfli*,
Morgenthaler, 1992.

The Other Side of the Moon,
ex cat, 1988.

Outsider Art, Cardinal, 1972.

Raw Vision No. 4, 1991, No. 18,
1997; No. 23, 1998.

Adolf Wölfli spent much of his life as a patient in the Waldau Clinic, a Swiss mental institution outside Bern. In 1921, his psychiatrist, Walter Morgenthaler, wrote a study of his work, introducing him to the art world. Wölfli became known as the quintessential Outsider artist. His childhood was scarred by family loss and brutality, near-bonded labour and illness. He was eventually incarcerated for sexual assaults on girls and was sometimes a violent patient. Drawing enabled him to handle and calm his outbursts, and to channel his intense obsessions and hallucinations. Wölfli's densely detailed drawings contain a matrix of elements, including buildings, 'bird' motifs, bands, text and his distinctive round faces, all crowded into the picture plane and framed with decorative borders. The compositions appear intense, organic and flowing. Wölfli also used musical notation in his art, which he would play on a 'trumpet' made of rolled-up cardboard. In 1908, he embarked on an epic illustrated story, which grew to 45 volumes, made up of 1,600 drawings, 1,500 collages and over 25,000 pages. This epic included accounts of his wealth and world travels with his entourage in the guise of 'St Adolf'.

Joseph
Yoakum
c.1890–1972

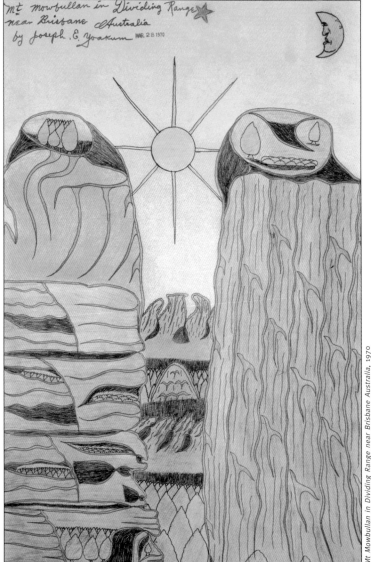

Mt Mowbullan in Dividing Range near Brisbane Australia, 1970

Museums etc
abcd Collection, Paris.

Akron Art Museum, OH.

Anthony Petullo Collection,
Milwaukee, WI.

L'Aracine Collection, Musée d'Art
Moderne, Lille Métropole.

Art Institute of Chicago, IL.

Intuit, Chicago, IL.

Milwaukee Art Museum, WI.

Museum of Contemporary Art,
Chicago, IL.

Museum of International Folk
Art, Santa Fe, NM.

Smithsonian American Art
Museum, Washington, DC.

References
*Art Outsider et Folk Art des
Collections de Chicago*, ex cat,
1998.
Black Folk Art in America,
Livingston & Beardsley, 1982.

The Clarion Vol. 15, No. 1, 1990.

Raw Vision No. 16, 1996; No. 47,
2004.

Travelling the Rainbow, De
Passe, 2001.

The key to the work of the landscape artist Joseph Yoakum is travel: he claimed to have visited every continent except Antarctica. During his early years, he worked as a sailor, porter and circus performer, before settling in Chicago in the 1950s. He began to create art in his seventies, having been instructed by God in a dream to begin to draw. Yoakum mostly depicted landscapes, or possibly 'dreamscapes'. He said he had visited every locale he drew, and often had a story to accompany his pictures. He carefully wrote captions on his works, identifying each view. His drawings often resemble geological studies or biological cross-sections rather than conventional illustrations of the landscape. Yoakum worked in pens, pencils and watercolours, and his palette included pastel shades of blues, greens and yellows. He finished his drawings by rubbing them with toilet paper, giving them an added sheen. The fluidity of his lines gave the rocks, clouds, oceans and mountains a mysterious, dreamlike quality. Yoakum's success as an artist was assisted by the patronage of Whitney Halstead of the Art Institute of Chicago, and he influenced a number of local artists in the Chicago Imagists group.

Purvis
Young
b. 1943

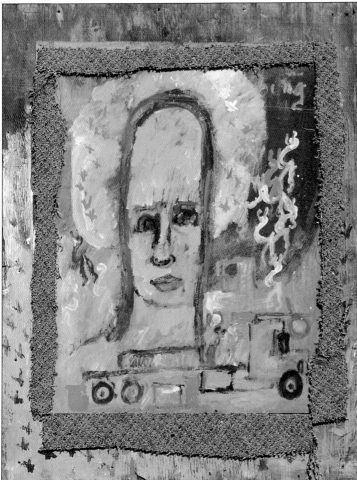

Angel Watching Over Trucks, n.d.

Museums etc
abcd Collection, Paris.

Akron Art Museum, OH.

American Folk Art Museum, NY.

Fayette Art Museum, Fayette, AL.

Fenimore House Museum, Cooperstown, NY.

Kentucky Folk Art Center, Morehead, KY.

The Louisiana State Museum, New Orleans, LA.

Milwaukee Art Museum, WI.

New Orleans Museum of Art, LA.

Newark Museum, Newark, NJ.

Rockford Art Museum, IL.

Taubman Museum, Roanoke, VA.

References
American Anthem, ex cat, 2001.

American Self-Taught, Maresca & Ricco, 1993.

Passionate Visions, 1993.

Pictured in My Mind, ex cat, 1995.

Raw Vision No. 36, 2001; No. 65, 2008.

Souls Grown Deep, Vol. 2, Arnett et al, 2001.

Purvis Young, born in Liberty City near Miami, Florida, left the education system when young and spent his early years scraping together a meagre living, undertaking numerous odd jobs. At the age of 21, he was imprisoned following a conviction for breaking and entering. Although he experimented with drawing in prison, it was on his release that Young was inspired to create art full time. He produced his first mural, 'Goodbread Alley', in the mid-1970s, attaching hundreds of painted panels onto the walls of disused buildings in a nearby town. Since then, Young has continued to create paintings on wooden panels, Formica plates, found boards, walls and even cars, making use of household paints, crayons, coloured pens and pencils. His subjects cover a wide range of issues, but a human figure is usually depicted as the central character. Themes include sex, social relationships and explorations of people, animals and objects, all executed in his gritty and intense style. The experience of the African American is, according to Young, his main inspiration. Young possesses a relentless creative drive and his total dedication has produced hundreds of pictures over time.

Anna
Zemánková
1908–1986

Museums etc
abcd Collection, Paris.

Anthony Petullo Collection,
Milwaukee, WI.

L'Aracine Collection, Musée d'Art
Moderne, Lille Métropole.

Arnulf Rainer Collection, Vienna.

Collection de l'Art Brut, Lausanne.

Intuit, Chicago, IL.

Musée de la Création Franche,
Bègles.

Museum Dr Guislain, Belgium.

Olomouc Museum of Art, Czech
Republic.

References
L'Art Brut, fascicule No. 14,
1986.

Artists of Pure Heart, ex cat, 2001.

Oinirické vize Anny Zemánkové,
ex cat, 1998.

Raw Vision No. 2, 1989; No. 14,
1996; No. 52, 2005; No. 55,
2006.

*Vernacular Visionaries:
International Outsider Art*,
Carlano, 2003.

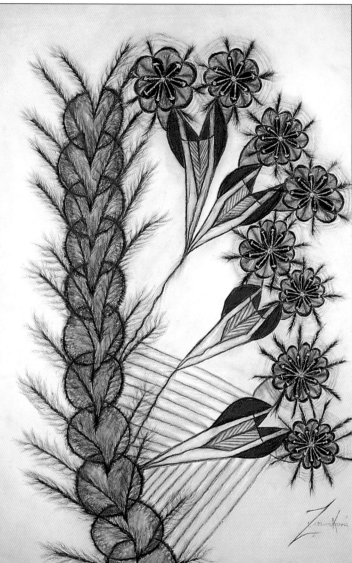

Untitled, c. 1960s

Anna Zemánková was born in Moravia in the Czech Republic and spent most of her life in Prague. Although she showed an interest in art from an early age, her father persuaded her to study dentistry. She worked as a dental technician until her marriage in 1933. In her early fifties, Zemánková suffered a bout of depression and, at the suggestion of her artist son, Bohumil, started to draw. She worked obsessively in the early mornings before she started her housework, almost certainly in an entranced state (which she described as 'exalted'), heightened by listening to classical music and possibly influenced by her 'creator spirits'. Her organic and swirling drawings were executed with a sure sense of style and design and a subtle use of colour. They resemble fantastical botanical illustrations from an earlier era, or images of exotic animal or insect species. In her later pieces Zemánková used several techniques to emphasise the form of the drawings, including piercing and crimping the paper, and adding embroidery, appliqué and collaged materials. She drew spontaneously, with no previous plan or design, but may well have been influenced by traditional Czech textile designs and floral patterns.

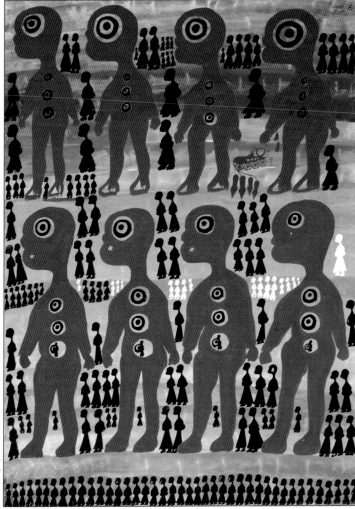

Untitled, 1964

Carlo
Zinelli
1916–1974

Museums etc
abcd Collection, Paris.

Anthony Petullo Collection,
Milwaukee, WI.

L'Aracine Collection, Musée d'Art
Moderne, Lille Métropole.

Carlo Zinelli Foundation, Verona.

Collection de l'Art Brut, Lausanne.

References
*American Anthem: Masterworks
from the American Folk Art
Museum*, ex cat, 2001.

L'Art Brut, fascicule No. 6, 1966;
No 11, 1982.

*Carlo: tempere, collages,
sculpture 1957–1974*, ex cat,
1992

Carlo Zinelli, catalogo generale,
ex cat, 2000.

Masters of the Margin, ex cat,
2000.

Raw Vision No. 29, 1999;
No. 34, 2001.

*Vernacular Visionaries:
International Outsider Art*,
Carlano, 2003.

Zwischen Wahn und Wirklichkeit,
Bader & Navratil, 1976.

The Italian painter Carlo Zinelli suffered severe trauma and paranoia following his experiences during the Second World War, and in 1947 he was committed by his family to a psychiatric hospital in Verona. The overcrowded and unpleasant conditions possibly made his condition worse, and were certainly reflected in his first drawings – graffiti scratched in stone on the hospital walls. When an art studio opened at the hospital in 1957, Zinelli began to paint on a daily basis, as he would for the next 14 years. His early paintings feature rows of almost identical human figures silhouetted against a plain background, perhaps evoking his experience of the hospital exercise yard. He also added other forms to his paintings, including boats, birds and beasts, cramming the picture space with motifs of diminishing size according to the gaps remaining. In the 1960s he began using a new technique, laying down areas of wash and adding images of figures, often in sets of four. In his later works he also added words and letters to his increasingly complex compositions. The closure of the hospital, and Zinelli's transfer to another institution, led to the virtual cessation of his painting.

169

Environments

Filippo Bentivegna
Il Castello Incantato
Sciacca, Sicily, Italy

Via Ghezzi, 92019 Sciacca (Agrigento), southern Sicily.

After emigrating to the USA and suffering a painful love affair, Filippo Bentivegna (1888–1967) returned to his native Sicily in 1913 and bought three acres of land at the foot of Mount Cronio, where he lived as a recluse until his death. Using a pocket-knife, he carved faces into the thousands of rocks that were lying amongst the trees. Standing alone and in groups, some were piled up to form mounds and others set in caves dug into the hillside. The heads of kings, warriors, shamans and ordinary people cover the land in a silent expression of Bentivegna's anger, disillusionment and loneliness. Bentivegna also carved faces into the olive trees, and the inside walls of the hut in which he lived are covered with murals depicting skyscrapers and fantastic castles. Known locally as 'Filippo of the Heads', Bentivegna became renowned worldwide for his sculptures, but he refused to sell his work. After his death the local council bought the land and opened it to visitors.

References
L'Art Brut, fascicule No 9, 1993.

Fantasy Worlds, Maizels & von Schaewen, 1999.

Raw Vision No. 22, 1998.

Irregolari, Art Brut e Outsider Art in Sicilia, di Sefano, Palermo, 2008.

Bunleua Surirat
Wat Khaek Buddha Park
Mong District, Nong Khai, Thailand

10, Bansamukkee, Mong District, Nong Khai.
By the Mekong river at Thai-Laos border, 50 km north of Udon Thani.

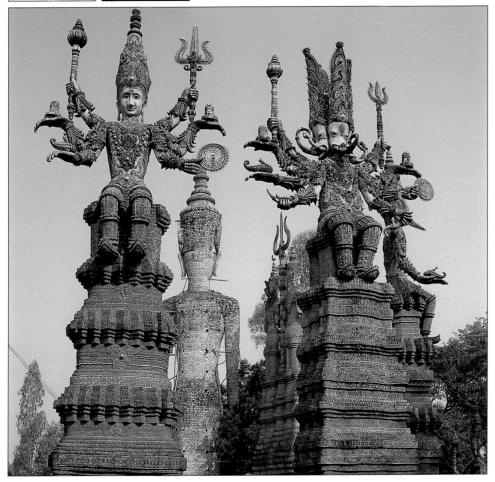

References
Fantasy Worlds, Maizels & von Schaewen, 1999.

Raw Vision No. 6, 1992.

The Wat Khaek Buddha Park in Thailand is being constructed by the visionary Bunleua Surirat, the leader of his own religious sect. Bunleua Surirat first created a Buddha Park at Vientiane, in his native Laos, but had to abandon the site when the country was taken over by Communist troops. The building of the Thai park began in 1977, on 16 acres of land specially purchased for the project. Wat Khaek Buddha Park combines elements of Buddhist and Hindu symbolism, with references to native Thai and Chinese religions. Huge concrete deities, including the Hindu gods Shiva, Vishnu and Rama, stand alongside images of the Buddha himself. The site also features secular concrete figures and tableaux, depicting the evils of drink and gambling. A huge temple is being constructed on the site. Bunleua Surirat is helped by an army of over 100 devotees who shape the structures and temple complex according to their master's detailed instructions.

Nek Chand
The Rock Garden
Sector 1, Chandigarh, India

In the north of Chandigarh, Sector 1.
The Shatabdi Express runs twice daily from New Delhi to Chandigarh.
www.nekchand.com and www.nekchand.org

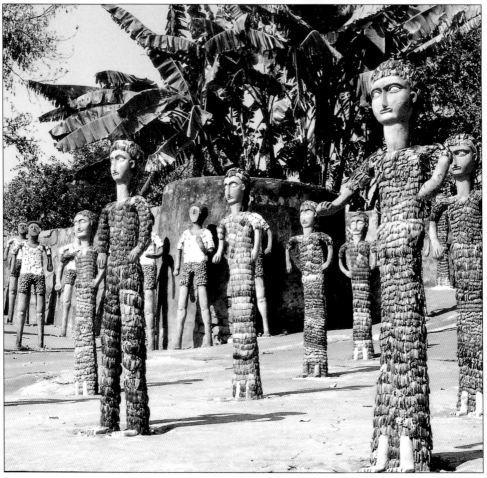

The Rock Garden, the world's largest visionary environment, is a fantasy kingdom created by Nek Chand Saini (b. 1924). Originally built in secret in a clearing on the outskirts of the newly constructed city of Chandigarh, it eventually gained official recognition and was inaugurated in 1976. Amid acres of woodland, the chambers and courtyards are populated by Chand's distinctive sculptures, created from cement and waste materials (see p. 58 in Artists section) .

The almost 2,000 figures include kings and queens, women collecting water, children exercising, a wedding party, gods, goddesses, beggars, saints and an animal kingdom. Chand later added a waterfall, using a pumping station, along with bridges, gorges, passageways and streams. The final phase of the Garden is fairly near completion, with an even larger waterfall, an amphitheatre, a snaking arcade with giant swings, and large walkways with full-size mosaic animals.

References
The Collection, the Ruin and the Theatre, Bandyopadhyay & Jackson, 2007.

Nek Chand's Outsider Art, Peiry, Lespinasse, 2005.

Nek Chand Shows the Way, ex cat, 1997.

Raw Vision No. 1, 1989; No. 9, 1994; No. 35, 2001.

The Rock Garden, Aulakh, 1986.

Ferdinand Cheval
Le Palais Idéal
Hauterives, Drôme, France

In the small town of Hauterives in Drôme, about 30 miles south of Lyon, at the crossing of the D51 and D538.
www.facteurcheval.com

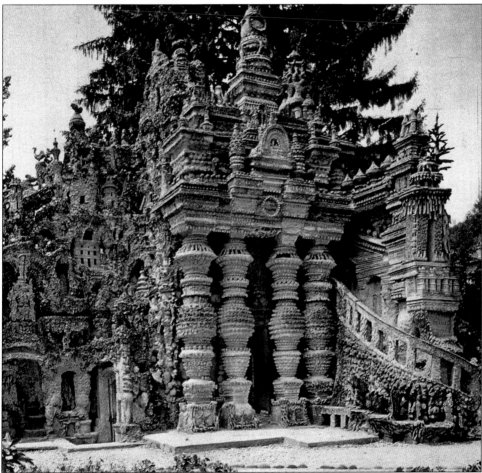

References
Fantasy Worlds, Maizels & von Schaewen, 1999.

La France Insolite, Arz, 1995.

Le Palais Idéal du Facteur Cheval, Prévost et al, 1994.

Raw Vision No. 38, 2002.

Self-Made Worlds. Visionary Folk Art Environments, Manley & Sloan, 1997.

The Palais Idéal in Hauterives, France, is one of the most celebrated of the Outsider Art environments. Ferdinand Cheval (1836–1924), a postman (*facteur*) in his local town, started to collect unusual and interesting stones during his rounds. Cheval taught himself masonry skills and began to shape concrete forms, decorated with the objects he found during his daily collections. He spent 33 years on the monumental structure, with winding stairs, turrets and ornamental columns. The grotto-like crypt has a shrine to the postman's trusty wheelbarrow, taken on his many trips for materials. The Facteur Cheval's poems appear on concrete slabs placed on the exterior walls, encrusted with stones and abstract rock shapes. Three enormous figures dominate: Caesar, Vercingétorix and Archimedes, their scale contrasting with the intricate architectural details. Cheval also built a second monument, an extraordinary tomb for himself in the local cemetery.

Niki de Saint Phalle
The Tarot Garden
Capalbio, Tuscany, Italy

Giardino Dei Tarocchi, Localita Garavicchio, Pescia Fiorentina, 58011 Capalbio, Provincia di Grosseto.
www.nikidesaintphalle.com

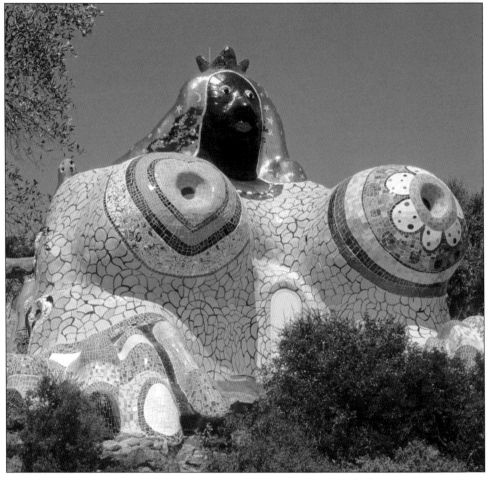

The large-scale figures of Niki de Saint Phalle (1930–2002) are strongly influenced by Gaudi's work in their surface decoration of mosaic and brilliant colour, but the grotesque yet often humourous forms are her own. In 1979 she began her Tarot Garden and, with a team of assistants, she continued work on it until her death. Set amongst trees near the town of Capalbio, in Tuscany, the sculptures are inspired by the 22 Major Arcana of the Tarot. The massive structures, some of which are designed to be entered, are built from concrete on a steel armature and are inset with thousands of glittering fragments of glass, ceramic and mirrors. Among the sculptures are: The Falling Tower, a building several stories high in which each window is a different shape; The Empress, a structure which became de Saint Phalle's home and workshop; and The High Priestess, representing the feminine principle of the universe and from the mouth of which issues a fountain.

References
Der Tarot Garten, de Saint Phalle, 1998.

Fantasy Worlds, Maizels & von Schaewen, 1999.

Niki de Saint Phalle, Prestel, 1998.

Raw Vision No. 60, 2007.

Margaret & Rev. H.D. Dennis
Margaret's Grocery & Market
Vicksburg, Mississippi, USA

4535 North Washington St, Vicksburg, MS / Route 4, Box 219, Vicksburg, Mississippi.
http://ucmmuseum.com/rev_dennis.htm

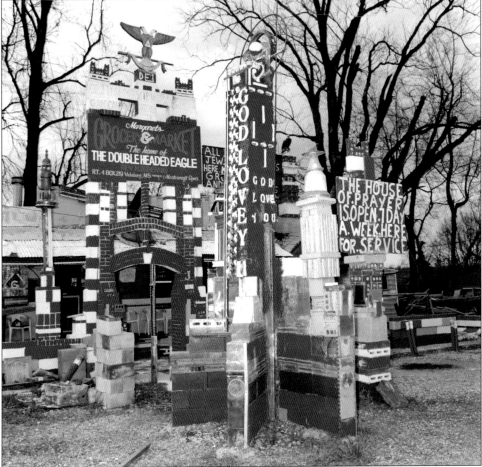

References
Detour Art, Ludwig, 2007.

Raw Vision No 15, 1996.

Self-Made Worlds. Visionary Folk Art Environments, Manley & Sloan, 1997.

When the Rev. H. D. Dennis (b. 1916) met his wife, Margaret in 1979, he offered to transform the run-down grocery store she had been managing for 37 years if she would agree to marry him. Following what he saw as a personal directive from God, Dennis set out to fulfil his promise. He stacked hand-painted blocks into a colourful façade of columns and walls extending 100 feet (30 meters) along the highway in front of the store. Plaster eagles stand at the four corners, guarding hand-written signs welcoming visitors to the grocery store and market and *The Bible* class. The columns and the window shutters bear Masonic symbols, and the fences and walkways are decorated with found objects and bear messages of salvation. In the interior, elaborate candelabras and chalices share the space with shelves of groceries. Outside stands Dennis' preaching bus, decked out in similar colours to the building and fitted with a pulpit and pews.

Brother Déodat
Little Chapel
Guernsey, Channel Islands, UK

At Blanchelande Girls College, Les Vauxbelets, St Andrews, Guernsey GY6 8XY.
t: +44 (0)1481 237200.
www.thelittlechapel.org

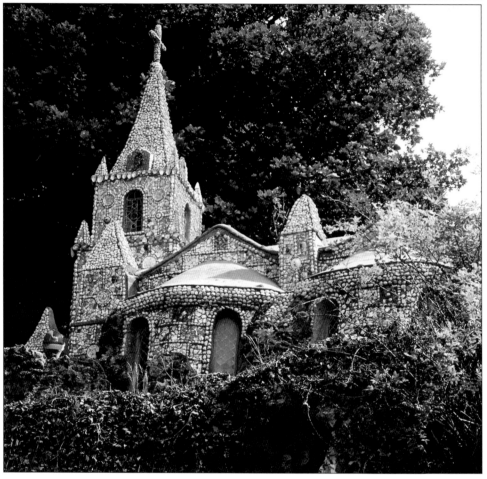

The Little Chapel of Les Vauxbelets was rebuilt twice before its creator was satisfied with his work. Brother Déodat (1878–1951) joined the Guernsey congregation of the Brothers of the Christian Schools in 1913 and devoted his life to building a miniature replica of the Basilica and Grotto of Our Lady of Lourdes. The first chapel measured less than 9 feet by 5 feet (3 m x 2 m), and he destroyed the second, larger building when the portly Bishop of Portsmouth was unable to pass through the door. The third chapel was bigger and holds ten people. Déodat collected rocks for the foundations and built the walls from boiler clinker. Pillars and archways divide the interior, and steps lead down to the crypt and grotto. The walls, floors and altars are covered in a mosaic of pebbles, seashells and broken china, and light streams through the stained-glass windows. The building fell into disrepair in the 1960s but it has now been restored.

References
Fantasy Worlds, Maizels & von Schaewen, 1999.

Raw Vision No. 55, 2006.

Samuel Perry Dinsmoor
Garden of Eden
Lucas, Kansas, USA

At 2nd and Kansas Street, Lucas, Kansas, 67648, in central Kansas, about 12 miles north of junction 206 on Interstate 70.
www.garden-of-eden-lucas-kansas.com

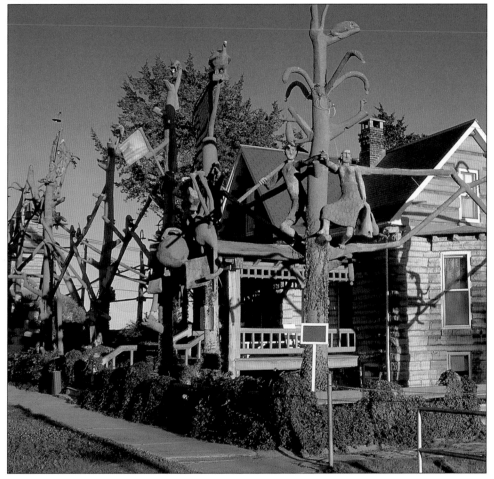

References
Backyard Visionaries, Brackman & Dwigans (ed.), 1999.

Detour Art, Ludwig, 2007.

Fantasy Worlds, Maizels & von Schaewen, 1999.

Gardens of Revelation, Beardsley, 1995.

Raw Vision No. 58, 2007.

Self-Made Worlds, Manley & Sloan, 1997.

The Garden of Eden was created by Samuel Perry Dinsmoor (1843–1932), a veteran of the American Civil War. Born in Ohio, Dinsmoor returned to his home state after the war, joined a Masonic Lodge and became interested in 'free-thought' philosophy. After various careers in and around the Midwest, Dinsmoor officially retired in 1905 and moved into the city of Lucas, Kansas. The last years of his life were intensely creative. He created his Cabin Home and Garden of Eden to illustrate his religious and radical political ideas. He made a series of inter-connected concrete trees and branches supporting over 150 cement figures, including a tableau he called the 'Crucifixion of Labor', Cain and Abel, angels, storks and a concrete American flag. In Dinsmoor's later life, he married a girl almost 60 years younger than himself and became a father again. Dinsmoor lies in a glass coffin, in a mausoleum he constructed for himself in his Garden.

179

Father Dobberstein
Grotto of the Redemption
West Bend, Iowa, USA

300 North Broadway, PO Box 376, West Bend, IA 50597.
t: 515 887 2371.
www.westbendgrotto.com

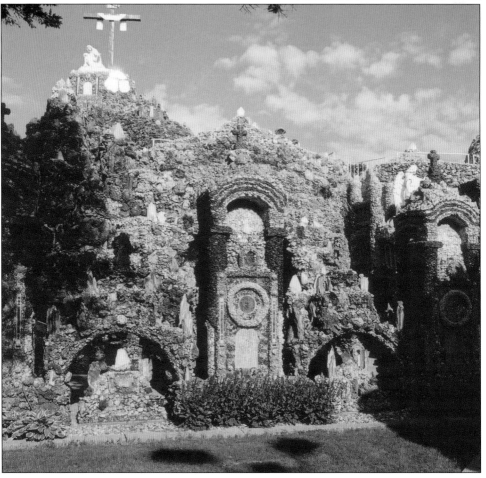

Critically ill with pneumonia as a young man, Father Paul Dobberstein (1872–1954) promised to build a shrine in honour of the Virgin Mary if he survived. Over a period of more than ten years he gathered materials with which to build what was to become the largest grotto in the world, in his parish at West Bend, Iowa. In 1912 he began its construction, and continued to work on it until his death 42 years later, incorporating bought, found and donated rocks, semi-precious stones, shells and fossilised wood from as far away as Russia and Australia. The Grotto illustrates the story of the Redemption in a series of linked shrines, with smaller shrines representing the Stations of the Cross. The shrines house specially commissioned marble statues from Italy, and a figure of Christ stands above the mineral-encrusted entrance to the site. The Grotto became a world-renowned place of pilgrimage, and after Dobberstein's death work on its construction and upkeep was continued.

References
Backyard Visionaries, Brackman & Dwigans (eds.), 1999.

Fantasy Worlds, Maizels & von Schaewen, 1999.

Gardens of Revelation, Beardsley, 1995.

Sacred Spaces and Other Places, Stone & Zanzi, 1993.

Self-Made Worlds, Manley & Sloan, 1997.

Kevin Duffy
Tudor Village
North Ashton, Lancashire, UK

Rectory Garden Centre, 97 Rectory Road, North Ashton, near Wigan, Lancashire, WN4 oQD.
www.kevinduffy.info

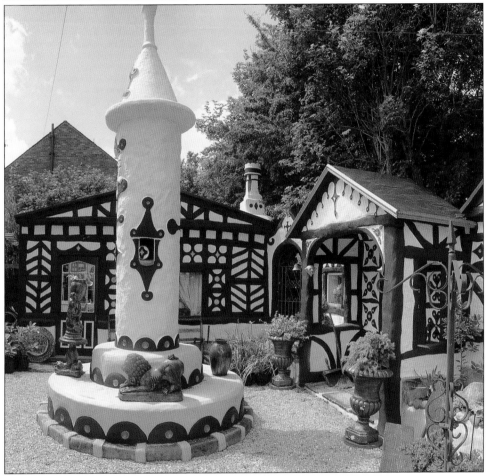

References
Raw Vision No. 62, 2008.

For more than 30 years Kevin Duffy (b. 1945) has been constructing his Tudor Village in the grounds of his garden centre near Wigan. Largely based on English vernacular architecture, most of the three-quarter-size buildings have ornamented black-and-white façades constructed on reclaimed doors using a sand and cement render over mesh. Others are three-dimensional and include a castle and a tower. Each forms part of a carefully composed scheme, with houses, clock towers and sculptures creating a realistic setting around a village square. Duffy incorporates only found or donated objects into his structures, often turning everyday items to extraordinary use, and has built a museum and replica antique shop to house his more unusual acquisitions. He is also inspired by other cultures, and the site includes a niche devoted to ancient Egypt and another labelled 'Aztec'. A small memorial is dedicated to his beloved wife, Pat.

St EOM
Pasaquan
Buena Vista, Columbus, Georgia, USA.

Eddie Martin Road, County 76, Buena Vista, Columbus, GA 31803.
t: 229 649 9444.
www.pasaquan.com

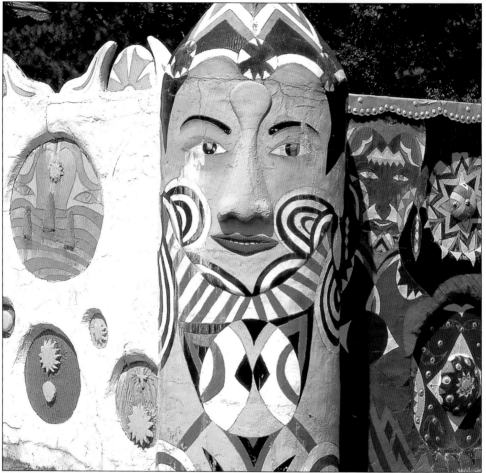

Eddie Owens Martin (1908–1986), known as 'St EOM', created Pasaquan in Georgia, a monument to his own personal faith. Martin had returned to Georgia in the 1950s after a period spent in New York, where he explored the city's art galleries and museums, suffered depression, and experienced several hallucinatory episodes. After inheriting his mother's home he settled in Georgia permanently and began to transform the four-acre site. The main building and the imposing sculpted and painted walls that ring the compound are decorated with cosmic images, mandalas and symbols from Eastern religions. The huge vivid figures represent the mystical occupants of the Land of Pasaquan. St EOM lived by telling fortunes, dressed in the elaborately colourful robes of the high priest of Pasaquan. He worked on his personal temple until he committed suicide, taking his own life with a single bullet. The site is now cared for by a local organisation.

References
Detour Art, Ludwig, 2007.

Fantasy Worlds, Maizels & von Schaewen, 1999.

Gardens of Revelation, Beardsley, 1995.

Raw Vision No. 19, 1997.

Self-Made Worlds. Visionary Folk Art Environments, Manley & Sloan, 1997.

Tom O Every (Dr Evermor)
Forevertron
Lodi, Wisconsin, USA

On Highway 12, five miles south of Baraboo, Wisconsin, behind Delaney's Surplus, across from the Badger Ammunition Plant, about 35 miles north of Madison. t: 608 219 7830.

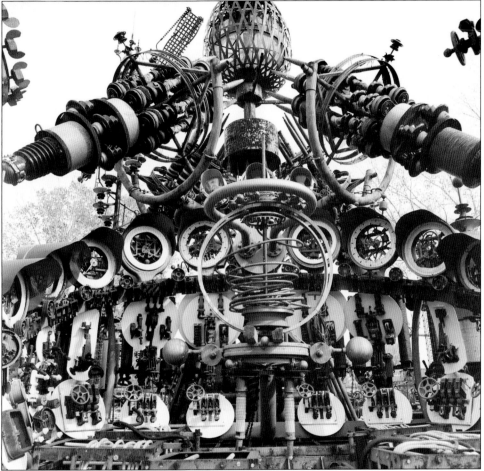

References
Detour Art, Ludwig, 2007.

Fantasy Worlds, Maizels & von Schaewen, 1999.

Raw Vision No. 25, 1998.

In 1983 salvage worker Tom O Every (b. 1939) passed his scrap business on to his son, began to call himself 'Dr Evermor', and started on the task of creating 'Forevertron', a massive construction designed to travel in space. The visionary piece of sculpture, made from scrap metal, machine parts from breweries, paper mills, engineering factories and even an Apollo decontamination chamber, weighs 300 tons and is 45 feet /15 m high by 105 feet/35 m wide. One section includes a spiral staircase and a wrought-iron gazebo. On the summit of the vast assemblage sits a copper egg housing a glass ball, waiting to shoot Dr Evermor into space, once it has been activated by a magnetic lightning beam. Around the structure sit various other constructions and animal figures, including a 46-member bird band, made from brass bed posts, old tools, gasoline nozzles and a full complement of musical instruments.

John Fairnington Jr
The Cement Managerie
Branxton, Northumberland, UK

Braemar, Branxton, Cornhill-on-Tweed, Northumberland, near the English–Scottish border.

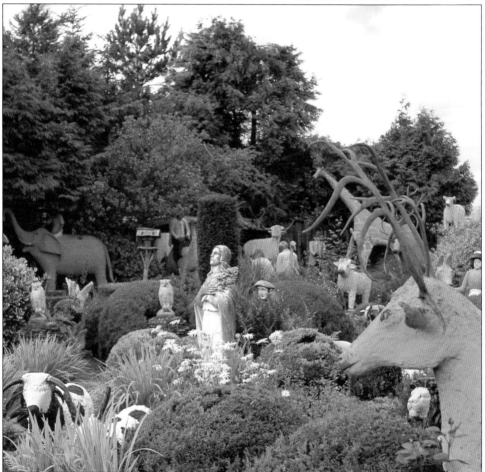

Created by retired joiner John Fairnington (1883–1981) for his disabled son, Edwin, with the help of his neighbours William Collins and James Beveridge, the garden known as the Cement Managerie contains around 300 sculptures of animals, among them rams, rabbits, zebras, polar bears, a giraffe and an elephant, and life-size figures including Winston Churchill and Lawrence of Arabia. Fairnington also installed a monument to the Battle of Flodden, which was fought nearby, and a shrine to Robert Burns. Beginning in 1962, he drew up full-scale drawings, and the painted sculptures were built by Beveridge over a period of nine years, using cement on a galvanised-wire armature. Evergreen shrubs, a wishing-well and a fish pool with a waterfall and a fountain completed the garden. When Edwin died in 1971, his father added a Memory Corner. Fairnington bequeathed the garden to charity, but his son John raised the money to buy it back and open it to the public.

References

Brilliant Gardens, Green & Lawson, London, 1989.

Fantasy Worlds, Maizels & von Schaewen, 1999.

Adolphe Julien Fouré
Les Rochers Sculptés, Rothéneuf
Saint-Malo, Brittany, France

Chemin des Rochers sculptés, Rothéneuf, 35400 Saint-Malo, Brittany, a few miles east of Saint-Malo. t: +33 (0)2 99 56 97 64.
www.saint-malo.net/saint-malo-rotheneuf.htm

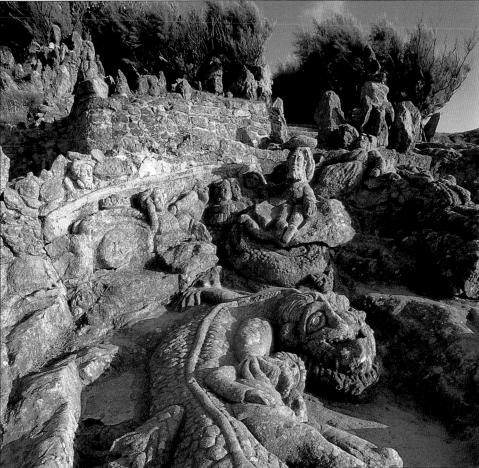

References
Fantasy Worlds, Maizels & von Schaewen, 1999.

La France Insolite, Arz, 1995.

Raw Vision No. 7, 1993.

Self-Made Worlds. Visionary Folk Art Environments, Manley & Sloan, 1997.

The country priest Adolphe Julien Fouré (1839–1910) started to chisel figures into the granite coastline at Rothéneuf, Brittany, following an illness which left him partially paralysed and mute. He resigned his church position and, over a period of 25 years, devoted himself to his creative work. More than 300 sculptures were produced, spreading across an area of 6,400 square feet (600 sq m). Some of the carvings are free-standing; others follow the natural contours of the shore. The sculptures narrate the daring exploits of the Rothéneufs, a notorious family of local pirates, as well as devotional scenes, sea monsters and other tableaux. Fouré also made wooden sculptures of birds, animals, figures and totems, a collection he exhibited in a small space known as the 'Diabolic Gallery'. The gallery was burnt down during bombing in the Second World War and only a handful of his wood creations survived, but Fouré's coastline rock carvings are still strongly in evidence.

Pearl Fryar
Topiary Garden
Bishopsville, South Carolina, USA

*145 Broad Acres Road, Bishopsville, SC 29010-2819. The garden has the number
165 (the old number) spelled out in the front yard.*
www.fryarstopiaries.com and **www.amannamedpearl.com**

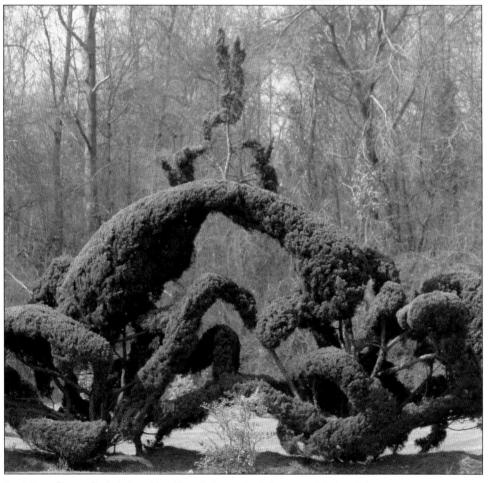

Pearl Fryar (b. 1940) started making his Topiary Garden in 1984 in a successful bid to win a prestigious local competition. He taught himself to prune and shape the trees and shrubs he had planted in his 3-acre garden, using a petrol-driven hedge trimmer and starting with a few plants. Working from his imagination, Fryar coaxed over 100 specimens of more than 20 different trees and plants, including holly, yew and juniper, into fantastic shapes: hearts, animals and abstract forms.

Between the living, convoluted sculptures messages of love, peace and goodwill are spelled out in flowers. More recent additions include metal structures and fountains in similar vein. Fryar has spent up to 50 hours a week maintaining his creation, working at night by the light of spot lamps and using a tall ladder to reach the highest branches. In 2006 he was awarded the Winthrop University Medal of Honor in the Arts for his work and his contribution to the community.

References
Detour Art, Ludwig, 2007.
Raw Vision No. 21, 1997.

Ed Galloway
Totem Pole Park
Foyil, Oklahoma, USA

North east of Tulsa on State Route 28A, Foyil, Oklahoma.
t: 918 342 9149.

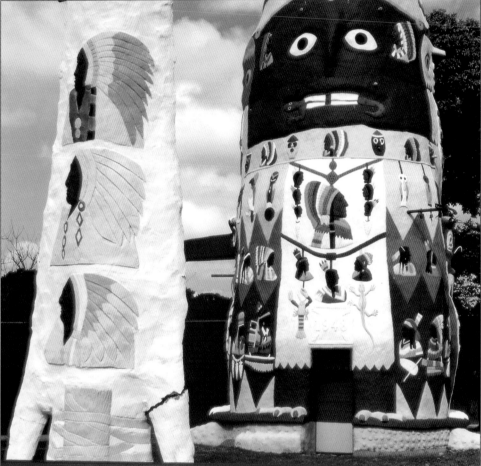

References
Backyard Visionaries, Brackman & Dwigans (ed.), 1999.

Detour Art, Ludwig, 2007.

Fantasy Worlds, Maizels & von Schaewen, 1999.

Gardens of Revelation, Beardsley, 1995.

Self-Made Worlds. Visionary Folk Art Environments, Manley & Sloan, 1997.

In a 14-acre park in Oklahoma stands the world's largest concrete totem pole. Begun in 1937 by retired woodwork teacher Ed Galloway (1880–1962), this monument to Native Americans took 11 years to build and stands 90 feet/27 m high. On the outside, painted in vivid colours, are low-relief carvings of 200 members of Native American tribes. Near the top stand the figures of four great chiefs. Galloway added further concrete structures to the site, including a birdhouse, a birdbath and several totem-pole gate-posts, and built a museum to house his collection of carved and inlaid furniture and decorative fiddles, all made by him. The 11-sided building is inspired by a Navajo hogan, and 26 carved columns support the roof. After Galloway's death many of his finest pieces were stolen from the unoccupied site and the structures deteriorated. In 1982 the Kansas Grassroots Association initiated restoration work, and the site was reopened to visitors.

Richard Greaves
Anarchitecture
Quebec, Canada

Oiseaux Chausse Gros, 494 Rang Chausse-Gros, St-Simon-les-Mines, CND-Beauce Québec GOM IKO.

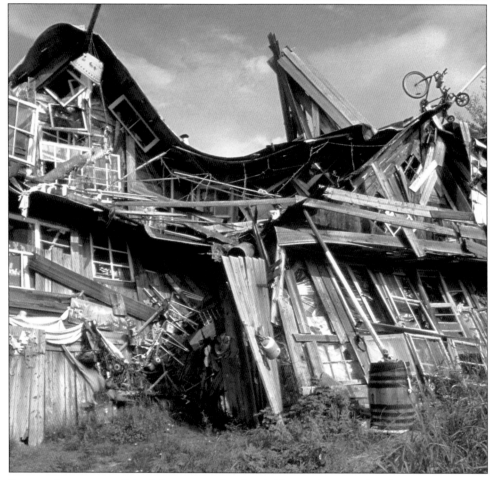

For more than 25 years Richard Greaves (b. 1950) has been creating sculpture from reclaimed materials on the isolated land he occupies in the Quebec. Several hundred pieces made from old vehicles, machinery, fridges and computer components and lashed together with rope stand among the trees or hang from branches. Greaves has also built a dozen architectural structures, their walls and roofs arranged at odd angles and their surfaces covered with a conglomeration of textiles, found objects and woven strips of wood. Window frames, doors and reclaimed timber from abandoned buildings are ingeniously assembled to form apparently precarious but remarkably solid buildings. The interior surfaces are covered with layers of photos, newspaper articles, pages torn from books, along with functioning items of furniture that sit incongruously between the disturbingly sloping walls. Quotations hang among pieces of Greaves' philosophical writing.

References
Fantasy Worlds, Maizels & von Schaewen, 1999.

Raw Vision No. 43, 2003.

Richard Greaves: Anarchitecte, Lombardi & Rousseau (ed.), 2006.

Tyree Guyton
The Heidelberg Project
Detroit, Michigan, USA

On the 3600 Block of Heidelberg Street, Detroit, Michigan 48219.
t: 313 267 1622.
www.heidelberg.org

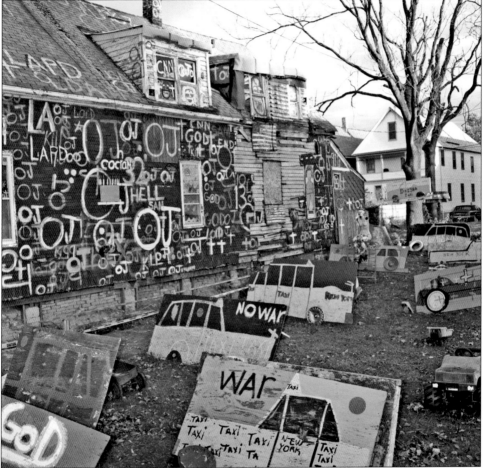

References
Connecting the Dots.
Tyree Guyton's Heidelberg
Project, Herron et al,
2007.

Fantasy Worlds, Maizels &
von Schaewen, 1999.

Raw Vision No. 6, 1992;
No 54, 2006.

Having grown up on Heidelberg Street and witnessed the tragic effect of the Detroit riots as a child, Tyree Guyton (b. 1955) set about cleaning up the decaying area with the help of his grandfather Sam Mackey, his former wife Karen, and neighbourhood children. In 1986, using the refuse they collected, Guyton began to transform the street into a massive open-air environment. In constant battle with the authorities since he began work on his project, Guyton continues to decorate abandoned buildings, vacant lots and pavements with all manner of discarded objects such as shoes, toys and old bicycles. His own paintings and messages cover the area, as well as the brightly painted polka dots that have become the trademark of the Heidelberg Project. Through his art, Guyton highlights the problems of poverty and urban ghettos, aiming to save forgotten neighbourhoods and inspire people to use and appreciate art as a means to enrich their environment.

Kenny Hill
Chauvin Sculpture Garden
Chauvin, Louisiana, USA

5337 Bayouside Drive, Chauvin, Louisiana 70344.
t: 985 594 2546.
www.nicholls.edu/folkartcenter

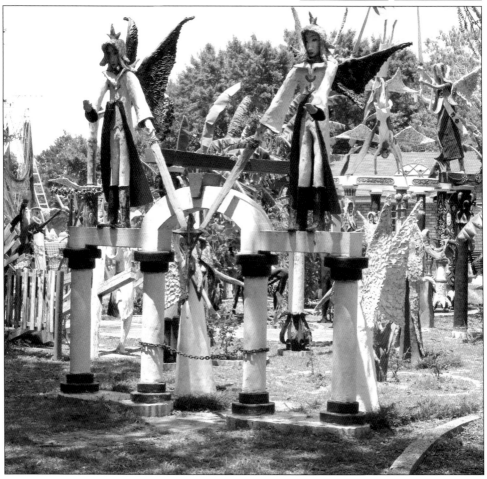

The garden created by Kenny Hill (b. 1950) over a 13-year period is a poignant manifestation of his spiritual vision and struggle. Begun when he was in his thirties, it comprises over 100 concrete sculptures. A brick-built lighthouse 45 feet (15 meters) high dominates the site, with painted relief sculptures of characters including Native Americans, soldiers and jazz singers clinging to its sides, and figures of angels at the top cradling the artist in their arms. Self-portraits of Hill appear throughout the garden, often appearing to be melancholy or suffering. Freestanding sculptures continue the theme of redemption. Life-sized figures watched over by angels stand on different levels between pathways inscribed with phrases such as 'Enter in to my heart'. The symbol of the nine planets appears a number of times and is echoed in the garden's nine circular platforms. In 2000, a disillusioned Hill left the site which has since been restored.

References
Raw Vision No. 53, 2005.

Raymond Isidore
La Maison Picassiette
Saint-Chéron, Chartres, France

22 Rue du Repos, Saint-Chéron, 28000 Chartres.
Closed Tue and Nov 1-Mar 31 and some holidays.
t: +33 (0)2 37 34 10 78, t: +33 (0)2 37 36 41 39.
www.thejoyofshards.co.uk/picassiette

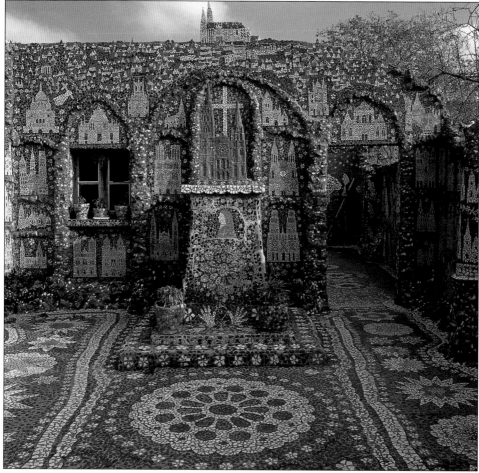

References
Fantasy Worlds, Maizels & von Schaewen, 1999.

La France Insolite, Arz, 1995.

Le Paradis terrestre de Picassiette, Kloos, 1979.

Picassiette: Le jardin d'assiettes, Fuks, 1992.

Raw Vision No. 30, 2000.

Self-Made Worlds, Manley & Sloan, 1997.

La Maison Picassiette was created by Raymond Isidore (1900–1964), a sweeper at the Saint-Chéron cemetery. Having built a house for his wife and stepchildren, Isidore started collecting pieces of broken china, glass and crockery and made simple mosaics around the house. This hobby became progressively more serious and in 1956, when Isidore retired, he devoted himself wholly to his obsession. He now worked continuously, eventually covering the interior, outside walls and garden. He included themes of femininity, death, religion and the famous cathedral of his home town of Chartres. His flowing, highly ordered images covered everything from Madame Isidore's sewing machine, to chairs, beds and tables. Isidore went on to build a courtyard complex around the back of the house, including a tiny chapel, free-standing sculptures and depictions of Jerusalem and Chartres in relief mosaic. He died from exhaustion, just two years after completing his project.

Danielle Jacqui
La Maison de Celle-qui-peint
Pont-de-l'Etoile, Provence, France

*11 Chemin de Rolland, Pont-de-l'Etoile en Provence, 13360 Roquevaire,
30 km north of Marseilles.
t: +33 (0)4 42 04 25 32. http:documentsdartistes.org/artistes/jacqui*

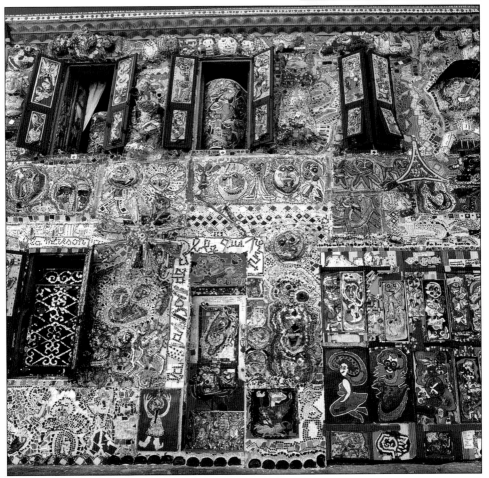

Danielle Jacqui's (b. 1934) first creative work was a large and vividly coloured piece of embroidery. This took her over a year to finish and marked her style of densely packed forms and vibrant colours from the outset. She progressed to paintings, becoming a leading member of the *artistes singuliers* group of self-taught artists in Provence, but also continues to produce her detailed three-dimensional embroidered figures and objects. Jacqui's powerful creative drive extends into her home and the entire house has been transformed into a living artwork: the walls, ceilings and staircase are covered in paintings and reliefs with beautifully calligraphed words and lettering. Mosaic has also played an important role; both the interior and exterior are bombarded with colourful pieces of glass and china, building up an overpowering texture. The brightly painted exterior wall includes some of Jacqui's paintings as the ever-evolving house merges into a single entity.

References

Art Brut et Compangnie, ex cat, 1995.

Fantasy Worlds, Maizels & von Schaewen, 1999.

La France Insolite, Arz, 1995.

Raw Vision No. 5, 1991.

Edward James
Las Pozas
Posada El Castillo, Xilitla, Mexico

Xilitla lies near Tamazunchale, some 300 km north of Mexico City in the east Sierra Madre mountains, Huasteca region. Accommodation is available within walking distance at El Castillo, Ocampo #105, Xilitla, SLP, CP 79900 Mexico. t: +52 (0) 489 365 0038. www.junglegossip.com

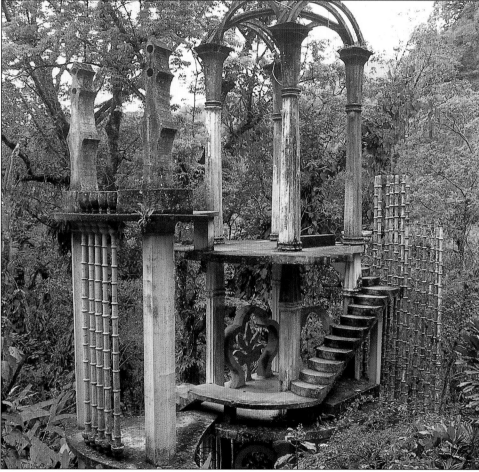

References
Fantasy Worlds, Maizels & von Schaewen, 1999.

Raw Vision No. 20, 1997.

A Surreal Life: Edward James, ex cat, 1988.

This large-scale flowing construction, set in the remote Mexican jungle, was devised by the eccentric English aristocrat Edward James (1907–1984). A poet and patron of Surrealist artists, James fell in love with this isolated area in 1945 on a trip to Xilitla. By 1962 James was able to begin constructing a magical surreal palace on 2,500 acres of land he had purchased. Using up to 60 local labourers, James worked from dawn to dusk, obsessively directing his complex plans. Flowing forms were created by local carpenters and masons who would mould the coloured concrete around curved wooden slats. The enormous nature-inspired columns resemble giant plants. Stairways lead nowhere; pools, fountains and arcades link parts of the site. The overall impression is of a temple from a long-lost civilisation. Although James worked on the site from the late 1940s until the mid-1980s, the construction was never completed, and it remains a place of mystery and intrigue.

Clyde Jones
Haw River Crossing
Bynum, North Carolina, USA

Route 15-501 South, six miles south of Chapel Hill.
www.carrboro.com/clyde/

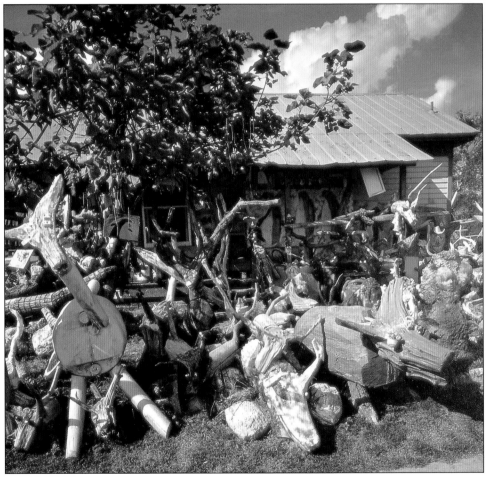

When an accident forced Clyde Jones (b. 1938) to give up his job as a logger, he began to make 'critters' from tree stumps and remnants of wood, cut with a chainsaw and assembled using nails. Plastic flowers and other found objects form facial and other features, and some of the figures are painted. In 1987 Jones also began to paint images of wildlife on plywood and old doors, using house and car paint; his house in the small milltown of Bynum is adorned with sea creatures and penguins. Many of the numerous wooden reindeer and other animals in the yard around the house are adorned with lights at Christmas. Jones's figures have been exhibited in places as far apart as the Smithsonian Institute and the Great Wall of China. He refuses to profit financially from the sale of his works, but offers them to be sold or raffled for charity, or simply gives them away. Jones loves to welcome visitors, particularly children, to see his critters.

References
Detour Art, Ludwig, 2007.

Karl Junker
Junkerhaus
Lemgo (near Hanover), Germany

Hamelner Str 36, 32657 Lemgo, southwest of Hanover and east of Bielefeld, and 20 km from the Dortmund-Hanover autobahn. The Junkerhaus is on the east side of the town. April to Oct open Tue–Sun; Nov. 1 – March 31 open Fri–Sun, t: +49 (0) 52 61 213 463. **www.junkerhaus.de**

Visionary Environments

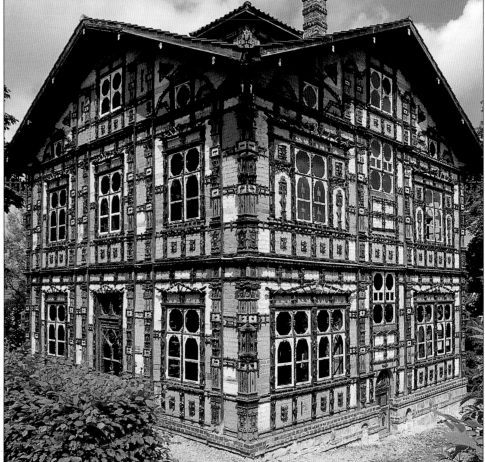

References
Fantasy Worlds, Maizels & von Schaewen, 1999.

Karl Junker und das Junkerhaus, Fritsch & Scheffler, 2000.

Raw Vision No. 41, 2002.

Karl Junker (1850–1912) devoted his life to a single visionary project, constructing a heavily ornamented house at Lemgo, near Hanover, in Germany. After studying architecture in Munich, Junker used money he had received from an inheritance to build the house. He led a solitary life, living alone for 22 years, even though the house was designed for a non-existent wife and family. In some ways reminiscent of the local 'weserrenaissance' building style, the Junkerhaus is crammed with numerous knobbled images and carvings. Subtle love and religious themes appear throughout the house, with embracing figures carved alongside images of Christ. The brown of the wooden interior glows mysteriously, lit by the small windows. The exterior of the house is painted with pale blues, yellows, whites and browns, in strict geometric patterns. A local museum now maintains the house and stores many of Junker's artworks, including paintings, drawings and sculptures.

Leonard Knight
Salvation Mountain
Niland, California, USA

Main Street, the road to Slab City, PO Box 298, Niland, California 92257, three miles east of Niland, about 100 miles inland from San Diego.
www.salvationmountain.us

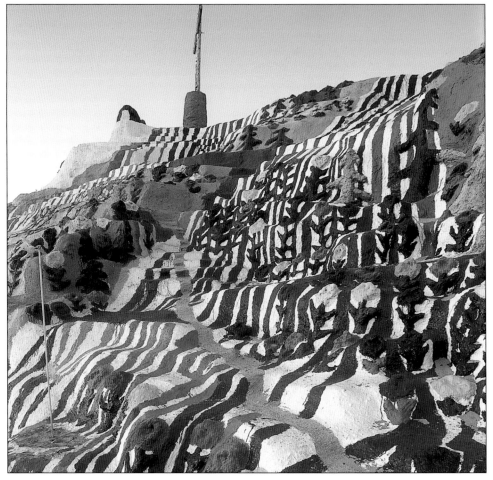

Leonard Knight (b. 1931) began painting and creating his Salvation Mountain after a failed attempt to fly the world's largest balloon, which he had spent ten years trying to make. Knight decided to stay on in the launch area, in a part of the desert known as Slab City. Using hundreds of gallons of donated paint, Knight has moulded and painted the side of a desert ridge as his monument to God and Love. He has used wet adobe clay to form giant letters spelling out biblical scriptures and religious commands. Steps have been carved into the side of the mound for viewers to scale. Knight now lives in his truck which is covered with religious slogans and images of angels and flags. He is very patriotic, despite the failed threat by local authorities to tear the amazing monument down as a health hazard, after concerns that it had been made using lead paint. The mountain is ever evolving, with Knight continuing to add to his creation.

References
Detour Art, Ludwig, 2007.

Fantasy Worlds, Maizels & von Schaewen, 1999.

Raw Vision No. 16, 1996.

Salvation Mountain: the Art of Leonard Knight, Yust, 1998.

Self-Made Worlds. Visionary Folk Art Environments, Manley & Sloan, 1997.

Louis Lee
Louis Lee's Rock Garden
Phoenix, Arizona, USA

4015 E. McDonald Drive, Phoenix, Paradise Valley, AZ.
McDonald abruptly turns north into a residential street; the house is at
the end of McDonald, on the south side.

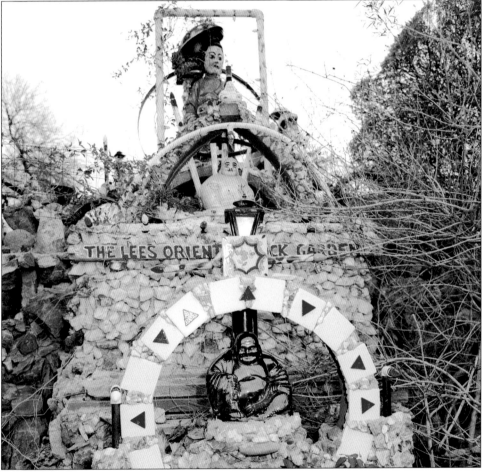

Louis Lee (1914–2006) moved to the USA from China in the 1920s. In 1958 he bought a house in Phoenix, Arizona and began building a rock garden in front of it. Over the years the garden came to obscure the house as Lee added larger rocks and constructed hundreds of delicate arches, walls and niches from adobe brick, into which he incorporated found objects such as crockery, bottles, plastic toys, bells, seashells, masks and sports trophies. In amongst the trees, shrubs and cacti the narrow, paved walkways are lined by closely packed displays festooned with coloured lights, with characters such as Uncle Sam appearing incongruously amongst oriental figures including Buddhas, elephants and Samurai warriors. Lee continued working on his garden until his death at the age of 92. Although the garden is not open to visitors, much of it can be seen from the road, and Lee's family has agreed to maintain it in his memory.

Edward Leedskalnin
Coral Castle
Homestead, Florida, USA

28655 South Dixie Highway, Homestead, Florida 33030.
t: 305 248 6345.
www.coralcastle.com and **www.waitingforagnes.com**

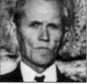

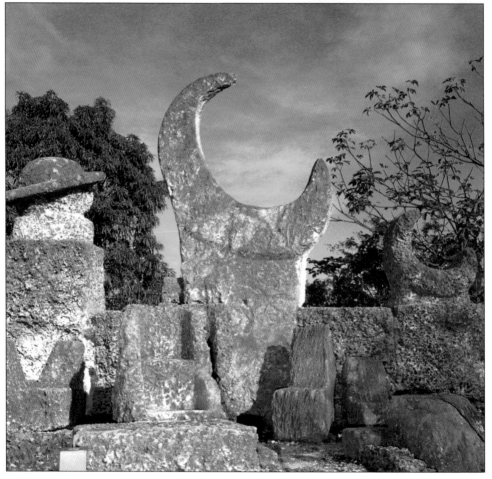

On the eve of his wedding, Ed Leedskalnin (1887–1951) was jilted by his fiancé. Heartbroken, he left his native Latvia and wandered around Europe before emigrating to North America, eventually settling in Florida in 1918. There he began to create a memorial to his lost love. Working alone and at night, and using homemade tools, over a period of 25 years he quarried and carved huge pieces of limestone into forms including a heart-shaped table, a rocking chair and a 9-ton perfectly balanced door. In 1936 he transferred his work to a walled compound on a 10-acre site. How he managed to move these massive pieces, which weigh as much as 30 tons, remains a mystery run through with speculation about earth energies, UFOs and the secrets of the pyramids. Rich in symbolism and designed to mimic an Egyptian temple, the castle includes a throne room, a repentance corner, an open air bath and a sundial inspired by Aztec culture.

References
Fantasy Worlds, Maizels & von Schaewen, 1999.

Gardens of Revelation, Beardsley, 1995.

Self-Made Worlds. Visionary Folk Art Environments, Manley & Sloan, 1997.

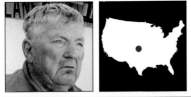

M.T. Liggett
Political Sculpture Garden
Mullinville, Kansas, USA

On Highway 400, just west of Mullinville, Kansas 67109.
On the north side of the road, on the west edge of town.
t: 316 548 2597.

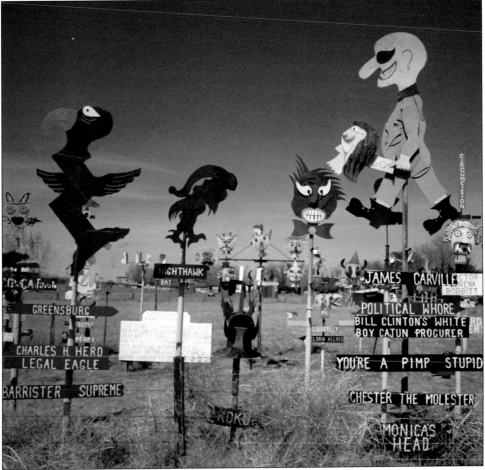

References
Detour Art, Ludwig, 2007.

M.T. Liggett's brightly painted metal cartoon figures dominate the roadside along a busy highway near Mullinville, Kansas for almost a mile. In 1989, after retiring from a career in the military, Liggett (b. 1930) returned to the farm on which he was born and began making metal sculptures using cutting and welding equipment and any scrap iron he could lay his hands on. Many of the sculptures have moving parts which whirl in the wind. The figures of humans, animals and mythical beasts are a graphic expression of Liggett's view of the world. Questioning assumptions, and often highly offensive, his visual vitriol is directed at individuals, including local characters and US politicians of both right and left, and organisations such as the Environmental Protection Agency; yet he does not hesitate to draw attention to others whom he admires. Each sculpture bears a painted caption, often in more than one language, adding written emphasis to Liggett's visual message.

199

Jean Linard
La Cathédrale
Neuvy-Deux-Clochers, Cher, France

*Les Poteries, 18250 Neuvy-Deux-Clochers, 30 km NE of Bourges on the D196
towards Neuilly-en-Sancerre, France.*
http://www.jillbelldesigns.com/photosfrance2.html

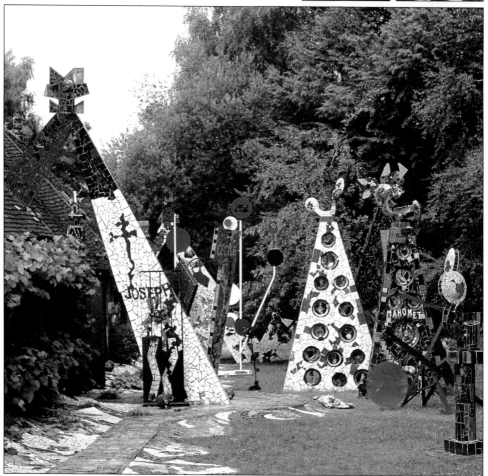

In 1961 Jean Linard (b. 1931) bought a quarry near Bourges, France, built himself a house and began erecting an open-air cathedral beside it. A potter, ceramicist and engraver, Linard makes his own tiles and mosaics, which cover the angular concrete structures and circular forms. Set amongst trees and flowers, the pure lines of the various elements of the cathedral recall the monumental architecture of the Middle Ages. The entrance is through a narrow ceramic doorway decked with painted sculptures. The arched nave is constructed from roughly hewn stone and supported by blue-tiled buttresses, and the baptistery is a large, mosaic-inlaid pyramid which stands in front of a pool. The rose windows incorporate bottles and pieces of mirror. Sandstone chairs are surmounted by gilded heads of angels, and mirrored mobiles representing the four evangelists contrast with ceramic blocks bearing the names of inspirational figures such as Nelson Mandela.

References
Fantasy Worlds, Maizels & von Schaewen, 1999.

La France Insolite, Arz, 1995.

Maisons de l'imaginaire, Ronné, 2004.

Raw Vision No. 14, 1996.

Self-Made Worlds. Visionary Folk Art Environments, Manley & Sloan, 1997.

Jacques Lucas
La Maison Sculptée de l'Essart
L'Essart, Brittany, France

L'Essart, off D92, Janzé, 30 km south east of Rennes, France.
www.rom.fr/lucas

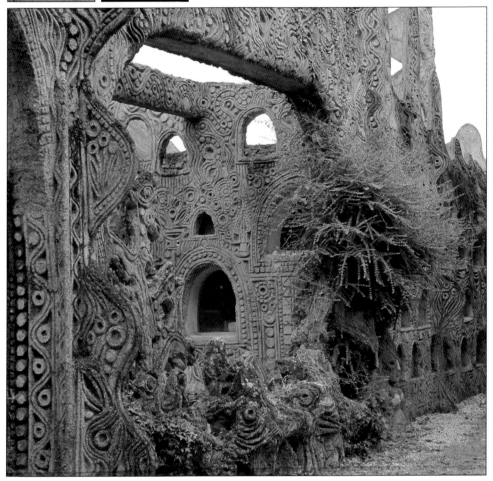

References
Maisons de l'imaginaire, Ronné, 2004.

After meeting the sculptor Robert Tatin in 1968, Jacques Lucas (b. 1944) was inspired to begin work on his house near Rennes, Brittany. He covered the building with heavily ornamented reinforced structures, their forms and swirling patterns reminiscent of the stonework of medieval cathedrals. Lucas brought his wide knowledge of the architecture and sculpture of many different cultures to his vision, building a kiln and a workshop within the ornate architecture in order to realise his creation. A labyrinth of concrete and vegetation surrounds the house with arcades, paths, stairways and bridges. Strange animals that recall a medieval bestiary manifest in the highly decorated surfaces of the sculptures, some of which appear and disappear according to the clarity and level of the water in the pools that punctuate the architecture. Since completing the major part of the work in the 1980s, Lucas has divided his time between the house and his studio.

201

Helen Martins
The Owl House
Nieu-Bethesda, South Africa

River Street, Nieu-Bethesda 6286, South Africa.
t: +27 (0)49 841 1733.
www.owlhouse.co.za

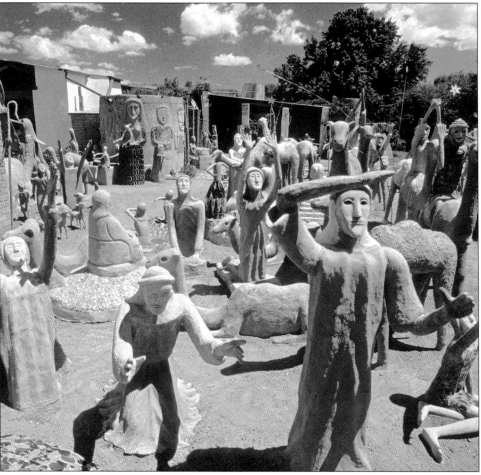

As Helen Martins (1898–1976) lay in bed one night looking at the moon shining in through her window, she decided to brighten up her life by covering the walls and ceilings of her house with ground glass. Strategically placed mirrors, shaped like crescent moons, stars and hearts, reflected the moonlight and the glow from dozens of candles and coloured paraffin lamps from room to room to transform the interior of the house. Tinsel twisted around giant candles increased the glitter, and large sheets of coloured glass were inserted in the walls to amplify the effect. Outside the house more than 300 free-standing cement sculptures and bas-reliefs on a variety of themes including owls, camels, mermaids, pyramids, Eastern philosophy and Christianity stand among brick towers and cut-out metal suns, stars and moons. Cacti are the only vegetation in the garden. All the work was carried out by three local men over a period of 18 years to Martins' specifications.

References
Fantasy Worlds, Maizels & von Schaewen, 1999.

Gardens of Revelation, Beardsley, 1995.

Raw Vision No. 5, 1991.

This is my world: The life of Helen Martins, creator of the Owl House, Ross, 1997.

Jeff McKissack
The Orange Show
Houston, Texas, USA

2401 Munger Street, Houston, Texas 77023.
t: 713 926 6368.
www.orangeshow.org

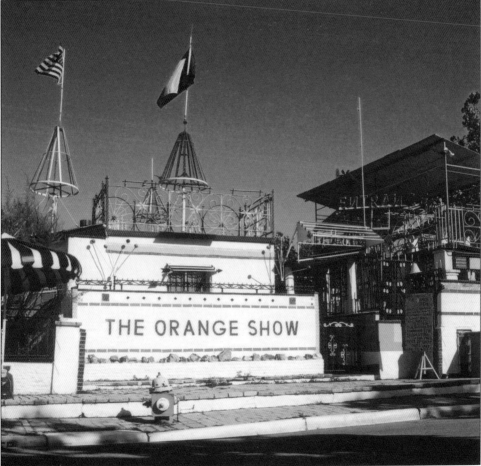

THE ORANGE SHOW

References
Detour Art, Ludwig, 2007.

Gardens of Revelation,
Beardsley, 1995.

The Orange Show was created single-handedly by postal worker Jefferson Davis McKissack (1902–1980) over a period of 23 years. McKissack believed that hard work, good food and oranges are the key to a long, productive and happy life. Using building materials and found objects, he made a series of linked walkways, balconies and arenas to house displays that demonstrate the virtues of the orange and its contribution to good health and longevity. Literary quotations and aphorisms encouraging positive living are integrated into scenes peopled by clothed mannequins and wooden figures and paintings and mosaics. A map showing the orange-growing regions of the United States combines with McKissack's original writings about the nutritional value of oranges, in an environment that is uniquely entertaining and informative. After McKissack died a foundation was set up to preserve the Orange Show.

John Milkovisch
The Beercan House
Houston, Texas, USA

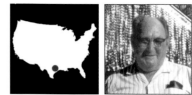

222 Malone, Houston, Texas 77007. Just off Memorial Drive between Shepherd and Westcott.
www.beercanhouse.org *and* **www.orangeshow.org/beercan.html**

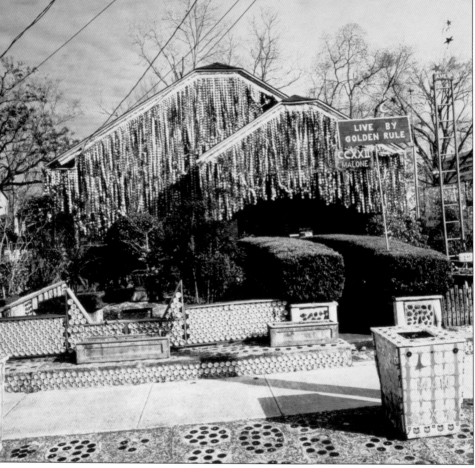

In 1968, tired of mowing his lawn, retired railway upholsterer John Milkovisch (1912–1988) concreted over his garden and embedded thousands of marbles, buttons, rocks and pieces of metal in the paths, the walls and the wooden fence. When his wife, Mary, asked him to clad the walls of their clapboard bungalow with aluminium, he decided to use flattened beer cans. Over a period of 18 years he attached tens of thousands of cans to the walls, making a feature of the printed designs. He hung the pull-tabs, tops and bottoms in strings from the roof to form curtains that shimmered and jingled as they turned in the wind. He also used cans to repair and decorate the outside fences and to make planters, arches, sculptures and whirligigs. After the Milkovischs died, the house was acquired by the Orange Show Center for Visionary Art and after restoring it by replacing the corroded sections with donated vintage beer cans, it was reopened to the public in 2008.

References
Fantasy Worlds, Maizels & von Schaewen, 1999.

Simon Rodia
Watts Towers
Los Angeles, California, USA

1727 East 107th Street, Los Angeles, CA 90002.
t: 213 847 4646.
www.wattstowers.us

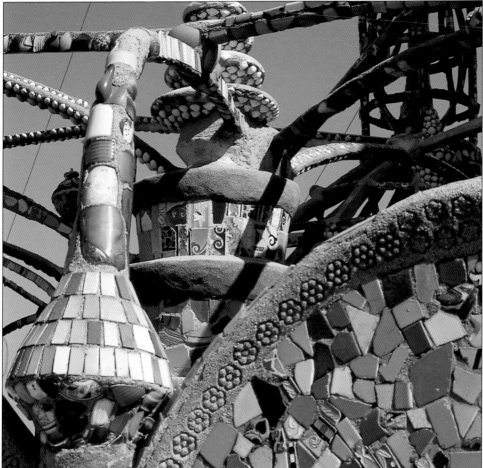

References
Detour Art, Ludwig, 2007.

Fantasy Worlds, Maizels & von Schaewen, 1999.

The Los Angeles Watts Towers, Goldstone, 1997.

Raw Vision No. 37, 2001.

Self-Made Worlds, Manley & Sloan, 1997.

Simon Rodia's Towers in Watts, Rosen & LaPorte, 1962.

Simon (or Sam) Rodia (1879–1965) came to the USA from Italy during the 1890s, finding employment mainly as an itinerant construction worker. In the 1920s Rodia acquired a small plot of land in Watts, Los Angeles. Working slowly and alone, he built the main structures by lashing together shaped and bent lengths of metal with wire. He then coated the structures with mortar in which he embedded a rich mosaic of shells, rocks, glass and colourful china. Rodia used no plans, welds or bolts and the structures acted as their own scaffold. The main tower, one of eight, reaches a height equivalent to a ten-storey building. The west tower includes the tallest reinforced concrete column in the world. Rodia left Watts, ceding the land to a neighbour before moving away, never to return. The Towers were threatened with demolition by Los Angeles city authorities but a successful campaign proved their safety and eventually they were given national landmark status.

Veijo Rönkkönen
Paradise (Sculpture Garden)
Parikkala, Finland

Kuutostie 611, 59130 Koitsanlahti, Parikkala, on main road 6, 300 km from Helsinki, 50 km north of Imatra, 7km before Parikkala village. The sign 'patsaspuisto' guides you towards the garden.
http://80.75.96.68/sptkul/userfiles/kansantaide/tmp/veijo_ronkkonen_18.html

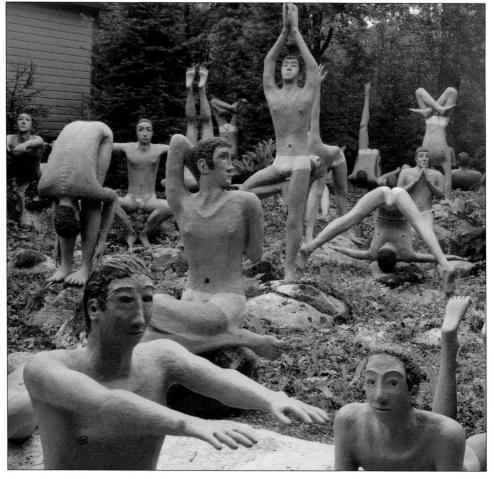

Hundreds of life-size painted figures inhabit the verdant garden of Finnish artist Veijo Rönkkönen (b. 1944). Built over the last 40 years from chicken wire and concrete, they represent people from all walks of life and from different cultures. Many of the figures have bright, staring glass eyes and authentic-looking teeth. Standing and sitting in groups amongst the abundant vegetation or strolling beside the path, they chat, play or go about their business. From the open mouths of some of them music can be heard. There are dancers, musicians, women with pots, a nun, a priest, a sheriff, a mechanic – all dressed in the clothes and carrying the tools of their trade. Naked figures of children cavort in the sunshine. In one area of the garden more than a hundred figures, self-portraits of the artist, hold a variety of yoga postures, facing the rising sun. In 2007 Rönkkönen won the Finland prize for his work.

References
Raw Vision No. 46, 2004.

The Real Life of Veijo Rönkkönnen, Granö, 2007.

Vollis Simpson
Windmill Farm
Lucama, North Carolina, USA

Wiggins Mill Road - Route 1, junction of 1103 and 1109 off Route 301, between Wilson and Lucama, North Carolina.
www.smm.org/sln/vollis

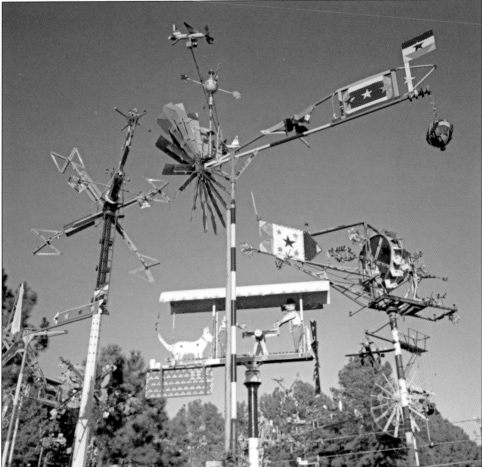

References
Detour Art, Ludwig, 2007.

Fantasy Worlds, Maizels & von Schaewen, 1999.

Self-Made Worlds. Visionary Folk Art Environments, Manley & Sloan, 1997.

Signs and Wonders; Outsider Art Inside North Carolina, Manley, 1989.

Vollis Simpson (b. 1919) built his first whirligig from the remains of a downed plane to power a washing machine when he was serving in the army during the Second World War. After he retired in 1986, he erected more than 30 giant whirligigs constructed from machine parts and metal accumulated from his welding and repair business. Haunting sounds accompany the motion of the massive, colourful steel structures, some of them over 40 feet/12 m high, which are covered with thousands of reflectors to make them shine at night. Mounted on the brightly painted whirligigs are moving figures of humans and animals cut from sheet metal: musicians play guitars and banjos, woodsmen saw wood, dogs wag their tails, birds flap their wings, and planes fly through the air as the wind catches the blades. Simpson incorporates all kinds of discarded material into his large-scale creations, including kitchen appliances, ventilators and broken silverware.

Fred Smith
Wisconsin Concrete Park
Phillips, Wisconsin, USA

State Highway 13, Phillips, WI 54555.
t: 715 339 4505 / 800 269 4505.
www.friendsoffredsmith.org

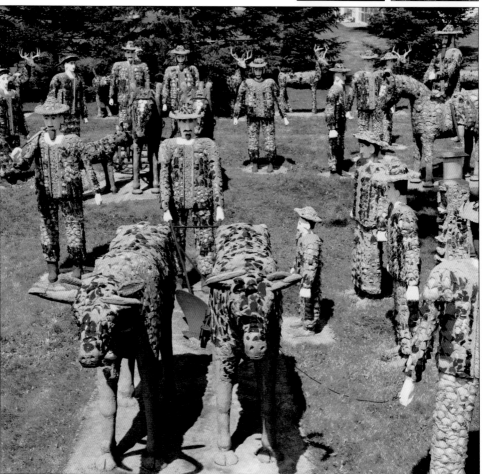

Lumberjack, farmer and musician Fred Smith (1886–1976) started work on his sculpture park in his mid-sixties. He had already built his Rock Garden Tavern next to his home, using collected stones bonded with cement. Smith built some 200 sculptures depicting human and animal forms, constructed from concrete placed over rough wooden armatures, with the surfaces covered with coloured rocks, broken crockery and glass. His numerous figures include Ben Hur, the Statue of Liberty, Abraham Lincoln, Kit Carson and the famous lumberjack Paul Bunyan, while animals include elks, deer, moose and numerous horses After Smith's death the site was purchased by Kohler Foundation, Inc., which funded an initial restoration and gifted the site to Price County in 1978. Since 1995 it has since undergone major restoration and been maintained by the Friends of Fred Smith organisation. There is now an ongoing conservation programme with regular newsletters.

References
The Art of Fred Smith, Stone & Zanzi, 1991.

Fantasy Worlds, Maizels & von Schaewen, 1999.

Gardens of Revelation, Beardsley, 1995.

Raw Vision No. 42, 2003.

Sacred Spaces and Other Places, Stone & Zanzi, 1993.

Self-Made Worlds, Manley & Sloan, 1997.

Robert Tatin
Le Musée Robert Tatin
Cossé-le-Vivien, Loire, France

La Frénouse, Cossé-le-Vivien, 53230 Laval, about 30 km south of Laval. Closed for month of Jan and Dec 25.
t: +33 (0)2 4398 8089. www.musee-robert-tatin.fr

References
Etrange musée Robert Tatin, Tatin, 1977.

Fantasy Worlds, Maizels & von Schaewen, 1999.

La France Insolite, Arz, 1995.

Raw Vision No. 32, 2000.

Self-Made Worlds, Manley & Sloan, 1997.

Tatin, ex cat, 1978-79.

Unlike most intuitive builders, Robert Tatin (1902–1983) had experienced some success as a ceramic artist before he purchased the derelict rural farmhouse of La Frénouse. After imaginatively restoring the house and with the assistance of his wife Lise, Tatin went on to build a personal temple to the heavens, reflecting his unique beliefs, a mixture of ancient and New Age philosophies. A series of life-size sculptures representing Tatin's own heroes stand along the Avenue of the Giants which leads to the open dragon's mouth at the entrance to the walled compound. Within, tall-standing sculptural structures representing the sun and moon look down on various figures, including those of Tatin and his wife, which are installed in arcades surrounding a central pool. Behind these are chambers that house Tatin's paintings and other creations. Unlike a purely intuitive builder, Tatin had an overall scheme in mind and worked with some premeditation and planning.

Grover Cleveland Thompson
Sunnyslope Rock Garden
Phoenix, Arizona, USA

10023 N. 13th Place, Phoenix, AZ.
www.gemland.com/sunnyslope.htm

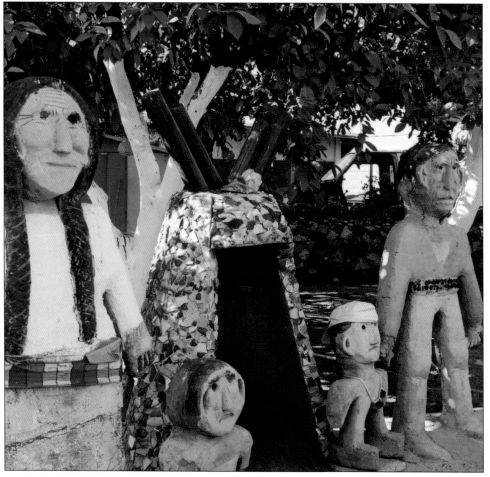

As a young man Grover Cleveland Thompson (d. 1978) built miniature fountains and visited Peterson's Rock Garden near his birthplace in Oregon. In 1954 he retired from his job as a heavy equipment operator and moved to the Arizona desert with his wife, Nancy. Thompson spent the next 22 years erecting more than 50 structures including miniature working windmills and fountains, fabricated from sheet metal and covered with small stones, glass and fragments of tile bonded with resin. He lined the paths between the buildings with archways made from concrete applied to metal armatures, with stones, seashells and fragments of pottery and glass embedded into the wet concrete to create a mosaic effect. The heads of the numerous figures around the site were made by pouring concrete into 1950s' Hallowe'en masks. After Thompson's death Marion Blake took over the conservation of the abandoned garden.

References
Raw Vision No. 52, 2005.

Richard Tracy
Richart's Ruins (The Art Yard)
Centralia, Washington, USA

203 M Street, Centralia, Washington.
I-5 Exit 82 to Harrison Avenue east. The Art Yard is on the left.
t: 360 736 7990.

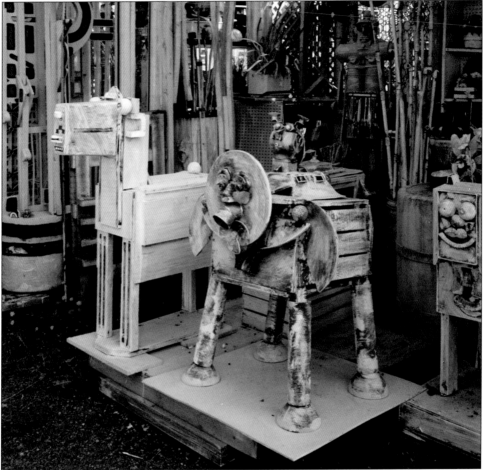

The eye-catching spires and kinetic sculptures that surround Richard Tracy's house in Ellenburg, Washington stand in stark contrast to the neatly kept neighbouring properties. Tracy (b. 1933), who prefers to be known as 'Richart', has been building his Art Yard since the early 1980s, inspired by a visit to Dick Elliott's nearby folk-art house. After studying art at Central Washington University, Tracy taught in schools for ten years and then worked in a hardware store. Diagnosed with bipolar disorder, he has found the condition an inspiration to his work. Monsters, humans and other animals made from found materials such as polystyrene, old light bulbs and roller skates peer out from the structures. Open to the elements, the work evolves through the ravages of the weather. Visitors to the Yard are invited to make their own art from polystyrene, beads and other found materials. In recent years the site has become a major local tourist attraction.

Billy Tripp
The Mindfield
Brownsville, Tennessee, USA

1 Mindfield Alley, Brownsville, TN.
On the southeast corner of the intersection of Highway 54/19 and Highway 70
South. Go west on 54/19 from the town square. t: 731 772 2193.

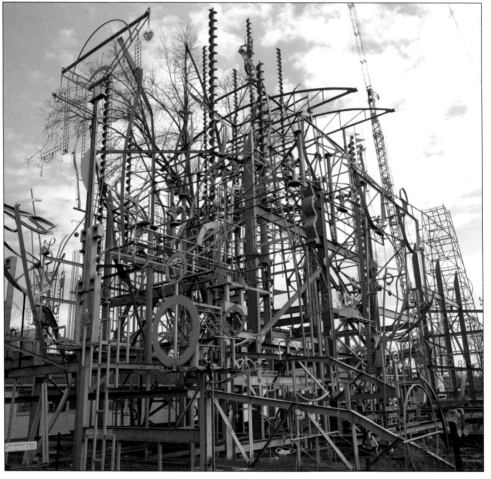

Close to the centre of Brownsville, Tennessee stands a colossal work consisting almost entirely of welded steel. Built by Billy Tripp (b. 1956), The Mindfield is a work in progress that was begun in 1989 and will be the artist's resting-place after his death. Described by Tripp as 'a conversation with myself', the 80 feet/25 m towers, girders and scrap metal of all kinds combine to tell the story of Tripp's life and to stand as a memorial to his parents and a testimonial to his belief in the inherent beauty of the world. Steel cut-outs of Tripp's hands and feet, skulls and crossbones and hearts share the space with found items such as a bathtub, a water tank and trusses salvaged from demolished buildings. Some of the components sway in the wind. In front of the huge structures stand colourful pieces expressing the importance of tolerance and freedom within the law. Tripp's flow-of-consciousness books *The Minefield Years* complement the structures.

Cleveland Turner
Flower Man's House
Houston, Texas, USA

2305 Francis Street, Houston, Texas. (Corner of Francis and Bastrop Streets.)

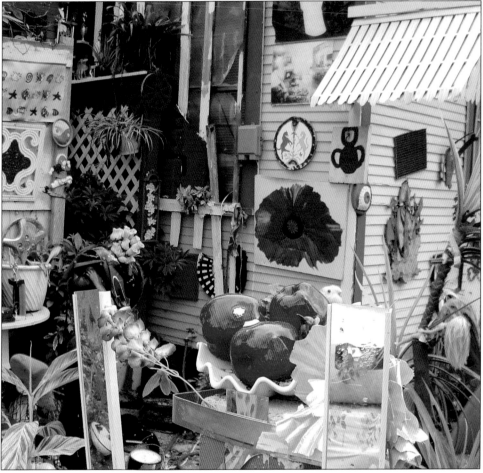

References
Detour Art, Ludwig, 2007.

As a child, Cleveland Turner (b. 1935) dreamed of having his own flower-filled house. Things did not turn out too well for him, and after spending 17 years homeless and eating scavenged food, he was found lying in the street suffering from alcohol poisoning and was taken to hospital. While he was convalescing he had a vision of beauty, which he vowed to create as part of his bid to stay sober. He rented a house and began to transform the interior and the outside with flowers, both living and plastic, as well as broken toys, painted tools, and other discarded objects. Turner travels ten miles each day on his plastic-flower-decked Flowercycle in search of more items, particularly from wealthy neighbourhoods, to add to his art environment. In 2004 he bought a house in the same neighbourhood as his first site. There he began anew, planting flowers and re-siting his collection, placing each instinctually to create a colourful, ever-changing display.

Frank Van Zant
Thunder Mountain Monument
Imlay, Nevada, USA

Between Winnemucca and Lovelock off I-80, about 120 miles east of Reno.
www.thundermountainmonument.com

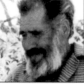

In 1968, Frank Van Zant (1921–1989) changed his name to Chief Rolling Thunder and moved from California to rural Nevada, where he built a house as a memorial to Native Americans. It began as a one-room trailer to which he added corridors, stairways and two more storeys. The walls are constructed from 'bottle and daub', and car windscreens form windows. Sculptures and arches stand on the roof, the tallest 50 feet/15 m high, and on top perches a carved wooden eagle. The outside walls are covered with bas-reliefs depicting historic massacres. Outside the house, concrete sculptures portray Native American heroes, family and friends. Also on the site are a roundhouse, a hostel building, guest cabins and an underground hut. In 1983 the three-storey hostel building burned down and the underground hut caved in. Van Zant's wife and children abandoned him, and he took his own life in 1989, leaving the site to his son Dan, who undertook its restoration.

References
Fantasy Worlds, Maizels & von Schaewen, 1999.

Gardens of Revelation, Beardsley, 1995.

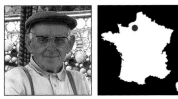

Robert Vasseur
La Maison à Vaisselle Cassée
Louviers, France

*80 rue du Bal-Champêtre, 27400 Louviers, 20 km south of Rouen.
t: +33 (0)2 32 40 22 71 / +33 (0)2 32 25 14 40.*

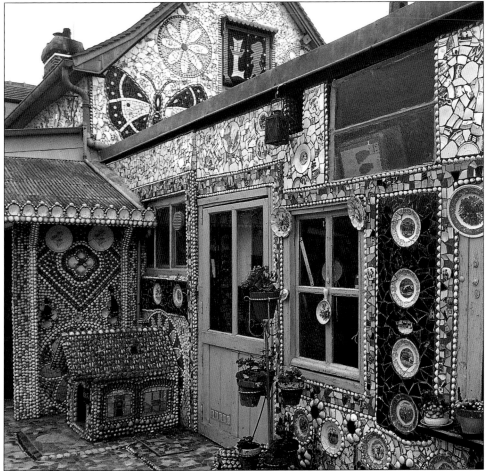

References
Bonjour aux promeneurs!,
Thiébaut, 1996.

Fantasy Worlds, Maizels &
von Schaewen, 1999.

La France Insolite, Arz,
1995.

La Maison à Vaisselle Cassée (The House of Broken Crockery) was the creation of retired milkman Robert Vasseur (1908–2002). In 1952, with the help of his wife, Vasseur started covering his house with crockery, shells and stones. A huge butterfly dominates the exterior of the dwelling which is almost entirely encrusted with mosaic of predominantly geometric forms. Inside the house, everything – the ceilings, walls, appliances and even pieces of furniture – is covered in expertly executed mosaic. The courtyard behind the property is also covered with shells and broken china, as are a dog's kennel, a gazebo and a rotating mechanical feature, powered by flowing water. Vasseur's sources of material were wide: he managed to acquire pieces from nearby restaurants and friends who worked at the local dump put aside materials for him. Vasseur then cleaned and sterilised the broken china and shells before using them to further embellish his home.

Milton & Florence Walker
Walker Rock Garden
Seattle, Washington, USA

5407 37th Ave SW, Seattle.
t: 206 935 3036.

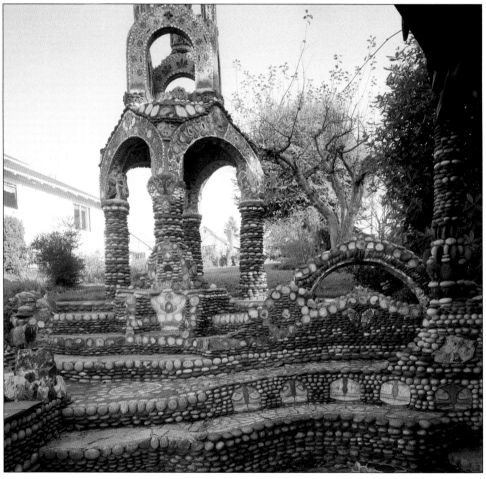

In 1959 Milton Walker (1905–1984) built a pond in his back garden, embellished it with rocks and went on to create a miniature landscape around it into which his wife, Florence (1909–2000) planted small succulents and flowering plants. Over the next 20 years, with Florence's assistance, Milton filled the space with a tribute to nature: a fanciful mountain scene built around a central volcano fountain from which water issued to fill rivers and a lake. Paths and butterfly-shaped stepping stones meander between walls, arches, towers and sculptures, all built from concrete set with thousands of river-worn rocks and pebbles, many collected by the Walkers themselves. The fanciful forms are enhanced with geodes, slabs of polished petrified wood and mosaics of seashells, coloured glass and semi-precious stones. After Milton's death Florence continued to care for the garden for many years.

Bruno Weber
Weinrebenpark
Dietikon, Zürich, Switzerland

Spreitenbach, 8953 Dietikon.
t: +41 (0)44 740 02 71.
www.bruno-weber.com and ***www.labyrinthe.com/bruno_weber***

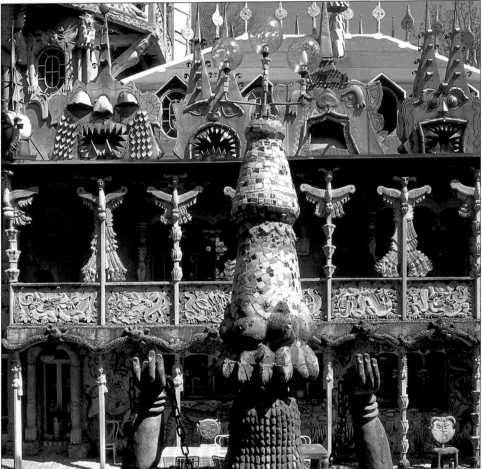

References
Fantasy Worlds, Maizels & von Schaewen, 1999.

Raw Vision No. 44, 2003.

Self-Made Worlds. Visionary Folk Art Environments, Manley & Sloan, 1997.

Created by Bruno Weber (b. 1931) and his wife Marianne, Der Weinrebenpark is built on land Weber inherited in 1962. Having received some formal art training, Weber began by constructing and decorating a studio which, over time, expanded and transformed into a land of monsters, giant statues of cat-headed elephants, vast snaked bridges and lizard-like hybrids. The environment now consists of a three-storey building surrounded by two 22 metre towers leading up through a grand colonnaded entrance. A number of structures are coated with a mosaic of colourful china fragments. Oriental male figures, fashioned as seats, line an avenue outside. Animal-shaped gates and unusual water gardens also appear from within the undergrowth surrounding the house. Weber is a prolific creator who supports the construction of his environment through the sale of smaller artworks and continues to work on his formidable beast-like creatures.

Paul & Matilda Wegner
Wegner Grotto
Cataract, Wisconsin, USA

Highway 27 North on the corner of 27 and 71.
North of Sparta off Highway 27, West on Highway 71, near the town of Cataract.
www.mclhr.org/wegnergrotto.php and **www.kohlerfoundation.org/wegner.html**

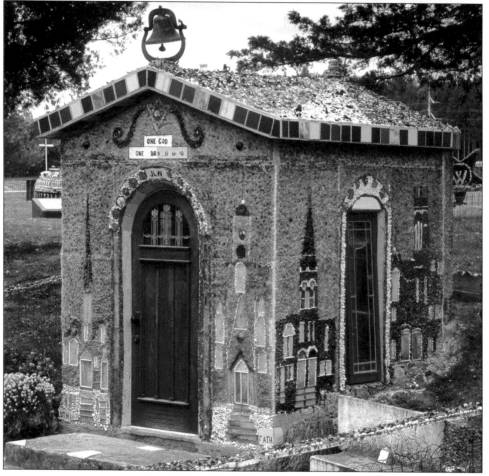

In 1885, Paul (d. 1937) and Matilda Wegner (d. 1942) emigrated from Germany to the USA and bought a farm near Cataract, Wisconsin. A visit to Dickeyville inspired them to create their own grotto, and in 1929 they began by building a 12-foot replica of an ocean liner from concrete, into which they set coloured glass to form glittering mosaics. Over the next seven years they made a variety of buildings and monuments, including a chapel, a bird-house, a US flag and a scaled-up reproduction of their 50th anniversary cake, incorporating pieces of crockery, seashells and Indian arrowheads, and working names in crushed glass. The chapel is known locally as the Glass Church, and Paul's funeral service was held there in 1937. Matilda continued work on the grotto and also embellished the cemetery where they are both now buried. Restoration took place after 1986 when the Grotto was bought from the Wegner family by the Kohler Foundation.

References
Sacred Spaces and Other Places, Stone & Zanzi, 1993.

Father Mathias Wernerus
Dickeyville Grotto
Dickeyville, Wisconsin, USA

305 W. Main Street, Dickeyville, WI 53808.
t: 608 568 3119.
www.dickeyvillegrotto.com

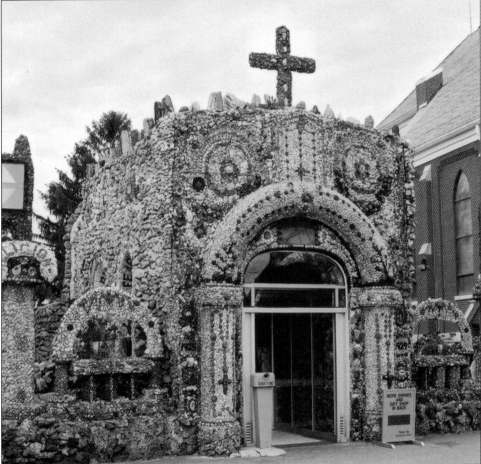

References
Detour Art, Ludwig, 2007.

Dickeyville Grotto: The Vision of Father Mathias Wernerus, Niles, 1997.

Fantasy Worlds, Maizels & von Schaewen, 1999.

Gardens of Revelation, Beardsley, 1995.

Sacred Spaces and Other Places, Stone & Zanzi, 1993.

Inspired by Dobberstein's Grotto of the Redemption, the Dickeyville Grotto was built in the 1920s by Father Mathias Wernerus (1873–1931) and is dedicated to the virtues of religion and patriotism. It consists of a series of shrines made from cement panels encrusted with coloured stones, crystals, shells, stalactites and a variety of discarded materials including tiles, glass and crockery donated by Wernerus' parishioners. The entrance to the main chapel, the Grotto of the Blessed Virgin, is through a Roman arch, and standing in the richly ornamented interior is a Carrera marble statue of the Virgin and Child. Set into the outside back wall is a Tree of Life made from petrified wood, with fruits represented in coloured glass, tiles and stones. The other major feature of the Holy Ghost Park in which the grotto stands is a patriotic shrine in the form of a semi-circular wall studded with shells and glass flowers, with statues of Columbus, Abraham Lincoln and George Washington.

Isaiah Zagar
Philadelphia's Magic Gardens
South Street and surrounding area, Philadelphia, Pennsylvania, USA

www.isaiahzagar.org and *www.philadelphiasmagicgardens.org*

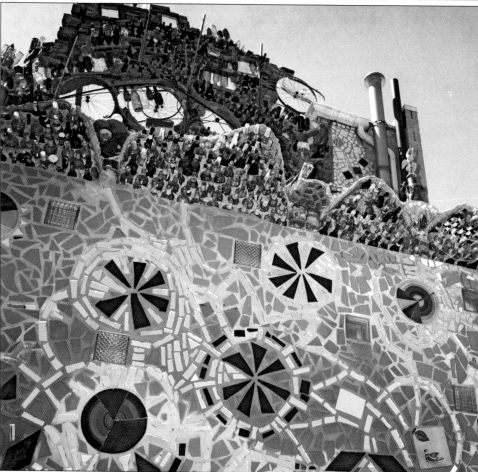

In the late 1960s Isaiah Zagar (b. 1940) opened a gallery on South Street, Philadelphia, in an area slated for demolition to make way for a new road. A visit to Clarence Schmidt's House of Mirrors had inspired him and he began to decorate the space with a mixture of objects collected in South America and materials from abandoned warehouses, creating a mosaic that spread through the building and out onto the street. Over the next several decades he gradually covered many buildings in the neighbourhood with his mosaic murals. He began work on a sculpture garden, in which fragments of glass and ceramics formed images and words in a glorious conglomeration of colour, pattern and poetry, its shimmering walls piled high with objects including bicycle wheels, coloured bottles and wire sculptures. When the owner decided to sell the land on which the Magic Garden was built, local citizens raised the money to purchase it and preserve Zagar's work.

References
Philadelphia's Magic Gardens, 1999.

Raw Vision No. 49, 2004.

Brother Joseph Zoettl
Ave Maria Grotto
Cullman, Alabama, USA

1600 St. Bernard Drive SE, Cullman, AL.
t: 256 734 4110.
www.avemariagrotto.com

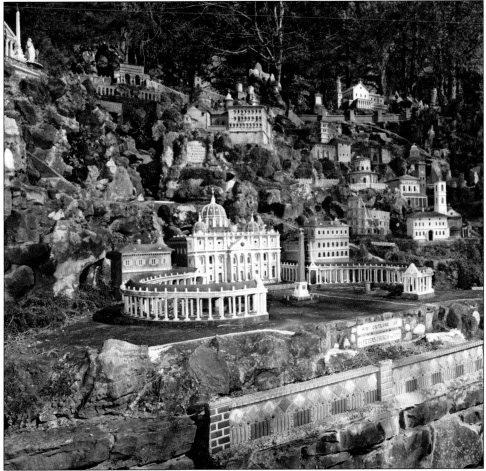

References
Fantasy Worlds, Maizels & von Schaewen, 1999.

Gardens of Revelation, Beardsley, 1995.

Self-Made Worlds. Visionary Folk Art Environments, Manley & Sloan, 1997.

To help pass the time while he was working in the power plant at the Benedictine monastery of St Bernard Abbey, lay brother Joseph Zoettl (1878–1961) made models of churches and other holy buildings. He also built thousands of miniature grottoes and shrines for sale in the monastery's shop. In 1932 the abbot permitted him to move his collection of models to a disused quarry in the monastery grounds. He also asked Zoettl to build a grotto. The cement-reinforced structure, completed within two years, stands 27 feet/8.2 m high and contains commissioned marble statues of the Virgin and two saints in a setting of marble, coloured glass, shells and concrete stalactites. It is surrounded by more than 100 miniature painted concrete replicas of religious and secular buildings from America, Europe and the Holy Land, their walls adorned with a rich variety of objects and textures. Many of the decorations were sent by admirers of Zoettl's work.

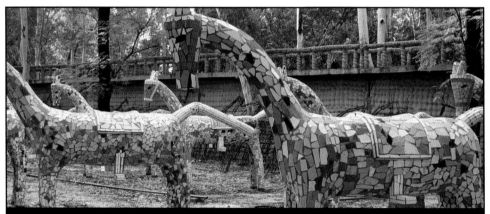

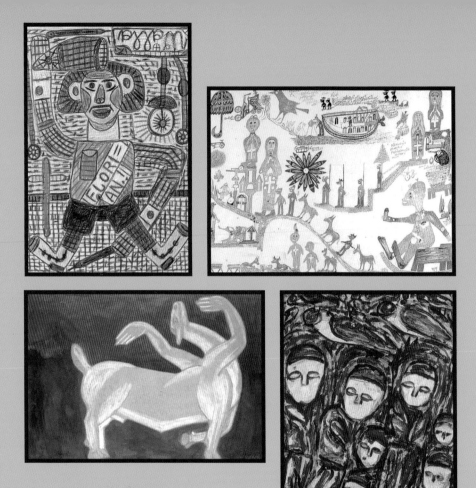

JUDY A SASLOW GALLERY

Outsider Art • Folk Art • Contemporary Art

300 West Superior Chicago Illinois 60610
phone 312 943 0530 fax 312 943 3970
jsaslow@corecomm.net www.jsaslowgallery.com
Tuesday – Friday 10 to 6, Saturday 10 to 5:30

See our website for a complete list of artists represented

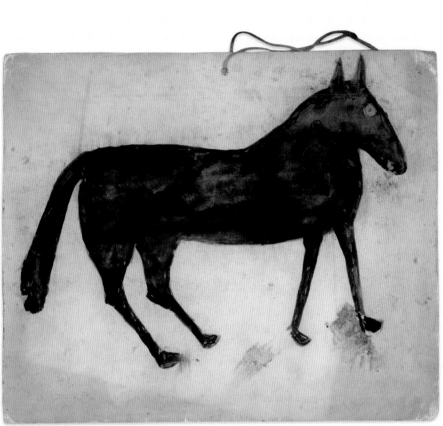

Bill Traylor "HORSE." Paint and graphite on paper, original string. 22" x 20"

American Folk and Outsider Art

Susan Baerwald and Marcy Carsey

2346 Lillie Avenue ı PO Box 578 ı Summerland, CA 93067
(805) 969-7118 T ı www.justfolk.com ı (805) 969-1042 F

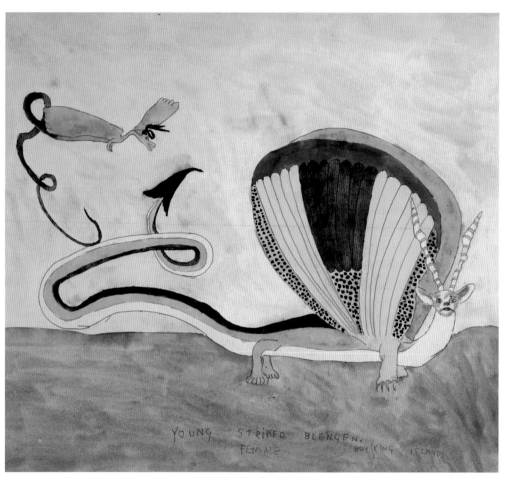

Young Stripped Female Blengen. Boy King Islands, 48 x 61 cm, watercolor, pencil on paper

HENRY DARGER

Edlin Gallery

529 w. 20th st. 6th fl.
New York, NY, 10011

212.206.9723
www.edlingallery.com

JP Ritsch-Fisch Galerie
6 place de l'Homme de Fer / 67000 Strasbourg - France
Tél. (+ 33) 03 88 23 60 74 / fax. (+33) 03 88 22 34 05 / ritsch.fisch@wanadoo.fr

Membre du Comité Professionnel des Galeries d'Art (CPGA), Paris.

Carlo Zinelli, *Untitled*, 1970, gouache on paper, (no verso) 27½ x 19¾ in.

YLLIS KIND GALLE

236 w 26th Street #503, New York, NY 10001

212 925 1200 email: staff@phylliskindgallery.cc

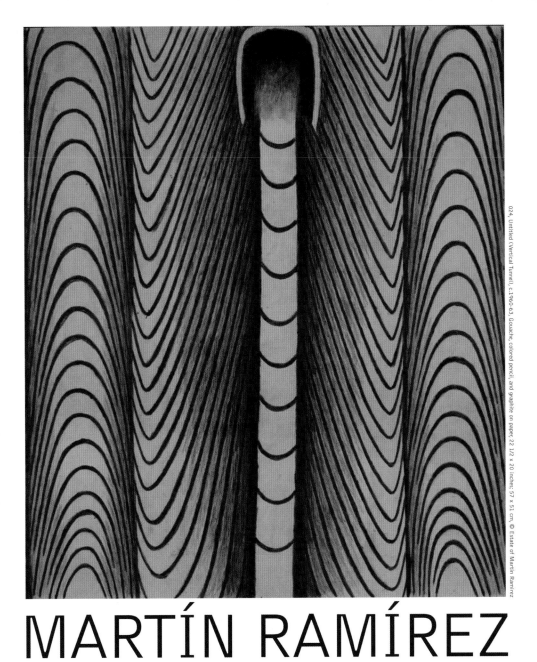

024, Untitled (Vertical Tunnel), c.1960-63, Gouache, colored pencil, and graphite on paper, 22 1/2 x 20 inches, 57 x 51 cm, © Estate of Martín Ramírez

MARTÍN RAMÍREZ

HENRY BOXER GALLERY

98 Stuart Court, Richmond Hill, Richmond TW10 6RJ
t/f: +44 (0) 20 8948 1633 henryboxer@aol.com
by appt www.outsiderart.co.uk

Henry Boxer has dealt in outsider and visionary art since the 1970's. He specialises in the
work of European Art Brut masters, including Wölfli, Monsiel, Scottie Wilson, Madge Gill
and Johann Hauser. He also represents American artists George Widener, Malcolm McKesson,
Joe Coleman, and British artists, Nick Blinko, Vonn Stropp, Donald Pass, Dora Holzhandler,
Albert Louden, Austin Spare and Louis Wain.

George Widener

WEEKEND GALLERY

86 High Street, Hastings, East Sussex TN34 3EY
t: +44 (0)1424 719296 info@weekendgallery.co.uk
Thur–Sat, 10am – 6pm www.weekendgallery.co.uk
Sun, 11am – 5pm

The Weekend Gallery is based on the Sussex coast showing a program of contemporary
figurative art and original printmaking, by artists such as: Jane Andrews, Pamina Stewart,
Michael Davies, Alexis Rago, Jeremy Townsend, Gary Goodman, Charlotte Snook, Anne Batty,
Janet Waring, Charles Williams, Gordon Robin Brown, Leigh Walker, Jola Spytkowska.

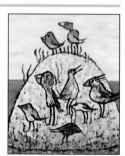

Alexis Rago

CANADA

GALLERY GACHET

88 East Cordova Street, Vancouver BC V6A1K2
t: +1 604 687 2468 gallery@gachet.org
Wed-Sun 12-6 & by appt www.gachet.org
(Irwin Oostindie, Lianne Payne)

Gallery Gachet is an outsider artist-run centre with two exhibition spaces, and art
production studios for painting, ceramics, woodworking, media arts, performance art and
community art collaborations. Collectively-managed, Gachet is Canada's premiere mental
health arts centre, exhibiting local and international artists and voted Vancouver's second
most popular art gallery in 2005 and 2007.

Laurie Marshall

FRANCE

GALERIE IMPAIRE

47 rue de Lancry, Paris 75010 www.galerieimpaire.fr
t: +33 (0)142 49 07 58

Creative Growth Art Center (CGAC) opened this new Paris art gallery in June 2008. Galerie
Impaire will showcase artists with disabilities, self taught artists and artists whose work
responds to this genre; Paris offers the opportunity to open a venue at a crossroads of art
collectors, visitors, and an international community of collectors. The idea to blend genres
comes from Creative Growth's desire to have its artists with disabilities be seen as who
they are – contemporary art makers

Galerie Impaire

GALERIE OBJET TROUVÉ/CHRISTIAN BERST
24, rue de Charenton, Paris 75012 contact@objet-trouve.com
t: +33 (0)1 53 33 01 70 www.objet-trouve.com
Wed–Sat 2–7 & by appt
(Christian Berst)

The Galerie Objet Trouvé/Christian Berst was founded in 2005 in Paris, the cradle of Art Brut. It offers the widest range of Art Brut & Outsider Art of any gallery in Europe. It has earned a remarkable reputation among collectors from all over the world, who visit the gallery to find works by classic Art Brut artists and exceptionally rare pieces by lesser-known creators, and to discover the great names of tomorrow.

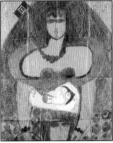
Augustin Lesage

FRANCE

GALERIE RITSCH-FISCH
6 place de l'Homme de Fer, 67000 Strasbourg
t: +33 (0)3 88 23 60 74 ritsch.fisch@wanadoo.fr
f: +33 (0)3 88 22 34 05
(Jean-Pierre Risch Fisch, Jean-Claude Kaiser)

For 12 years the Ritsch-Fisch Gallery has focused on presenting major works of art brut and outsider art, including those of ACM, Aloïse Corbaz, Joseph Crépin, Augustin Lesage, Barbus Müller and Adolf Wölfli. The gallery also attends major art fairs in Paris, Cologne and New York. An ideal place to find rare works which may be unavailable elsewhere.

Aloïse Corbaz

GERMANY

GALERIE SUSANNE ZANDER
Delmes & Zander GbR, Antwerpener Str. 1, 50672 Cologne
t: +49 (0)221 521625 info@galerie-susanne-zander.com
f: +49 (0)221-5101079 www.galerie-susanne-zander.com
Tue-Fri 12–6, Sat 11–2
(Susanne Zander, Nicole Delmes)

The gallery was founded in 1988 and specialises in European and East European Outsiders and mediumistic art. They include the artists of Gugging, Madge Gill, Wolfgang Hueber, Michel Nedjar, Heinrich Nüsslein, André Robillard, Foma Jaremtschuk, Miroslay Tichy, Alexander Lobanov, Blalla W. Hallmann, Thomas Grundmann, Sava Sekulic

Miroslav Tichy

HAITI

GALERIE BOURBON-LALLY
12 Rue Garnier, Bourdon, Petion-Ville, Ouest, Haiti
t: +1 646 233 1260/509 2257 1775 info@bourbonlally.com
by appt www.bourbonlally.com

Outsider, Haitian, Latin American and Voodoo Art. Constant, Anne-Marie Grgich, Daniel Belardinelli, Haitian Flags, Nasson, St.Eloi, St Soleil, Damian Michaels, Guyodo, Celeur, Eugene, Pierrot Barra, Frédéric Bruly Bouabré, Baya, Brazilian Art, Scott Griffin.

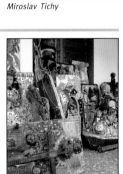
Galerie Bourbon-Lally

ITALY

ART VERONA

Veronafiere, Viale del Lavoro, Verona 37135
t: +39 (0)45 8039204 staff@artverona.it
f: +39 (0)45 8015004 www.artverona.it

Being now in its 4th year, Art Verona is the big art fair in Italy for the opening of the Autumn-Winter market of modern and contemporary art. It is the only one in Europe which dedicates an exhibition and special section to Outsider Art, through the presence of specialised international galleries.

Art Verona

JAPAN

GALERIE MIYAWAKI

Nijo-agaru, Teramachi-dori, Nakagyo-ku, Kyoto-city, Kyoto 640-0915
t: +81 75 231 2321 info@galerie-miyawaki.com
f: +81 75 231 2322 www.galerie-miyawaki.com
Tue–Sun 11–6
(Yutaka Miyawaki)

Founded in 1959, originally specialised in Surrealism and Cubism, nowadays known as the leading commercial dealer who is devoted to developing its unique presence, focusing on primordial artistic creativity, covering from up and coming contemporary artists to the authentic outsider artists. It shows European and American well known works of Art Brut.

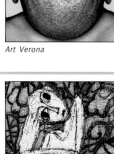
Rosemarie Koczÿ

NETHERLANDS

GALERIE HAMER

Leliegracht 38, 1015 DH Amsterdam
t: +31 (0)206 267 394 galeriehamer@hetnet.nl
Tues–Sat 1.30–5.30 www.galeriehamer.nl
(Nico van der Endt)

Galerie Hamer was founded by Nico van der Endt in 1969 and since 1970 has specialised in European naive and folk art. In 1975 Willem van Genk was rediscovered and Art Brut/ Outsider Art was added to the exhibition programme. Other artists include: Roy Wenzel, Vasilij Romanenkov, Franz Kernbeis, Semerak, Nedjar, Nikifor and many others.

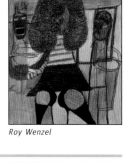
Roy Wenzel

NETHERLANDS

GALLERY ATELIER HERENPLAATS

Schiedamse Vest 56-58, 3011 BD Rotterdam.
t: +31 (0)102 141 108 atelier@herenplaats.nl
Open daily 9–5 www.herenplaats.nl

Twentyfour disabled artists are connected with atelier Herenplaats. They work daily at the studio, receive special attention and make use of the collective work and exhibition spaces. Gallery Herenplaats helps them with the commercial and business aspects of being an artist. A new exhibition of work by both mainstream and Outsider artists is held every two months.

Minke de Fonkert

NETHERLANDS

OLOF ART GALLERY
Volmolengracht 29, 2312 PG Leiden
t: +31 (0)71 5234800 huib@olof-art.nl
(Huib van den Wijngaard) www.olof-art.nl

Olof Art Gallery is a venue dedicated to the promotion, exhibition and sale of Outsider Art and its related fields including self-taught and visionary art, art singulaire, art brut and artwork by marginalised individuals. Outsider and auto-didactic artists from around the globe will be on view throughout the year with frequently changing exhibitions.

Mark de Bruija

SWITZERLAND

GALERIE DU MARCHE
1, esc. du Marché, 1003 Lausanne
t: +41 21 311 41 80 info@galeriedumarche.ch
f: +41 21 617 33 44 www.galeriedumarche.ch
(Jean-David Mermod) mobile 0041 79 212 14 17

Established in 1988, specialising in Swiss art from the XIX and XX centuries. Every year numerous Art Brut and Neuve Invention exhibitions are organised. Swiss Art: Auberjonois, Bocion, Bosshard, Giaccometti, Vallotton etc. Outsider Art: Aloïse, Bailly, Bois-Vives, Bonjour, Burland, Burnat-Provins, Duhem, Fleuri, Madge Gill, Gordon, Helmut, Lamy, Nedjar, Robillard, Scottie, Sendrey, Soutter, Teucher, Théo, Pépé Vignes etc.

Aloïse Corbaz

SWITZERLAND

UNE SARDINE COLLÉE AU MUR
Rue des Bains 24, Geneva 1205
t: +41 22 800 09 79 mail@sardine.ch
Wed–Fri 2.30–6.30, Sat 2–5 & by appt www.sardine.ch
(Flora Berne)

The gallery was founded in 2000 and is dedicated to art brut, self-taught and folk art. Includes some well known names and a range of emerging / alive artists. Virtual exhibitions on www.sardine.ch. Gallery in Geneva with 4 or 5 personal shows a year. Research service for collectors.

Scottie Wilson

SWITZERLAND

SUSI BRUNNER GALLERY
Spitalgasse 10, 8001 Zürich
t: +41 44 251 23 42 galerie@susibrunner.ch
f: +41 44 251 66 57 www.susibrunner.ch
Tue–Sat 1–6 & by appt **(Susi Brunner, Kathrin Herzog, Laura Bomio)**

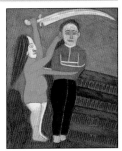

Founded in 1973, focusing on international contemporary art. Main domain is Outsider Art & Art Brut: François Monchâtre, Alexandra Huber, Michel Nedjar, André Robillard, Pépé Vignes, artists from Gugging and from La Tinaia, also: Ulrich Bleiker, Max Raffler, Nikifor, Emeric Fejes, Ivan Rabuzin, Sava Sekulic, Oswald Tschirtner. Publications: *Animales* (a book about animals in Outsider Art), *French Outsider Art*, and *La Tinaia*. Participants at Art Fairs in Basel, Paris, Bologna, Zürich, New York, Verona and Haarlem.

Sava Sekulic

THE AMES GALLERY
2661 Cedar Street, Berkeley, CA 94708
t: 510 845 4949 info@amesgallery.com
f: 510 845 6219 www.amesgallery.com
Mon–Fri 10.30–3 & by appt
(Bonnie Grossman)

Established in Berkeley in 1970, The Ames Gallery introduced outsider art to California. The Gallery has two areas of focus: antique Americana and contemporary self-taught, visionary and outsider art, primarily by Californians such as AG Rizzoli, Dwight Mackintosh, AA Maldonado, Jon Serl, Ted Gordon and Barry Simons.

A.G. Rizzoli

CREATIVE GROWTH ART CENTER
355 24th Street Oakland, CA 94612
t: 510 836 2340 info@creativegrowth.org
 www.creativegrowth.org

Creative Growth is an internationally acclaimed gallery and studio for artists with disabilities. For three decades it has been acclaimed worldwide for the quality of its artists and the innovation of its studio and gallery programs. Artists represented include Dwight Mackintosh, Judith Scott, Donald Mitchell, Regina Broussard, Louis Estape and Dan Miller.

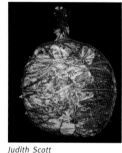
Judith Scott

CREATIVITY EXPLORED
3245 16th Street, San Francisco, CA 94103
t: 415 863 2108 info@creativityexplored.org
f: 415 863 1655 www.creativityexplored.org
Mon–Wed 10-3, Thur 10-7, Sat 1–6

Creativity explored is a non-profit visual arts center where artists with development disabilities create, exhibit and sell art. The gallery showcases artwork by more than 125 studio artists who use a wide variety of media and exhibit throughout the world. Artists represented include: Thanh Diep, Daniel Green, Camille Holovet, Michael Bernard Loggins, John Patrick McKenzie, James Miles, Evelyn Reyes.

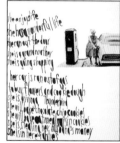
John Patrick McKenzie

JUST FOLK
2346 Lillie Avenue, P.O. Box 578, Summerland, CA 93067
t: 805 969 7118 reachus@justfolk.com
f: 805 969 1042 www.justfolk.com
Wed–Sat 10–5, Sun 11–5
(Marcy Carsey, Susan Baerwald)

Just Folk has one of the most extensive and unique American folk art and outsider art collections on the West Coast. The diverse inventory is featured in an architecturally adventurous building created for Just Folk in 2007. Artists include: Elijah Pierce, Felipe Archuleta, Thornton Dial, Purvis Young and Sam Doyle among many others.

Elijah Pierce

CALIFORNIA

NATIONAL INSTITUTE OF ART & DISABILITIES
551 23rd Street, Richmond, CA 94804
t: 510 620 0290 directorofartsales@niadart.org
f: 510 620 0326 www.niadart.org
Mon–Fri 9–4 & by appt
(Brian Stechschulte, Pat Coleman)

For over 25 years NIAD has furnished an art studio and gallery that promotes creativity, independence, dignity and community integration for people with developmental and other disabilities. Over 50 artists with no formal training are represented and exhibited worldwide, including Sylvia Fragoso, Jeremy Burleson, Sam Gant and Donald Walker.

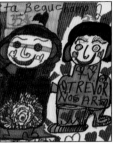
Donald Walker

CALIFORNIA

NEIGHBOURHOOD CENTER OF THE ARTS
200 Litton Drive, Suite 212, Grass Valley, CA 95945
t: 530 272 7287 ncadirector@nccn.net
f: 530 272 7688 www.neighbourhoodcenterofthearts.com
Mon–Fri 10–4
(Glen Baird, Christina McMaster)

NCA is a non-profit center for artists with developmental disabilities founded in 1984. The gallery and website feature paintings, drawings, ceramics, fiber art and mixed media by more than 60 artists including Roberta Beauchamp, Diana Bouchie, Carol Heilmann, Larry Mills, Spencer McClay, Helen Powell, Haley Smith and Barbie Wilkins.

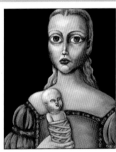
Roberta Beauchamp

CONNECTICUT

BEVERLY KAYE GALLERY
15 Lorraine Drive, Woodbridge, CT 06525
t: 203 387 5700 beverlyskaye@aol.com
by appt www.artbrut.com
(Beverly Kaye)

Private dealer offering original work to collectors, curators, galleries and museums. Extensive portfolios, sculpture show, lectures and exhibitions at lovely country gallery. Fresh discoveries and masters: Alexandra Huber, Sandy Mastroni, Paul Pitt, Ronald Sloan, Ann Harper, DeMarco, Guyther, Hart, Manero, Prokop, Purvis, Fain, Sesow, etc. Near Yale University Art Museum.

Ann Harper

GEORGIA

AROUND BACK AT ROCKY'S PLACE
3631 Highway 53 East, Dawsonville, GA 30534
t: 706 265 6030 aroundbackatrockysplace@hotmail.com
Sat 11–5, Sun 1–5 & by appt www.aroundbackatrockysplace.com

The gallery features folk art pieces in all mediums, Southern folk pottery, paintings, woodcarvings, metal sculptures, and fiber art. See art pieces of 200+ artists, from emerging to the old masters. Gallery favorites are Cornbread, Blacktop, and Billy Roper. Check the website for new artists, new work, and special events.

John 'Cornbread' Anderson

GEORGIA

BARBARA ARCHER GALLERY
280 Elizabeth Street, Suite A012, Atlanta, GA 30307
t: 404 523 1845 info@barbaraarcher.com
t: 404 523 3171 www.barbaraarcher.com

Self-taught, outsider, folk and contemporary art. Artists include: Benjamin
Jones, Nellie Mae Rowe, George Lowe, Sindy Lutz, J.B. Murry, Troy Dugas,
Fort Guerin, Henry Speller, (very early) Howard Finster and others.

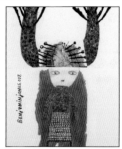

Benjamin Jones

GEORGIA

MAIN STREET GALLERY
51 North Main Street, P.O. Box 641, Clayton, GA 30525
t: 706 782 2440 mainst2@windstream.net
Mon, Tue, Thur–Sat 10.30–5 www.mainstreetgallery.net

Established in 1985. We represent over 60 self-taught artists including; Rudolph Bostic,
Richard Burnside, Chris Clark, John 'Cornbread' Anderson, Kenneth Dickerson, Dorethey
Gorham, Leonard Jones, RA Miller, Mary Proctor, Sarah Rakes, Taft Richardson, OL Samuels,
Jay Schuette, Jimmy Lee Sudduth, Annie Tolliver, and Purvis Young.

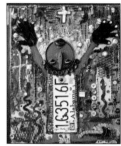

Chris Clark

GEORGIA

MIKE'S ART TRUCK
Doppler Studios, 1922 Piedmont Circle, NE, Atlanta, GA 30324
t: 678 357 2777 mikesarttruck@bellsouth.com
by appt www.mikesarttruck.com

Contemporary folk art gallery and website featuring art from the American South. Fresh
work direct from living artists. Myrtice West, Willie Tarver, Michael Banks, Cornbread, Johnny
Ace, Jim Shores, Ab the Flagman, "theartist", Bennie Morrison, Butch Anthony, Paul Flack,
Dede Spitz, bailey jack, Carol Roll, Sarah Rakes, Charlie Lucas.

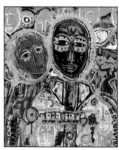

Eric Legge

ILLINOIS

OUTSIDER GALLERY
409 N. Erickson Street, P.O. Box 116, Bishop Hill, IL 61419
t: 309 927 3314 outsider@winco.net
daily 10–5 www.bishophillgallery.com

Socially incorrect, scary to half-wits, this west-central Illinois gallery exhibits the mixed-
media work of Steve Carleson and Marsha Carleson. The Gallery also represents seven
other artists working in a variety of mediums. Outsider Gallery is small but mighty. Come
see us!

Steve Carleson

RUSSELL BOWMAN ART ADVISORY
311 W. Superior Street, Suite 115, Chicago, IL 60610
t: 312 751 9500　　　　rb@bowmanart.com
Tue–Sat 10–5.30　　　　www.bowmanart.com

Representing the estate of Charles Steffen.
Artwork available by: David Butler, Carlo, Miles Carpenter, Thornton Dial, Sam Doyle,
William Hawkins, Simon Sparrow, Mose Tolliver, Eugene Von Bruenchenhein, Joseph Yoakum.

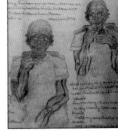
Charles Steffen

LOUISIANA

ANTON HAARDT GALLERY
2858 Magazine Street, New Orleans. LA 70115
t: 504 891 9080　　　　anton3@earthlink.net
(Anton Haardt)　　　　www.antonart.com

Contemporary Folk Art from the deep south. Representing work by Thornton Dial, Sam
Doyle, Minnie Evans, Roy Ferdinand, Howard Finster, Sybil Gibson, Bessie Harvey, Calvin
Livingstone, Charlie Lucas, Mexican Retablos, James Purdy, Royal Robertson, Juanita Rogers,
Welmon Sharlhorne, Mary T Smith, Jimmy Lee Sudduth, Big Al Taplet, James 'Son' Thomas,
Annie Tolliver, Mose Tolliver, Purvis Young, Inez Walker, and with additional works by David
Butler, Lonnie Holley, Clementine Hunter, RA Miller, BF Perkins and WC Rice.

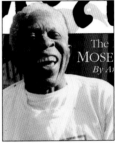
Mose Tolliver

LOUISIANA

THE LOUISIANA ART GALLERY
495 SW Railroad Ave, Ponchatoula, LA 70454
t: 985 386 0471　　　　lfia@i-55.com
Tue–Sat 11.30–4.30　　　　www.billhemmerling.com

Upon retirement in 2003 Bill Hemmerling started to paint on recylced materials using house
paint. He explores many themes depicting southern culture, but is best known for his
image of a sweet, African American woman named 'Sweet Olive'.
Bill has since become one of the most successful and prolific artists in Louisiana.

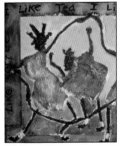
Bill Hemmerling

MASSACHUSETTS

BERENBERG GALLERY
4 Clarendon Street, Boston, MA 02116
t: 617 536 0800　　　　berenberg@berenberggallery.com
f: 617 536 0800　　　　www.berenberggallery.com
(Lorri Berenberg)　　　　Tue-Sat 11-6

Boston's only gallery dedicated to contemporary folk and Outsider Art showcases the work
of over 80 established and emerging artists including Scott Griffin, Jennifer Harrison,
Abdellah RamRam, Cher Shaffer and Gabriel Shaffer. Prominently represented are artists
with disabilities from Creative Growth Art Center, Creativity Explored, First Street Gallery,
Gateway Arts, GRACE, NIAD and Spindleworks.

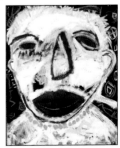
Cher Shaffer

GALERIE BONHEUR

10046 Conway Road, St Louis, MO 63124
t: 314 993 9851 gbonheur@aol.com
f: 314 993 9260 www.galeriebonheur.com
by appt
(Laurie Carmody Ahner, Elena Rodriguez)

Galerie Bonheur has been exhibiting International Folk and Outsider art since 1980. We specialize in colourful and unique art from nations on six continents and feature Castera Bazile, Amos Ferguson, Pavel Leonov, Justin McCarthy, Nikifor, Seneque Obin and Mary Whitfield. Check our webiste for up-to-date information and our newest artwork.

Mary Whitfield

AMERICAN PRIMITIVE GALLERY

594 Broadway Rm 205, New York, NY 10012
t: 212 966 1530 american.primitive@verizon.net
Tue–Sat 11–6 www.americanprimitive.com
(Aarne Anton)

The gallery is known for showing the work of self-taught, visionary and outsider art in New York. A diverse selection of American folk art is available from the 19th-20th century. Among self-taught artists represented are; Eugene Andolsek, Charles Benefiel, Larry Calkins, Sam Gant, Gerard Cambon, L-15 (Bernard Schatz), Ted Ludwiczak, Max Romain and Terry Turrell.

Eugene Andolsek

CAVIN-MORRIS GALLERY

210 Eleventh Avenue, Suite 201 New York, NY 10001
t: 212 226 3768 bluegriot@aol.com
f: 212 226 0155 www.cavinmorris.com
Tue–Fri 10–6, Sat 11–6
(Shari Cavin, Randall Morris)

Artists represented: Sabhan Adam, Chelo Amezcua, Emery Blagdon, Ignacio Carles-Tolra, Mort Golub, Keith Goodhart, Chris Hipkiss, Zdenek Kosek, Pushpa Kumari, Ed Nelson, Lubos Plny, Anthony J Salvatore, Kevin Sampson, Christine Sefolosha, John Serl, Sandra Sheehy, Lidia Syroka, Gregory Van Maanen, Jerry Wagner, Timothy Wehrle, Anna Zemánková.

Timothy Wehrle

EDLIN GALLERY

529 West 20th Street, 6th Floor, New York, NY 10011
t: 212 206 9723 ae@edlingallery.com
Tue–Sat 11–6 www.edlingallery.com
(Andrew Edlin)

Exclusive worldwide representative of the Henry Darger Estate. Artists represented: Frank Calloway, Tom Duncan, Paul Edlin (estate), Brent Green, Albert Hoffman (estate), Hans Krusi, Marc Lamy, Martin Ramirez, Michael Ryan, Linda Carmella Sibio, Charles Steffen (estate), Willem Van Genk, Adolf Wölfli, Malcah Zeldis.

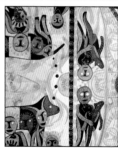
Henry Darger

FOUNTAIN GALLERY
702 Ninth Avenue @ 48th Street, New York, NY 10019
t: 212 262 2756 jason@fountaingallerynyc.com
Tue–Sat 11–7, Sun 1–5 www.fountaingallerynyc.com

Fountain Gallery is the premier venue in New York City for artists living and working with mental illness. Through its unique exhibition space and programs, the gallery provides a lucrative environment in which emerging and self-taught artists with mental illness can pursue their personal visions.

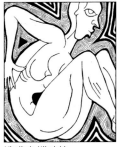

Vladimir Nikolski

GALERIE ST ETIENNE
24 West 57th Street, New York, NY 10019
t: 212 245 6734 gallery@gseart.com
f: 212 765 8493 www.gseart.com

Henry Darger, John Kane, Gugging, Grandma Moses, Michel Nedjar and others.

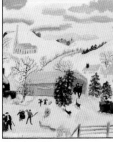

'Grandma' Moses

THE GALLERY AT HAI
548 Broadway, 3rd Floor, New York, NY 10012
t: 212 575 7696 outsider@hospaud.org
Mon–Sat 12–6 www.hospaud.org/hai/gallery.htm

Representing North American outsider artists: Everette Ball, Oscar Brown, Rocco Fama, William Gonzalez, Carl Greenberg, Harper Deering Hair, Ray Hamilton, Mercedes Jamison, Jenny Maruki, Gaetana Menna, Kenny McKay, 'Lady Shalimar' Montague, Adeyinka Perry, Irene Phillips, Jose Rivera, Joe Simms, Rodney Thornblad, Laura Anne Walker and Melvin Way.

Gallery at HAI

KNOEDLER & CO
19 East 70 Street, New York, NY 10021
t: 212 794 0550 info@knoedlergallery.com
Tue–Fri 9.30–5.30, Sat 10–5.30 www.knoedlergallery.com

Representing the art of James Castle.

James Castle

NEW YORK

PHYLLIS KIND GALLERY
236 W 26th Street, #503, New York, NY 10001
t: 212 925 1200 info@.phylliskindgallery.com
f: 212 941 7841 www.phylliskindgallery.com
(Phyllis Kind, Ron Jagger)

New York's oldest established gallery specialising in Outsider Art and Folk Art. Represents classic art brut artists such as Adolf Wölfli, Carlo Zinelli, Johann Hauser and Augustin Lesage and the great figures of American self-taught art such as Howard Finster, Martin Ramirez and JB Murray, in addition to emerging artists such as Hiroyuki Doi and Domenico Zindato.

Domenico Zindato

NEW YORK

PHYLLIS STIGLIANO
62 Eighth Avenue, Brooklyn, New York, NY 11217
t: 718 638 0659 artjump2@gmail.com
by appt and scheduled exhibitions. www.phyllisstigliano.com
(Phyllis Stigliano)

Phyllis Stigliano Gallery represents contemporary artists and researches art projects. She is agent for self-taught Mary Whitfield who is known for her powerful paintings - visions of American history of slavery; agent for Robert Kobayashi who uses strips of painted tin for his intuitive and vivid collages; self-taught Brandon d'Leo's steel sculpture, and others. She is organising an exhibition of early work - shooting paintings of Niki de Saint Phalle.

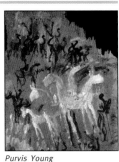

Mary Whitfield

NEW YORK

SKOT FOREMAN GALLERY
478 West Broadway, New York, NY 10012
t: 212 452 2000 info@skotforeman.com
daily 11–6 www.skotforeman.com
(Skot Foreman, Melissa Stevens)

The Gallery's focus is on contemporary 20th century artists with an emphasis on the self-taught. We maintain a sizeable inventory in the work of Rev. Harold Finster, Thornton Dial and Purvis Young.

Purvis Young

OHIO

LINDSAY GALLERY
986 North High Street, Columbus, OH 43201
t: 614 291 1973 lindsaygallery@hotmail.com
Wed–Sat 12–6 & by appt www.lindsaygallery.com

The only gallery in Ohio dedicated to self-taught, folk and outsider art. Exclusively representing Irist painter Karl Mullen. Also featuring Elijah Pierce, William Hawkins, Popeye Reed, William Dawson, Morris Jackson, Stanley Greer, Harry Underwood, Bill Miller and Jane Winkelman. See our website for selections from the Wenstrup collection.

Karl Mullen

INDIGO ARTS GALLERY
The Crane Arts Building
1400 North American St., #104, Philadelphia, PA 19122
t: 215 765 1041 indigofamily@indigoarts.com
f: 215 765 1042 www.indigoarts.com
Wed–Sat 12–6 & by appt.
(Anthony Fisher)

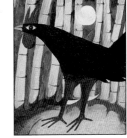

International folk and self-taught artists: Cuba, Haiti, India, Mexico, Nicaragua, Nigeria and more. Artists include José Benitez Sanchez, Gurupada Chitrakar, Myrlande Constant, Gerard Fortuné, Serge Jolimeau, Pushpa Kumari, José Montebravo, Antoine Oleyant, Twins Seven-Seven, Pierre-Joseph Valcin.

Gallo Montebravo

OUTSIDER FOLK ART GALLERY
Goggleworks centre for the Arts
201 Washington Street, 5th Floor, Reading PA 19601
t: 610 939 1737 george @outsiderfolkart.com
Wed–Sun 11–5 & by appt www.outsiderfolkart.com
(George Viener, Margaret Murphy)

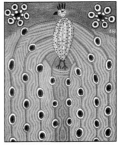

Outsider Folk Art Gallery is a premier art gallery featuring the works of local, world renowned and emerging outsider and self-taught artists from the collection of George & Sue Viener.

Jim Bloom

ROBERT CARGO FOLK ART GALLERY
110 Darby Road, Paoli, PA 19301
t: 610 240 9528 info@cargofolkart.com
by appt www.cargofolkart.com
(Caroline Cargo)

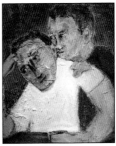

Established in 1984 in Alabama. Relocated to Main Line Philadelphia in 2004. Broad inventory of works by 70+ artists. Exceptional collection of early works by 'first generation' outsider artists including Jimmy Lee Sudduth, Mose Tolliver, Rev. Benjamin Perkins, Fred Webster, Joseph Hardin and Sybil Gibson. Also specialises in African-American quilts.

Rev BF Perkins

GEORGE JACOBS SELF-TAUGHT ART
PO Box 476, Newport, RI 02840
t: 401 847 0991 selftaughtart@aol.com
by appt www.self-taughtart.com

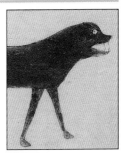

Respected dealer of Self-taught Art since 1986. Affable source with eye for value, quality, authenticity and relevance to your collection. Inventory includes work by over 25 established artists. Multiple offerings available by Thornton Dial, David Butler, Minnie Evans, James Harold Jennings, Melissa Polhamus, Jon Serl, Mary T. Smith, Jim Sudduth, Mose Tolliver, Riet van Halder, Jerry Wagner, Purvis Young and others. Appraisals made.

Bill Traylor

ARTISTIC SPIRIT GALLERY

10 Storehouse Row, Navy Yard at Noisette, N. Charleston, SC 29401
t: 843 579 0149, 317 694 6085 info@artisticspiritgallery.com
by appt www.artisticspiritgallery.com
(Julie Klaper, Marty Klaper)

The name of the gallery celebrates the creativity in all of us and focuses on those
"outsiders" who express themselves in a unique manner. We carry well-known names but
our objective is to provide exposure to emerging artists who are driven to create and
whose work carries a strong, personal message.

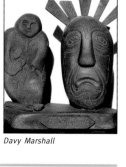

Davy Marshall

FOUR WINDS GALLERY

709 Bay Street, Beaufort, SC 29902
t: 843 379 5660 marianne@fourwindsgallery.com
Mon-Sat 10.30-5.30 & by appt www.fourwindstraders.com
(Marianne Norton)

Bringing together the best in folk art and handicrafts from every part of the world. Works
from Southern folk and outsider artists such as Johnnie Simmons, Dr. Bob, Lorraine
Gendron, Pat Juneau and Ivy Billiot meet with selections from the finest from Eastern
Europe, India, Africa, South America and Central and Southeast Asia. Stunning regional
photography is also featured as well as rugs, weavings, textiles and embroideries.

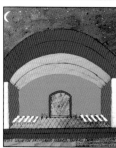

Johnnie Simmons

RED PIANO TOO ART GALLERY

870 Sea Island Parkway, St. Helena Island, Beaufort County, SC 29920
t: 843 838 2241 RedPianoToo@islc.net
Mon–Sat 10–5, Sun 1–4.30 www.RedPianoToo.com

Red Piano Too Art Gallery one of the South's most important collections of Folk Art with a
wide range of Gullah and Regional Artists: Cassandra Gillens, Alan Fireall, Diane Britton
Dunham, Johnny Griner, Mary Proctor, Charles Desaussure, John Preble, Brian Dowdall, Alyne
Harris, Irene Tison, Helen Stewart, Jay Wilkie, Jimmy Lee Sudduth and Mose Tolliver.

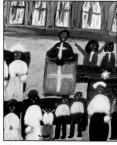

Alyne Harris

TRAM FAIR

PO Box 466, Travelers Rest, SC 29690
t: 864 834 2388 info@trartsmission.org
first weekend of October annually www.trartsmission.org
(Nichole Livengood)

The TRAM Fair is located at Gateway Park in Travelers Rest, SC and features outsider and
folk artists from across the southeast as well as some of Greenville County's most talented
artists. Past participants include: Jim Shores, Susan Sorrell, Paul Flack, Ernest Lee, Ramona
Hotel and many others.

Tram fair

TEXAS

KOELSCH GALLERY
703 Yale Street, Houston, TX 77007
t: 713 862 5744
Tue–Sat 11–6
(Franny Koelsch, Vanessa Estrada)

franny@koelschgallery.com
www.koelschgallery.com

Artists represented: Sally S Bennett, Camp Bosworth, Henry Ray Clark, Claire Cusack, Patrick Davis, Carl Dixon, Richard Kurtz, Sasha Milby, Ike Morgan, Isaac Smith, Al Taplet, Heinrich Reisenbauer, Mr Imagination (Gregory Warmack), Purvis Young and more.

Mr Imagination

VIRGINIA

GREY CARTER - OBJECTS OF ART
1126 Duchess Drive, McLean, VA 22102
t/f: 703 734 0533
by appt
(Grey Carter, Linda Ortega)

gcarter@greyart.com
www.greyart.com

Grey Carter has been buying and selling works by self-taught artists for over 40 years. Located just outside Washington, DC, we serve clients creating fine collections of folk and outsider art. Our large inventory includes major figures such as Gatto, McCarthy, Murry and Savitsky, plus many significant contemporary self-taught artists such as Cromer, Cross, Fields, Lancaster, Lucas, Milestone, Montes and Van Pelt.

JJ Cromer

WASHINGTON

GARDE RAIL GALLERY
110 Third Avenue South, Seattle, WA 98104
t: 206.621.1055
Wed–Sat 11am–5pm & by appt
(Karen Light, Marcus Pina)

gallery@garde-rail.com
www.garde-rail.com

Opened in June of 1998 and specialises in work by contemporary folk, self-taught, and outsider artists from across North America. The gallery presents 10 shows per year from their space in downtown Seattle, and also curates exhibits in the Northwest, and at art shows around the country. Among artists represented are John Taylor, Holly Farrell, Jennifer Harrison, and the gallery exclusively represents Gregory Blackstock.

Gregory Blackstock

WISCONSIN

THE FLYING PIG GALLERY
N6975 State Highway 42, Algoma, WI 54210
t: 920 487 9902
f: 920 487 9904
April–Oct: daily 9–6; Nov–Mar: Fri–Mon 10–5
(Susan Connor, Robyn Mulhaney)

theflyingpig@charterinternet.com
www.theflyingpig.biz

The indoor and outdoor gallery space, established in 2003, sells original works ranging from folk to contemporary arts as well as traditional crafts by over 100 regional, national and international artists. Annually May to October, our Back Gallery Series focuses on emerging artists in a range of mediums.

C. Daniel Johnson

Ho Baron

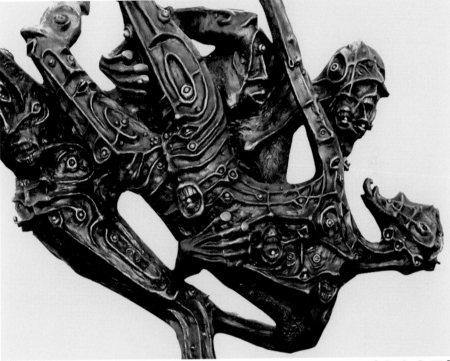

A Novel Romance (2005)
bronze 75x90x40"

SURREAL
SCULPTURE

2830 Aurora, El Paso, Tx. 79930
915-562-7820 www.hobaron.com

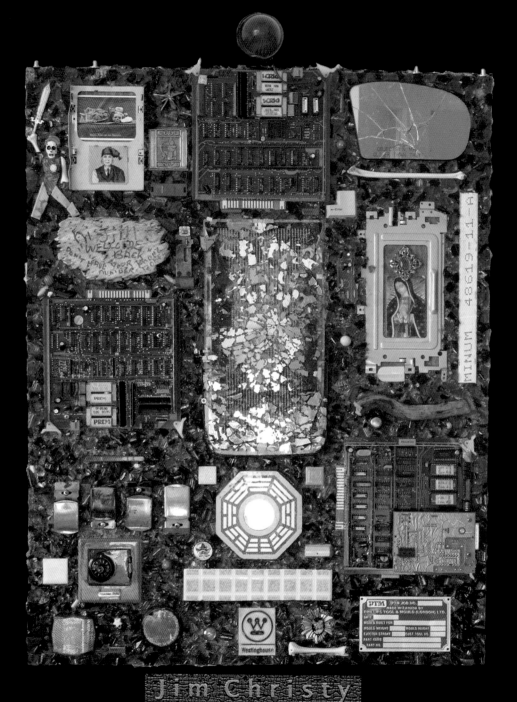

Jim Christy

info@jimchristyoutsiderart.com

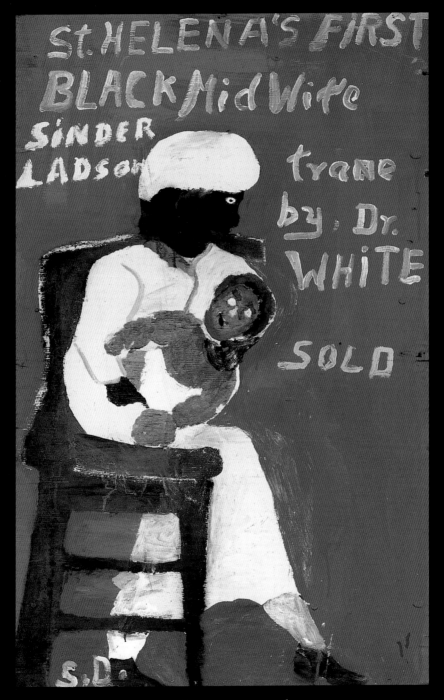

www.SamDoyle.com

Fusco (Sylvain), 63 x 48 cm (25 x 19 in), pastel on paper, 1938

**the only
art brut gallery
in Paris**

Aloïse • Carlo • Darger
Domsic • Duhem • Fischer
Ghizzardi • Gill • Gironella
Hauser • Hipkiss • Hofer
Lesage • Lobanov • Lonné
Monsiel • Plny • Podesta
Ratier • Robillard • Scottie
Steffen • Stoffers • Tschirtner
Vondal • Walla • Wölfli
...

**galerie
objet trouvé**
christian berst

24 rue de charenton 75012 paris | +33 (0)1 53 33 01 70
www.objet-trouve.com • contact@objet-trouve.com

Museums

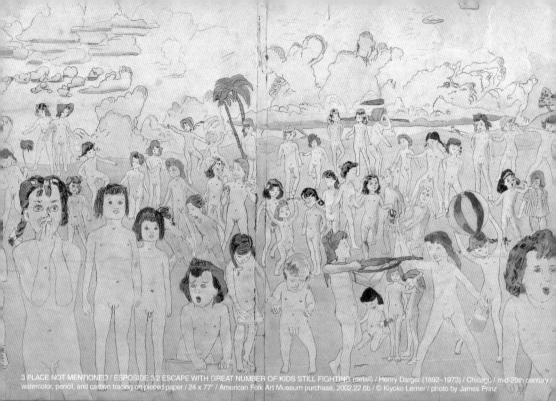

3 PLACE NOT MENTIONED / ESPOSIDE 3 2 ESCAPE WITH GREAT NUMBER OF KIDS STILL FIGHTING (detail) / Henry Darger (1892–1973) / Chicago / mid-20th century / watercolor, pencil, and carbon tracing on pieced paper / 24 x 77" / American Folk Art Museum purchase, 2002.22.6b / © Kiyoko Lerner / photo by James Prinz

AMERICAN FOLK ART MUSEUM

Founded in 1961, the American Folk Art Museum is a leading cultural institution dedicated to the collection, exhibition, preservation, and study of traditional folk art and the work of contemporary self-taught artists from the U.S. and abroad. Through its **Contemporary Center**, the museum has played a pivotal role in the development of the field and bringing the work of self-taught artists to a wider audience.

The museum's **Henry Darger Study Center** houses all four of Darger's voluminous manuscripts and more than two dozen paintings, as well as approximately three thousand items from the artist's archive of ephemera and source material. The **Henry Darger Study Center Fellowship** is awarded each year to a scholar to study the museum's Darger holdings in depth for four weeks with museum staff.

Hailed by critics as "a jewel, a brilliant emblem," the museum's **building**, designed by Tod Williams Billie Tsien Architects, is "destined to be one of the most influential examples of modern architecture of the century."

45 WEST 53RD STREET, NEW YORK CITY 212. 265. 1040 www.folkartmuseum.org

Flustered Rustics by J.J. Cromer

AMERICAN VISIONARY ART MUSEUM • BALTIMORE • USA • WWW.AVAM.ORG

COLLECTION DE L'ART

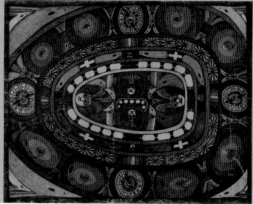

The Collection de l'Art Brut presents works by self-taught creators who, for various reasons, have eluded cultural conditioning and social conformity. Loners, social misfits, psychiatric hospital patients, prisoners, elderly people – every one of them creates oblivious to tradition and artistic trends, paying no heed to the public's reactions or the opinions of others. Embarking on their artistic projects in totally unfettered fashion, the authors of Art Brut produce works of remarkable inventiveness. These they execute in secrecy, silence and solitude.

The historical value of the Collection de l'Art Brut.
The Collection de l'Art Brut in Lausanne, Switzerland has an important historical value as far as Art Brut is concerned. The collection assembled by Jean Dubuffet – to whom we owe the concept of "Art Brut" – constitutes the origin and the heart of this museum. In 1971, the French artist donated a body of 6,500 pieces to the City of Lausanne. In 1976, the Collection de l'Art Brut opened its doors to the public. Michel Thévoz served as its curator, working in close collaboration with Geneviève Roulin for twenty-five years. In 2001, Lucienne Peiry was appointed curator of the museum.

Collection de l'Art Brut
11, avenue des Bergières
CH-1004 Lausanne
Tél. +41 21 315 25 70
Fax +41 21 315 25 71
www.artbrut.ch
art.brut@lausanne.ch

Opening hours:
Tuesday to Sunday,
11 am to 6 pm
(including public holidays).
July and August,
Monday to Sunday,
11 am to 6 pm.

BRUT LAUSANNE
SWITZERLAND

Aloïse
Dans le manteau de Lüther l'herbe fleurie,
between 1959 and 1964,
colored pencil,
120 x 74 cm.

Adolf Wölfli
District de Biela Villa,
c. 1924,
colored pencil,
51 x 68 cm.

Pascal Maisonneuve
Tête cornue,
between 1927 and 1928,
sea shells,
h 47,5 cm.

Jean Dubuffet in 1946
©Archives
Fondation Jean Dubuffet,
Paris.

66,000 works by 1,000 creators

Today, the Collection de l'Art Brut boasts some 66,000 works – paintings, drawings, sculptures, pieces of embroidery, ceramics and writings – by the hand of over a thousand creators. It exhibits such major figures as Aloïse, Adolf Wölfli, Augustin Lesage, Carlo, Madge Gill, August Walla and Johann Hauser. It also features other important artists, such as Henry Darger, Nek Chand, Judith Scott, Willem van Genk, Hans Krüsi and Takashi Shuji.

Having expanded since Jean Dubuffet's original donation, today the collection continues to be enriched by acquisitions that are the fruit of ongoing research work and generous donations.

The public and the museum

Thanks to its international impact, the Collection de l'Art Brut attracts an ever growing public. Every year, some 40,000 visitors from Europe, the United States, Japan and Australia flock to the museum to discover original and subversive works. The permanent exhibition comprises nearly 800 works: these are presented in the 18th-century Château de Beaulieu, which has been restored and specially laid out to host them. The museum also regularly proposes temporary, personal or themed exhibitions.

Publications and special activities

Since its inception, the Collection de l'Art Brut has produced its own publications. Notably, it has to date brought out 22 issues of the Art Brut series of fascicules initiated by Jean Dubuffet. In addition to its exhibition catalogues, the museum also produces documentaries and short films that are unique tributes to the highly original worlds of Art Brut artists.

Visitors to the museum will find around 200 books and reviews, as well as a series of 70 posters and a selection of 100 postcards at the bookshop located at the museum entrance.

The Collection de l'Art Brut library boasts 8,000 reference books and reviews in various languages, relating to Art Brut and diverse forms of maverick creations. It welcomes international researchers, students and readers.

Guided tours are available to visitors in French, English, German and Italian. The Collection de l'Art Brut also organizes numerous youth activities.

Why not start out with a virtual visit to: www.artbrut.ch?

galerie gugging

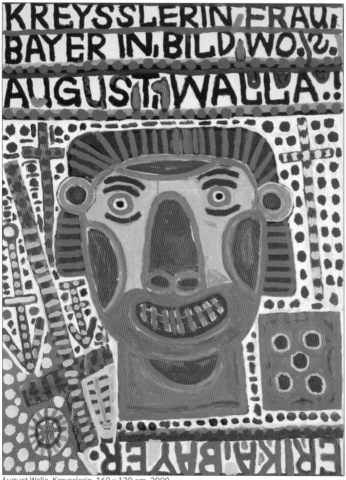

August Walla, Kreysslerin, 160 x 120 cm, 2000

artenjak
bachler
blahaut
dobay
fink
fischbach
fischer
garber
hauser
horacek
kamlander
kernbeis
koller
korec
limberger
opitz
reisenbauer
schmidt
schöpke
schützenhöfer
tschirtner
vondal
walla
zittra

Opening Hours: Tuesday - Saturday 10 am - 5 pm
A-3400 Maria Gugging, Am Campus 2, Austria www.gugging.org, Tel.: +43/676/84 11 81 200

HALLE SAINT PIERRE

Temporary exhibitions

Art Brut
Outsider Art

Bookshop

Tearoom

Halle Saint Pierre
2 rue Ronsard - 75018 Paris
0 33 (0)1 42 58 72 89
info@hallesaintpierre.org

www.hallesaintpierre.org

AUSTRALIA

ARTS PROJECT AUSTRALIA
24 High Street, Northcote, Victoria 3070
t: +61 (0)3 9482 4484
info@artsproject.org.au
www.artsproject.org.au
Mon–Fri 9–5, Sat 10–1

A Collection of over 14,000 works produced by artists with an intellectual disability. The project holds regularly changing exhibitions. Artists represented include Julian Martin, Chris Mason, Jodie Noble and Cathy Staughton.

Leo Cassen

AUSTRALIA

COLLECTION ART VISIONARY
Katanas House, 11 Church Street,
South Melbourne, Victoria 3205
t: +61 (0)466 458 625
artvisionary@gmail.com
www.artvisionary.com
by appt.

Australia's largest private collection of international outsider and visionary art. Drawings, paintings and prints by Alex Grey, Norbert Kox, Claudia Sattler, Anne Grgich, Anthony Mannix, Andrew Rizgalla, Laurie Lipton, Ernst Fuchs, Brigid Marlin, Keek Richardson, Koczy, Sendrey and many others.

Anne Grgich

AUSTRIA

ART/BRUT CENTRE GUGGING
Am Campus 2, 3400 Maria-Gugging
t: +43 (0)676 84 11 81 200
info@gugging.org
www.gugging.org
Wintertime Tue–Sun 10–5
Summertime Tue–Sun 10–6

The Art/Brut Centre Gugging unites the House of Artists, place of work and residence for artists and poets who have left behind the stigma of being former chronic psychiatric patients, with the gallery run by these artists, and a museum which comprises an extensive collection of Gugging and international art.

August Walla

BELGIUM

ART EN MARGE
Rue Haute 312, 1000 Brussels
t: +32 (0)2 511 04 11
info@artenmarge.be
www.artenmarge.be
Wed–Fri 12–6, Sat 11–4
closed August

This non-profit organisation holds a collection of over 1500 works by Belgian and international self-taught artists. It researches and presents their art through numerous temporary exhibitions and publications.

Jean-Marie Heyligen

BELGIUM

MAD MUSEE
Parc d'Avroy, Liège 4000
t: +32 (0)4 222 32 95
info@madmusee.be
www.madmusee.be
15 Nov–1 April, Mon–Fri 10–5, Sat 2–5
Rest of year, Mon–Fri 10–6, Sat 2–6

A selection of works from the permanent collection of some 1300 paintings, drawings and sculptures by Belgian and international studios for mentally disabled artists is on permanent display. Temporary exhibitions take place in the gallery.

Hendrick Heffinck

BELGIUM

MUSEUM DR J GUISLAIN
Jozef Guislainstraat 43, Ghent 9000
t: +32 (0)9 216 3595
info@museumdrguislain.be
www.museumdrguislain.be
Tue–Fri 9–5, Sat & Sun 1–5

Located in the grounds of a psychiatric hospital, the permanent collection comprises three parts: the history of psychiatry; photographs illustrating life in a psychiatric institution and an extensive collection of Outsider Art including works from the former De Stadshof Museum in Zwolle, as well as changing themed exhibitions.

Nek Chand

BRAZIL

MUSEU BISPO DO ROSARIO

Estrada Rodrigues Caldas, 3400
Taquara, Jacarepaguá, Cep 22713-370
t: +55 (0)21 21 446 6628
www.museubispodorosario.art.br

The major holding of works by Arthur Bispo do Rosario, Brazil's most prominent outsider artist.

Bispo do Rosario

BRITAIN

BETHLEM ROYAL HOSPITAL ARCHIVES & MUSEUM

Monks Orchard Road, Beckenham,
Kent BR3 3BX
t: +44 (0)203 228 4227
www.bethlemheritage.org.uk
Mon-Fri 9.30-4.30

The museum houses a small permanent display of works by people with mental illness, including former residents Jonathan Martin and Richard Dadd, plus the cats of Louis Wain, from the extensive archives of art, photography and other documentation related to the history of psychiatry and the treatment of mental disorders.

William Kurelek

BRITAIN

LA COLLECTION BRÉTANIQUE

www.colbre.com

Foundation for the collection, restoration and discovery of 19th, 20th and 21st century self-taught and creativist art.

Henry Darger

CROATIA

CROATIAN MUSEUM OF NAÏVE ART
Sv. Cirila i Metoda 3,
Gornji grad, 10000 Zagreb
t: +385 (0)1 485 1911
info@hmnu.org
www.hmnu.org
Tue-Fri 10-6, Sat-Sun 10-1

The world's oldest museum of naïve art (1952). It houses an extensive collection of Croatian and world naïve art, many originating from the famous Hlebine school. It contains many works by classic naïve artists such as Ivan Generalic and Mirko Virus, in addition to pieces by Outsiders such as Ilija Bosilj and Willem van Genk.

Willem van Genk

CROATIA

HLEBINE GALERIJA

Trg Ivana Generalica 15,
48323 Hlebine
t: +385 (0)48 836 075
galerija-hlebine@muzej-koprivnica.hr
Mon-Fri 10-4, Sat 10-2

A small museum specialising in the work of naïve artists from the famous village of Hlebine and surrounding area. The exhibits include many historical pieces and some examples of more contemporary work. There is a special gallery dedicated to celebrated local artist, Ivan Generalic.

Ivan Generalic

CROATIA

MUSEUM OF CONTEMPORARY ART

Habdeliceva 2, 10000 Zagreb
t: +385 (0)1 48 51 930
msu@msu.hr
www.mdc.hr/msu/
Tue-Sat 11-7, Sun & hols 10-1

A dedicated department of Outsider Art was opened in 1994, although many international, solo and group exhibitions of Outsider Art have been held since 1987. The Museum also holds an important collection of Croatian Outsider Art and a special collection of the work of Karl Sirovy (1896-1948).

Zvonko Bratic

DENMARK

GAIA MUSEUM - OUTSIDER ART

Lene Bredahlsgade 10, Randers 8900
t: +45 (0)8640 3323
gaia@randers.dk
www.gaiamuseum.dk
Tue–Thur 10–4.30, Sat 11–4

The museum holds a collection of more than 300 works from approximately 40 Danish and international artists, including Werner Voigt, Kenneth Rasmussen and Hein Dingemans.

Judith Damgaard Nielsen

DENMARK

MUSEUM OVARTACI

Aarhus University Hospital,
Skovagervej 2, Viborg, 8240 Risskov
t: +45 (0)7789 3860
museum@ovartaci.dk
www.ovartaci.dk
Mon–Fri 10–4, Sat & Sun 12–4

The museum houses one of Scandinavia's major Art Brut and Outsider Art collections (approximately 10,000 works) as well as a psychiatric historical exhibition. At the centre of it all, you encounter the works by Ovartaci – our most significant artist – mystic, visionary and patient for 56 years.

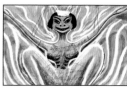

Ovartaci

FINLAND

MUSEUM OF FINNISH CONTEMPORARY FOLK ART

Jyväskyläntie 3, PO Box 11,
69601 Kaustinen
t: +358 (0)207 291 206
folk.art@kaustinen.fi
www.kaustinen.net

Finnish visual folk art enjoyed a renaissance in 2000, when the Folk Arts Centre organised the first national exhibition on the subject. Since then the museum has researched, stored and archived Finnish contemporary folk art. The large 'DIY Lives' (ITE) exhibition was co-organised with the Meilati Art Museum in Helsinki.

Ilmari 'Imppu' Salminen

FRANCE

abcd: art brut connaissance & diffusion

12 rue Voltaire, 93100
Montreuil sous Bois
t: +33 (0)622 26 70 56
abcd@abcd-artbrut.org
www.abcd-artbrut.org

abcd is concerned with the research of historical Art Brut. Based on the collection of Bruno Decharme, abcd organises exhibitions, publishes books and produces films. The collection includes such masters as Adolf Wölfli, Scottie Wilson, Edmund Monsiel, Anna Zemánková, Schröder-Sonnenstern and artists from Gugging.

Adolf Wölfli

FRANCE

LA FABULOSERIE

Dicy 89120, near Auxerre
t: +33 (0)3 86 63 64 21
www.fabuloserie.com
Jul–Aug daily 2–6
April–Nov, Sat & Sun 2–6

Created by the late Alain Bourbonnais, the museum includes many outstanding examples by well known Outsider artists. Environmental constructions are exhibited in the gardens that surround the museum, including a re-construction of Pierre Avezard's mechanical Manège.

J.P. Vidal

FRANCE

HALLE SAINT-PIERRE

2 rue Ronsard, 75018 Paris
t: +33 (0)1 42 58 72 89
info@hallesaintpierre.org
www.hallesaintpierre.org
Daily 10–6
Closed weekends 12–6 during August

A former 19th century market building, the museum holds large temporary exhibitions dedicated to Outsider Art. Recently covered areas include American Outsider Art, Haitian art, mediumistic art, and surveys of European Art Brut.

Halle Saint Pierre

FRANCE

MUSEE DE L'ABBAYE SAINTE-CROIX rue de Verdun,
85100 Les Sables d'Olonne
t: +33 (o)2 51 32 01 16
musee@lessablesdolonne.fr
Oct–June: Tue–Sun 2.30–5.30,
July–Sept: Tue–Sun 10–12 & 2.30–6.30

The museum includes the major collection of work by Gaston Chaissac.

Gaston Chaissac

FRANCE

MUSÉE D'ART MODERNE LILLE METROPOLE
1 allée du Musée,
59650 Villeneuve d'Ascq
t: +33 (o)3 20 19 68 68
info-mamlm@cudl-lille.fr
http://mam.cudl-lille.fr

Since 1999 the museum has held the largest French collection of Outsider Art, from a donation by the l'Aracine association. Over 3000 works by 170 artists are held, including Aloïse, Hauser, Lesage, Nedjar, Robillard, Walla, Scottie Wilson and Wölfli. The collection will be presented in a new wing when the Museum re-opens in Spring 2010.

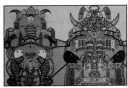

Joseph Crépin

FRANCE

MUSÉE DE LA CRÉATION FRANCHE 58 avenue du Maréchal-
de-Lattre-de-Tassigny, 33130 Bègles
t: +33 (o)5 56 85 81 73
contact@musee-creationfranche.com
www.musee-creationfranche.com
daily 3–7

The Musée de la Création Franche behaves without any consideration for theories and conventional boundaries. If criteria were called for, the crucial one would be of creativity within a vital refusal of academic schemes. Over 8000 artworks include Sanfourche, Goux, Koczÿ, Sattler, Mouly and many others.

Jean-Joseph Sanfourche

FRANCE

MUSÉE INTERNATIONAL DES ARTS MODESTES 23 quai
Maréchal de Lattre de Tassigny,
34200 Sète. t: +33 (o)4 67 18 64 00
miam@miam.org
www.miam.org
Tue–Sun 10–12 & 2–6

Museum specialising in popular and kitsch artforms, indoor environments, Mexican imagery etc.

Mexican sculpture

FRANCE

MUSEE INTERNATIONAL D'ART NAIF ANATOLE JAKOVSKY
Château Sainte Hélène, Avenue de Fabron, 06200 Nice
t: +33 (o)4 93 71 78 33
http://www.nice.fr/mairie_nice_198.html
closed Tues, otherwise open 10–6

Paintings, sculptures, drawings and posters trace the history of naive art through the works of some of its most famous painters: Bauchant, Bombois, Vivin, Séraphine, Rabuzin, Ivan and Josip Généralic and Grandma Moses.

Camille Bombois

FRANCE

MUSEE JARDIN DE LA LUNA ROSSA
6 rue Damozanne, 14000 Caen,
Normandy
open Sundays only,
April–Oct, 10–6

Open air Art Brut museum of rescued sculptural and environmental pieces from the greater Normandy area. Includes works by Fernand Châtelain, Raymond Mace and Séraphin Enrico.

Jardin de la Luna Rossa

FRANCE

MUSEE DU VIEUX-CHATEAU
Place de la Trémoille, 53000 Laval
t: +33 (0)2 43 53 39 89
www.musees.laval.fr/infospratiques.htm
Tue–Sun 2–6, June–Sept

Paintings, sculptures, drawings and posters trace the history of naive art through the works of some of its most famous painters: Bauchant, Bombois, Vivin, Séraphine, Rabuzin, Ivan and Josip Généralic and Grandma Moses.

Camille Bombois

FRANCE

LE PETIT MUSÉE DU BIZARRE
La Villedieu, Ardèche
t: +33 (0)4 75 94 83 28
15 June–15 Sept, 3–7 or by appt

Private museum including large collection of paintings by Gérard Lattier and works by French rural Outsiders.

Musée du Bizarre

FRANCE

SÉCRETARIAT DE LA FONDATION JEAN DUBUFFET
137 rue de Sèvres, 75006 Paris
t: +33 (0)1 47 34 12 63
www.dubuffetfondation.com/fondfset.htm
Mon–Fri 2–6
closed Aug & holidays

For appointments to visit the Closerie Falbala environment and the Dubuffet museum at Pèrigny-sur-Yerres, just north of Paris.

Closerie Falbala

GERMANY

CHARLOTTE ZANDER MUSEUM Schloss Bönningheim,
Hauptstrasse 15, 74357 Bönnigheim
t: +49 (0)7143 4226
charlotte.zander@sammlung-zander.de
www.sammlung-zander.de
Tue–Sat 11–3, Sun 11–4

This important museum, one of the world's greatest collections of naïve art, holds a collection of approximately 4000 pieces, including classic Outsider pieces by Adolf Wölfli, Gugging artists and many others.

Johann Fischer

GERMANY

KUNSTHAUS KANNEN
Alexianerweg 9, 48163 Münster
t: +49 (0)25 01 966 20560
kunsthaus-kannen@alexianer.de
www.kunsthaus-kannen.de

Within Maron's pictures you can clearly see how far his fantasy reaches. His works are characterised by clear and often symbolic structures whereby frequently used motifs are women, planets, hearts and abstract forms.

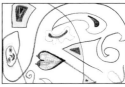

Gerd Maron

GERMANY

PRINZHORN COLLECTION
Vosstrasse 2, 69115 Heidelberg
t: +49 (0)6221 564492
prinzhorn@uni-hd.de
www.prinzhorn.uni-hd.de
Tue, Thur–Sun 11–5, Wed 11–8

Approximately 5000 pieces of artwork by the mentally unwell and institutionalised, collected by the psychiatrist Hans Prinzhorn. This highly influential collection affected Klee, Ernst and Dubuffet. It includes works by Johann Knopf, Karl Genzel ('Brendel'), August Natterer ('Neter'), Barabara Suckfüll and many anonymous creators.

Barbara Suckfüll

ICELAND

SAFNASAFNID

The Icelandic Folk & Outsider Art
Museum, Svalbardsstrond, Akureyi 601
t: +354 (0)461 4066
safnasafnid@simnet.is
www.safnasafnid.is
May to Sep: 10–6 & by appt

The museum stores around 3900 works of art. It
exhibits folk and outsider art together with
progressive modern art, thus presenting a novel
view on different outlets for creativity and what is
the inspiration behind it.

Safnasafnid Museum

ITALY

COOPERATIVA DI ATTIVITA ESPRESSIVE 'LA TINAIA'

Via di San Salvi 12, 50135 Florence
t: +39 (0)55 626 3578
latinaia@asf.toscana.it
www.latinaia.org

One of Europe's renowned patient/artists'
workshops, founded in 1975 by Massimo Mensi.
Its members have exhibited widely, including in
Lausanne, Rome, Paris and Chicago. Resident
artists include Angela Fidilio, Giordano Gelli and
Marco Raugei. There are workshops and a gallery
area.

Giordano Gelli

POLAND

STATE ETHNOGRAPHICAL MUSEUM

ul. Kredytowa 1, 00-056 Warsaw
t: +48 (0)22 827 7641
sekretariat@ethnomuseum.pl
www.pme/waw/pl
Tue, Thur, Fri 9–4; Sat–Sun 10–5, Wed 11–6

The museum's permanent collection houses many
pieces of work by native Polish visionary artist
Edmund Monsiel.

Edmund Monsiel

RUSSIA

MOSCOW MUSEUM OF OUTSIDER ART

30 Izmailovski Blvd., 105043 Moscow
t: +7 (0)495 465 6304
outsider@izmaylovo.ru
www.museum.ru/outsider
Wed–Sun 12–7pm

Russia's only independent Museum of Outsider
Art, located in central Moscow. More than 200
Russian, East European and international artists
are featured, including R.Zharkikh, P.Leonov,
Vasiliev, I.Osipov, A.Rudov and A.Lobanov.

Museum of Outsider Art

RUSSIA

MUNICIPAL MUSEUM OF NAIVE ART

15-A Soyuznyi Avenue, 111396 Moscow
t: +7 (0)495 301 03486
musnaive@aha.ru
www.russianmuseums.info/M2086

The first state museum in Russia devoted to the
collection, preservation and popularisation of
Russian native art and crafts.

Boris Pavlov

SERBIA

MUSEUM OF NAÏVE AND MARGINAL ART

Boska Duricica 10, 35000 Jagodina
t: +381 (0)35 223 419
mnujagodina@gmail.com
www.naiveart.org.yu
Tue–Fri 10–5, Sat–Sun 11–3

Large collection of Serbian and former-Yugoslav
naïve art. It includes work by Emerik Fejes, Janko
Brasic, Ilija Bosilj and Sava Sekulic.

Ilija Bosilj

SLOVAKIA

SLOVAK NATIONAL GALLERY
Reicna 1, 81513 Bratislava
t: +421 (0)25443 2081
info@sng.sk
www.sng.sk
Tue–Sun 10–6

In addition to its own collection of naïve art, every three years the Museum is host to the large INSITA exhibition which combines naïve art from Eastern Europe with Outsider Art from the rest of Europe and the United States.

Ondrej Steberl

SWITZERLAND

ADOLF WÖLFLI FOUNDATION
Kunstmuseum Berne,
Hodlerstrasse 8-12, 3000 Berne 7
t: +41 (0)31 328 09 44
www.adolfwoelfli.ch
Tue 10–9, Wed–Sun 10–5

The Foundation holds an archive and most of Wölfli's work, including his massive illustrated volumes, although only a selection of works are on public exhibition at any one time.

Adolf Wölfi

SWITZERLAND

COLLECTION DE L'ART BRUT
Avenue des Bergières 11, 1004
Lausanne
t: +41 (0)21 315 25 70
art.brut@lausanne.ch
www.artbrut.ch
Tue–Sun 11–6, July & Aug: daily 11–6

The Collection de l'Art Brut opened in 1976. A historically important institution in the realm of Art Brut, the museum came into being thanks to Jean Dubuffet's major donation of a body of 6,500 works. Today, the holdings of the museum come to over 66,000 works by international artists, and it hosts some 40,000 visitors annually.

Pascal Maisonneuve

SWITZERLAND

MUSEE CANTONAL DES BEAUX-ARTS
Palais de Rumine,
Place de la Riponne 6, 1014 Lausanne
t: +41 (0)21 316 34 45
info.beaux-arts@vd.ch
www.musees-vd.ch
Tue–Wed 11–6, Thur 11–8, Fri–Sun 11–5

This regional museum holds works by local Outsider artists Aloïse Corbaz and Louis Soutter.

Aloïse Corbaz

SWITZERLAND

MUSEUM IM LAGERHAUS
Davidstrasse 44, 9000 St Gallen
t: +41 (0)71 223 5857
www.museumimlagerhaus.ch
Tue–Fri 2–6, Sat–Sun 12–5

The *Stiftung für schweiserische Naive Kunst und Art Brut* includes an extensive Outsider Art and folk art in a permanent collection and holds regular exhibitions..

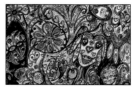
Ella Maier

SWITZERLAND

PSYCHIATRIC MUSEUM
Bolligenstrasse 111, 3000 Berne 60.
t: +41 (0)31 930 9756
www.puk.unibe.ch/cu/museum/museu
mra.html
Wed–Sat 2–5 & by appt.

Based on the collection assembled by Dr Morgenthaler, including former patients at the Waldau Asylum, Heinrich Anton Müller and Adolf Wölfli. The collection includes Wölfli's decorated furniture.

Adolf Wölfli

ALABAMA

BIRMINGHAM MUSEUM OF ART
2000 8th Avenue North,
Birmingham, AL 35203
t: 205 254 2565
museum@artsbma.org
www.artsbma.org
Tue–Sat 10–5, Sun 12–5

Large folk art representation including works by JB Murray, Charlie Lucas, William Edmondson, Howard Finster, Sister Gertrude Morgan, Mary T Smith, Clementine Hunter and Mose Tolliver.

JB Murray

ALABAMA

FAYETTE ART MUSEUM
530 North Temple Avenue, Fayette,
AL 35555
t: 205 932 8727
www.fayette.net/chamber/locart.htm
Mon, Tues, Thur & Fri 9–12 & 1–4
Folk art galleries also open Sun 1–4

Alabama folk artists Jimmy Lee Sudduth, Rev. BF Perkins, Sybil Gibson and others are showcased in the Folk Art Galleries.

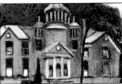
Jimmy Lee Sudduth

ALABAMA

MONTGOMERY MUSEUM OF FINE ARTS
Wynton M. Blount
Cultural Park, 1 Museum Drive,
Montgomery, AL 36117
t: 334 240 4333
museuminfo@mmfa.org
www.mmfa.org Tue–Sat 10–5, Sun 12–5

This museum holds a large collection of works by Bill Traylor and other well known Southern folk artists including Clementine Hunter and Mose Tolliver.

Bill Traylor

CALIFORNIA

MUSEUM OF CRAFT & FOLK ART
51 Yerba Buena Lane,
San Francisco, CA 94103
t: 415 227 4888
info@mocfa.org
www.mocfa.org
Mon–Fri (closed Wed) 11–6, Sat–Sun 11–5

Changing exhibitions are complemented by education programmes, workshops, panel discussions and publications.

Museum of Craft & Folk Art

FLORIDA

THE MENNELLO MUSEUM OF AMERICAN ART
900 E. Princeton
Street, Orlando, FL 32803
t: 407 246 4278
mennello.museum@cityoforlando.net
www.mennellomuseum.org
Tue–Sat 10.30–4.30, Sun 12–4.30

Core collection of paintings created by the Florida self-taught painter Earl Cunningham. Permanent collection of 20th Century American folk art. Changing exhibitions of American art to include American folk art.

Earl Cunningham

GEORGIA

HIGH MUSEUM OF ART
1280 Peachtree Street, N.E.
Atlanta, GA 30309
t: 404 733 4400
www.high.org
Tue–Sat 10–5, Sun 12–5

The museum has a dedicated folk art section, including many rescued items from Howard Finster's Paradise Garden.

Nellie Mae Rowe

GEORGIA

MORRIS MUSEUM OF ART
1 Tenth Street, Augusta, GA 30901
t: 706 724 7501
morrismuseum@themorris.org
www.themorris.org
Tue–Sat 10–5, Sun 12–5

Museum of Southern art and culture with a large collection of folk art including works by Minnie Evans, Howard Finster, Sister Gertrude Morgan, Jimmy Sudduth, Bill Traylor and Mose Tolliver.

Nellie Mae Rowe

ILLINOIS

ART INSTITUTE OF CHICAGO
111 South Michigan Avenue, Chicago, IL 60603-6404
t: 312 443 3600
www.artic.edu
Mon–Fri 10.30–5, Sat–Sun 10–5

Large holding of Joseph Yoakum drawings and archival material but not on permanent exhibition. Also holds works by Henry Darger and Lee Godie.

Joseph Yoakum

ILLINOIS

INTUIT: THE CENTER FOR INTUITIVE AND OUTSIDER ART
756 N. Milwaukee Avenue, Chicago, IL 60642
t: 312 243 9088
www.art.org
intuit@art.org Tue–Sat 11–5

Intuit promotes public awareness, understanding, and appreciation of intuitive and outsider art through education, exhibition, collecting and publishing.
Intuit is also the home of The Henry Darger Room Collection; the contents of Henry Darger's Chicago Apartment, a gift of Kiyoko Lerner.

Darger's room

ILLINOIS

ROCKFORD ART MUSEUM
711 N. Main Street, Rockford, IL 61103
t: 815 968 2787
staff@rockfordartmuseum.org
www.rockfordartmuseum.org
Mon–Sat 10–5, Sun 12–5

An expanding permanent collection of folk art. Artists represented from the American South include Thornton Dial, Sam Doyle, Lonnie Holley, JB Murray, Mose Tolliver and Purvis Young.

Thornton Dial

KANSAS

GRASSROOTS ART CENTER
213 South Main Street, Lucas, KS 67648
t: 785 525 6118
grassroots@wtciweb.com
www.grassrootsart.net
May–Sep: Mon–Sat 10–5, Sun 1–5
Oct–Apr: closed Tues, Wed, Fri

The museum displays numerous works and includes an extensive resource library. The site also plays host to concerts, 'trash art' children's classes and a large collection of sculpture by Ed Root in the rear courtyard.

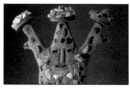

Ed Root

KENTUCKY

KENTUCKY FOLK ART CENTER
102 West First Street, Morehead, KY 40351
t: 606 783 2204
m.collinswor@moreheadstate.edu
www.kyfolkart.org
Mon–Sat 9–5, Sun 1–5 (excl Jan–Mar)

A collection of over 1000 pieces that includes the works of ZB Armstrong, Minnie Black, RA Miller, BF Perkins, QJ Stevenson, Jimmy Sudduth, Mose Tolliver and Purvis Young.

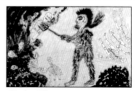

Charley Kinney

KENTUCKY

OWENSBORO MUSEUM OF FINE ART
901 Frederica Street,
Owensboro, KY 42301
t: 270 685 3181
mail@omfa.museum
www.omfa.us
Tue–Fri 10–4, Sat–Sun 1–4

Jessie and Ronald Cooper, James Harold Jennings SL Jones, Tim Lewis, BF Perkins and Jimmy Lee Sudduth all feature in the permanent collection.

Ronald Cooper

LOUISIANA

AFRICAN HOUSE
Melrose Historic Home, Melrose
Plantation, Melrose, LA 71452
t: 318 379 0055
parrishvj@aol.com
www.preservenatchitoches.org
daily 12–4

The walls of the upper storey of this historical museum are entirely covered with Clementine Hunter creations. The house is now owned by the Association for the Preservation of Historic Natchitoches. Hunter worked at the plantation as field hand and a cook at the Melrose mansion.

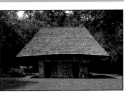

African House

LOUISIANA

LOUISIANA STATE MUSEUM
Madame John's Legacy, 632 Dumanine
Street, New Orleans, LA 70116
t: 504 568 6968 /800 568 6968
lsm@crt.state.la.us
http://lsm.crt.state.la.us/madam.htm
Tue–Sun 9–5

With an emphasis on southern folk and regional Outsider Art, the museum holds work by Clementine Hunter and Mary T Smith within its permanent collection.

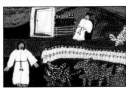

Mary T Smith

LOUISIANA

NEW ORLEANS MUSEUM OF ART
1 Collins Diboll Circle, City
Park, New Orleans, LA 70124
t: 504 658 4100
www.noma.org
Wed 12–8, Thu–Sun 10–5

Large collection of contemporary American folk art, including works by David Butler, Raymond Coins, Thornton Dial, William Edmondson, William Hawkins, Sister Gertrude Morgan, Nellie Mae Rowe, St EOM, Mary T Smith and Jimmy Lee Sudduth.

Sister Gertrude Morgan

MARYLAND

AMERICAN VISIONARY ART MUSEUM
800 Key Highway, Inner
Harbor, Baltimore, MD 21230
t: 410 244 1900
info@avam.org
www.avam.org
Tue–Sun 10–6

America's first museum specialising in Outsider and visionary art. In addition to the large gallery rooms, it also includes permanent installations, a shop, restaurant and important resource library. Guest curators bring different perspectives to annual large themed exhibitions.

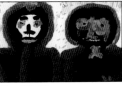

American Visionary Art Museum

MISSISSIPPI

MISSISSIPPI MUSEUM OF ART
380 South Lamar Street,
Jackson, MI 39201
t: 601 960 1515
www.msmuseumart.org
Tue–Sat 10–5, Sun 12–5

The museum's folk art collection includes works by Burgess Dulaney, James Harold Jennings, BF Perkins, Royal Robertson, Herbert Singleton and Jimmy Lee Sudduth.

B.F. Perkins

NEW JERSEY

THE NEWARK MUSEUM
49 Washington Street, Newark,
NJ 07102-3176
t: 973 596 6550
www.newarkmuseum.org
Wed–Sun 12–5

An extensive collection of American folk art includes a large representation of William Edmondson and works by Eddie Arning, Hawkins Bolden, Minnie Evans, William Hawkins, the Philadelphia Wireman and Bill Traylor.

William Edmondson

NEW JERSEY

SELDEN RODMAN COLLECTION OF POPULAR ARTS
Ramapo College of NJ, 505 Ramapo Valley Rd, Mahwah, NJ 07430
t: 201 684 7147
www.ramapo.edu/berriecenter/galleries/rodman.html Tue 1–4.30, Wed 1–7

A champion of humanism in the arts, Selden Rodman always insisted that invention in form alone is not enough. The self-taught artists in his collection express universal human concerns – birth, death, love, war, and survival – with unique focus on each individual culture, be it Haitian, Caribbean, Brazilian or American.

La Fortune Felix

NEW MEXICO

MUSEUM OF INTERNATIONAL FOLK ART
Museum Hill, 706 Camino Lejo, Santa Fe, NM 87505
t: 505 476 1200
info@moifa.org
www.moifa.org
Tue–Sun 10–5

Large holding of international folk art includes the Girard Collection of over 100,000 objects from around the world. There are strong representations from Mexico and South America as well as more recent additions such as Nek Chand's sculptures from India.

Anna Zemánková

NEW YORK

AMERICAN FOLK ART MUSEUM
45 West 53rd Street, New York, NY 10019
t: 212 265 1040
info@folkartmuseum.org
www.folkartmuseum.org
Tue–Sun 10.30–5.30, Fri 10.30–7.30

Home to one of the world's finest collections of folk and Outsider Art and the Henry Darger Study Center. Works by Nek Chand, Thornton Dial, William Edmondson, William Hawkins, Nellie Mae Rowe, Eugene Von Bruenchenhein and Adolf Wölfli. It organises major exhibitions and produces accompanying scholarly publications.

Henry Darger

NEW YORK

FENIMORE ART MUSEUM
5798 State Highway 80 (Lake Road), Cooperstown, NY 13326
t: 607 547 1400
info_fenimore@nysha.org
www.fenimoreartmuseum.org
April–Dec: Tue–Sun 10–4

Originally a large historical folk art collection, it has been supplemented by a growing holding of contemporary American folk art, including Edmondson, Finster, Hawkins, Sudduth and Mose Tolliver.

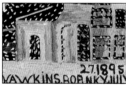
William Hawkins

OHIO

AKRON ART MUSEUM
1 South High, Akron, OH 44308
t: 330 376 9185
mail@akronartmuseum.org
www.akronartmuseum.org
Tue–Sun 11–5, Thur 11–9

Works by Elijah Pierce, David Butler, Justin McCarthy, Sister Gertrude Morgan, Joseph Yoakum and other folk and Outsider artists are included in the permanent collection of this museum.

Justin McCarthy

OHIO

COLUMBUS MUSEUM OF ART
480 East Broad Street, Columbus,
OH 43215
t: 614 221 6801
info@cmaohio.org
www.columbusmuseum.org
Tue–Sun 10–5.30, Thurs 10–8.30

The Museum boasts the largest public collection of woodcarvings by Columbus folk artist Elijah Pierce. Also featured in the permanent collection are William Hawkins, SL Jones and Edgar Tolson.

Elijah Pierce

PENNSYLVANIA

LEHIGH UNIVERSITY ART GALLERIES 420 E. Packer Ave,
Bethlehem, PA 18015
t: 610 758 3615
www.luag.org
Wed–Sat 11–5, Sun 1–5

The permanent collection includes works by Howard Finster and members of the Finster family. Commissioned environmental pieces by Mr Imagination and international Outsider artists are installed in the grounds.

Mr Imagination

TENNESSEE

CHEEKWOOD FINE ARTS CENTER 1200 Forrest Park Drive,
Nashville, TN 37205
t: 615 356 8000
info@cheekwood.org
www.cheekwood.org
Tue–Sat 9.30–4.30, Sun 11–4.30

This includes an impressive gallery devoted solely to the work of Nashville Outsider artist, William Edmondson.

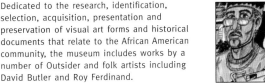
William Edmondson

TEXAS

AFRICAN AMERICAN MUSEUM
3536 Grand Avenue, Dallas Fair Park,
Dallas, TX 75315
t: 214 565 9026
www.aamdallas.org
Tue–Fri 12–5, Sat 10–5, Sun 1–5

Dedicated to the research, identification, selection, acquisition, presentation and preservation of visual art forms and historical documents that relate to the African American community, the museum includes works by a number of Outsider and folk artists including David Butler and Roy Ferdinand.

Roy Ferdinand

TEXAS

THE ART CAR MUSEUM
140 Heights Blvd, Houston, TX 77007
t: 713 861 5526
info@artcarmuseum.com
www.artcarmuseum.com
Wed–Sun 11–6

The museum is dedicated to art cars, and has another exhibition space at 1502 Alabama, Houston 77004, for exhibitions of contemporary fine art.

Phantom by T. Burge

TEXAS

ORANGE SHOW CENTER FOR VISIONARY ART
2402 Munger St, Houston, TX 77023
t: 713 926 6368
oranges@orangeshow.org
www.orangeshow.org
Sat–Sun 12–5, Summer: Wed–Fri 9–1

The Orange Show Center for Visionary Art preserves the Orange Show and Beer Can House, produces the world's largest art car parade and celebrates the artist in everyone.

The Orange Show

VIRGINIA

ABBY ALDRICH ROCKEFELLER FOLK ART MUSEUM 325 West Francis Street, Williamsburg, VA 23185
t: 757 220 7698
www.history.org/history/museums/abby_art.cfm
daily 10–7

A collection of traditional and antique folk art with a smaller contemporary section.

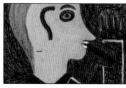
Eddie Arning

VIRGINIA

TAUBMAN MUSEUM OF ART
110 Salem Avenue SE, Roanoke, VA 24011
t: 540 342 5760
info@taubmanmuseum.org
www.taubmanmuseum.org
Tue–Sat 10–5, Sun 12–5

This museum holds an extensive folk and visionary art collection which includes works by Leroy Almon, Richard Burnside, JJ Cromer, Howard Finster, James Harold Jennings, Mose Tolliver, Purvis Young and others.

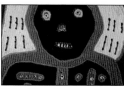
Richard Burnside

WASHINGTON DC

SMITHSONIAN AMERICAN ART MUSEUM
8th & F Streets, Washington, DC 20004
t: 202 633 1000
saaminfo@si.edu
www.americanart.si.edu
daily 11.30–7

The museum houses America's largest collection of Outsider, folk and naïve art, including James Hampton's Throne of the Third Heaven. Regular exhibitions display aspects of the collection.

James Hampton

WISCONSIN

ANTHONY PETULLO COLLECTION OF SELF-TAUGHT AND OUTSIDER ART
219 N. Milwaukee St, 3rd floor, Milwaukee, WI 53202
t: 414 272 2525
www.petulloartcollection.org

A 400 piece collection of European and American twentieth century artworks. The collection is housed in a non-profit educational centre with rotating exhibitions. Artists include Amézcua, Darger, Dixon, the Gugging artists, Scottie Wilson, Nek Chand, Adolf Wölfli.

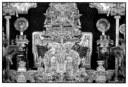
Josef Karl Rädler

WISCONSIN

JOHN MICHAEL KOHLER ARTS CENTER 608 New York Ave, Sheboygan, WI 53081
t: 920 458 6144
lumberger@jmkac.org
www.jmkac.org
open daily

JMKAC is an internationally acclaimed leader in the fields of self-taught, folk and vernacular art, especially artist-environments. Its collections, aspects of which are always on view, include major holdings of Blagdon, Chand, Nohl, Charles Smith, Von Bruenchenhein, etc.

Eugene Von Bruenchenhein

WISCONSIN

MILWAUKEE ART MUSEUM
700 North Art Museum Drive, Milwaukee, WI 53202
t: 414 224 3200
mam@mam.org
www.mam.org
daily 10–5, Thur 10–8

Large holding of American contemporary folk art and Outsider Art, including Henry Darger, William Edmondson, Dwight Mackintosh, Howard Finster, JB Murray, Nellie Mae Rowe, Joseph Yoakum and Bill Traylor. It also holds an extensive collection of Haitian art as well as a representation of European Outsiders, including Adolf Wölfli.

Howard Finster

Intuit

756 N. Milwaukee Ave., Chicago, IL 60642 USA
T 312.243.9088 intuit@art.org
F 312.243.9089 www.art.org
Tues - Sat 11-5, Thurs 11-7:30

Intuit: The Center for Intuitive and Outsider Art promotes public awareness, understanding, and appreciation of intuitive and outsider art through education, exhibition, collecting and publishing.

Intuit is also the home of *The Henry Darger Room Collection*; the contents of Henry Darger's Chicago apartment, a gift of Kiyoko Lerner.

photo © 2007

Organisations

BRITAIN

BARRINGTON FARM ARTISTS
Barrington Farm, Walcott, Norfolk NR12 oPF
t: +44 (0)1692 650633 roar_art@hotmail.com
 www.roarart.com

Barrington Farm is a unique arts centre for adults with learning disabilities. Artists include Leofric Baron, Roy Collinson, Barbara Symmons, Michael Smith and Ian Partridge.

Roy Collinson

CANADA

LES IMPATIENTS
100 Sherbrooke St. E., Suite 4000, Montreal, Quebec H2X 1C3
t: 514 842 1043 info@impatients.ca
 www.impatients.ca

We provide a place of artistic expression to people suffering from mental health problems and work to demystify this illness by disseminating their work.

Romain Peuvion

FINLAND

KETTUKI ART CENTRE
Keinusaarentie 1, Hämeenlinna, Häme 13200
t: +358 44 259 2294 esa.vienamo@kettuki.fi
 www.kettuki.fi

Kettuki Art Centre is Finland's nationwide art centre for people learning disabilities

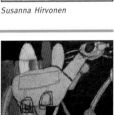

Susanna Hirvonen

GERMANY

ATELIER HPCA
Hirschplanallee 2, Oberschleissheim/Munich 85764
t: +49 (0)89 31581 161 atelier@hpca.de
 www.atelier-hpca.de

atelier hpca, by Augustinum Munich comprises of a studio community of mentally handicapped artists, a connected gallery and its own art collection. Also at www.euward.de.

Thomas Schlimm

JAPAN

atelier incurve
1-1-18　Uriwariminami, Hiranoku, Osakashi, Osaka 5470023
t: +81 (0)6 6707 0165 info@incurve.jp
 http://incurve.jp

Atelier incurve founded in 2002 is Japan's first art studio for people with mental and developmental disabilities. Artists of atelier incurve devote themselves to their creative activities with the support from the Japanese government and certain culture-conscious companies.

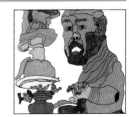

Tomoyuki Shinki

UK / USA

NEK CHAND FOUNDATION

1 Watford Road, Radlett
Herts WD7 8LA, UK
t: +44 (0)1923 853175
(Julia Elmore, administrator)
nekchand@rawvision.com
www.nekchand.com

P.O. Box 567, Madison,
WI 53701, USA
t: +1 608 249 7042
(Tony Rajer, coordinator)
rajert@gdinet.com
www.nekchand.org

see page 222 for full details of volunteer trips etc

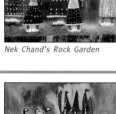

Nek Chand's Rock Garden

USA

ARTS AND SERVICES FOR DISABLED, INC.

3962 Studebaker Road, #206, Long Beach, CA 90808
t: 562 982 0247

info@artsandservices.com
www.artsandservices.org

ASD provides opportunities to transform and transition lives of individuals with intellectual and developmental disabilities personally, educationally, and vocationally through the creative arts.

Arts & Services

USA

ART CONSERVATION SERVICES

P.O. Box 567, Madison, WI 53701
office: 608 249 7042
cell: 920 246 1407

rajert@gdinet.com

Specialising in the conservation of l'Art Brut, Folk Art and Eccentric Visionary work, such as Nek Chand, Nick Engelbert, Rudy Rotter.

Master at work

USA

ARTS OF LIFE

2110 W. Grand Ave., Chicago, IL 60612
t: 312 829 2787

info@artsoflife.org
www.artsoflife.org

An artistic community providing developmentally disabled adults an environment to experience personal growth. Daily working beyond the dynamic art created cultivating self-respect, independence, and building community.

Veronica Cuculich

USA

CENTER FOR THE ARTS AT LITTLE CITY FOUNDATION

1760 W. Algonquin Road, Palatine, IL 60067
t: 847 221 7761

ftumino@littlecity.org
www.littlecityarts.org

The Center for the Arts serves developmentally disabled artists, providing an environment for the creation of textile, media and studio arts. Through community outreach, promotion and exhibitions, it has become known for the quality and diversity of the art being produced there. Harold Jefferies, Charles Beinhoff, Tarik Echols.

Harold Jefferies

USA

GAGA ARTS CENTER
55 W. Railroad Avenue, Garnerville, NY 10923
t: 845 947 7108

info@gagaartscenter.org
www.gagaartscenter.org

On the first weekend every May, GAGA presents its annual Outside In Exhibition. GAGA Arts Center is also the home of the Ted Ludwiczak Stonehead Project. The creation of this amazing visionary environment of sculptures began in 2008 and will continue to grow for many years to come.

Ted Ludwiczak

USA

GATEWAY ARTS
60–62 Harvard Street, 2nd Floor, Brookline, MA 02445
t: 617 734 1577

gatewayarts@vinfen.org
www.gatewayrarts.org

For over 30 years, Gateway Arts, a service of Vinfen, has been providing self taught and other artists with disabilities the opportunity to create, exhibit and sell their work. Over 100 artists with support and facilitation from a staff of professional artists, occupy extensive studio space with an onsite gallery and crafts store.

Robert Kirshner

USA

INTERACT CENTER FOR THE ARTS
212 Third Ave. North, Suite 140, Minneapolis, MN 55401.
t: 612 339 5145

info@interactcenter.com
www.interactcenter.com

We are a professional-level visual arts studio and theatre that supports the creative growth of 100+ artists with disabilities. Creating work that is captivating, inspiring and recognised as a significant statement in the visual arts, Interact Artists' work is affordable and highly collectable in the contemporary arts environment.

Interact Center

USA

NAEMI
PO Box 350891, Miami, FL 33135
t: 954 922 8692

naemi@bellsouth.net
www.naemi.org

NAEMI is an international organisation dedicated to discovering, promoting and exhibiting artwork by artists with mental illnesses with presence in USA and the European Union.

Mario Mesa

USA

ORANGE SHOW CENTER FOR VISIONARY ART
2401 Munger Street, Houston, TX 77023
t: 713 926 6368

info@orangeshow.org
www.orangeshow.org

The Orange Show Center for Visionary Art preserves the Orange Show and the Beer Can House, produces the world's largest art car parade and celebrates the artist in everyone.

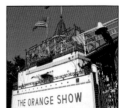

The Orange Show, Houston

Publications

OUTSIDER ART
SOURCEBOOK

L'ART BRUT fascicules

Collection de l'Art Brut, Avenue des Bergières 11, CH 1004 Lausanne, Switzerland
t: +41 (0)21 315 25 70 art.brut@lausanne.ch
 www.artbrut.ch

CHF 48 each

The *L'Art Brut* series of fascicules, originally edited by Jean Dubuffet, provides in-depth analysis and information on the Collection artists. Published in French, with numerous illustrations. Over Twenty issues have appeared to date.

CREATION FRANCHE

58 Avenue du Maréchal-de-Lattre-de-Tassigny, 33130 Bègles, France
t: +33 (0)5 56 85 81 73

French journal produced by the Musée de la Création Franche and dedicated to the 'ordinary geniuses' of art. A lively magazine that includes articles covering French and international artists and environments.

DETOUR ART

Kelly Ludwig
t: 816 686 9219 queenodesign@detourart.com
 www.detourart.com

Detour Art highlights art and images by visionaries, untrained artists, and folk creators found along the back roads of America. It honours the creative spirit that is at once traditional and whimsical, spiritual and irreverent, earthy and sublime. This full-colour, hard-bound book features 99 artists (including photographs of 37 environments).

FOLK ART

American Folk Art Museum, 45 West 53rd Street, New York, NY 10019, USA
t: 212 265 1040 info@folkartmuseum.org
 www.folkartmuseum.org
Annual subscription rate for members is included in membership dues.
Single copy $10.00

Folk Art magazine, formerly *The Clarion,* is the publication of the American Folk Art Museum and is sent to Museum members. The magazine covers a range of subjects, from antique quilts and frontier portraits to major figures of contemporary folk art.

FOLK ART MESSENGER

PO Box 17041, Richmond, VA 23226, USA
t: 800 527 FOLK (3655)/+1 804 285 4532 fasa@folkart.org
 www.folkart.org

sub rates vary

Membership publication of the Folk Art Society of America, *Folk Art Messenger* features articles on individual artists, reports on events and a regular exhibitions calendar.

GAZOGENE

108 rue Jean-Baptiste-Delpech, 46000 Cahors, France
2 issues per year

This French review focuses on various forms of singulier and marginal subjects, but also specialises in presenting historical material on French environments and early Art Brut artists.

MOSE TOLLIVER A to Z

Anton Haardt Gallery, 2858 Magazine Street, New Orleans, LA 70115 USA
t: 504 891 9080 anton3@earthlink.net
 www.antonart.com

Mose T From A to Z: The Folk Art of Mose Tolliver by Anton Haardt
Available at Capital Books & News Company at 1140 E Fairview Avenue, Montgomery, Alabama, New Orleans Garden District Books and at the gallery. Price is $46 plus $5 shipping and handling. The book has been awarded the prestigious Nautilus Silver Award and New York Book Festival Art/Photography Award.

THE OUTSIDER

Intuit: The Center for Intuitive and Outsider Art
756 N. Milwaukee Avenue, Chicago, IL 60642 USA
t: 312 243 9088 intuit@art.org
2 issues per year www.art.org/theOutsiderMag/current.htm

The newsletter of Intuit, The Outsider provides in-depth coverage of Intuit's exhibits, programs and special events as well as other important discoveries in outsider art. Free with Intuit Membership, back issues available for purchase.

RAW VISION

P.O. Box 44, Watford WD25 8LN, UK
t: +44 (0)1923 853175 info@rawvision.com
 www.rawvision.com

Leading international journal of Outsider Art, Art Brut, contemporary folk art and the marginal arts. Featuring articles on artists and visionary environments from every corner of the globe, plus exhibitions, book reviews and international news.

WILLIAM THOMAS THOMPSON

thompsonart99@hotmail.com
arthompson.com

Website featuring work of visionary artist. *Art World of William Thomas Thompson, Visionary Artist: Genesis to Revelation* is a 84 page, 8.5 x 11 inch Art Book available from xlibris.com in hard or soft cover.

Websites

ACCIDENTAL MYSTERIES

www.accidentalmysteries.com

A website featuring vernacular photography through the collection of John and Teenuh Foster. These collected 'found' snapshots have been hand-picked from estate sales, antique shops and auctions. They include not only ordinary snapshots but scientific photographs, press photos, school pictures, photobooth pictures and travel slides.

ANIMULA VAGULA

http://animulavagula.hautetfort.com

French website under the direction of writer Jean-Louis Lanoux which features a variety of art brut subjects and environments.

ALP MAGIE

www.alpmagie.ch

Swiss outsider artist Ueli Dubs presenting his latest book in German and his homepage in English/German: objets trouvés.

ART INSOLITE

www.art-insolite.com

Discover Art Singulier, Art Brut, Insolite, Hors Norme, Marginal and Outsider. French website presenting a rich variety of self-taught artists and environments in photographs and film.

ART ON THE STREET

www.artonthestreet.net

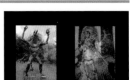

On the street is where Joseph Eschenberg gets the inspiration and materials for many of his projects. He works mostly with mixed media and mixed surfaces.

ART SINGULIER

www.art-singulier.eu

French based website that focuses on self-taught artists and detailed documentation of visionary environments.

ARTESIAN

www.artesian-art.org

Website of former Scottish Outsider Art magazine that still contains much useful information on British and international outsider and self-taught artists.

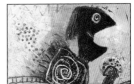

BEVERLY KAYE GALLERY

www.artbrut.com
blog: http://BeverlyKayeGallery.blogspot.com/

Award winning website for Beverly Kaye Gallery. 400 strong images and supporting text focusing on Art Brut, Outsider Art, *Neuve Invention*, Pueblo and edgy Contemporary Art.

Alexandra Huber

BRITISH OUTSIDER ART

www.britishoutsiderart.com

Website featuring biographical details and art of British Outsiders. Full details on museums, collections, past and current exhibitions and events. Photographs, videos and information on artists, environments and related subjects.

CANDYCE BROKAW

www.visionary-art.net

Candyce Brokaw is a self-taught artist and curator. She has been exhibited Internationally in France, Austria, Canada and the Netherlands as well as throughout the USA. Her work is created through stream of consciousness, embedded with characters from her family and past. She is also the Founder & Director of Survivors Art Foundation.

Toasted with Shades

COLLECTION DE L'ART BRUT

www.artbrut.ch

The website features historical information and articles on the museum, biographical data on the museum artists, full details on current and past exhibitions, museum-related events, workshops for children, guided tours and the museum bookshop.

DARK BLACK ART

www.darkblackart.com

Self-taught visionary artist Steven V Mitchell won international acclaim for his sculpture and tattoo work until he found full creative freedom in painting.

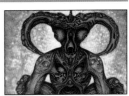

Homage

279

DETOUR ART

www.detourart.com

Detour Art is an online outsider and visionary art resource of over 2,000 artists, folk art environments and sites, as well as galleries, museums and collections. Includes links to outsider resources, photos and more.

DONNA BALMA GALLERY

http://donna.balma.net

Donna Balma is a self-taught artist living in the northwest Pacific coast of British Columbia. She began to paint her visions at age 54.

EILEEN SCHAER

www.eileenschaer.com

Self-taught artist Eileen Schaer creates enchanting works from her imagination.

ERIK VON PLOENNIES

www.ErikVP.com

Self-taught, primitive abstract, mixed media artist whose art is an improvisational collage of random thoughts, feelings, inspiration, engineering, mathematics, and New York City.

HAPPY HOUR KITTY ART

www.happyhourkittyart.com

Unique, one-of-a-kind repertoire of mixed-media pieces with a whimsical, quirky attitude, intuitively created from a never ending supply of re-purposed found items and ephemera.

HELLFIRE POTTER'S CLUB

www.hellfirepottersclub.co.uk

Self taught visionary outsider Michael Duffey uses a hypnotic graphic device of mushroom gills and makes his subjects mushroom, balloon, mutate or insinuate themselves into unexpected forms.

Michael Duffey, Two Flowers

INTUIT

www.art.org

Intuit's website features information on past and present Intuit events, exhibitions, publications and education programs; as well as links to other Outsider art sites and sources. intuit@art.org

LAURA CASTELLANOS

www.lauracastellanos.com

Urban visionary art created by Laura Castellanos. Laura talks about her work on her television feature, available at www.seattlechannel.org.

LOCATING THE SOUL

http://www.perlentaucher.de/buch/29011.html

Link to the excellent guide to Museums of Psychiatry in Europe by Rolf Brüggemann and Gisela Schmid-Krebs: *Verortungen der Seele / Locating the Soul.*
Text in Engllish and German.

MARY MICHAEL SHELLEY

www.maryshelleyfolkart.com

Painted low-relief woodcarvings since 1974. Every one is original: diners, farms, dreams. Call her what you will, she just keeps working. Yes. Yes. Please visit.

MATCHSTICK MARVELS

http:/marvelsofmatchstick.50webs.com

Website showcasing the work of famed Indian matchstick artist Pradeep Kumar whose work is in several European and American museums and collections. Also features his chalk stick sculptures of figures and deities.
swami_nrw@yahoo.com

Pardeep Kumar

MATT SESOW

www.sesow.com

Struck by the propeller of a landing airplane as a child, Sesow is highly collectable and uncommon. His website is updated daily with new paintings.

NARROW LARRY

www.narrowlarry.com

Documenting nearly 20 years of pilgrimages to visionary folk art environments in the United States. An essential reference and source of information.

NORBERT KOX

www.apocalypsehouse.com

Artwork of contemporary religious painter and apocalyptic visionary Norbert Kox.
Contact: nhkox@yahoo.com

PAMELA IRVING

www.pamelairving.com.au

Whimsical and quirky Australian artist working over the past 25 years in mosaic, clay, bronze and making hand-coloured limited edition etchings. The wacky world of Pamela's own creations and collaborations.

RARE VISIONS

www.rarevisionsroadtrip.com

Interactive website and public television series for those who appreciate the road less travelled. Discover America's best Outsider Art and offbeat attractions with Randy, Mike and Don the Camera Guy. Maps, information and images for art sites such as the Garden of Eden, Luna Parc, and Isaiah Zagar, plus Howard Finster, Melissa Polhamus etc.

RAW ART LINK

www.rawartlink.com

Dedicated to helping anyone interested in Raw Art.

The site also contains artwork by Piers Midwinter.

Piers Midwinter

RAW VISION

www.rawvision.com

Website of the world's only international magazine of Outsider Art, Art Brut and Contemporary Folk Art. Now published for over 20 years. Subscribe, order back issues and books. Special offers. Latest news. Index of artists and articles, PDF versions etc. Links to galleries, artists and organisations.

RIDGE ART

www.ridgeart.com

The site showcases a large collection of Haitian Vodou flags, paintings, sculpture, works on paper from Africa and Cuba as well as tribal arts.

Maxon Sylla

RUDY ROTTER

www.rudyrotter.com

Thousands of sculptures made by dentist-turned-artist, including wood carvings, assemblages, collages, ceramic and plastics.
Dr Rudy Rotter Museum of Sculpture
851 North 5th Street, Manitowoc, Wisconsin 54220-3356 t: 920 684 8394

Rudy Rotter Museum

SARDINE

www.sardine.ch

Une sardine collée au mur is in English and French. The site offers virtual exhibitions (with three sizes of picture for each art piece, details, artists and biographies). It has a secured payment system, free e-cards, texts and many links to explore the Outsider Art World.

Ignacio Carles-Tolrà

TIM CHESS

www.timchess.com

Self-taught artist Tim Chess's work is prolific and varied, spanning 16 years. His work is featured at Slotin, America Oh Yes!, and Hurn Museum.

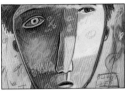

Tim Chess

WILLIAM THOMPSON

www.arthompson.com
The artwork of William Thomas Thompson; *Apocalyptic art of William Thomas Thompson; 7 Days of Creation* by William Thomas Thompson; Gassaway Mansion Art Museum.
www.thecolorfulapocalypse.com Collaborations by William Thomas Thompson and Norbert H. Kox thompsonart99@hotmail.com

ZAK ZAIKINE

www.zakzaikine.com

Zak Zaikine has been a professional artist for 46 years. In 1982 Jay Johnson of American Folk Art Heritage Gallery called him a Neo-Folk Artist. It has stayed.

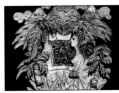

Zak Zaikine

RV Index

OUTSIDER ART SOURCEBOOK

RAW VISION MAGAZINE
issues 1 – 65
1989 – 2008
SUBJECT INDEX

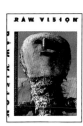

RV#1 1989

RV#2 1989

RV#3 1990

RV#4 1991

RV#5 1991

RV#6 1992

RV#7 1993

RV#8 1993

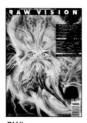

RV#9 1994

RV#10 1994

RV#11 1995

RV#12 1995

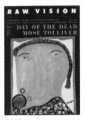

RV#13 1995

RV#14 1996

RV#15 1996

RV#16 1996

RV#17 1996

RV#18 1997

RV#19 1997

RV#20 1997

RV#21 1997

RV#22 1998

RV#23 1998

RV#24 1998

RV#25 1998

RV#26 1999

RV#27 1999

RV#28 1999

RV#29 1999

RV#30 2000

RV#31 2000

RV#32 2000

RV#33 2000

RV#34 2001

RV#35 2001

RV#36 2001

RV#37 2001

RV#38 2002

RV#39 2002

RV#40 2002

RV#41 2002

RV#42 2003

RV#43 2003

RV#44 2003

RV#45 2003

RV#46 2004

RV#47 2004

RV#48 2004

RV#49 2004

RV#50 2005

RV#51 2005

RV#52 2005

RV#53 2005

RV#54 2006

RV#55 2006

RV#56 2006

RV#57 2006

RV#58 2007

RV#59 2007

RV#60 2007

RV#61 2007

RV#62 2008

RV#63 2008

RV#64 2008

RV#65 2008/9